The visual arts in Germany 1890–1937

MANCHESTER
UNIVERSITY PRESS

THE VISUAL ARTS IN GERMANY
1890–1937 • Utopia and despair

SHEARER WEST

Manchester University Press

Published by Manchester University Press
Oxford Road, Manchester M13 9NR, UK
and Room 400, 175 Fifth Avenue, New York, NY 10010, USA
http://www.manchesteruniversitypress.co.uk

British Library Cataloguing-in-Publication Data
A catalogue record for this book is available from the British Library

ISBN 0 7190 5278 5 *hardback*
 0 7190 5279 3 *paperback*

First published 2000

07 06 05 04 03 02 01 00 10 9 8 7 6 5 4 3 2 1

Typeset in Sabon with Futura display
by Graphicraft Ltd, Hong Kong
Printed in Great Britain
by Alden Press, Oxford

To my daughter, Eleanor, with hopes for her generation

Contents

List of illustrations

Every effort has been made to obtain permission to reproduce the illustrations. If any proper acknowledgement has not been made, the copyright-holder is invited to contact the publisher

Preface and acknowledgements

Synoptic accounts of art historical periods are not, at the moment, fashionable, and there are some good reasons for this. Recent cultural theories have under-mined structural views of history and have inspired scholars to adopt a micro-historical approach which has much to commend it. Certainly, a sceptical view of narrative history is healthy, but it has been clear to me for some time that students and those who are new to art history still need some kind of frame-work or perspective from which to start. I hope that this book will serve such a purpose. I have tried to learn from those historians and art historians who have made me question approaches to history, and I have therefore tried to avoid over-simplifications or an excessive reliance on narrative. Instead, I have aimed to pull out a series of overlapping themes and discourses that I feel give this very distinct period of modernity in Germany some sort of coherence. I have tried to be accessible without sacrificing academic integrity and to provide enough basic information to allow an intelligent beginner to follow the threads of analysis. This has not always been easy to do – especially as I am wading into an area dominated by close analysis and archival research. The text as it stands has been through several drafts and 'rest' periods, and I could no doubt continue to rest it and draft it until I retire. I do not pretend to the impossible goal of being exhaustive, or of present-ing every angle, but I hope the book will clarify some of the major issues of an exciting and problematic period of German modernity and will provide a starting point for thinking further about some of these issues.

Germany has always been a fascination and a passion for me. When involved in other research projects, I have continually returned to it and found renewed interest each time. I have also taught German art for a number of years now, with a growing realisation that there is a need for a book like this one that ranges widely over German modernism, rather than focusing on its component elements, and which attempts to look at both 'fine art', and photography, film and illus-trated journals. There are many excellent books on the German *fin de siècle*, Expressionism, and visual culture in the Weimar Republic. There are books which sweep over the twentieth century, or see German modernism as part of a Europe-wide phenomenon. To my knowledge, there is not a book which serves the pur-pose of this one – a thematic study of the visual arts in Germany from the Secession movements of the 1890s to Hitler's 'Degenerate Art' exhibitions of 1937. Ideally a book like this would be lavishly illustrated, but the now prohibitive costs of copyright and reproduction mean that I have had to be more modest in my choice of illustration than I would have liked. The problems all art historians now face in trying to publish any illustrated text have become a deterrent to writing books that include essential reproductions. I am grateful for the assistance of all the

German museums and galleries, as well as private individuals, who waived or reduced reproduction fees in the understanding that an academic book like this one deserves support.

As many readers of this book may not read German, I have ensured that all quotations from the German are translated. Wherever possible, I have made use of the many good translations of primary German texts available; when necessary, I have translated passages myself and included the original German in the notes.

My fascination with German visual culture, language and history has been fuelled by a number of individuals over the years. I am especially indebted to my students at Leicester University and Birmingham University who participated in my special subjects on German modernism. I owe a great debt to Marsha Meskimmon, who has been a collaborator and a friend for many years now, and to my former student, Dorothy Rowe, who has become a successful German specialist. I am grateful as well to my German language tutors – Rhys, Sean and Bettina – who were patient with an adult learner without natural fluency. I have been continually inspired by the many rigorous and clear-sighted scholars of German modernism who have made the subject both accessible and interesting to a sometimes resistant English-speaking audience.

I am deeply grateful to the British Academy, who awarded me a small personal research grant in 1993 to travel to Germany and fill some of the many gaps in my visual education and understanding. I would like to thank the staff at the British Library, the British Film Institute, the Taylorian and Bodleian Libraries, Oxford, and the libraries of the Universities of Birmingham, Warwick and Leicester for their help with the research for this book. I am grateful to the Leicester Urban History Centre for giving me the opportunity to air an early draft of chapter 2 and to use my ideas in a distance learning video. I received many helpful criticisms on an earlier manuscript of this book from both Colin Rhodes and Marsha Meskimmon, as well as the anonymous reader at Manchester University Press. I have tried to take all their points on board, but the deficiencies in the manuscript are entirely my own. Without the support and patience of all the staff at Manchester University Press, the manuscript may never have come to fruition. I owe a special debt to my colleagues at Birmingham University, particularly David Hemsoll, who took on the onerous job of Acting Head of Department during my study leave in 1999, and thus allowed me trouble free time to finish the book. As always, I thank Nick and Eleanor, for creating a supportive and stimulating environment that makes writing a pleasure.

Introduction

HISTORIANS of modern Germany have long debated the distinctiveness of German historical development from the time of Bismarck's attempts to unify the country through political and administrative reforms from the 1870s, to Hitler's more savage campaign for cultural homogeneity in the 1930s. The *Sonderweg*, or special path, of German history has dominated historical thinking, even among those scholars who interpret Hitler's rise to power as an anomaly, rather than an inevitable development from the previous 70 years.[1] A strong tradition of authoritarianism from the time of Bismarck's reign as Chancellor, combined with the wreckage of the First World War, the unsettled period of revolution and the political compromises of the Weimar Republic are all seen as the fertilisers for what finally happened in the 1930s, when Hitler made genocide and world conquest his megalomaniac goals. Culture has long been identified as one of the foundation stones of Hitler's eventual rise to power, and the formal reunification of Germany in 1992 led to renewed attempts to understand cultural history in the light of the unique and horrible events of Germany's modern period.[2] Fritz Stern's seminal study, *The Politics of Cultural Despair* of 1961 continues to convince that the seeds of Nazism were sown through German cultural development many decades before Hitler's assumption of power.[3]

However, Stern's concern in his book was for culture in its anthropological sense – that is, all the institutions that foster a society's distinctiveness, whether they be legal, educational or literary. The visual arts have only a small role to play in his argument, as the history of art in Germany during the same period undermines any attempts to read history as a coherent entity. The arts have been interpreted as mirroring the political vicissitudes of Germany during the period of unification, but they can more appropriately be seen as resisting, as well as feeding into, the dominant political discourses. While the modernisation of Germany moved rapidly forward from unification in 1871, the arts and the art world lagged behind, only to undergo dramatic changes from the 1890s onwards. From this point, German modernism remained in a somewhat unique position, being simultaneously carried by the pull of avant-gardism while remaining ensconced within a prevalent cultural traditionalism. Somewhat in opposition to Stern's all-encompassing approach, the vast literature about German art and visual culture from unification to the First World War rarely attempts to categorise the period as a whole, to isolate its salient features, or to tease out its ambiguities. It is always dangerous to interpret a phase of history or art history in any sort of Hegelian sense, as leading inevitably

to some dramatic conclusion. However, the visual arts in Germany from the 1890s until the beginning of the Second World War is characterised by a number of obvious tensions and ambivalences that can be related to its perceived cultural mission. In terms of the visual sphere, Hitler's cultural politics can be seen as a grotesque anomaly which appropriated, then subverted, the experiments of the avant-garde.

Nevertheless, in viewing this period as an art historical entity, it is important not simply to look at the works produced during these years in terms of modernist taxonomies of style, but to peer beneath these categories to discover the important social, political, economic and cultural factors which made German art what it was. Therefore, although focusing primarily on the visual arts – that is, painting, sculpture and graphic work – this book will consider these media in relation to a wider idea of German visual culture. By visual culture, I am referring not only to 'high' art such as easel painting, but to other aspects of modern mass media, such as film and illustrated journals as well as performance and design. While this may seem too all-encompassing, the practitioners of these diverse aspects of modern German visual culture shared many themes, aspirations and aesthetic concerns.[4] In the period of German modernism, from the Secession movements of the 1890s until Hitler's degenerate art exhibitions in 1937, categories of high and low, elite and mass visual culture interpenetrated and both responded to, and fed into, the same social, political and cultural tropes.[5]

Although there has been a large literature on various aspects of German visual culture, studies of European modernism have traditionally privileged Paris as the site of innovation and avant-gardism.[6] While there are good reasons for this emphasis, German artists' persistent concern with social, philosophical and wider cultural and political issues seem anomalous in the light of narratives of modernism that stress abstraction and art for art's sake. However, the varied and complex activities of artists in Germany from the 1890s onwards are in some respects paradigmatic of the ways in which modernisation impinged upon the theories and practices of European artists as a whole.

Although it is difficult, and even misleading, to separate the cultural, social and political in histories of German art, political and social change worked in counterpart to artistic modernism. In political terms, the period 1871–1940 was an era of unity, which can be studied as a distinct historical entity bounded on one end by Germany's victory in the Franco-Prussian War (and subsequent unification), and on the other by the Second World War, the final result of which was a new division of Germany along political lines. But cultural unity does not naturally follow political unity, and the continuation of regional traditions, loyalties and rivalries militated against a truly unified country for many years. Unlike Italy, where the drive for cultural unity after the Risorgimento seemed unrealisable, German high culture veered relentlessly towards a coherent solution to the fragmentation of German society. This compulsion for unity was facilitated in Germany by the consolidating power of the German language, as well as the efficacy of a national education system. Neither of these factors was implemented as successfully in Italy, where regionalism remained prevalent even after Mussolini and local dialects were spoken by the majority of the population. In Germany, state institutions,

a rigorously organised political system and the talismanic authority of the German language nudged the newly formed country in the direction of cultural unity more swiftly.

It is worth investigating the Janus-faced role of the visual arts in the wake of unification. In a number of ways, art evinced or supported the drive for unification. First of all, art academies, which had been focused on competing regional centres throughout the nineteenth century were superseded by new institutions of art which became alternative points of cohesion. Rebellions against academic hegemony by Secession movements in Munich, Berlin and Vienna during the 1890s led to separate arenas for artistic display, while new forms of private and public training schools drew aspirant artists away from the traditional teaching methods of the art academies. Such training and exhibition societies looked to international styles and tendencies in art, rather than to the local traditions which had informed academies. As part of this new internationalism, a well-organised commercial system of art dealership and art publishing developed and helped obliterate the regional boundaries that had made previous German art so diverse in aim and function. While Munich, Dresden, Cologne and other major German cities continued to have important and distinct art lives of their own, Berlin increasingly came to dominate the art market and thus became a lure for artists throughout the German-speaking world. The very presence of such a cultural centre by 1914 indicates just how far Germany had come from a federation of culturally distinctive states to a unified nation with unified institutions.

This cultural unity was facilitated by traditions of German Romanticism, which led to a theorisation of the function of the arts, and an idealism about art's role in society that fed into the modernist art movements of the early twentieth century. Hans Belting has examined this streak of Romanticism in German art and has identified it as one cause of the tendency of scholarship to assign more programmatic meanings to German modernism than to that of other Western European nations.[7] It is a stereotype of modern German art history that the Germans intellectualised their art, while the French responded more to the pure plastic qualities of form and colour, but underlying such nationalist stereotypes is a grain of truth. The Romanticism of the nineteenth century lingered on in an altered form until the First World War, while Nietzsche became the late Romantic bible of several generations of artists. Expressionist artists of the Brücke and Blaue Reiter groups were among the most enthusiastic admirers of Nietzsche, but most artists of the modern period read or knew Nietzsche's theories of the *Übermensch* (superman or higher man) and the regenerating power of art.[8] This was particularly true of the avant-garde which perceived itself as a sort of new elite with a cultural mission. Avant-garde artists and groups evolved notions of recreating art afresh as a means of wiping out the traces of bourgeois philistinism that they felt lingered from the Biedermeier period of the nineteenth century. Such elitism may have separated avant-garde artists from the vast majority of the population, but they saw themselves as harbingers of a new unified age. The idealist tendencies of German Romanticism did not fully lose their impetus until well after Germany's losses in the First World War and the subsequent period of revolution, when such idealism no longer seemed appropriate.

Although it is possible to isolate a certain amount of institutional and theoretical unity during this period, the question of artistic style renders the issue more problematic. At the end of the nineteenth century, stylistic eclecticism remained, even while artists such as Max Liebermann and Lovis Corinth developed their own form of Impressionism, and artists such as Paula Modersohn-Becker and Karl Schmidt-Rottluff looked to the Post-Impressionist colourism of Gauguin and Van Gogh, as well as the art of the Fauves. Adoption of foreign, and especially French, styles prevailed in the early twentieth century, but our perception of German art is skewed from 1905 onwards by the dominance of what we now call Expressionism. To a certain extent, Expressionism could be considered the distinctive German style during the period of unity. By the First World War it was recognised nationally and trumpeted as the modern style for a modern German age, and even after the war, its vestiges lingered, particularly in graphic media and film. However, Expressionism was not the endemic style that many claimed, and its very popularity was achieved in part through the support of commercial and cultural institutions which conspired to give the 'movement' a false coherence. For German art dealers and exhibition organisers, it was important that German art appeared both modern and distinct from the art of other nations, particularly France. Expressionism filled this bill nicely, but it was a label applied to a variety of works by a range of artists, including those from outside Germany itself.

In these variant ways the period of political unity seems to have obtained some of the nation's goals for cultural unity, but the visual arts in Germany from 1890 were more notably characterised by a series of disunities, polarities and ambivalences which were sometimes reconciled but more often existed in unstable parallel with each other. Despite discursive calls for cultural unity, Germany, like all modern nation-states, was a hybrid entity, with a plurality of classes, cultures and institutions that resisted the totalising tendencies of a holistic Germany, even while they internalised or even promoted some of its components.[9] In an attempt to write a history of the visual arts during this period, it is important to identify what these tensions were, as their existence reveals more about the state of modern German culture than any apparently seamless historical or stylistic narrative.

First of all, extreme political divisiveness was an issue in both party politics and in the politics of visual culture. Right-wing extremism never entirely disappeared from German political life, although it often took more muted forms in political parties devoted to specific nationalist or religious issues. In terms of the visual arts, the cultural conservatism of Kaiser Wilhelm II at the end of the nineteenth century was later echoed by Hitler, as both favoured a form of classical idealism which denied ugliness as well as overt modernity. While the dominant artistic ideology during a large part of this period was thus academic classicism, the artists who obtained the most notable international reputations were non-academic artists, many of whom had strong affiliations with left-wing politics. This is particularly true after the German Revolution of 1918, when the mildly leftist Novembergruppe embraced Expressionism, and the vehemently communist Berlin Dada circle used new techniques of photomontage for tendentious ends. Throughout the period, art

styles and subject-matter contained some sort of political resonance – if not a party-political message – and such politicising of art prevented any easy reconciliation of artistic styles and subject-matter.

Politics permeated all aspects of culture, but perhaps more essential for an understanding of the disunities in German visual culture during this period is the relationship between regionalism, nationalism and internationalism in German society.[10] As mentioned above, regionalism was eroded as commercial institutions of art gravitated towards Berlin while modernist artists showed their sympathy with the recent stylistic developments of other countries, particularly France. But regional sympathies lingered, and more than one generation of artists continued to be trained in regional academies, even while the avant-garde made Berlin its home. Regionalism prevailed after the First World War when Dada artists formed groupings in Berlin, Hanover and Cologne, while Expressionist supporters of the German Revolution founded societies in Kiel, Dresden and other cities. Academic artists continued to train in regional academies, and to work, but during the majority of this period, they were outside the mainstream of the international commercial art world and an art publishing industry that increasingly promoted modern styles. Without the continued strength of local tradition, it would have been impossible for Hitler to mobilise so effectively a whole army of artists during the 1930s to paint Nazi-approved subject-matter in the academic style.

While developing both regional and national cultural habits and institutions, German artists also cultivated international relationships. At the end of the nineteenth century, German artists saw France as a rival; but many of them were lured by the innovations of artists living in Paris, and Impressionism, Cubism and Fauvism were all embraced, even while an anti-French rhetoric pervaded much art criticism. The British Arts and Crafts movement provided an inspiration for a new emphasis on craft and design. In the 1920s, the modernity of America and the experimentation of communist Russia were the two attractions for artists who sought to internationalise their works. German artists looked to different forms of cultural authority in a spirit partly of emulation and partly of competition. German art could often be defined by what it was not, so that a careful adoption of foreign styles could be incorporated into an aesthetic that could be seen as distinctly German.

In considering these relationships between regionalism, nationalism and internationalism it is equally important to observe the boundaries of Germany itself. This book is concerned primarily with Germany, but it would be artificial to deny the essential place of neighbouring German-speaking nations to the development of modern German visual culture. The boundaries of Germany may have seemed firmly drawn in the 1890s, but the Balkan Wars that preceded the First World War and Hitler's annexation campaigns indicated just how fluid the political boundaries actually were (figure 1). The cultural historian Benedict Anderson has argued that a sense of nation is contingent upon modernising forces which foster linguistic unity through mass media and educational reform.[11] If people speak the same language, attend the same school system and read the same newspapers, they will learn to think of themselves as a nation, however illusory this category may appear to be. The German language did not exist only in Germany, but in Austria and Switzerland, as

well as the high culture of Hungary and Poland. A feeling of Germanness was possible outside the geographical boundaries of Germany itself. Although perhaps a study of the visual arts in modern Germany should be confined within the historical geography of Germany, it would be artificial to ignore aspects of Austrian, Swiss and Hungarian culture in a number of cases where cross-fertilisation is crucial to our understanding of Germany itself.

The disunities apparent in Germany during this period were exacerbated by tensions between traditionalism and modernity in most spheres of visual culture. Germany's industrial revolution came later than that of some other European nations, but it was also quicker and more effective. Unlike Italy and France, where rural peasant traditions lingered long after urban modernisation, Germany had become a wholly modern industrial nation by the First World War. Certainly many artists and writers were enthusiastic about the possibilities of a modern Germany, and particularly the growing metropolitan cultures which seemed to open up possibilities for new ways of life. But the enthusiasm for the city that coloured the rhetoric of such Futurist sympathisers as Ludwig Meidner was the exception, rather than the rule. Although artists

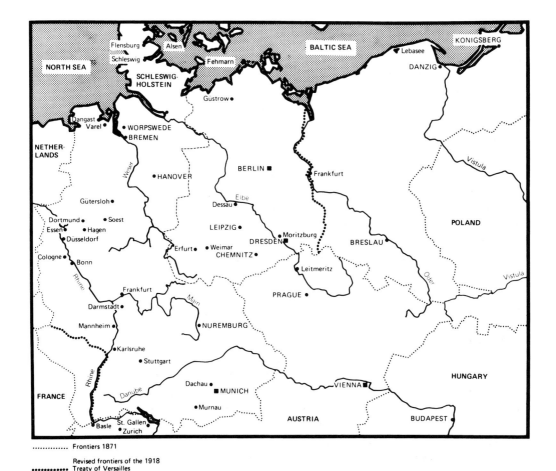

............ Frontiers 1871

Revised frontiers of the 1918
●●●●●●●●●● Treaty of Versailles

---------- East German Frontiers

1 Map of Germany

avidly sought the commercial benefits of urban culture, they also embraced a creed of ruralism that lingered from the mid-nineteenth century. The city enabled artists to compete in the modern commercial world, but the country offered them their inspiration. These seeming opposites were held in balance by many artists during the period of unity. The worship of German peasant culture and rural life, which was a strong component in right-wing ideology, was also common to artists who nevertheless saw the city as their main home and source of income. Without the possibilities opened up by modernity, these artists would not have been able to market their rural idylls quite so effectively.

Tradition and modernity coexisted in other aspects of visual culture as well. Many of the Secession 'rebels' of the 1890s combined the novelty of French Impressionism with the conventionality of academic subject matter. Expressionist groups explored primitivism and Germany's medieval heritage in the context of their distinctly modern styles and obsessions. The Werkbund and the Bauhaus balanced concern for the possibilities of mass production with ideals about the social role of art. Even Hitler – who may be thought to have turned the clock back in every way – made effective use of mass media and technology in his propaganda campaigns.

One of the consequences of modernisation was a pluralism of media and the new possibilities of mass media. The age of mechanical reproduction, as it was christened by Walter Benjamin, potentially enabled artists to evolve more effective means of mass culture. Painting, sculpture and graphic art dominated visual culture before the First World War, but during the Weimar Republic film and illustrated journals superseded them in importance. These latter media were potentially available to a much larger population who did not require any particular artistic understanding or education, while painting and sculpture continued to have a more limited appeal, albeit to a fairly broad sector of the middle class. Different media existed side by side, and one could argue that they were complementary, rather than competing. However, their very existence, and the complexities of their functions, render any consideration of this period of German history more problematic. The many strands of visual culture, whether intended primarily for aesthetic, communicative or propagandist purposes created fractures: the audiences were different, the works themselves were multi-coded, their media became part of the message they intended to convey – a message that was not always understood, or could be deliberately distorted.

Another ambivalence of German modernity was the coexistence of a commercial art market with an idealistic view of artistic freedom and purposes. The new and effective machinery of dealers, commercial exhibitions and critics did not simply support the careers of avant-garde artists, but at times could even create a movement or an artist's reputation. Herwarth Walden's journal, *Der Sturm* codified the aesthetics of Expressionism, just as G. F. Hartlaub in 1925 invented an oppositional 'movement' called *Neue Sachlichkeit* (New Objectivity). However, amidst the sometimes brutally commercial culture of the avant-garde prevailed a discourse of artistic freedom, genius, struggle and heroism that rested uneasily with the uncompromising demands of the marketplace.[12] This valorising of predominantly male practitioners created an

additional paradox. There were many women producers and consumers of visual culture during the period of unity, but despite the important contribution of artists such as Käthe Kollwitz, Hannah Höch, Gabriele Münter, Emmy Hennings; poets like Else Lasker-Schüler and patrons such as Nell Walden, Rosa Schapire and 'Mutter' Ey, the theory and practice of the avant-garde continued to relegate women to traditional gender roles.

The institutional, commercial and rhetorical unities of Germany during the period 1890–1937 were thus ruptured by disunity on nearly every level of cultural production and consumption. However, this does not rule out the necessity of considering this period as a whole, of balancing the competing strands against each other, and of finding a way through the material that involves neither a simple recounting of styles and movements, nor an avoidance of the problems that such a survey involves. I have subtitled this book *Utopia and Despair* partly in ironic reference to my own aspirations and frustrations in attempting to understand and convey the complexities of German cultural history. But the terms also serve to suggest the extreme contradictions of a period in which artists and architects could strive for world-saving solutions, while succumbing to a deep disgust with the present state of humanity. The Nietzschean discourse of the Brücke artists was tinged with both idealism and contempt. Kandinsky's apocalyptic visions foresaw a new world which could be created only when the old one had been destroyed. Bruno Taut's fairy-tale crystal cities were conceived at the same time that Max Beckmann disparaged the corruption of the human condition. The Bauhaus was initially organised to recreate a medieval community spirit, but it gradually abandoned this ideal to face the realities of the post-war economic situation. But the terms 'utopia' and 'despair' also indicate the aspirations for cultural unity which underlay a number of the artistic experiments of the period, while drawing attention to the palpable fractures which made such hopes unrealisable. The irony of the cultural situation in Germany was that the desires of individuals and groups worked against any form of cohesion, until unity was finally imposed violently by Hitler.

The term 'utopia' indicates the persistence of Romanticism that still retained a strong hold in cultural circles until the First World War. It alludes to the prevalence of spiritual solutions to cultural problems – ones that were adopted by artists who looked to theosophy or philosophy for their inspiration. It also refers to total environments and modernist answers to housing shortages that were devised by architects, especially after the First World War – few of which solved the problems they sought to address. It evokes as well the hopes – especially of left-wing artists and writers – that art could somehow gain a wider appeal, that it could help educate and better the lives of a mass population. I chose the term 'utopia', rather than 'idealism' because in each instance, an explicit or implicit critique of contemporary culture underlay the often unrealisable goals of artists, architects and film makers. Utopias are propositions for alternative worlds, but they are also judgements on the existing world.

Despair, on the other hand, I have adopted unashamedly from Fritz Stern's classic study, *The Politics of Cultural Despair*, which I mentioned at the beginning of this introduction. Stern's work is crucial to an understanding

of German culture during this period, as he shows the cultural strands that made Nazism so accessible to a broad population. I am not adopting Stern's teleology, nor do I feel that such an interpretation is wholly appropriate for the visual arts of Germany in this period. In a sense, my use of his word allows me to engage in a dialogue with his theory. The 'despair' which underlay much cultural rhetoric of this time was not the driving force in the visual arts, but a constant disillusionment and disappointment that ideals were not, or could not, be realised. By the 1920s the dominance of the *Neue Sachlichkeit* in art, literature, film and journalism connoted a sense of detachment and knowingness borne of a deep cynicism. The ultimate disillusionment came with the power Hitler so quickly gained and exploited.

The number of choices that had to be made in writing a book of this scope was enormous, and not always in conformity to previous histories of the period. Indeed, published surveys of German art rarely isolate this particular period for attention, perhaps because of the problems involved.[13] It is much simpler (although perhaps misleading) to see the history of visual culture in terms of styles and artists, which organise history differently than political and social events. German art historians, for instance, have understandably felt more comfortable concentrating on individuals and movements and thereby avoiding any obvious pandering to nationalist sentiment.[14] The Secessionist 1890s is treated as part of the history of Symbolism or art nouveau, while Expressionism is given a separate, coherent block, and the dominant *Neue Sachlichkeit* mode of the Weimar Republic is considered as an entirely discrete issue. Media studies embrace film and illustrated journals, while architectural histories construe the history of housing projects and town planning as a subject requiring separate treatment.[15] In attempting to reconcile these diverse aspects of the visual arts, I have undoubtedly failed to give each individual strand the full attention it deserves, but I feel that looking across boundaries is an essential step on the path to understanding why the visual was so important to German modernity.

To an extent, I have retained a chronological basis for my book. The chapters are thematic, yet together they constitute a roughly (although not exclusively) chronological continuance. More important to me are the themes which dominate the visual culture of the period, and I have tried to tackle these themes in what I hope is a sensible and enlightening way. In the process, I have not always 'followed the rules' of writing a standard history of art, nor have I succumbed entirely to the canons of German modernism. This was necessary in order to survey a familiar period with a fresh perspective. The most obvious case of this is the place of Expressionism in the book. Although Expressionism forms a very important point of my argument, I have avoided the tendency of recounting the histories of the Brücke and Blaue Reiter groups in a primarily narrative way. This may seem perverse, but I felt that it was important to examine these very different movements in terms of the cultural themes that informed them. It may seem artificial to avoid the blanket category 'Expressionism' as a means of explaining the dominant aesthetic tendency of the period, but given the problematic nature of the term, and its commercial origins (discussed in chapter 4), I felt that overemphasis on it would obfuscate, rather than enhance, the significance of the book's themes.

The eight chapters of this book attempt to engage with the political, social and cultural discourses which created and sustained the visual culture of Germany from the time of the Secession movements of the 1890s to Hitler's 'Degenerate Art' exhibitions in the late 1930s. It does not answer all the questions, but attempts to address them in a new way and one which, I hope, will allow the reader to think not only about the development of German cultural history, but about the function of visual culture in modern society.

NOTES

1 For the *Sonderweg*, see Michael Laffan (ed.), *The Burden of German History 1919–45*, London, 1988.

2 See, for example, Walter Grosskamp, 'A historical continuity of disjunctures', in Irit Rogoff (ed.), *The Divided Heritage: Themes and Problems in German Modernism*, Cambridge, 1991, pp. 14–23. For the problems of modernist art and post-war disunity, see Yule F. Heibel, *Reconstructing the Subject: Modernist Painting in Western Germany 1945–50*, Princeton, 1995.

3 Fritz Stern, *The Politics of Cultural Despair: A Study in the Rise of Germanic Ideology*, Berkeley, 1961.

4 Deborah Cherry gave a subtle and astute analysis of the vagaries of the term 'visual culture' in a lecture at the conference 'Visual Culture: Interpretation, History and the Human Sciences', held at the University of East Anglia, 11–13 September 1998. For a typical all-inclusive definition, see John A. Walker and Sarah Chaplin (eds), *Visual Culture: An Introduction*, Manchester and New York, 1997, pp. 1–2: 'visual culture can be roughly defined as those material artefacts, buildings and images, plus time-based media and performances, produced by human labour and imagination, which serve aesthetic, symbolic, ritualistic or ideological-political ends, and/or practical functions, and which address the sense of sight to a significant extent'. See also Nicholas Mirzoeff (ed.), *The Visual Culture Reader*, London, 1998.

5 See Jeffrey Weiss's thorough and convincing analysis of the symbiosis between mass and high visual culture within French modernism in his *The Popular Culture of Modern Art: Picasso, Duchamp and Avant-Gardism*, New Haven and London, 1994.

6 Richard Brettell's recent survey history of modernism is a case in point. Although he admits that master narratives of modernism privilege French art, he also finds it difficult to avoid perpetuating this tendency in his otherwise very helpful and readable account. See Richard Brettell, *Modern Art 1851–1929: Capitalism and Representation*, Oxford, 1999.

7 This problem is explored by Hans Belting, *The Germans and Their Art: A Troublesome Relationship*, New Haven and London, 1998.

8 For Nietzsche's influence on the arts, see, for example, Steven Aschheim, *The Nietzsche Legacy in Germany 1880–1990*, Berkeley and Oxford, 1992; Richard Hinton Thomas, *Nietzsche in German Politics and Society 1890–1914*, Manchester, 1983; Jürgen Krause, *'Märtyrer' und 'Prophet': Studien zum Nietzsche-Kult in der bildenden Kunst der Jahrhundertwende*, Berlin, 1984; Seth Taylor, *Left-Wing Nietzscheans: The Politics of German Expressionism 1910–1920*, Berlin and New York, 1990; and Ivo Frenzel, 'Prophet, pioneer, seducer: Friedrich Nietzsche's influence on art, literature and philosophy in Germany', in C. Joachimides, Norman Rosenthal and Wieland Schmied (eds), *German Art in the Twentieth Century: Painting and Sculpture 1905–1985*, exhibition catalogue, London, 1985, pp. 75–81.

9 Homi Bhabha expresses these fractures most eloquently when he talks about the nation as 'an uneven, incomplete production of meaning and value, often composed of incommensurable demands and practices, produced in the act of social survival'. See Homi Bhabha, *The Location of Culture*, London and New York, 1994, p. 172.

10 For a very interesting discussion of the ways nationalism, internationalism and regionalism coexist in modernist discourse, see Serge Guilbaut, *How New York Stole the Idea of Modern Art*, Chicago, 1983.

11 Benedict Anderson, *Imagined Communities: Reflections on the Origin and Spread of Nationalism*, London and New York, 1991.

12 A persuasive argument about this tension is contained in Robert Jensen, *Marketing Modernism in Fin-de-Siècle Europe*, Princeton, 1994. See also Robin Lenman, 'Painters,

patronage and the art market in Germany 1850–1914', *Past and Present*, 123 (1989), 109–40.

13 For examples of different periodisations, see Joachimides *et al.*, *German Art*; Eckhart Gillen (ed.), *German Art from Beckmann to Richter: Images of a Divided Country*, New Haven and London, 1997; *Art et résistance: les peintres allemands de l'entre-deux guerres*, The Hague, 1995; *Figures du moderne 1905–14: Dresde, Munich, Berlin: l'expressionisme en Allemagne*, exhibition catalogue, Paris, 1992; Ulrich Finke, *German Painting: From Romanticism to Expressionism*, London, 1974; *Symboles et réalités: La peinture allemande 1845–1905*, exhibition catalogue, Paris, 1985; and Keith Hartley, Henry Meyrich Hughes, Peter-Klaus Schuster and William Vaughan (eds), *The Romantic Spirit in German Art 1790–1990*, exhibition catalogue, London, 1994.

14 Belting, *The Germans and Their Art*, p. 35.

15 A notable exception to this is Stephanie Barron and Wolf-Dieter Dube (eds), *German Expressionism: Art and Society*, London, 1997, but this book focuses solely on Expressionism.

Unity and fragmentation: institutions, Secessions, Jugendstil

The problem of the spiritual union of Germany has comprised the content of our history since 1871 . . . The Bismarck of Germany's spiritual union will be an artist. (Albert Dresdner, *Der Weg der Kunst*, 1904)[1]

IN mapping a history of the visual arts in modern Germany, it is first necessary to understand the uneasy symbiosis between political and social change, on the one hand, and cultural change, on the other. It is misleading to separate the political history of modern Germany from its visual history, but it is equally false to posit either one as the cause of the other. When Bismarck emerged victorious from the Franco-Prussian War after the Armistice of 1871, the domestic consequence was the unification of Germany. As Germany had existed in up to 1,800 separate states in the past, the task of unification, begun by Napoleon, was lengthy and complex. The imposition of national political systems after Bismarck retained a place for regional government, and individuals maintained a loyalty to their local states that was not challenged by an abstract notion of a modern, united Germany. In the 20 years or so following unification, dramatic changes in both political life and cultural life therefore coexisted with deep-seated traditions, regional loyalties and fiercely held factional religious and political beliefs. Unification was thus a chimera, but national unity had a rhetorical strength not only in political theory, but in writings about art, literature, music and other spheres of life. During the 75-year period of German unification from 1870 to 1945 – when Germany was again divided – the consequences of artificial political union without concomitant cultural union can be traced.

In the first 30 years of this period, old and new mingled, coexisted and competed.[2] Art became an arena in which the opposing extremes of regionalism and internationalism appeared together in an odd coupling. The continuance of an academy system alongside regional Secession and art nouveau movements that had international pretensions became the focus of this fluctuating and ambivalent new German culture. While changes in the art world manifested themselves locally in Berlin and Munich, artists reached out to an international audience and market, as well as to cognate arts such as music and theatre. Histories of European modernism traditionally represent this period of turmoil as existing on a trajectory of rebellion and progression. The Secession movements and art nouveau have been read as releasing visual culture from moribund academic traditions and prejudices, forming the first real German avant-garde.[3] While there is truth in this perspective, it is perhaps more useful

to view this period as one in which a desire for international recognition fuelled the motivation of artists who otherwise worked within quite local systems and institutions.[4]

Bismarck devoted most of his post-unification energies to political reformism, and he built up a powerful contingent of middle-class support through his advocacy of a liberal parliamentary government. The years between 1870 and 1890 were known as the *Gründerzeit*, or 'taking-off period', as this was a time of transformation, and the growth of bourgeois political and economic power. While focusing on legal, political and social changes, and the implementation of a new national parliamentary government, Bismarck had little time for art. However, he realised that without cultural cohesion, Germany would remain fragmented and thus emasculated. His solution was a negative one – the *Kulturkampf* ('culture battle') of the 1870s. This was an attempt to achieve secondary integration by gagging the strong Catholic element in the German education system. By secularising educational institutions, Bismarck hoped to smash the power of the Catholic Centre party and break off allegiance between Catholic Germany and the Pope. Although extreme, his efforts were in line with those of other countries in Europe with strong Catholic constituencies, including France and Italy. European liberalism called for a rejection of the power of the church. Bismarck's interest in *Kultur* was thus concentrated on educational systems, rather than on the fine arts. His repressive measures were ultimately unsuccessful, and he never turned more directly towards art as a means of achieving this cultural integration. Indeed, during his 20 years as Reich Chancellor, the production of art remained directed by institutions which had been founded as far back as the late eighteenth century.[5]

By the early part of the nineteenth century, each major city in Germany had its own art academy, and each academy had different reputations and specialisms which varied from one decade to another. Munich, Berlin, Weimar, Dresden, Düsseldorf and Hamburg, among other cities, had academies, and it was common for an artist to move away from his home to study with a particular specialism at one or other of these centres. The training received in the academy was complemented by the work of regional exhibition societies, the *Kunstvereine* (art unions), which were responsible for regular showings of artists' work. The *Kunstverein* was designed to encourage local art, and thus stimulate the art market. These unions purchased works of art, exhibited them, then sold them off by lottery, thus increasing the potential buyers for art, but also enabling a levelling middle-class taste to prevail.[6] The 'democratic' profile of the *Kunstverein* resulted in a sort of eclecticism that did not favour one particular style or subject over another. Aside from the common nature of these institutions, it is impossible to talk about German art as an entity before and immediately after unification. The Romanticism of the first half of the nineteenth century had created an ostensible unity by valorising Germany's mythical and heroic past, but even the Romantics were torn between Johann Wolfgang von Goethe's passion for the classical world and Friedrich von Schlegel's evocation of Germany's medieval Christian heritage.

There was, for instance, a certain amount of variety in academy practice. The success of such artists as Franz Lenbach, Anton von Werner, Hans Makart and Ferdinand Piloty rested on the use of academic training to appeal to the

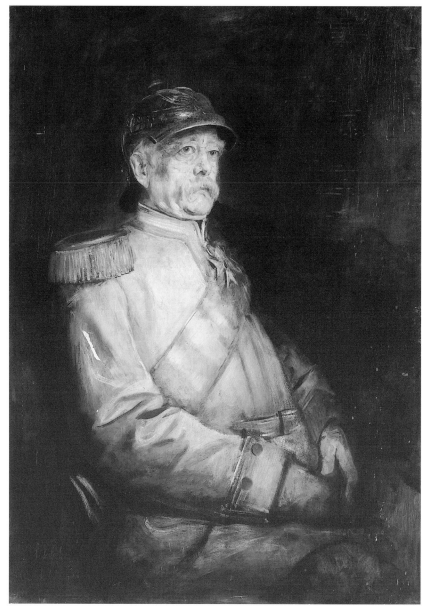

2 Franz Lenbach, *Portrait of Otto von Bismarck*, 1880s

interests and obsessions of the liberal middle class that asserted itself during the *Gründerzeit*. Piloty, Makart and Werner were history painters whose works contributed to a glorification of Germany's past as well as of the new regime. Lenbach was a fashionable portraitist, whose conservative but skilful images gave a face to Germany's rising middle classes as well as provided a public image for Bismarck (figure 2). Each of these artists worked within academic institutions and produced works which, on one level, served to validate and eulogise the Germany that Bismarck was trying to create.[7] While Lenbach and Werner were gaining fame, respectability and fortune through their tame

images of a new Germany, other artists such as Anton Feuerbach and Hans von Marées were turning their back on Germany altogether and looking to Italy for inspiration.[8] Feuerbach began his artistic training in Düsseldorf, but he also studied in Paris under the academic artist, Thomas Couture. Despite earning the Chair of the Vienna Academy, Feuerbach spent many years in Italy between 1855 and his death in 1880, and he cultivated a stylistic monumentality and thematic classicism which contained reverberations of Italian, rather than German, culture. Unlike Lenbach and Werner, who were models of social respectability, Feuerbach became known for his torrid relationship with his Roman model Nanna Risi and, after his death, for his tortured and revealing letters to his stepmother. According to the art critic Julius Meier-Graefe, Feuerbach 'fled into the wilderness to fulfil a high mission', which was 'to answer to the needs of the culture of a great people'.[9] Marées also gained posthumous status as prophet of a new art, and he too spent much of his career in isolated poverty working in Italy.

The retrospective judgement of avant-garde critics in the early twentieth century gave a precedence to Feuerbach and Marées over Makart, Piloty and Lenbach, but all of these artists were products of the German academy system, and each of them followed his own path to artistic achievement or financial success. In varying ways, each of these artists served the maintenance of a regional academy system, and although some eventually achieved international notoriety, they did not produce art that was associated specifically with newly unified Germany. A more effective starting point for German cultural unification was not the art academy but the national museum. The formation of a National Gallery in Berlin in 1876 was the beginning of a conscious effort to build a new culture and to validate it by a nod to the past. A national gallery was a place that ostensibly unified by cultivating a sense of shared cultural values. Visitors to the gallery could view old masters and art of the German past presented in a chronological or stylistic hanging that seemed to validate current academic practice. But in 1896 the appointment of Hugo von Tschudi as director of the National Gallery redirected national attention to non-German modern art. Tschudi saw the gallery's purpose as an educator, rather than a validator.[10] His acquisition policy was explicitly designed to rejuvenate German art through promotion of recent European trends: 'A deeper understanding of German art will not be possible without a view of the art of other countries.'[11] Through his ideology and acquisition policy, Tschudi helped pave the way for German appreciation of French Impressionism – a style that was beginning to have a profound affect on German academic hegemony by the 1890s.[12] Other gallery directors throughout Germany followed Tschudi's example, so that by the end of the first decade of the twentieth century, Manet, Monet, Van Gogh and other harbingers of French modernism were fulsomely represented in Germany's national and regional art galleries. This tendency to purchase recent or contemporary art for public museums was a particularly innovative aspect of German cultural practice and one that both fuelled interest in contemporary art and continued to be provocative to more conservative members of the viewing public well into the 1920s.[13]

These clear manifestations of changes in the institutions of visual culture occurred in the 1890s, which was a significant decade in many ways. Politically

speaking, 1890 was a watershed, as it was the year in which the new Kaiser Wilhelm II forced Bismarck to resign from his post as Chancellor. This was decisive for a number of reasons. Wilhelm inherited the throne in 1888 when Bismarck was 73 years old. By this time, Bismarck's reforms and repressive measures were beginning to take their toll, and there was widespread dissatisfaction with his heavy-handed domestic policies and censorship of political and religious freedoms. Wilhelm was a contrast to Bismarck in every way: he was young, imaginative, engaging and charismatic. But he was also capable of frivolity, caprice and ill-informed political decisions. Unlike Bismarck, who had no time for the arts, Wilhelm could be interventionist and opinionated.[14] He regularly interfered in artistic decisions in Prussia and, in public speeches, he made his attitude to art clear.

The most notable of these was a speech of 18 December 1901, which was given when 32 life-sized statues of German heroes were unveiled as part of the new Siegesallee (Victory Avenue) in the Berlin Tiergarten. The Kaiser was pleased by these bland idealised representations of Germany's past, and he was roused to make a pronouncement about what modern German art should be:

> Art should provide an influence on the people by giving the lower classes the possibility of fresh heart after hard toil and work. We, the German people, have maintained the great ideal of lasting goodness, which other peoples have more or less lost. Only the German people remain who are ... appointed to tend this great ideal which belongs to them, so that the working, toiling classes are given the possibility of raising themselves and their thoughts up to the beautiful. But if art, as now happens again and again, shows us misery, made out to be as hideous as it is in reality, then it sins against the German people.[15]

The Kaiser's speech was a combination of nationalist and populist sentiment, but it reinforced the academic tendencies in art which he favoured. The Kaiser's direct intervention in artistic matters should not be overestimated, and his greatest impact was in Prussia, while the rest of Germany seemed oblivious to his direct influence. Nevertheless, he set the tone for a traditionalist approach to art which echoed the convictions of many artists who favoured the old academic system, but incited resentment among artists whose aesthetic and cultural orientation was towards naturalism and Impressionism.

During the 1890s in a number of cities in Germany, these disaffected artists broke away from the academy structures to form Secessions. On one level, the Secessions further fragmented the German art world. Not only did each region and city have its own art practices, but now cities with Secession groups had more than one competing institution within their bounds.[16] Rupture seemed to exist on all levels: while Germans were seeking cultural unity in the years following political unification, the German middle classes were also searching for a cultural identity to complement their new social and political hegemony. The favouring of Makart, Piloty, Lenbach and Werner was largely a product of this bourgeois aspiration, but the Secession movements sought to dethrone the icons of *Gründerzeit* liberalism and to expose the deficiencies of middle-class taste. The Secession movements were elitist and aristocratic, disruptive and cosmopolitan – qualities which rested uneasily in the conservative

Germany that Bismarck had tried to create. Secession movements in Germany were contradictory in several ways. They trumpeted a rhetoric of youth and freedom, but were largely composed of established artists with academic training. They sought a solution to Germany's cultural fragmentation, but they lacked programmes or stylistic coherence. They initiated institutional change, but instead of reforming established academies, exhibitions and *Kunstvereine*, they set up competing organisations. They abjured commercialism, but were dependent for their success on a growing commercial art market.[17] Finally, Secessions were international in their pretensions, yet regional in their loyalties. The two major German Secession movements, in Munich and Berlin, were seen as manifestations of local art politics and competition between Bavaria and Prussia to be the best *Kunststadt* (art city).

The complexities and contradictions of the Secession movements were appreciated at the time. The English magazine, *Studio*, of 1894 claimed that the Munich Secession was 'little more than a convenient meeting place for irreconcilables of all sorts'.[18] The Secession movements were not designed to promulgate a single style, but to remove the strictures on stylistic freedom which were laid down by the academies. The inscription on the Secession building in Vienna – 'To each age its art, to art its freedom' – was the basis of all the Secession movements. The Secession movements are also associated with rebellion, radicalism and the beginnings of modernism, but this sort of stylistic teleology is somewhat misleading. Certainly some Secession artists practised a type of painting which favoured the brushwork and colourism of the Impressionists over hard-edged academic idealism, but rather than seeing the Secessions purely in such aesthetic terms, it is important to question the very notions of modernity and the 'new' that underlay their aims and functions. The Secessionists may have been rebels, but they were merely creating new institutions to replace the old ones; they may have been revolutionaries, but they were not as democratic in their promotion of art as the well-established exhibition societies.

The influential cultural commentator of the 1890s, Max Nordau, viewed the avant-garde in general, and, by implication, the Secessions, as a sign of a cultural malaise which was pervading Europe. To him, the new disdain for or indifference to tradition was evidence of a deep-seated social neurosis or degeneration, and rebel artists meeting in cafés were little better than criminal bands.[19] Nordau's theories were influential, but opposition to his traditionalism was endemic: throughout Germany, the word 'youth' (*Jugend*) became a rallying cry not so much for a generation of artists but for a like-minded contingent of them. The identifying traits of the new state of mind were varied, but Nordau with his negative perspective managed to identify some of them. The rebel artists were opposed to the parliamentary liberalism of the 1870s and 1880s and the eclectic historicist architectural and painting styles which accompanied it; they advocated artistic quality; they looked for inspiration to other European countries, particularly France; and, not insignificantly, they often favoured escapist art which neither engaged with, nor commented upon, politics and the modern world. The latter point is particularly ironic, as, in order to achieve a new art for a new age, artists turned to the inner life (*Innerlichkeit*) and away from the cultural attitudes they sought to change.

The first city to form a Secession was Munich. In many ways this was logical, as Munich was considered by many to be the artistic capital of Germany, with a tradition of both royal and lay support. King Ludwig I had been responsible for a regeneration of the city's cultural life in the first half of the nineteenth century, and the erection of the massive Glaspalast for the 1854 German Industrial Arts and Crafts exhibition provided a distinctly modern venue for periodic art exhibitions. These exhibitions were sponsored by the Munich Künstlergenossenschaft (Artists' Cooperative Society), the local branch of the Allgemeine Deutsche Kunstgenossenschaft (General German Art Cooperative), which had been founded in 1856 as a way of consolidating regional exhibition societies. The exhibitions of the Künstlergenossenschaft were microcosms of liberal culture during the *Gründerzeit*: they contained vast numbers of works; they treated professional artists as equals (regardless of the quality of their work); and they drew a disparate, if predominantly petit bourgeois, audience.[20] The Munich exhibitions epitomised the tensions between the lingering institutions of pre-unification Germany and the new liberal ideals of Bismarckian Germany. They were successful in terms of popular appeal, and they stimulated the local art market in ways that were satisfying for the large number of artists who lived in Munich.

But there were deficiencies as well. When the success of the Künstlergenossenschaft exhibitions led the organisers to launch annual art exhibitions from 1888, the Munich art world began to appear more factional than it had before. The biggest controversy arose over whether or not these exhibitions should be international, and, if so, to what extent international contributors should be fostered over the home-grown variety. Some artists, whose ideology was a bleary mirror of *Gründerzeit* liberalism, advocated protectionism and protested against the cultivation of foreign art in Munich. Others felt that artistic quality was more important than national or local self-interest, and they demanded a generous selection of foreign art. By 1891 it was apparent that the traditionalists were gaining ground. At this point, a group of artists, including Fritz von Uhde, Leopold von Kalckreuth, Bruno Piglhein and Ludwig Dill formed a new organisation, the Verein Bildender Künstler (Society of Fine Artists), which was christened a 'Secession' by Munich newspapers. Although initially a display of bravado led the Künstlergenossenschaft to pour scorn on the Secession and reject their premises and principles, other German cities began inviting the Secessionists to exhibit. At this point, the traditionalists in Munich had to think again. They tried to lure the Secessionists to participate in a joint exhibition with the Künstlergenossenschaft, but their terms were so stringent that in 1893, the Secessionists instead exhibited in Berlin. Eventually, the local authorities granted the Secession its own building and exhibition space in Munich. The reasons for this change of heart were complex, but it was in no small way due to the sense the Munich art community had of losing its cultural authority to Berlin. While conservatives in Munich derided the rebellion of the Secession artists, their loyalty to Munich as a *Kunststadt* made it difficult to reject entirely this powerful new institution.[21] In a country already riven by cultural polarity, further divisions were not politically expedient. The attempts to assimilate the Secession within the established artistic structures represented a desire for clarification and consolidation, but also a yearning to

maintain a control over artistic production. Meanwhile, wealthy benefactors sympathetic to the Secessionist cause began to finance their activities. The Secessionists quickly became an accepted part of Munich art life and superseded the increasingly moribund Künstlergenossenschaft as the centre of new artistic production.

The political significance of the Secession should not be underestimated. They announced their formation in a paper circulated to Munich artists and, more publicly, in the *Münchener Neueste Nachrichten* of June 1892. In both instances, they used language that was overtly politicised but which, notably, also played on Munich's sense of local pride. They stated: 'That annual exhibitions must continue to be held here . . . seems only a fulfilment of the noble mission to which Ludwig I and his illustrious ancestors felt themselves called', but they then proceeded to attack contemporary art for its mediocrity and backwardness. Their statements were confrontational and contained barely-disguised political allusions: they wrote of 'the battle that had been waged' in the art world, and they used the labels 'progressive' and 'reactionary'. Most notably, they fumed, 'No longer do we wish to be controlled by painting lawyers and parliamentarians' – a decisive sneer at the liberal sensibilities that had dominated Munich art before that time.[22]

In many respects, the art that they produced was seen by contemporaries in Munich to serve subversive ends, particularly given the Catholic dominance in Munich politics at the time. Even before the Secession was formed, works by Max Liebermann and Fritz von Uhde which were exhibited in the 1889, 1890 and 1891 Künstlergenossenschaft exhibitions were condemned for their emphasis on peasant themes. Liebermann was particularly singled out for disapprobation: paintings such as his *Woman with Goats* (figure 3) earned him the title 'the apostle of ugliness', even though it won a gold medal at the exhibition and was subsequently purchased by the state. The ugliness of Liebermann's paintings was seen to lie in both the subject matter – unidealised views of rural peasantry – and the modified Impressionist style, which resonated with French associations. The *Freilichtmalerei* (*plein air* painting) of Liebermann did not adhere to the strict rules of Impressionist optics, but rather to the effects of their brushwork and palette. However, the association of this style with Germany's perennial enemy, France, allowed cultural traditionalists to demonise it. Impressionism was seen to embody all those aspects of French national character so abhorred by the Germans, most notably femininity, frivolity and moral laxity. Impressionism was also dominating the German art market, and protectionists felt that it was stifling the production of native artists. The classification of style as an embodiment of national character was so prevalent that one of Liebermann's contemporary apologists, Hans Rosenhagen, felt the need to justify the artist's impressionist work by insisting on its Germanic 'masculinity', in opposition to the 'femininity' of French Impressionism.[23] Representations of the lower class were considered acceptable if they were sanitised and if they contained local colour clearly identifiable by costume or setting as German. Nordau, for example, praised genre scenes set in Munich beer halls, and lamented that 'the aim of the creative arts in former ages was the reproduction of the beautiful . . . The art of today . . . examines nature with a frowning brow and a keen, malicious eye, skilled in discovering

faults and blemishes'.[24] Liebermann's work was not perceived to be a safe image; it did not allow the observer to laugh or to feel superior to the subject. It transgressed the boundaries of acceptable painting of the rural poor, and its very surface seemed to embrace the stylistic features of an enemy nation.

The negative response to Liebermann's work was fuelled by the fact that he was a Jew. Anti-Semitism was not confined to the Catholic south, but Liebermann had offended many observers well before the founding of the Secession by his attempt to represent Christ in his painting *Jesus in the Temple* (1879, private collection). This rather harmless work caused such offence that it stimulated a debate in Parliament about the propriety of its being exhibited at all. One speaker complained of

> the noble, divine subject of this picture portrayed in such a vulgar and vile manner that every devout Christian must feel deeply insulted by this blasphemous image . . . I do not wish to violate the religious beliefs of the painter, who, as is well known, is not of the Christian confession, nor do I wish to force him to see as we do the subject of the picture, the divine Saviour in whom we place our faith; but that the Munich art community, which wants support, did not prevent such an incident, this, gentlemen, I must firmly censure, and I am horrified that this picture was accepted in a state that is dominated by devout Christians.[25]

The combination of patronising tolerance and racist disgust which permeates this speech indicates the degree in which a work of art could be seen to

3 Max Liebermann, *Woman with Goats*, 1890

4 Fritz von Uhde, *Difficult Path*, 1890

transgress unspoken and unwritten cultural laws and become a target for specifically regional political and religious concerns.

Indeed, the Munich Secessionists seemed particularly prone to exhibit subjects that stirred up religious controversy. This was as true of the solidly Protestant Fritz von Uhde as it was of the Jewish Liebermann. Uhde's father had been president of the Lutheran Church Council in Wolkenburg, and Uhde inherited some of his father's religious preoccupations.[26] After studying under Makart in the Dresden Academy, Uhde began a military career and painted battle scenes until a trip to Paris in 1878–79 brought him in contact with the Hungarian artist Michael Munkáscy. Uhde became interested in the depiction of 'common people', and he tailored his representations to fit his religious interests. This is apparent in works such as *Grace* (1885, Berlin, Staatliche Museen Preussischer Kulturbesitz, Nationalgalerie) which represents a lower-class family who, in the midst of praying, 'Come, dear Jesus, be our guest', are greeted by the appearance of Jesus in their humble parlour. The most controversial of Uhde's religious works was *Difficult Path* (figure 4), which was originally intended to represent Mary and Joseph searching fruitlessly for an inn. The depiction of the holy couple as impoverished and despairing went against the view that holy figures should be idealised.[27]

Both Liebermann's and Uhde's new visions of the holy family raised religious hackles, but the response was no less muted with works that did not have overtly sacred subject-matter. Franz von Stuck, another Secessionist, was

5 Franz von Stuck, *Sin*, 1893

in many ways the most socially respectable of the group. By 1895 he was Professor at the Munich Academy, and he was wealthy enough to build a new villa in one of the most exclusive sections of Munich. With their vague mythological and religious allusions, Stuck's paintings were firmly within the new and widespread sphere of European Symbolism, but their erotic subject-matter inspired controversy when they were exhibited.[28] One of his most famous works, *Sin* (figure 5), was shown at the first Munich Secession of 1893, and it drew enormous attention for its representation of a sensual Eve, with a snake coiled suggestively around her lubricious body. Observers commented on the painting's combination of sensuality and religion, and many felt that it carried anti-Catholic sentiments. *Sin* even found its way into an autobiographical novel by Stuck's contemporary, Hans Carossa, *Das Jahr der schönen Täuschungen* (*The Year of Sweet Illusions*), in which the author describes the picture in language that reveals the picture's erotic impact:

Its wide, monumental gold frame was placed on a special easel, positioned to meet the gaze of a semicircle of curious observers who surrounded it. We had all removed our hats in deference before the work ... now we stared at the impressive pulsating darkness which only reveals a little of the woman's pallid body, the shadowy face with the bluish white of the dark eyes, ... the blood-sucking snake pressed close to her, its malicious head outlined against the languid rhomboid of her spine, the silver-blue line which was the only separation between woman and snake. The whole painting hovered in darkness and pallor.[29]

Descriptions such as this indicate that *Sin* was perceived as a sensual, or perhaps even pornographic, image of a woman, even while it personified a religious transgression. Liebermann, Uhde and Stuck may not have intended their paintings to offend the Catholic community, but the fact that they were perceived to breach religious decorum separated their work from the accepted conventions of academic art. Those commentators who wished to preserve the *status quo* saw the Secessionists as not simply a group of rebellious artists, but a collection of individuals who sought to undermine all established and traditional institutions, the Church as well as the Academy. Their international allegiances and their specifically French stylistic affinities aroused regional concern, while their respectability and notoriety gave their rebellion a stamp of authority.

The same situation arose in Berlin, and here again the fissure between Secession and *Kunstverein* was a stimulus for moral and political panic-mongering. Like the Catholic conservatives in Munich, Kaiser Wilhelm II was opposed to the Secession in Berlin and the stylistic biases and internationalism of the artists concerned. The case of the Berlin Secession highlights most intensely the severe divisions in the German art world and the manoeuvrings that sought to reconcile or erase those tensions.[30] In Berlin the established institutions were the art academy and the Verein Berliner Künstler (Association of Berlin Artists). Both of these institutions not only became objects of the Kaiser's interest, but their Director was a man whose ideals and aspirations mirrored those of the Kaiser himself. Anton von Werner became director of the Berlin Academy in 1875 at the age of only 32, and between 1887 and 1895 he was also president of the Verein Berliner Künstler. His unique double function as director of both the training and the exhibiting institutions was complemented by the fact that he shared the Kaiser's desire for an academic, idealist art which glorified Germany's past.[31] His grandiose history paintings, such as *Proclamation of the German Empire* pandered to the most overtly nationalist concerns. Werner was the most powerful figure in the Berlin art world at the beginning of the 1890s, and Kaiser Wilhelm in his new role as 'father' to the German people exercised his artistic taste by interfering in decisions made by the juries of the Verein Berliner Künstler. This attempt to control the production of art was based on the Kaiser's desire to achieve the sort of cultural unity that Bismarck aspired to, but his methods were neither subtle nor effective.

One of the most notable tactics of both Werner and Wilhelm was an attempt to enhance Germanness by maligning French tendencies in contemporary art. The focus of such attacks were German artists like Uhde and

Liebermann whose *Freilichtmalerei* was targeted as unpatriotic. It is no surprise that the Kaiser refused to allow an official German representation at the 1889 Paris Exposition Universelle, nor that Liebermann and Uhde exhibited works there despite this prohibition. Both of them were awarded medals of honour, but they both also stimulated the ire of the Kaiser and his followers who felt that native Germans should not be supporting a French cultural cause. This event of 1889 was only the first in a series of confrontations that would lead to the founding of the Berlin Secession. The next major episode occurred in 1892, when the Verein Berliner Künstler held an exhibition of the work of Edvard Munch. One imagines that the artists of the Verein knew Munch only from reputation, because as soon as the exhibition opened, public and imperial agitation led to its closure. After the sudden cancellation of the exhibition, artists of the Verein formed the 'Group of Eleven' as a protest against the philistine policies of the public art institution. Members of this new group did not entirely renounce their association with the Verein, but they exhibited independently in 1892 and gained a great deal of recognition in subsequent years.

The ultimate split which led to the formation of the Secession did not occur until 1898, when the jury of the Verein rejected a landscape by Walter Leistikow, who was a prominent member of the Group of Eleven. This rejection was deemed malicious by some members of the Verein who resigned and formed the Berlin Secession, electing Liebermann as their president and Leistikow as their secretary. The Secession consisted initially of 65 members, both men and women, and it gained public recognition from the beginning. A number of wealthy benefactors put their money behind the Secession artists and helped them launch their first exhibition in 1899. The speed with which the Secessionists lured financial backers is notable, and what is even more significant is the number of supporters from the Jewish community.[32] Not only was the traditionalism of the Royal Academy anti-French, but its pan-German sentiments disenfranchised cultured and wealthy Jews who wished to become art patrons. The Jewish component of the Secession, particularly the dominance of the dealer cousins Paul and Bruno Cassirer, proved to be an easy target for later attack from nationalist and anti-Semitic elements in Berlin society.

Paul and Bruno Cassirer's association with the Secession was, from the first, explicitly self-interested. In exchange for their financial generosity, they demanded an unprecedented voice in the artistic affairs of the group. Although this was welcomed at first, in later years, the problems of the Secession were often blamed on the malign influence of the Cassirers. But in the beginning, their money was welcome and their interference was endured. Like the Munich Secession, the Berlin Secession was a heterogeneous group of artists, which encouraged all new tendencies in art that were felt to promote quality. In reality, it was elitist, commercial and cosmopolitan in its fundamental aims. This cosmopolitanism can be demonstrated not so much by the output of its artists but by the fact that it devoted exhibitions to Munch, Toulouse-Lautrec and Cézanne at a time when Munich and Berlin art audiences were still getting accustomed to Impressionism and Symbolism. These choices were due in no small part to the shrewdness of the Cassirers, who were aware of

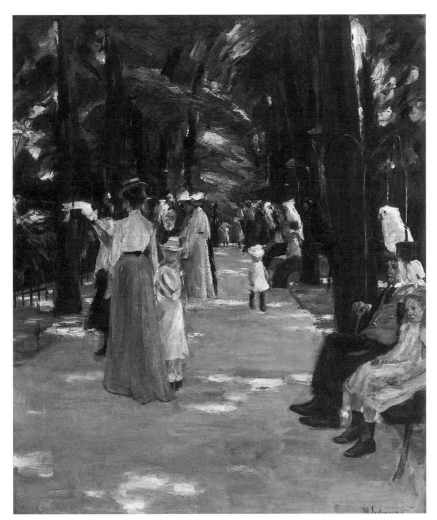

6 Max Liebermann, *Parrot Walk*, 1902

the most recent tendencies in art and kept their eye on France as a harbinger of these changes.

However, the major artists of the Berlin Secession were primarily advocates of Impressionism. Liebermann, Lovis Corinth and Max Slevogt, despite the individual differences in their subject-matter, all adopted a modified Impressionist style which, if it did not become the trademark of the Berlin organisation, at least gave a greater illusion of homogeneity than the exhibits of the Munich artists. Liebermann's early association with the Munich Secession and his favouritism of 'peasant' themes gave way by the end of the 1890s to more acceptable bourgeois subjects, while in works such as *Parrot Walk* (figure 6) he lightened his palette after frequent contact with French Impressionism. Liebermann felt a strong allegiance to Holland, which he first visited in 1871, and he chose to concentrate on subjects of scenes from Dutch life.[33] Like Liebermann, Slevogt also studied in Paris and adopted his impressionism for appropriate subjects. Works such as *The Champagne Aria from 'Don*

Giovanni' (1902, Hanover, Landesgalerie) make a clear reference to Degas's theatre scenes and the urban dimension of French Impressionist genre painting.

It was Corinth who represented a facet of the Berlin Secession that revealed most clearly the tensions between novelty and tradition that characterised the institution.[34] He became best known for his portraits and salacious representations of bacchic nudes – the latter subject paying homage to the tradition of one of his teachers, the Parisian Adolph-William Bouguereau. Although he held to academic subject matter, Corinth ruptured this tradition with his bravura paintwork and disturbingly aggressive treatment of his mythological and biblical themes. Like many Secessionists, Corinth reconciled stylistic modernity with academic tradition.

Despite an affinity with Impressionism, there was no stylistic programme or manifesto for the German Secession movements, apart from a vague advocacy of artistic freedom. The Secessions failed to provide a sense of unity, as they swiftly experienced their own rifts and divisions, and they proved to be unstable institutions for a new Germany. This is particularly significant as the Secessions had taken on the respectability and cultural authority of the old academies. Soon after their 'radical' inception, each of them gained prominence and support; they were recognised outside Germany and assimilated into the commercial art world within Germany. The Secessions became the new establishment, and rifts within them paralleled the cultural fractures that continued to split German society.

In Munich as early as 1893, a group of artists resigned from the Secession because they felt it was not progressive enough. The resulting Freie Vereinigung, or Free Association, was not successful, but it paved the way for later gestures of dissatisfaction with Secession policies. When Uhde, as president of the Munich Secession in 1900, cancelled an exhibition of Hermann Obrist's work in favour of an old master show, it seemed that the modernity which the Secession had hitherto favoured was no longer its preference. Further rifts in the Secession came when artists such as Kandinsky broke away to form their own exhibition societies.

The Berlin Secession also endured rupture, although its total life span (1899–1913) was longer than that of Munich. The problems arose in Berlin when the secretary of the Secession, Walter Leistikow, died in 1908, and his diplomatic skills no longer held the diverse elements within the group together. Many of the Secession artists were opposed to the Cassirers' influence, and Corinth, during his presidency from 1911, encouraged more academic tendencies and rejected the experiments of the avant-garde. In 1910 the Berlin Secession had rejected a number of paintings by artists such as Ernst Ludwig Kirchner, Max Pechstein and Emil Nolde, inspiring these artists to resign and form the Neue Sezession under Pechstein's directorship. Another group of artists resigned from the Secession in 1913 over a dispute about exhibition policy and, at this point, the tattered remnants of the old Secession were not enough to maintain its hegemony within the Berlin art world.

This diversity of aims and subsequent fragmentation meant that the Secessions did not provide Germany with a 'new' art that matched the nation's efforts towards a modernised and unified political culture. The dominance of Impressionism among the artists of the German Secessions did not really

constitute a national style, as it was balanced by other tendencies and prac-tices such as the Symbolism of Franz von Stuck. Impressionism was also not the most appropriate choice for those who advocated a 'national' style, given its French origins and associations. Other tendencies of the *fin de siècle* showed a clearer engagement with the place of Germany as part of a modern international art world and market. The development of art nouveau or, in its Germanised variant, Jugendstil, ran parallel to the rise of the Secessions, and offered a clearer programme towards a unified style, although in this case the unity was as much international as national. The label 'Jugendstil' did not gain circulation until after the turn of the century, but well before 1900 artists were beginning to adopt stylistic mannerisms associated with art nouveau in other parts of Europe. The pan-European nature of art nouveau constituted the first modern 'international' style.[35] This internationalism stimulated con-troversy inside as well as outside Germany, as critics began to associate art nouveau with a slick cosmopolitanism and a loss of cultural autonomy and individuality. During the mid-nineteenth century, each European nation had fostered historicist styles which referred directly to the country's past history. These styles could range from neo-Gothic to neo-Baroque, but in each case they were seen to carry national connotations. The erasure of the historicist associations which characterised art nouveau was welcomed by the prophets of modernity but loathed by those who wished to maintain some vestige of the old cultural life. This was particularly true in Munich, where art nouveau was promoted by Secession exhibitions – especially in the presentation of applied and graphic art – and where there was a reformist movement in theatre that involved innovations in both performance style and set design.[36] Part of the unity associated with the Jugendstil rested in the wider appro-priation of the term – which came to connote not only applied arts, but theatre as well.

In Munich, Secession exhibitions featured applied art from 1895, when artists such as Otto Eckmann, Bernhard Pankok, Hermann Obrist, August Endell and Richard Riemerschmid showed furniture, embroideries, tapestries (figure 7), wall hangings, stained glass, vases and other *objets* in the exhibi-tion.[37] The crucial year was 1897 when two rooms of the Glaspalast were devoted to decorative arts, and the enthusiasm this inspired led to the found-ing of the Vereinigte Werkstätten für Kunst im Handwerk (United Workshops for Art in Handicraft; see chapter 6). A new emphasis on two-dimensional design appeared in poster and graphic art, while the interest in all aspects of fine and applied art production led Franz von Stuck in 1897–98 to design his own house and all its furnishings in a manner based on Pompeiian villas.[38] In projects such as this, a very loose definition of the nineteenth-century composer Wagner's term '*Gesamtkunstwerk*' (total work of art) was applied.[39] Wagner saw the opera as the ultimate work of art – a place where epic, music, painting, poetry and other arts came together. The rage for Wagner's ideas in the 1890s fuelled the greater attention to a range of arts, and equally helped draw the theatre into the visual sphere.[40] In Munich, the written drama began to attract less attention than the visual and performative aspects of theatre, and in productions of works by Franz Wedekind and Oskar Panizza, among others, affinities with mime, cabaret, puppet shows and other aspects of

7 Hermann Obrist, *Whiplash Tapestry, c.* 1895

popular performance were demonstrated. Just as Jugendstil brought applied arts to the attention of cultural commentators, so cabaret groups such as the Elf Scharfrichter (Eleven Executioners) featured popular burlesque and mime as part of their work, as Peter Jelavich has shown.[41]

These tendencies in Munich had both an internationalist and a universalist flavour. Jugendstil in the production of applied art stifled national stylistic elements in favour of improvisatory serpentine forms, while popularisation of the theatre appealed to archetypes and universal childhood fantasies. But underlying these developments a strong regional dimension remained. Jugendstil artists exhibited in international exhibitions, but they presented themselves as associated with their local German base;[42] contemporary theatre in Munich drew on local festivals and practices for its innovations despite its sophisticated themes and plots.

These tensions between universal, international and regional were epitomised by the artist's colony at Darmstadt. This was a project initiated in 1898 by Grand Duke Ernst Ludwig of Hessen, whose motivation was a combination of utopian belief in the regenerating powers of art and a pragmatic desire to give a boost to the flagging Hessen economy.[43] In 1898 the Grand Duke summoned the Austrian architect Joseph Maria Olbrich to Darmstadt to oversee the creation of an artists' colony. Olbrich, who was dispirited by the negative public response to his innovative Vienna Secession building, took up the offer and joined other architects, including Peter Behrens, at Darmstadt in 1899. The Grand Duke's idealism was matched by a lavish financial contribution to the artists and his donation of an empty space on a local hill, the Mathildenhöhe, for the erection of this new 'colony'. Over the next few years, Olbrich oversaw the design and construction of a number of private homes, other buildings and their furnishings, which was first brought to public attention in an exhibition of 1901 entitled 'Ein Dokument deutscher Kunst' ('A

Document of German Art'). Darmstadt was eventually a financial failure and, one by one, the artists associated with it deserted the colony to pursue fame and fortune elsewhere.

But in its early years this colony epitomised the utopianism that permeated modern art at the turn of the century. The critic Hermann Bahr echoed the sentiments of the artists involved when he prophesied that 'everything [will be] controlled by the same spirit, the streets and the gardens and the palaces and the huts and the tables and the chairs and the lamps and the spoons'.[44] The desire to create a new culture from nothing is inherent in his remarks, just as Olbrich's own statement about the project revealed his dissatisfaction with the interaction between politics and art that characterised the Secession movements:

> At last a small, enthusiastic community, willing to work, in a town that is fortunate to possess neither a 'Glass Palace' nor an Academy, and doubly fortunate, therefore, because it also lacks the confined norms and standards of our fine art. The open grass, the flowering field, a land where the great labour-pains of a new art were known only from hearsay. Not the battlefield itself, where the intensive struggle between old and young still persists, rather, a field, where free feelings can be peacefully thought out. Free from all associations, free from all regards and obligations to Art Ministries, free from the quarrel between old and new.[45]

The weariness of Olbrich's tone suggests just how eager artists were to mould their new culture, but it equally reveals how difficult it was for them to escape the pressures and tensions of politics and art politics in the major cities.

Political and aesthetic localism is one aspect of German modernism that was remarkably persistent throughout the period of unification but has received little consistent attention from art historians. While it is important to see the internationalist and cosmopolitan tendencies that threatened the authority of regional academies, regionalism persisted in German art.[46] This regionalism in the midst of internationalism was only one of many tensions between fragmentation and unity that persisted in Germany during the first few decades after political unification. During this time, modernists and anti-modernists coexisted and at times overlapped. Institutions splintered, while stylistic coherence through Jugendstil and Impressionism was sought though not achieved. Commercialism grew beside a rhetoric of artistic independence, and calls for the freedom of art denied the clarity of a programme or manifesto. While the visual arts seemed to move closer together with an ideal of a *Gesamtkunstwerk*, there was a proliferation of media and type from easel painting, to furniture, to theatre – all competing for critical attention and the leisure market.

By 1913 the Secessions had replaced the academies as the institutions which regulated contemporary art, but, like the academies, they too were subject to corruption, bias, commercial constraints and aesthetic tyranny. None of these factors contributed to the creation of the kind of united cultural life to match the move to political unity. The infiltration of 'foreign' Impressionism, the enthusiasm for cosmopolitan art nouveau, and the persistence of taste among the middle classes for idealistic views of German history and '*lederhosen*'

painting did not make for an easy amalgamation. The Secessions were there-fore fragmenting forces, but while the Secessions were experiencing success and failure, other groups of artists were banding together who addressed much more explicitly the idea of a national visual culture.

NOTES

1 Albert Dresdner, *Der Weg der Kunst*, Jena and Leipzig, 1904, p. 37, quoted in Kenworth Moffett, *Meier-Graefe as Art Critic*, Munich, 1973, pp. 11–12.

2 For arguments about the coexistence of tradition and modernity, see Françoise Forster-Hahn, *Imagining Modern German Culture 1889–1910*, Washington, DC, 1996, espe-cially her own introduction and the essay by Kenneth D. Barkin, 'The crisis of modernity 1887–1902', pp. 19–35.

3 This view of German visual history was perpetuated from the beginning of the century by writers such as Julius Meier-Graefe (see chapter 2). See, for example, Richard Hamann and Jost Hermand, *Stilkunst um 1900: Epochen deutscher Kultur vom 1870 bis zur Gegenwart*, Berlin, 1967.

4 For a subtle and convincing discussion of the inconsistencies and institutional issues of the avant-garde in the 1890s, see Robert Jensen, *Marketing Modernism in Fin-de-Siècle Europe*, Princeton, 1994.

5 For histories of German culture of this period, see especially Fritz Stern, *The Politics of Cultural Despair: A Study in the Rise of Germanic Ideology*, Berkeley, 1961; Robin Lenman, 'Painters, patronage and the art market in Germany 1850–1914', *Past and Present*, 123 (1989), 109–40; and especially idem, *Artists and Society in Germany 1850–1914*, Manchester, 1997.

6 Lenman, *Artists and Society*, pp. 142–3 and William Vaughan, *German Romantic Painting*, New Haven and London, 1980, especially p. 21.

7 Apart from Werner, recent research on most of these artists is scanty. See Dominik Bartmann, *Anton von Werner: Zur Kunst und Kunstpolitik im deutschen Kaiserreich*, Berlin, 1985 and Werner's own *Erlebnisse und Eindrücke, 1870–1890*, Berlin, 1913.

8 For Feuerbach, see *Anselm Feuerbach: Gemälde und Zeichnungen*, exhibition catalogue, Karlsruhe, 1976; for Marées, see *Hans von Marées*, exhibition catalogue, Munich, 1987, and his own *Briefe*, Munich, 1923. These artists are often referred to by the generic tag 'deutsch-römer' or German Romans, because of their strong associations with Italy.

9 Julius Meier-Graefe, *Modern Art: Being a Contribution to a New System of Aesthetics*, Eng. trans. by Florence Simmonds and George W. Chrystal, 2 vols, New York, 1968, vol. 2, p. 111.

10 See Lenman, *Artists and Society*, pp. 52–61; Françoise Forster-Hahn, 'Constructing new histories: nationalism and modernity in the display of art', in Forster-Hahn, *Imagining Modern German Culture*, pp. 71–89; Barbara Paul, *Hugo von Tschudi und die moderne französische Kunst in deutschen Kaiserreich*, Mainz, 1993; and Peter Paret, 'The Tschudi affair', *Journal of Modern History*, 53 (1981), 589–618. Tschudi's own ideas can be examined in further detail in his *Gesammelte Schriften zur neuen Kunst*, ed. E. Schwedeler-Meyer, Munich, 1912.

11 'Ohne einen Blick auf das Ausland wird ein tiefergehendes Verständnis auch der deutschen Kunst der neueren Zeit nicht möglich sein.' *Ausstellung der neuen Erwerbungen*, Berlin, National-Galerie, 1896, p. 4, quoted in Klaus Teeuwisse, *Vom Salon zur Secession. Berliner Kunstleben zwischen Tradition und Aufbruch zur Moderne 1871–1900*, Berlin, 1986, p. 204.

12 See Evelyn Gutbrod, *Die Rezeption des Impressionismus in Deutschland 1880–1910*, Stuttgart, 1980.

13 See Shulamith Behr, 'Supporters and collectors of Expressionism', in Stephanie Barron and Wolf-Dieter Dube (eds), *German Expressionism: Art and Society*, London, 1997. For a discussion of the continued horror at the choice of art collectors in the 1920s, see Dennis Crockett's discussion of Otto Dix's *The Trench*, which was purchased by the Wallraf-Richartz Museum in Cologne in 1924, in *German Post-Expressionism: The Art of the Great Disorder 1918–1924*, University Park, 1999, pp. 95–6.

14 Martin Stather, *Die Kunstpolitik Wilhelms II*, Konstanz, 1994.

15 'Die Kunst soll mithelfen, erzieherisch auf das Volk einzuwirken, sie soll auch den unteren Ständen nach harter Mühe und Arbeit die Möglichkeit geben, sich an den

Idealen wieder aufzurichten. Uns, dem deutschen Volke, sind die grossen Ideale zu dauernden Gütern geworden Während sie anderen Völkern mehr oder weniger verloren gegangen sind. Es bleibt nur das deutsche Volk übrig das an erster Stelle berufen ist, diese grossen Ideen zu hüten, zu pflegen, fortzusetzen, und zu diesen Idealen gehört, dass wir den arbeitenden sich abmühenden Klassen die Möglichkeit geben, sich an dem schönen zu erheben und sich aus ihren sonstigen Gedanken kreisen heraus- und emporzuarbeiten': Johannes Penzler (ed.), *Die Reden Kaiser Wilhelms II*, Leipzig, 1907, vol. 3, pp. 61–2 (quotation on p. 61).

16 See Jenson, *Marketing Modernism*, especially p. 180.

17 *Ibid.*, especially pp. 167–71. The Vienna Secession was something of an exception to this pattern in some respects. Although its artists also demonstrated stylistic eclecticism, the distinctive style of Gustav Klimt became associated with the movement internationally. See Peter Vergo, *Art in Vienna 1898–1918*, 2nd edn, Oxford, 1981.

18 G. W., 'The Secessionists of Germany', *Studio*, 4 (1894), 24–8 (the quotation is on p. 26).

19 Max Nordau, *Degeneration*, Eng. trans., London, 1895, p. 30. I discuss Nordau's ideas in detail in my *Fin de Siècle: Art and Society in an Age of Uncertainty*, London, 1993.

20 For an excellent discussion of the Munich Secession, on which I have been heavily reliant, see Maria Makela, *The Munich Secession: Art and Artists in Turn-of-the-Century Munich*, Princeton, 1990. See also Markus Harzenetter, *Zur Münchner Secession: Genese, Ursachen und Zielsetzungen*, Munich, 1992; and Robin Lenman, 'A community in transition: painters in Munich 1886–1924', *Central European History*, 15:1 (March 1982), 3–33.

21 The battle between the pro-Secession newspaper, the *Münchener Neueste Nachrichten* and the conservative *Allgemeine Zeitung* was fought as a contest between international and local interests. This is discussed in both Jensen, *Marketing Modernism* and Makela, *Munich Secession*.

22 Both documents are reprinted in Makela, *Munich Secession*, pp. 143–53.

23 Hans Rosenhagen, *Liebermann*, Bielefeld and Leipzig, 1900, pp. 73–4.

24 Max Nordau, *The Conventional Lies of our Civilization*, Eng. trans., Chicago, 1884, p. 11.

25 This speech was made by Balthasar Daller in a parliamentary debate of 15 January 1880, quoted in Makela, *Munich Secession*, p. 33.

26 For Uhde, see B. Brand, *Fritz von Uhde, das religiöse Werk zwischen künstlerischen Intention und Offentlichkeit*, Heidelberg, 1983.

27 There is an interesting parallel here to the reaction of Charles Dickens and others in England to John Everett Millais's painting of *Christ in the House of his Parents*, exhibited in 1849, with its 'ugly' Jesus, Mary, Joseph and John the Baptist.

28 See Jean Clair, *Lost Paradise: Symbolist Europe*, exhibition catalogue, Montreal, 1995 and Edwin Becker, *Franz von Stuck: Eros and Pathos*, exhibition catalogue, Amsterdam, 1995.

29 The writer's tone owes a lot to J. K. Huysmans's novel *Au Rebours*, in which the author describes the effect of Gustav Moreau's *Salome*. The German reads as follows: 'In seinem breiten, monumentalen Goldrahmen war es auf einer besondern staffelei zur Schau gestellt; ein Halbkreis von Neugierigen umgab es ... Die Hüte hatten wir aus Achtung vor der Kunst ohnehin schon abgenommen ... nun starrten wir auf die Haar- und Schlangennacht die von dem blassen Frauenleib nicht allzuviel sehen ließ. Das beschatte Gesicht mit dem bläutichen Weiß der dunkeln Augen ... Eisenglanz der angeschmiegten Schlange, ihrem bösen, schön entworfenen Kopf und der matten Rautenzeichnung des Rüchens, über den eine silberblaue Line zog wie eine Naht. In Düsternis und Blässe schwebte das ganze Bild.' Quoted in *Neue Pinakothek*, Munich, 1989, p. 331. This novel was published in Leipzig in 1941.

30 The Berlin Secession is discussed most thoroughly by Peter Paret, *The Berlin Secession: Modernism and its Enemies in Imperial Germany*, Cambridge, Mass., 1980; Rudolf Pfefferkorn, *The Berliner Secession*, Berlin, 1972; and Teeuwisse, *Vom Salon zur Secession*.

31 See Bartmann, *Anton von Werner*.

32 For the reasons Jews became such significant figures in German culture, see especially Ekkehard Mai and Peter Paret (eds), *Sammler, Stifter und Museen: Kunstförderung in Deutschland im 19. und 20. Jahrhundert*, Cologne, 1993.

33 There are a number of books and exhibition catalogues on Liebermann, and early published versions of his own writings. See, for instance, Matthias Bunge, *Max Liebermann als Künstler der Farbe*, Berlin, 1990; Matthias Eberle, *Max Liebermann*

1847–1935, Munich, 1995–96; Max Liebermann, *Gesammelte Schriften*, Berlin, 1922, and his *Siebzig Briefe*, ed. Franz Landesberger, Berlin, 1937. On Liebermann's persecution under Hitler, see Bernd Schmalhausen, *'Ich bin doch nur ein Maler': Max und Martha Liebermann im Dritten Reich*, Hildesheim, 1994.

34 See Lovis Corinth, *Selbstbiographie*, ed. Charlotte Berend Corinth, Leipzig, 1926; Charlotte Berend-Corinth and Hans Konrad Röthel, *Lovis Corinth: die Gemälde*, Munich, 1992; Horst Uhr, *Lovis Corinth*, exhibition catalogue, Berkeley, 1990; and *Lovis Corinth*, exhibition catalogue, London, 1996.

35 For the international context of art nouveau, see Jeremy Howard, *Art Nouveau: International and National Styles in Europe*, Manchester, 1996.

36 Although Jugendstil had only a small impact on German Secession artists, the Austrian equivalent, Sezessionstil, was associated with the Vienna Secession.

37 See Hermann Obrist, *Neue Möglichkeiten in der bildenden Kunst*, Leipzig, 1903; Sonja Günther, *Interieurs um 1900. Bernhard Pankok, Bruno Paul und Richard Riemerschmid als Mitarbeiter der Vereinigten Werkstätten für Kunst im Handwerk*, Munich, 1971; and Winifried Nerdinger, 'Richard Riemerschmid und der Jugendstil', *Die Weltkunst*, 52 (1982), 894–7.

38 See Kathryn Bloom Hiesinger (ed.), *Art Nouveau in Munich: Masters of Jugendstil*, exhibition catalogue, Munich, 1988.

39 Peter Vergo, 'The origins of Expressionism and the notion of the *Gesamtkunstwerk*', in Shulamith Behr, David Fanning and Douglas Jarman (eds), *Expressionism Reassessed*, Manchester, 1993, pp. 11–19.

40 See David Large (ed.), *Wagnerism in European Culture and Politics*, Ithaca, 1984.

41 For an excellent discussion, see Peter Jelavich, *Munich and Theatrical Modernism*, Cambridge, Mass., 1985.

42 See Shearer West, 'National desires and regional realities in the Venice Biennale 1895–1914', *Art History*, 18:3 (1995), 404–34.

43 *Ein Dokument deutscher Kunst: Die Ausstellung der Künstler-kolonie in Darmstadt*, Munich, 1901; Alexander Koch (ed.), *Großherzog Ernst Ludwig und die Ausstellung der Künstlerkolonie in Darmstadt*, Darmstadt, 1901; and for recent works, *Ein Dokument deutscher Kunst: Darmstadt 1901–1976*, exhibition catalogue, 5 vols, Darmstadt, 1976–77; and Hanno-Walter Kruft, 'The artists' colony on the Mathildenhöhe', in Lucius Burckhardt (ed.), *The Werkbund: Studies in the History and Ideology of the Deutscher Werkbund 1907–33*, London, 1980, pp. 25–34.

44 Hermann Bahr, *Ein Dokument deutscher Kunst*, Berlin and Leipzig, 1901, quoted in Ian Latham, *Joseph Maria Olbrich*, London, 1980, p. 6.

45 Joseph Maria Olbrich, 'Unsere nächste Arbeit' in *Deutsche Kunst und Dekoration*, 6, p. 366, quoted in Latham, *Olbrich*, pp. 50–1.

46 For examples of this regionalism, see, for instance, Kirchner's comments in his Chronicle of Brücke about the importance of Dresden as a centre of the movement. Cited in Reinhold Heller, *Brücke: German Expressionist Prints from the Granvil and Marcia Specks Collection*, Evanston, 1988, p. 16: 'through the charms of its landscape and its historical culture, Dresden offered much inspiration. Here too Brücke found its first art historical corroboration in Cranach, Beham and other German masters of the Middle Ages'. For studies of regional manifestations of Expressionism, Dada and the Neue Sachlichkeit, see for example, Peter Ludewig (ed.), *Schrei in die Welt: Expressionismus in Dresden*, Zurich, 1990; Jörgen Schäfer, *Dada Köln: Max Ernst, Hans Arp, Johannes Theodor Baargeld und ihre literarischen Zeitschriften*, Wiesbaden, 1993; Bridget Lohkamp, 'On the artistic geography of the twenties in Germany', in Wieland Schmied, *Neue Sachlichkeit and Magic Realism in Germany 1918–33*, Hanover, 1969; and Shulamith Behr, 'Anatomy of the woman as collector and dealer in the Weimar period: Rosa Schapire and Johanna Ey', in Marsha Meskimmon and Shearer West (eds), *Visions of the 'Neue Frau': Women and the Visual Arts in Weimar Germany*, Aldershot, 1995, pp. 96–107. Dietmar Elger in *Expressionism: A Revolution in German Art*, Cologne, 1989, chapter 2, distinguishes northern and southern Expressionism.

Rural and urban: seeking the *Heimat*

All will again be great and tremendous,
the land simple and the water rippling,
the trees colossal and the walls very small;
and in the valleys, strong and varied
a pastoral, agricultural folk.
(Rainer Maria Rilke, *Das Stundenbuch*)[1]

Let's paint what is close to us, our city world! The wild streets, the elegance
of iron suspension bridges, gas tanks which hang in white-cloud mountains,
the roaring colours of buses and express locomotives, the rushing telephone
wires ... the harlequinade of advertising pillars, and the night ... big city
night. (Ludwig Meidner, 'Introduction to the painting of the metropolis',
1914)[2]

Berlin is Germany's political capital, but one does not wish for it to become
Germany's spiritual capital. (Julius Langbehn, *Rembrandt as Educator*, 1890)[3]

THE Secession movements were exclusively urban phenomena, but the
artists of the Secessions drew much of their inspiration from the German
countryside: the peasant themes of Liebermann and Uhde, the organic
imagery of Jugendstil and the beautified landscapes of French Impressionism
were among the ways in which rural influences permeated the productions of
artists during the 1890s. But it was not only the rebels of the Secession who
were drawn to rural representation. From the early part of the nineteenth
century, German Romantic artists such as Caspar David Friedrich and Philip
Otto Runge invested rural imagery with spiritual connotations, while artists
of the mid-century Biedermeier period produced genre paintings which focused
on idealised aspects of peasant and country life. The idealism that underlay
such images lingered after unification, when rural representation became more
prominent, as economic and industrial changes transformed a predominantly
agricultural country into an urban one. The changes in the appearance of the
landscape, the way of life of the people and their attitudes towards the
'Fatherland' were so extreme and rapid that a plethora of new responses to
both the country and the city became apparent in literature and in art. The
city was both adored for its modernity and despised for its degeneracy; the
country was embraced both by radicals for its liberating potential and by tradi-
tionalists for its associations with German character. Individual artists from
1870 onwards concentrated on various aspects of the landscape and its rural

inhabitants, and by the end of the century, artists' colonies consolidated the importance of landscape painting in Germany. These inevitably romanticised views of the country contrasted with the rarer images of the city. The polarity between country and city was defined in visual as well as verbal terms, but artistic responses were bound up with the cultural associations that rural and urban landscapes held for Germans.

Representations of both the country and the city focused the visual arts in Germany on a national agenda, which coincided with the mixed motivations of regionalism and internationalism discussed in the previous chapter. It is important to recognise that nationalism had many cultural manifestations. It was not simply a refuge for socially conservative elements; the German avant-garde equally reinforced their programmatic statements as well as their artistic production with nationalist sentiments. The appeal of nationalism for all sectors of society was one of its many strengths, as was the way in which nationalist associations could be employed when representing both urban and rural environments. Nationalism's great power in modern Germany lay partly in its appropriation by opposing tendencies. It allowed modernity to be represented as built on ancient, traditional and deep-rooted foundations. Visual culture contributed to the creation of what Benedict Anderson has called an 'imagined community' – the illusory unity of modern Germany which was created by nationalist rhetoric, as much as political reality.[4]

The question of how a nation's character can be embodied in the visual was considered in relation to landscape, and, by extension, landscape painting during the first few decades of a united Germany.[5] By the end of the nineteenth century Germany was experiencing an intense period of urbanisation and depopulation of the countryside. The less central rural life became to this burgeoning urban culture, the more reverently writers and artists began to eulogise it. The rural landscape was seen as an embodiment of lost cultural values and a disappearing way of life. The first major book to address this problem was published shortly before unification. Wilhelm Riehl's *Natural History of the German People*, which appeared in three volumes between 1851 and 1869, drew heavily upon Rousseau's idea of the 'noble savage' in its advocacy of the more 'natural' life of the country. To Riehl, the city was a seat of artificiality and corruption, which provided a nest for inciting the discontent of the proletariat. Riehl contrasted the evil urban proletariat with the uncorrupted peasantry (*Bauerntum*), whom he felt embodied all the fundamental qualities of the true German character. Aside from nostalgia, Riehl's work revealed its political orientation in a suspicion and fear of the urban working classes, who became symbols or scapegoats for the lost rural idyll.[6]

Riehl's commentary was conceived and produced before unification, but the elements which comprised this 'true German character' were the subject of much discussion after 1870. Given the fact that united Germany was an artificial political unity embracing a vast range of cultural, regional and religious affiliations, identifying the national characteristics became a particular concern. Germany was seen to be the masculine and patriarchal 'Fatherland', but the ways in which the individuality of this 'Fatherland' could be described were varied and problematic. As one contemporary writer observed,

One can love German fields, German woods, German seas, but this love is primary and platonic; the concept 'Fatherland' preserves a sense of abundance and colour if the love finds no living image: the blonde parting of a German child, the deep soul of a German woman, the shining goodness of a German man; but more still than abundance and colour: fire and flame convey for us the sense of the Fatherland, those of us who are touched by the powerful current, the living spirit of great German men.[7]

The evocative language, the mingling of nostalgia and pride, the combination of specificity and vagueness endowed this sort of commentary with power and influence. The 'Fatherland' was an abstraction, but it was both broad enough and specific enough to open itself to personal interpretation. But writers were not content with abstractions and endeavoured to go further. In an attempt to give substance to the abstraction, many commentators claimed that the nation's character was contained in the regions and in the way of life which they attributed to the peasantry. The term *'gemütlich'* (good-natured) was used to evoke an image of happy peasants going about their daily tasks in an uncorrupted landscape. Fantasy and imagination were also attributed to the German people: both Nordic mythology and the modern fairy tales of the Grimm brothers were perceived to represent a child-like imagination and idealism which was essentially German.[8] The cultural critic Julius Langbehn claimed that 'Music and sincerity, barbarism and piety are the dominant characteristics of the German people', and he went on to argue that such character should speak through the nation's art. According to Langbehn, 'Just as men consist of soul and body, flesh and bone, skeleton and marrow', art should comprise a symbiotic relationship of 'soul and style'.[9] Langbehn's views on the relationship between artistic style and national character were widely held, even by those who did not agree with his own individualistic interpretation of German art. True German art, like true German character, was concerned with nature, the peasantry and fantasy. Attempts to make specific artistic links to such abstract views of national character brought several artists to the forefront of cultural debate at the end of the nineteenth century. Among others, Hans Thoma, Wilhelm Leibl and Arnold Böcklin came to be seen as embodying one or more of these qualities of German character, and their reputations were fed by this yoking of national identity to artistic production.

Hans Thoma's landscape paintings were very different from the Impressionist emphasis of artists such as Liebermann, although he studied in Paris and was influenced by French art. But Thoma's inspiration came from the realist landscapes of the Barbizon school and Courbet, rather than the later Impressionist *plein air* painting. Ironically, this slightly earlier influence meant that Thoma's works never became associated with the French nation to the same extent as the productions of the German Impressionists. It was common in critical writings about Thoma to emphasise how he took what he needed from his French training but resolutely maintained his Germanness throughout.[10] Thoma's sweeping panoramas of the Black Forest and Taurus mountains (figure 8) both echoed and updated the Romantic landscapes by artists such as Friedrich, and they were identified as *'echt* [genuinely] national'[11] by his contemporaries. Both native and foreign critics read into his work those stereotypes most closely associated with German national character

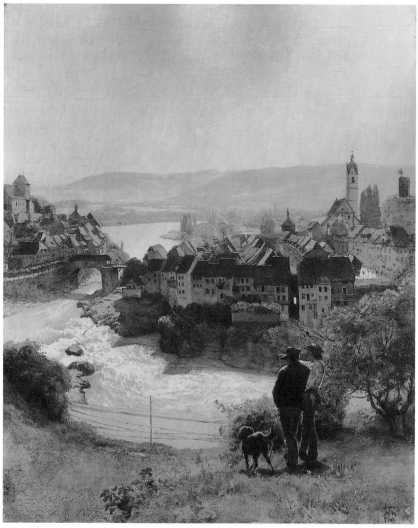

8 Hans Thoma, *The Rhine at Laufenburg,* 1870

in contemporary polemic. The critic Meier-Graefe claimed that Thoma's work was 'real peasant art', 'old German without being Holbein', and he elaborated:

> Such phenomena appeared in the great ages of craftsmanship, when in the country or in little towns men untouched by direct artistic influences produced sincere and convincing work, unimportant indeed to the connoisseur, but displaying a high and growing development of popular culture. It is a thousand pities that nowadays such men are confined to the artistic life of cities, that they cannot remain among the people to whom they belong, and that there is no longer any public for a truly popular art.[12]

The English art magazine, *Studio*, likewise classified Thoma's art as 'national': 'He is the genuine child of his soil . . . He remains truly German and incorporates one of the most distinctive and amiable traits in the national character,

the love for the dreamy poesy of the household tale.'[13] The emphasis of these observations is significant. First of all, Thoma's own background is seen to qualify him for the label of true German. He was the child of a poor family, was born and raised in Bernau in the Black Forest, and despite spending time in Paris, Munich, Frankfurt and Karlsruhe, he maintained his affection for the Black Forest. Second, the very directness of his landscape style equated him, rightly or wrongly, with German popular art and the peasant traditions from which he came. Thoma's rural imagery reinforced popular consciousness about German national character and its relationship with the land.

But Thoma's primary emphasis was on the landscape itself, whereas writers such as Riehl saw the peasant as being the essential component in the search for German character. The peasant was the main subject-matter of one of Thoma's most important contemporaries, Wilhelm Leibl, who was known as the 'peasant painter' (*Bauernmaler*).[14] The peasant was seen to be the human embodiment of the land itself, and idealisation of the peasantry contributed to the idea of the *Volk* or the 'people'. The concept of the *Volk* is one which now contains echoes of National Socialism, as it was an idea later harnessed by Hitler in his attempt to unite a diverse population behind his invidious political policies (see chapter 8). The very tenuousness of the term lent it to such appropriation, but in the last quarter of the nineteenth century it was associated with earnest attempts to qualify aspects of national character; it was used by people of all political affiliations; and it grew out of an idealisation of the peasantry that was the result of rapid changes in the countryside. Leibl's paintings are naturalistic studies of individuals (figure 9) which could serve as portraits, although the identity of the sitters is inevitably obscure. Leibl thus presents individuals as types: his concentration on character and facial configuration give each painting a distinctiveness that is belied by the anonymity of the sitters. During his lifetime, there was a certain amount of suspicion about the lack of idealisation in his paintings. However, his careful rendering of individual features was also characteristic of Rembrandt, an artist admired by advocates of German national character, and the contrived simplicity of his style sought to echo the 'piety' that commentators attributed to Germanic consciousness. Like Leibl, Thoma's work came to be identified as essentially German by the turn of the century, and his representations of rural character was sharply contrasted to the evasive and stylistically Francophile peasants of Secession artists such as Liebermann and Uhde.

If Thoma's works embodied the German landscape, and Leibl's gave a face to the German *Volk*, Böcklin was understood to be the artist who painted the fantasy of

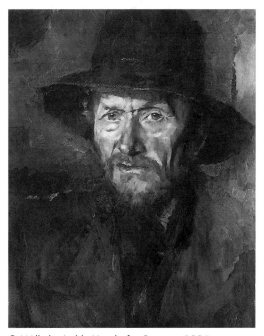

9 Wilhelm Leibl, *Head of a Peasant*, 1896

German myth and fairy tale.[15] In fact, it was Böcklin, despite his Swiss nationality and Italian residence, who was later seen to stand for everything that was essential in German national character. Böcklin's early landscape paintings were respected for their rich painterly qualities and warm colour harmonies, but as his fame and success grew, his focus began to change. He travelled extensively to Brussels, Antwerp, Paris and throughout Italy, where he eventually settled, and he gained extensive bourgeois patronage which secured him international acclaim. However, his real success came late in his life, when his works were discovered by a new generation eager to give a visual form to national consciousness. His Swiss nationality and expatriation were brushed aside, as he was seen to embody an essential 'Germanness' that was endemic to his artistic character and transcended narrow national boundaries. The changes in Böcklin's manner appeared in a greater and greater emphasis on the figures in the landscape, rather than the landscape itself. However, these figures were not, like those of Leibl, the real, or typical, German peasants, but mythological characters. Significantly, Böcklin's world of myth was not that of the gods and goddesses from classical literature, but of anonymous, nameless minor deities, such as nymphs, satyrs, tritons and naiads (figure 10). These beings interact in semi-human relationships, in which love and war play equal roles. The lack of identifiable literary reference combined with the seduction of fantasy gave Böcklin's work a wide appeal for audiences with varied levels of classical education. Indeed, by distilling the references of 'high art' (the classical world) with those of contemporary life (the landscape and the human relationships), Böcklin's work became one of the most popular forms of art for the bourgeoisie.

The very vagueness of Böcklin's imagery, and his emphasis on the landscape, left his work open for numerous interpretations. By the 1890s, when nationalist rhetoric was penetrating cultural criticism, Böcklin was frequently evoked by writers searching for German national characteristics. The critic Carl Neumann's comments were typical: 'Böcklin's roots go far into the heart of our soil, where the deepest racial characteristics lie.'[16] These 'racial characteristics' were seen to be a spiritual quality which was partly pantheistic. Despite the fact that Böcklin was Swiss, writers made much of his 'Germanic' temperament, and referred to Böcklin's birthplace, Basle, as the city chosen by the quintessential German artist, Hans Holbein. In nationalistic writings about culture, artists such as Böcklin were validated by comparisons between their work and that of 'great' German artists of the past. Böcklin's paintbrush was a 'magic wand' (*Zauberstab*) which was capable of imbuing nature with increased spiritual significance.[17] His Italian sojourn was dismissed as insignificant to his development or the focus of his art:

> Whatever Böcklin touched became something spiritual. Art in this sense, northern, Germanic art, is all that he created. No matter how many ideas he took from the south, he took them as a conqueror who seeks to expand Germany's possessions.[18]

Böcklin's imaginary scenes thus opened themselves up for more than one interpretation, and their rural and pantheistic character fuelled their association with a German yearning for the land and for the *Volk*.

10 Arnold Böcklin, *Idyll*, 1875

Böcklin, Thoma and Leibl were used as tools in debates about national character and the nature of modern Germany long after their deaths. The most notable of these cultural debates was a published battle between the champion of the avant-garde, critic Julius Meier-Graefe, and the conservative art historian Henry Thode. In 1905 Meier-Graefe published *Der Fall Böcklin* (*The Case of Böcklin*), in which he argued that the passion for Böcklin's works represented a degeneracy and philistinism in modern taste.[19] Meier-Graefe did not dislike all of Böcklin's paintings – he admitted the beauty and power of his lyrical early work – but he felt that the artist had accommodated himself to a debased market, dominated by the uneducated taste of the bourgeoisie. Thode delivered a vehement rebuttal to Meier-Graefe's argument in a series of lectures on Böcklin and Thoma which he presented at the University of Heidelberg in 1905. Thode resented Meier-Graefe's contempt for the Swiss

artist, and he defended the mission of Böcklin and Thoma as essential for the cultural regeneration of modern Germany. Thode, like Langbehn, insisted that 'art was always the expression of the nature and culture of a people (*Volk*)',[20] and he went on to ascribe to German art qualities of expression of feeling, love of nature and fantasy. Thode rather deftly equated art with national character, and defined German art in opposition to the French stylistic tendencies that Meier-Graefe favoured. Thode's collapsing of art with national character placed the rural qualities of Germany in the forefront.

Many of these responses to rural culture were positive expressions of what was really an aversion to the growth of cities, and while some writers and artists were escaping into rural fantasies, others focused on the cities themselves. In the last quarter of the nineteenth century, the city became an object of fear and disgust, as well as fascination and obsession, for a number of reasons. Berlin is the supreme example of what could happen to a city in a short period of time. In 1871 Berlin became the capital of Germany, and it quickly evolved into the political, financial, industrial and cultural centre. From a population of just under 600,000 in 1865, Berlin and its suburbs grew to four million by 1920. This growth was fed by massive immigration from agricultural communities and from other parts of Europe. The results of such a rapid change were housing shortages, appalling conditions for the working class, unhealthy living environments, and the spread of diseases, most notably syphilis. Increasingly, other factors became apparent as well, as the city underwent increasing segregation according to function and social class. Different parts of the city served as administrative, shopping and cultural centres, and different classes congregated in separate residential areas. Berlin in particular, and the city in general, came to be seen as a hotbed of violent crime, alcoholism, madness and revolution. The very blending of classes in urban centres was said to go against nature; cities were perceived to be threats to women's virtue and thus the sanctity of the home; and the money culture of metropolitan life was construed as dehumanising. The city was condemned as a 'Hell', a 'Cement Mountain' (*Zementgebirge*) and an 'Asphalt Wasteland' (*Asphaltwüste*).[21] Even avant-garde artists could denigrate Berlin as 'that vile city', and 'a grotesque tragi-comic puppet theatre'.[22]

This negative reaction was visualised as a kind of fascinated horror in Max Klinger's series of etchings and aquatints, *Dramas, Opus IX* of 1883. In Plate 7, 'A Murder', the setting is recognisably Berlin, and Klinger even inserted Berlin landmarks in order to make the reference obvious. However, the specific city represented is less significant than its metaphorical status as a place of disorder and violence, mass upheaval and inhumanity. Klinger's engravings give an image to the dystopian myths of city life.

However, while the city inspired very vocal diatribes about its physically and morally disrupting influence, it also carried a strong attraction and fascination. This was not expressed so frequently or extremely, but responses to the city were by no means all negative. This ambivalence about the city appeared in examples of cityscapes produced in the last decades of the nineteenth century. Some of the earliest modern cityscapes were painted by the realist artist Adolf Menzel, whose famous *Iron Rolling Mill* represented factory production in an industrial town. Although not concentrating on the modernity of urban

life, this work was seen by contemporaries as representing the 'age of the machine',[23] and thereby symbolising the changes in class structure which this age had engendered. Menzel was best known for woodcuts which he produced to accompany Franz Kugler's *History of Frederick the Great* of the 1840s, but his attempt to come to terms with modernity in the *Iron Mill* made him a 'realist' painter on a par with Courbet in France. Well before the French Impressionists, Menzel also painted empirical cityscapes that focused on railway stations and the chaos of urban planning. Following the lead of Menzel, the next generation of urban artists, such as Franz Skarbina and Hans Baluschek, painted views of Berlin that stressed the poverty and despair of the city – even while they displayed its beauty through careful manipulations of lighting and Impressionist colourism.[24] In addition to his peasant subjects, Liebermann also specialised in views of city life, but unlike Skarbina and Baluschek, he took his cue from the Impressionist tendency to beautify the city and to choose aspects of the urban scene which contained vestiges of the rural, such as parks and zoos (see Figure 6). Liebermann also focused his urban scenes on Amsterdam rather than Berlin, thus softening the urban associations, as Berlin was condemned as ugly by Liebermann's contemporaries.

Such a mixing of the urban and the rural was likewise characteristic of the contemporary 'garden city movement', which aspired to a city with all of the advantages of both country and town. This movement has been most strongly associated with the notoriety of the Englishman Ebenezer Howard's *Tomorrow: A Peaceful Path to Real Reform* (1898), which postulated a 'third' alternative to town and country. Howard wanted to 'restore the people to the land' by organising cities around substantial patches of garden and park which were available to all citizens.[25] He had a large following in Germany, and his ideas inspired the founding of a German Garden Cities Association in 1902. But Howard had been anticipated by the anti-Semitic writer, Theodor Fritsch, who proposed a 'city of the future' which had affinities with Howard's example but was much more extreme in all its elements. Fritsch attacked the modern city for its ugliness and moral corruption, which he saw as mutually reinforcing evils: the city was a jumble, with 'the factory next to the pleasure palace, the barracks next to the temple of art, the slaughterhouse next to the school, the bordello next to the house of God'.[26] According to Fritsch, the centre of town ought to contain the cultural centre of the city with library, town hall, cathedral, schools and museums, with residential areas radiating out from the centre, punctuated by generous patches of parks and gardens. Factories and railway lines were consigned to the outskirts of Fritsch's city, as was working-class housing, and all unsightly public works were buried underground.

Although there were some attempts in Germany and other parts of Europe to realise these utopian garden cities, these were never more than isolated experiments. The real urban problems continued to worsen. This was more than simply an aesthetic disaster for lovers of beauty, or a moral peril for traditionalists: the city changed the ways in which people lived, their relationships with each other, their pace of life and their priorities. Sociologists and philosophers found it increasingly necessary to define urban experience as essentially different from rural life, as compromises like the garden city became

less viable. The writer who set the pace for these arguments was Ferdinand Tönnies, whose *Community and Society* of 1887 suggested a polarity between the community (*Gemeinschaft*), which was rural, natural, based on kinship and family feeling, and the society (*Gesellschaft*) which was urban, individualist and mechanistic.[27] These ideas were highly influential in nationalist writings, as 'community' became associated with a better, lost way of rural life, while 'society' was criticised as egotistical, dehumanising and urban.

After the publication of Tönnies' work, the polemics about the beauties of rural life which began with Wilhelm Riehl in the 1860s, were consolidated and institutionalised. A number of important societies were formed, including The Committee for Land Welfare (founded 1896), which became the German Society for the Support of Rural Welfare and Homelands in 1904, and the Bund Heimatschutz (Society for the Protection of the Homeland). The latter was the German equivalent of the English National Trust and the French Society for the Protection of the French Countryside, and its purpose was to protect historical 'monuments', endangered landscapes, animals, plants, as well as 'practices, customs, celebrations and costume festivals' (*Sitten, Gebräuche, Feste und Trachten*).[28] Significantly, the society aimed to safeguard not just the physical appearance of the country, but its character and inner essence as well.[29]

The use of the term '*Heimat*' was another of those vague words, like *Volk*, which had infinite connotations for Germans at the turn of the nineteenth century. In its strictest sense, it means 'home' or 'homeland', but it also refers to 'native country' and 'natural habitat'. After unification, Germans spent a great deal of time talking and writing about the *Heimat*, but despite their self-assurance, their words indicated that they were searching for a very elusive ideal. A literary movement christened '*Heimatkunst*' ('homeland art') in 1897 inspired such works as Adolf Bartels' *Der Bauer in der deutschen Vergangenheit* (*The Peasant in German History*, 1900) and a periodical *Heimat* was produced by Bartels and Fritz Lienhard from the same year. *Heimatkunst* ideals favoured a rural Germany, and the customs, festivals and traditions which were rooted in it. Although less centralised and organised, there was also an equivalent of *Heimatkunst* in the visual arts, and this consisted of a number of artists' colonies which spread throughout Germany between the middle of the nineteenth century and the beginning of the First World War.[30]

The idea of the artist colony was not German but pan-European.[31] Artists' colonies appeared throughout Europe after the example of the French Barbizon school; with the popularity of Impressionist *plein air* painting, the desire to paint outdoors in a rural environment became even more attractive to artists. But artists' colonies were paradoxical places: artists claimed that they went to colonies in order to get 'back to nature', but many colonies in Germany were within 30 kilometres of a large city and easily accessible by rail. German artists expressed their hopes that they could touch the German soul by painting an unspoiled patch of German rural landscape and life, but their very presence in that landscape sullied it, as artists became voyeurs spying upon a way of life that was significantly different from their own. They were, in every sense of the word, colonisers; they entered the countryside and took it over; they were spoilers, even while they tried to preserve the untainted

ideal on their canvases. They also travelled to these colonies with clear
preconceptions about what they hoped to find, and their representations con-
tributed to the perpetuation of stereotypes about particular places and their
significance to German culture.

Both traditional and avant-garde artists were attracted to rural locations.
Artists congregated in over a dozen rural centres in both north and south.
They flocked to the North Sea coast, to paint Dangast and the islands of Vilm
and Fehmarn; they met in the mountains of Bavaria and Austria; they gathered
at the lakes of Moritzberg near Dresden and the forests at Kronberg near
Frankfurt and Grünewald near Berlin. The search for the *Heimat* was not
located in one specific place in Germany, and this diversity of artistic region-
alism added to the rich associations that *Heimatkunst* ideology attributed to
the German countryside.

The most famous German artists' colonies of the turn of the century were
in Dachau, near Munich, and Worpswede, near Bremen. The physical dis-
tance between these two colonies belies a certain geographical similarity, as
both places were dominated by moorlands. The marshy setting provided more
than just uncomfortable weather and living conditions; it also gave artists a
ready-made mood landscape and a means of conveying the ineffable element
of fantasy which was associated with the German character. Dachau was
located 17 kilometres north of Munich, and the Dachau group consisted of
a number of artists who came into contact with each other through their
participation in the Munich Secession. They were urbane and self-conscious
and took their rural landscape paintings back to Munich to participate in
exhibitions there. Ludwig Dill, Adolf Hoelzel and Arthur Langhammer were

often joined by Fritz von Uhde, whose
subject pictures were sometimes set in the
Dachau moors. Contemporaries referred
to these landscapes as 'colour poems', as
the artists sought to convey the melancholy
mood of the landscape, its mist and grey-
ness, the sense of chill humidity. The inhab-
itants of Dachau also became the subject
of paintings which idealised rural life, such
as Langhammer's *Peasant Girls* (figure 11),
which was similar to Dachau works that he
and others showed at the Munich Secession
exhibitions.

Artists in Worpswede also concentrated
on the dual subjects of landscape and the
peasantry, but their contribution to art was
noticeable and more lasting. One of the rea-
sons for this was the fact that these artists
actually did live in Worpswede; they did
not just visit it from time to time, and they
exhibited publicly as a group, thus drawing
attention to themselves and to their artistic
aims.[32] The ways in which Worpswede fed

11 Arthur Langhammer, *Peasant Girls from
Dachau*, 1900

the 'back to nature' ideals of German consciousness can be seen in a contemporary description of the place itself:

> The post coach and railway passed through it quickly, no Baedecker tourist guide reported on its natural beauty: smooth, flat land, here and there a small hill with pines rising from the ground, few corn and wheat fields but overwhelming moorland, through which the Hamme river and its little canals snake, miserable huts of the inhabitants, which for centuries have grown out of the soil, a place of popular life long lost from our big city world – that was Worpswede until very recently.[33]

This author stresses the unspoiled quality of Worpswede, as revealed by its absence from conventional guidebooks, its long heritage, the prominence of the peasantry, as well as the landmarks of the area, but he also reveals a certain ambivalence about its ugliness and poverty. Worpswede was not a beautiful place, but it was an evocative one, and it was felt to possess a 'rough-hewn' quality which complemented many contemporary idealisations of German character. However, this description, written at the beginning of the twentieth century, already showed the ways in which the artists who settled in Worpswede were beginning to contribute to a mythology of the place.[34]

These artists were Fritz Mackensen, Otto Modersohn and Hans am Ende. Mackensen moved to Worpswede in 1884 and was followed by the others in 1889. Later they were joined by Fritz Overbeck, Carl Vinnen, Clara Westhoff, Heinrich Vogeler and Paula Becker, who became Paula Modersohn-Becker after marrying Otto Modersohn. The poet Rainer Maria Rilke was also associated with the Worpswede group, and his poetic visions of rural harmony likewise grew out of their idealisation of rural life. The personal relationships among the members of the Worpswede group, and Rilke's association with them, have led to much emphasis on their private interactions, rather than their public art. Modersohn-Becker's tempestuous and unhappy marriage with Otto, her attempt to desert him, and her tragic early death after childbirth have evoked a number of romantic spectres around Worpswede and its inhabitants. This mythologising masks the significance of their work, the fact that the presence of women artists distinguished Worpswede from many of its predecessors, and the very distinctive contribution of Modersohn-Becker, who both echoed and subverted the nationalist ideals of the colony. Like the Dachau artists, the Worpswede group concentrated on two types of subject matter – pure landscape and peasant life. Modersohn was particularly entranced by the romantic mists of the fens, and Vinnen's 'mood landscapes' attempted to capture the dream-like quality of the flat land. By contrast, Mackensen was primarily a painter of peasant life, and produced calm, idealised views of the peasantry which compared with those of François Millet in France. In her journals, Paula Modersohn-Becker claimed that Mackenson 'understands the peasants thoroughly. He knows their good sides, he knows all sides of them, including their failings',[35] and when she moved to Worpswede in 1889, she followed Mackensen's example in choosing to paint peasant life.

But Modersohn-Becker's paintings of peasants (figure 12) and inmates of the local poorhouse were different in essence from Mackensen's idealised

and sanitised views. Her diaries and paintings showed a similar sentimentality about the dignity of the German *Volk*, but her use of pure and luminous colours, laid on in blocks, owed much to her affinity with French artists like Gauguin. Modersohn-Becker travelled to Paris in 1900, and again in 1905 and 1906, and she absorbed the innovations of artists such as Gauguin who were, at the time, little known in Germany. Modersohn-Becker's stark, simplified representations were portraits of individuals she met in Worpswede, especially in the workhouse, and in her diaries she wrote about their lives, conversation and character. In many respects, Modersohn-Becker found a means of representing peasant life that brought out the fundamental 'earthy' qualities attributed to them by so many middle-class Germans at the turn of the century, but her unusual and innovative representations were ignored or dismissed by her Worpswede contemporaries.

Modersohn-Becker also provides us with clues to understanding how the countryside was perceived by nationalistic Germans at the turn of the century. Her letters and journals are full of enthusiastic and romantic pronouncements about Worpswede life which reveal the extent to which these artists were seeking a national identity through the 'unspoiled' landscape. Her first journal entry on the place itself is indicative:

> Worpswede! Worpswede! Worpswede! ... Birches, birches, pines, and old willows. Beautiful brown moors, exquisite brown! Canals with black reflections, asphalt black. The Hamme [river] with its dark sails. It's a wonderland, a land of the gods. I take pity on this beautiful piece of earth whose inhabitants don't know how beautiful it is.[36]

In her diaries, she enthusiastically related her wanderings around Worpswede, and the details which emerge from her descriptions of peasant life show how much she perceived local customs through the eyes of art. Her words evoke an image of Worpswede straight out of a painting by Bruegel. Her return to Worpswede after one trip to Paris led her to praise the local people for 'their great biblical simplicity'. Conversely, she claims she is 'horror-struck by big cities', although she could not hide her affection for the beauties of Paris.[37]

This ruralism was shared by her fellow artists. According to Modersohn-Becker, Heinrich Vogeler 'carries Walther von der Vogelweide and the *Knaben Wunderhorn* in his pocket and reads from them almost daily'.[38] Both Walther von der Vogelweide (a German medieval poet), and the *Knaben Wunderhorn* (a collection of folk songs) were favoured by the revivalism that resurrected Germany's folk heritage. There are two sides

12 Paula Modersohn-Becker, *Old Peasant Woman*, *c.* 1905

to the ruralism of the Worpswede artists: the first was anti-French sentiment and the second was a variant of *Heimatkunst* ruralism. Worpswede artists expressed the first of these by initiating and supporting their member Carl Vinnen's *Protest of German Artists*, published in 1911, four years after Modersohn-Becker's death. Although Modersohn-Becker's work had an unequivocal affinity with recent and contemporary French art, her fellow Worpsweders vociferously rejected this tendency by attacking not only French influence, but the vogue for recent French art among dealers and museum directors. Vinnen's work was an edited collection, including his own introduction, various statements of support from fellow artists and art professors, and a list of 118 signatories.[39] Significantly, nearly half of Vinnen's signatories gave their place of residence as Munich, compared with only 11 who were based in Berlin, and many of this group claimed a base in one of many smaller German towns. It is clear that the geographic support for the *Protest* came from conservative Munich and the non-metropolitan regions. The naming of locations also gave the tract an aura of pan-Germanic authority, while the supporting statements – many signed by 'professors' of art – endowed it with an intellectual weightiness.

The first object of Vinnen's work was to attack the immense sums being paid by German galleries and art dealers for works by Matisse, Van Gogh, Gauguin and Cézanne. Underlying this criticism were veiled anti-Semitic remarks that maligned an international art market dominated by powerful Jewish dealers. But the protest had another, more prominent, agenda. It was a manifesto of artistic nationalism, of an art which somehow grew from the *Volk* and expressed the *Heimat*. Vinnen's own remarks parroted the popular national stereotype about German character: 'The characteristics of our people lie . . . in . . . depth, fantasy, sensibility; I will perhaps be better understood if I name names of those in the nation's history who have carried these traits: Rethel, Menzel, Leibl, Boecklin, Marées'.[40] And he later insists that 'no art has developed in its totality without the spiritual and material assistance of its people [*ihres Volkes*]'.[41]

Despite these clearly nationalist sentiments, the contributors to the Protest backed away from an explicitly nationalist agenda. Vinnen asserted at the beginning that he wanted 'no chauvinistic Germanicism' (*keine chauvinistische Deutschtümelei*), and one of his supporters argued that German art wanted to be cosmopolitan, but the only way for it to achieve this was to be true to its national characteristics.[42]

This yoking of art to a nationalist agenda had clear cultural roots in an influential but idiosyncratic book by Julius Langbehn, entitled *Rembrandt als Erzieher* (*Rembrandt as Educator*). Langbehn began his career as a scholar, producing a Ph.D. thesis on Greek sculpture, but he renounced scholarship and instead spent several years wandering around Germany. These *Wanderjahre* were very much in a medieval tradition, as 'journeymen' in the Middle Ages were so named because they moved from one master to another, and one place to another in seeking the perfection of their craft. Langbehn was not a craftsmen, but he sought to produce his own masterpiece on the basis of his travels. *Rembrandt as Educator* was first published anonymously in Leipzig in 1890, and it went to 39 editions in two years. Its epigrammatic style and

assertive swagger were borrowed from the work of Nietzsche, whom Langbehn admired. It is difficult today to understand the appeal of this quirky, bizarre and extreme book. It has no structure; it is full of meaningless pronouncements; it is vehemently anti-intellectual. Its author was clearly unstable, paranoid and fanatical. However, *Rembrandt as Educator* was widely read and widely admired, so much so that the naturist Heinrich Pudor referred to it as 'a guide of the age' and claimed that the book was for modern Germany what Christ was for Christians and Muhammad for the Arabs.[43]

Langbehn was Thoma's friend, Böcklin's admirer and Nietzsche's follower, so it is no surprise that he saw art as a means of German spiritual regeneration. The role of art in general, and Rembrandt in particular, was central to Langbehn's argument. Although Dutch, Rembrandt was seen to embody the 'Niederdeutsch' (Lower German) quality of central Germany. One of Langbehn's methods was to extend the notion of 'Germanness' beyond the boundaries of Germany itself, and to look for evidence of Germanic temperament in the history of other places, such as England and Venice. Thus Shakespeare becomes as much an embodiment of German character as Martin Luther. Rightly or wrongly, Rembrandt became the symbol for German individuality, character and the peasant tradition. Langbehn also emphasised rural and local traditions as essential for the spiritual renewal of German life. He isolated Schleswigholstein in the far north as Germany's spiritual centre, and his admirer, Pudor, carried this national characterisation further:

> We have before our eyes the tribal characteristics [*Volksstämme*] of a people: the Frenchman has 'Esprit' (Voltaire), the Englishman has 'common sense' (Thomas Reid); the Oberdeutsche [Upper Germans] have fantasy (Schelling), the Niederdeutsch [low, north Germans] have intelligence (Kant); the Germans as a whole have feelings (Luther). England is the head, Germany the heart, Austria the belly of Europe. What should the correct guide now be? The heart. Where should this prevail? Europe's heart, Germany's heart, the true Germany – Thüringen, Niederdeutschland is the land of the plains and the sea, Oberdeutschland is the land of the woods and the mountains. In the heart of Germany, one finds meadows, pastures, hills and fields.[44]

Although their sentiments complement each other, it is interesting to note that while Langbehn attributes Germany's character to the historic northern province of Schleswigholstein, Pudor moves south to Thuringia – the geographical centre of modern Germany. Both authors read meaning and physiognomic significance into the specific and varied features of the regional landscapes. Such localism and ruralism was attacked by other contemporary authors who saw Langbehn's arguments as dangerously regressive. As one satirist put it:

> In spite of railways and art exhibitions, the Germans must reject the big city centres: no Düsseldorf, Stuttgart, Karlsruhe, Dresden, for all that no more Munich, either! From Holland to Poland we must have in each nook and cranny [*Krähwinkel*] a special 'local' art. – Not only a Westphalian, Hannoverian and Lower Schlesisch-märkisch art, no! an art of Meppen, Dalldorf, Sonnenstein, Itzehoe, etc.![45]

However, the emphasis on north central Germany as the spiritual centre of the nation offered the artists of Worpswede an important justification for their

own painting, while Langbehn's book valorised German regionalism and gave other artists' colonies a *raison d'être*. They were not simply *plein air* painters, but they became agents of regeneration seeking a cultural identity for Germany through their representation of the landscape.

Artists were not the only enthusiasts who began invading the landscape at the turn of the century in search of this essential quality which they felt was lacking in the modern world. The famous German youth movement was another example of this sort of colonising. The youth movement began in Steglitz, a suburb of Berlin, in 1896, when Hermann Hoffman, a student at Berlin University, started a study circle which was devoted to long walks in the Grünewald forests. By 1901, this organisation had grown and became institutionalised under the name 'Wandervogel' (wandering birds), with the writer Heinrich Sohnrey as president. The Wandervogel and similar groups spread throughout Germany, but they were concentrated mainly in Protestant areas and dominated the geographical centre of Germany where the Worpswede artists were also located.[46] As its name suggests, the 'youth movement' was concerned with young people and the young German nation. The later invidious associations of the 'youth movement' with the rise of National Socialism should not disguise the fact that many members of the early movement were innocent of political intriguing and favoured moral purification, temperance and vegetarianism. Unlike the similarly youth-oriented Futurist movement in Italy and the Union of Youth in Russia, both of which glorified urbanism and modernity as symbols of youthfulness, the German youth movement was predominantly rural in character, and located its values in the local landscape.

The youth movement, Langbehn's nationalism and the artist colony came together in what has been considered the first truly 'modern' artistic group in Germany – Brücke (Bridge).[47] Like the youth movement, the artists of the Brücke group were opposed to the materialistic values of bourgeois urban society, and they sought to subvert those values through an emphasis on a 'primitive' style and rural themes. Their 'Programme', published in September 1906, stated their primary aims most clearly:

> With a belief in continuing evolution, in a new generation of creators as well as appreciators, we call together all youth. And as youth that is carrying the future, we intend to obtain freedom of movement and of life for ourselves in opposition to older, well-established powers. Whoever renders directly and authentically that which impels him to create is one of us.[48]

Youth was a strong, but not the only programmatic aim of Brücke. The group was formed in 1905 by four architectural students in Dresden: Ernst Ludwig Kirchner, Erich Heckel, Karl Schmidt-Rottluff and Fritz Bleyl.[49] They recruited other members including Emil Nolde and Max Pechstein, and they also gathered a group of 'passive members' who paid them an annual subscription in return for a portfolio of prints. By 1906 Heckel had taken over the management of the group, and he set up a communal studio in a working-class district of Dresden. They held their first exhibition in a Dresden lamp factory, and they gradually gained recognition, largely through the distribution of their graphic work. By 1912, when their work was shown at the Cologne

Sonderbund exhibition, they were recognised artists, and their very success led to tensions which eventually resulted in the dispersal of the group.

None of this group was formally trained in an art academy, but their profession of auto-didacticism is belied by the quite full artistic grounding they gained as part of their technical training.[50] The cry of youth and freedom was rhetorically supported by their putative lack of artistic training, which they perpetuated through a deliberate incorporation of 'primitivist' influences in their art (see chapter 3). Their appropriation of the stark expressive nature of Oceanic art in particular was complemented by their affection for late medieval German graphic techniques. In their enthusiastic adoption of the artefacts of their own German heritage, Brücke artists were working within the same kind of nationalist agenda as the artists of Worpswede and Vinnen's many supporters.[51] Their resolute Germanness may in part explain Kirchner's extraordinary declaration in his account of the group's genesis that they were 'not influenced by today's fashionable tendencies such as Cubism, Futurism, etc.'.[52] This statement rings particularly false when looking at, for instance, Kirchner's *Girl Under a Japanese Umbrella*, which uses vibrant patches of strong primary colour in the manner of Matisse or Derain; or Erich Heckel's *Glassy Day*, which converts a nude bather into a faceted body in a lake that seems composed of Cubist angles.

The traditionalism of the Brücke group and their nod to a German cultural heritage was part of a wider tendency in German avant-garde art and criticism,[53] and it gave the group a foothold within both the cosmopolitan art world and the nationalist rhetoric of traditionalists. Thus while woodcuts by Schmidt-Rottluff (figure 13) and Heckel could theoretically pay a tribute to

13 Karl Schmidt-Rottluff, *Mourners on the Shore*, woodcut

Dürer or Schongauer, their excessively simplified forms and mournful subjects gave them a distinct tinge of modernity which would not have been characteristic of works solely paying homage to German art history.[54] Emil Nolde's choice of conventional religious subjects fulfils the same competing criteria. Although his subject-matter has a long iconographical tradition, the violence of his colourism, the caricatural distortion of his figures, and the sense of barely contained frenzy made his scenes both unique and unquestionably modern.

This combination of modernity and traditionalism even appears in the group's choice of a name. Their full title was the 'Künstlergemeinschaft Brücke'.[55] Translated literally, this becomes 'the artists' community, Bridge', but the connotations of the term 'Gemeinschaft' are particularly telling in the wake of Tönnies' pivotal work on social groupings. By calling themselves a 'Gemeinschaft', the artists of Brücke were deliberately associating themselves with the rural communities and rural ideals of family and kinship discussed by Tönnies. Kirchner stressed the 'communal sense' of Brücke in his Chronicle, and their incorporation of passive members who were not artists but approved of their ideals, gave this community a wider significance.

Just as their status as a 'Gemeinschaft' stressed a positive approach to past cultures, their choice of the title 'Bridge' is also significant. The title has been linked to lines from Nietzsche's Thus Spoke Zarathustra: 'Man is a rope, fastened between animal and superman – a rope over an abyss. A dangerous going-across, a dangerous wayfaring, a dangerous looking-back, a dangerous shuddering and staying-still. What is great in a man is that he is a bridge and not a goal.'[56] However, there may be another origin of the name, as Langbehn (perhaps following Nietzsche) also used the metaphor of a bridge, this time with reference to Germany's modern spiritual mission:

> Germans already have political mastership of the world, and their talents will enable them, at the same time, to gain spiritual mastery: they will, through strong war-readiness, maintain the one, and through genuine disposition to art, acquire the other. In order to achieve this high purpose, a mediator, a connecting link, a bridge between Germany and the rest of the world is needed.[57]

Langbehn most likely saw himself as this 'bridge' between Germany and the rest of the world, but his metaphor transposed Nietzsche's universalising image into something much more specific and much more nationalist. As the first proponents of what was later called 'Expressionism' (see chapter 4), the artists of Brücke were producing works in a style that was soon identified with Germany. Their Expressionist style contrasted directly with what they saw as the Impressionist superficiality of artists such as Liebermann, despite the debt all of these artists owed to French examples.

Brücke artists also shared with their late nineteenth-century forerunners an interest in the rural landscape, and they took numerous trips – together and separately – into various remote parts of northern Germany.[58] Between 1907 and 1910, Heckel, Kirchner and Pechstein spent parts of summers together on the Moritzburg lakes near Dresden; Schmidt-Rottluff divided his time between Dresden and Dangast, and also travelled to Norway. After 1909 Pechstein spent his summers on Nidden in East Prussia on the Baltic.

Members of the group also painted on the Baltic island of Fehmarn. In each of these places, Brücke artists painted both rural landscapes and pastoral images of nudes in the open air. Their rather conventional choice of subject was accompanied by stylistic experimentation. Heckel's fascination with vibrant colour was transformed into an interest in Cubist formalism, while Karl Schmidt-Rottluff produced works in which the actual landscape itself was increasingly overwhelmed by great splashes of primary colour. Kirchner also painted pure landscapes, but his most famous works from the period show nudes in the landscape, and they have been conventionally interpreted as examples of Brücke bohemianism and enthusiasm for the sexual energy of 'natural' life.

Because Brücke landscapes appear startlingly modern, one is tempted to accept them as progressive images which reveal the artists' commitment to the revolutionary youthfulness that they stressed in their original manifesto. Certainly, Brücke nudes were worlds apart from the idealised peasants that had been painted by artists in rural settings at the turn of the century, and the landscapes themselves were in no way the mood pieces that were produced by such painters such as Otto Modersohn. However, their adoration of rural settings was no less unquestioning than that of the Worpswede or Dachau groups; their choice of nudes in the landscape had a strong artistic tradition; their utopianism and idealism were equally single-minded. They embraced naturism in every sense of the word, but this was also advocated by members of the youth movement, whose practice of nudism was one component of the vegetarianism and pacifism that characterised their ideals. The primitivist echoes and sexual vitalism that characterises works such as Kirchner's *Striding into the Sea* (figure 14) were conjured up from a mish-mash of ethnographic

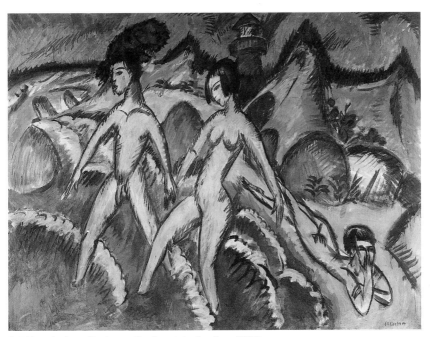

14 Ernst Ludwig Kirchner, *Striding into the Sea*, 1912

artefacts, leisure enjoyment on the beach and sexual involvement with female models, including his common law wives Doris Grosse and Erna Schilling.

Attempts to reconcile the traditional and the modern were also characteristic of the series of city scenes that Kirchner painted after moving to Berlin in 1911. The move to Berlin precipitated the fragmentation of Brücke. Although they were able to maintain some sort of unity while they were based in the smaller city of Dresden, after this relocation, each of them was sucked into a competitive art market which gradually turned them away from their communal ideals. By 1911 all the major Brücke artists were in Berlin, and the group's demise was consolidated when Max Pechstein exhibited with the Secession – a move which, to the other artists of the group, identified him with the establishment they all reviled. The artists of the group had painted city scenes before; Dresden and Cologne, among other places, figured in their earlier landscapes. But most artists of the group avoided the challenge of painting Berlin, a city that was overwhelming, unstructured and even ugly. Kirchner, by contrast, accepted this challenge, and his works reveal both passion and ambivalence for the city and city life. His choices about what and how to paint Berlin showed a marked contrast with the partly topographical and stylistically Fauvist views of Dresden and Cologne. In Berlin, Kirchner turned away from the cityscapes of Skarbina and Baluschek, with their representations of panoramic views and tired working people, and concentrated on the leisure behaviour of the middle classes.

The most famous of Kirchner's city scenes are the ten paintings of prostitutes (figure 15), most of which he constructed from rapid sketches taken on the spot. These scenes of women on the street have been variously interpreted,

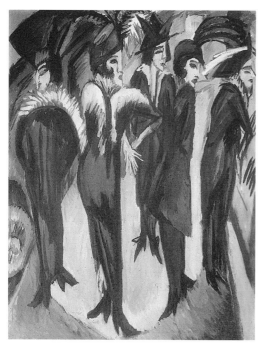

but scholars disagree as to whether they are negative images of alienation, or signs of Kirchner's own fascination with the vitalism of the erotic. The former argument is heavily contingent upon the appearance of a seminal critique of modern urban life, Georg Simmel's *Philosophy of Money*, first published in 1900, and his related essay, 'The metropolis and mental life' of 1903. Simmel argued that in the modern capitalist economy, the privileging of money had led to changes in social relationships and personal experience. In an industrial society, individuals were increasingly pitted against each other, and differentiation led to isolation. Money increased the pace of life and contributed to a view of the world that was relativist, rather than communal. The idolisation of money thus resulted in the 'levelling of emotional life'. Simmel's analysis located the site of this new consciousness firmly in the city, which became a place of alienation, calculation and a new

15 Ernst Ludwig Kirchner, *Five Women on the Street*, 1913

kind of emotional expression.[59] Kirchner's prostitutes could be seen as examples of this alienation: they are commodities for sale, rather than individuals; they are separated and isolated, rather than associating and communicating.[60]

However, in many ways, this explanation is too simple. Kirchner may have found the crowded and unhealthy urban space a disgusting one, but he was also excited by it, and many of his other images of urban life show scenes of the circus and dance hall – locations of positive, if often manic, or morally questionable, activity.[61] Such ambivalence about the city was common, and Kirchner was not necessarily moralising about alienation when he painted his prostitutes. What all of these city works share is a deliberate artificiality which contrasts readily with the contrived 'naturalness' of his rural scenes. The prostitutes are overdressed and overpainted; the circuses are ritualised and vulgarly flamboyant; the dance halls are dominated by machine-like gestures. This is not to suggest that the nudes in the landscape are any less contrived, but Kirchner sought to contrast this with urban artificiality.

What characterised the city views of Kirchner as well as the works of other Brücke artists was a propensity to reconcile the old and the new, the German and the foreign, the communal and the individual. Such ambivalence dominated representations of the city in a way they did not in the clearer nationalist messages contained in rural landscapes of the *fin de siècle*. Some of Kirchner's contemporaries were more extreme in their images of urban life, and they concentrated less on the city as it appeared and more on the dystopian anxieties built around it by contemporary writers. The American expatriate, Lyonel Feininger, who later became an important teacher in the Bauhaus, spent his early career drawing cartoons for progressive art journals, but he also painted several scenes of city life, including *Uprising* (1910, New York, Museum of Modern Art) and *Street in Dusk* (1910, Hanover, Sprengel Museum). The former painting visualises a commonly held fear that the city fostered an urban proletariat who would live out Marx's prophecy of revolution; the city was seen as a subversive space where such proletarian discontent could not be defused or controlled. Feininger's *Uprising* shares with Kirchner's city scenes an emphasis on artificiality: some of the revolutionaries are wearing masquerade dress which disguises their class and status. *Street in Dusk* is based on Munch's *Evening on Karl Johan Strasse*, which is the ultimate expression of urban anxiety. The street is dark, the violent angles arouse unease in the observer, each of the individuals is isolated. Feininger identified and represented the sorts of contemporary fears which constructed the city as a place of anarchy, danger and violence. However, his ironic reflection on these anxieties, and the beliefs held by socialists that revolution was a necessary and liberating experience, made these garish cartoons ambiguous essays on urban violence.[62] In the same tradition, but with more savage satire, were the post-war urban images of George Grosz. Works such as *Metropolis* and *Homage to Oskar Panizza* (1917–18, Stuttgart, Staatsgalerie) stress the unpredictability of crowd behaviour and the violence that accompanies lack of control. The post-war city scenes of Grosz, Otto Dix and Max Beckmann were more potent expressions of urban violence, but they also indicate a shift of artistic emphasis from rural to urban imagery for political, as well as aesthetic, purposes (see chapters 4, 6 and 7 for discussions of these artists).

Anarchy and violence, if carried to an extreme, were felt to point towards ultimate destruction, but violence was also part of the manifesto of the Italian Futurists – who admired the destructive potential of the modern metropolis. Their passion for destroying the old was appropriated in Germany by Ludwig Meidner, who used the term 'apocalypse' in retrospective titling of his paintings of city life, in which the city is bombarded, burned or destroyed. Meidner's bleak and tortured views of city life may appear to reinforce contemporary anxiety about the urban space, but Meidner was a sympathiser with the Futurists' ecstatic glorification of urbanisation.[63] He was associated with a group of like-minded poets, including Jakob von Hoddis and Georg Heym, who founded a group called the 'Neopathetisches Cabarett' in 1909. Like many other intellectual circles of the time, this group drew inspiration from Nietzsche's ideas, particularly Nietzsche's isolation of 'pathos' as a heightened sense of life's intensity. The term 'pathos' reflects the mixture of positive and negative sensations that characterised many contemporary responses to the city. The self-destructiveness of urban life was seen as a prelude to a new age. Meidner's passion for the city led him to refer to it as the *Heimat* – a term previously associated with the rural and regional aspects of German life.[64] Indeed, Meidner could not have been innocent in his use of such a loaded term, and he was trying to isolate and defend an essential change in the German way of life.

The city stood uneasily for the *Heimat* in German avant-garde culture, as artists transferred the nationalist feelings associated with the rural 'sense of place' to the urban settings that fascinated them, attracted them and gave them their livelihood. As early as 1908, the Jugendstil artist August Endell wrote an essay on big cities in which he represented their impressionistic beauty and declared them the new *Heimat*.[65] While other artists were less forthcoming in connecting the modern metropolis to the nationalist *Heimat*, their work demonstrated the same kind of intense affection and association. Meanwhile, rural Germany did not disappear from representation, but the dominant aesthetics of the post-war period were less timid of the urban landscape and less reverential of the rural one. The National Socialists later sought to erase the vision of the degenerate city from painting and replace it with the sort of rural *Heimat* that had obsessed artists at the turn of the nineteenth century (see chapter 8). But their appropriation of these images was laden with overt political connotations which transformed a yearning for the homeland into a dogmatic representation of its moral superiority.

NOTES

1 'Alles wird wieder groß und gewaltig,/die Lande einfach und die Wasser faltig,/die Bäume riesig und sehr klein die Mauern;/und in den Tälern stark und vielgestaltig/ein Volk von hirten und von Ackerbauern': Rainer Maria Rilke, *Das Stundenbuch*, Wiesbaden, 1959, p. 77.
2 Ludwig Meidner, 'Anleitung zum Malen von Großstadtbildern', *Kunst und Künstler*, 12 (1914), 299–301, Eng. trans. in Rose-Carol Washton-Long (ed.), *German Expressionism: Documents from the End of the Wilhelmine Empire to the Rise of National Socialism*, Berkeley and Los Angeles, 1995, pp. 101–3.
3 'Berlin ist Deutschlands politische Hauptstadt; aber es ist nicht zu wünschen, daß es seine geistige Hauptstadt werde': Julius Langbehn, *Rembrandt als Erzieher*, 2nd edn, Leipzig, 1890, p. 112.

4 Benedict Anderson, *Imagined Communities: Reflections on the Origin and Spread of Nationalism*, London and New York, 1991, does not devote much attention to the visual. Other helpful works on nationalism deal mainly with political and textual issues, e.g. John Breuilly, *Nationalism and the State*, Manchester, 1982; and Ernest Gellner, *Nations and Nationalism*, Oxford, 1983.

5 For more general considerations of the relationships between landscape and identity, see Raymond Williams, *The Country and the City*, London, 1985; and Simon Schama, *Landscape and Memory*, London, 1995.

6 Wilhelm Riehl, *Die Naturgeschichte des deutschen Volkes als Grundlage einer deutschen Sozialpolitik*, 3 vols, Stuttgart and Augsburg, 1857.

7 'Man kann deutschen Acker, deutschen Wald, deutsche See lieben, aber diese Liebe ist primär und platonisch; der Begriff Vaterland erhält erst Fülle und Farbe, wenn die Liebe keine lebendige Vorstellung findet: den blonden Scheitel eines deutschen Kindes, die dunkle Seele einer deutschen Frau, die helle Güte eines deutschen Mannes; mehr aber noch als Fülle und Farbe: Feuer und Flamme durchdringen den Sinn fürs Vaterland, wem erst der lebendige Geist der großen deutschen Männer die Brust mit rührenden Gewalten durch strömt': Max Bewer, *Rembrandt und Bismarck*, Dresden, 1891, pp. 6–7.

8 This is discussed by Robin Lenman, 'From "brown sauce" to "plein air": taste and the art market in Germany 1889–1910', in Françoise Forster-Hahn (ed.), *Imagining Modern German Culture 1889–1910*, Washington, DC, 1996, pp. 53–69 (quotation on p. 59).

9 Langbehn, *Rembrandt*, pp. 26, 27.

10 See Carl Vinnen (ed.), *Ein Protest deutscher Künstler*, Jena, 1911, p. 12: 'Es ist wahr, Leibl, Thoma, Klinger, Boecklin und die meisten anderen großen Namen ließen ihre Kunst in Paris befruchten, aber sie bleiben dabei so deutsch, daß wir sie niemals mit einem der damaligen franzosen verwechseln könnten.'

11 Alfred Köppen, *Die moderne Malerei in Deutschland*, Bielefeld and Leipzig, 1902, p. 114.

12 Julius Meier-Graefe, *Modern Art: Being a Contribution to a New System of Aesthetics*, Eng. trans. by Florence Simmonds and George W. Chrystal, 2 vols, New York, 1968, vol. 1, p. 158.

13 Hans W. Singer, 'Hans Thoma and his work', *Studio*, 10 (1897), 79–88 (quotation on p. 82).

14 For Leibl, see especially Michael Petzet (ed.), *Wilhelm Leibl und sein Kreis*, exhibition catalogue, Munich, 1974; Boris Rohrl, *Wilhelm Leibl: Leben und Werk*, Hildesheim, 1994; Eberhard Ruhmer, *Der Leibl-Kreis und die reine Malerei*, Rosenheim, 1984; and *Wilhelm Leibl zum 150. Geburtstag*, exhibition catalogue, Munich, 1994.

15 For Böcklin, see especially Andrea Linnebach, *Arnold Böcklin und die Antike: Mythus Geschichte, Gegenwart*, Munich, 1991.

16 Carl Neumann, *Der Kampf um die neue Kunst*, Berlin, 1896, p. 10.

17 Johannes Manskopf, *Böcklins Kunst und die Religion*, Munich, 1905, p. 9.

18 Ferdinand Avenarius, 'Böcklin', *Kunstwart*, 14:9 (1901), 396, quoted in Kenworth Moffett, *Meier-Graefe as Art Critic*, Munich, 1973, p. 139.

19 This work and its debt to Nietzsche's *Der Fall Wagner* is discussed by Robert Jensen, *Marketing Modernism in Fin-de-Siècle Europe*, Princeton, 1994, pp. 257ff; and Moffett, *Meier-Graefe*.

20 Henry Thode, *Böcklin und Thoma: acht Vorträge über neudeutsche Malerei*, Heidelberg, 1905, p. 20. See also Julius Meier-Graefe, *Der Fall Böcklin und die Lehre von der Einheiten*, Stuttgart, 1905.

21 There are a number of important studies on Berlin and its impact on visual culture. See especially Charles Haxthausen and Heidrun Suhr (eds), *Berlin Culture and Metropolis*, Minneapolis and Oxford, 1990; Dorothy Rowe, 'Desiring Berlin: gender and modernity in Weimar Germany', in Marsha Meskimmon and Shearer West (eds), *Visions of the 'Neue Frau': Women and the Visual Arts in Weimar Germany*, Aldershot, 1995, pp. 143–64; *Art in Berlin 1815–1989*, exhibition catalogue, Atlanta, 1989; and Iain Boyd White, 'Berlin 1870–1945: an introduction framed by architecture', in Irit Rogoff (ed.), *The Divided Heritage: Themes and Problems in German Modernism*, Cambridge, 1991, pp. 223–52. The nicknames for Berlin are discussed in Richard Hamann and Jost Hermand, *Stilkunst um 1900: Epochen deutscher Kultur von 1870 bis zur Gegenwart*, Berlin, 1967, p. 326.

22 The first quotation is from August Macke's letter to his wife Elisabeth of 22 December 1907, in *Briefe an Elisabeth und die Freunde*, ed. Werner Frese and Ernst-Gerhard

Güse, Munich, 1987, p. 164. The second quotation is from a letter Kandinsky wrote to Gabriele Münter, while he was visiting Moscow in 1910: cited in Annegret Hoberg (ed.), *Wassily Kandinsky and Gabriele Münter: Letters and Reminiscences 1902–1914*, Munich, 1994, p. 83.

23 Köppen, *Die moderne Malerei*, p. 21. For Menzel, see *Adolph Menzel 1815–1905: Between Romanticism and Impressionism*, New Haven and London, 1996. See also Peter Paret, *Art as History: Episodes in the Culture and Politics of Nineteenth-Century Germany*, Princeton, 1988; and Christiane Zangs, *Die künstlerische Entwicklung und das Werk Menzels im Spiegel der zeitgenossischen Kritik*, Aachen, 1992.

24 An especially insightful essay on these artists is John Czaplicka, 'Pictures of a city at work, Berlin, circa 1890–1930: visual reflections on social structures and technology in the modern urban construct', in Haxthausen and Suhr, *Berlin Culture and Metropolis*, pp. 3–36.

25 Ebenezer Howard, *Tomorrow: A Peaceful Path to Real Reform*, London, 1898, p. 5.

26 '... die Fabrik neben dem Lustschloss, die Kaserne neben dem Kunst-Tempel, der Schlachthof neben der Schule, das Bordell neben dem Gotteshaus': Theodor Fritsch, *Die Stadt der Zukunft*, Leipzig, 1896, p. 4. For a discussion of this and other aspects of the garden city movement in visual culture, see Shearer West, *Fin de Siècle: Art and Society in an Age of Uncertainty*, London, 1993, pp. 50–67.

27 Ferdinand Tönnies, *Community and Society* (1887), Eng. trans. by Charles Loomis, London, 1955. See the discussion of this in Donald Gordon, *Expressionism: Art and Idea*, New Haven and London, 1987, pp. 131ff.

28 See 'Mitteilungen des Bundes Heimatschutzes', quoted in Klaus Bergmann, *Agrarromantik und Großstadtfeindschaft*, Meisenheim, 1970, p. 122. See also Christian F. Otto, 'Modern environment and historical continuity: the *Heimatschutz* Discourse in Germany', *Art Journal*, 43:2 (1983), 148–57.

29 For the evolution of this agrarian-romantic attitude, see Bergmann, *Agrarromantik*, and for the continued importance of the small landowner in German society, see Richard Bessell and E. J. Feuchtwanger (eds), *Social Change and Political Development in Weimar Germany*, London, 1981, especially pp. 134–40.

30 See Joachim Petsch, 'The Deutscher Werkbund from 1907 to 1933 and the movements for the reform of life and culture', in Lucius Burckhardt (ed.), *The Werkbund: Studies in the History and Ideology of the Deutscher Werkbund 1907–33*, London, 1977, pp. 85–93; and Gerhard Kratzsch, *Kunstwart und Dürerbund: ein Beitrag zur Geschichte der Gebildeten im Zeitalter des Imperialismus*, Göttingen, 1969. See also Hamann and Hermand, *Stilkunst*, pp. 326ff.

31 For German artists' colonies see Gerhard Wietek (ed.), *Deutsche Künstlerkolonien und Künstlerorte*, Munich, 1976.

32 There are a number of exhibition catalogues and books on the Worpswede colony. See, for instance, Heinz Gartner, *Worpswede war ihr Schicksal: Modersohn, Rilke und das Mädchen Paula*, Düsseldorf, 1994; Guido Boulboulle, *Worpswede: Kulturgeschichte eines Künstlerdorfes*, Cologne, 1989; *Paula Modersohn-Becker, Worpswede*, exhibition catalogue, Worpswede, 1989; *Worpswede Künstler Kolonie Norddeutschlands*, exhibition catalogue, Worpswede, 1992; and *Worpswede: 100 Jahre Künstlerort*, Fischerhude, 1989.

33 'Schnell durcheilte sie die Postkutsche, durchbrauste sie die Eisenbahn, kein Bädeker wußte von ihrer Naturschönheit zu berichten: glattes, flaches Land, hie und da eine kleine hügelige, mit Kiefern bestandene Bodenerhebung, wenig korn- und weizentragende Felder, überwiegend Moorbaden, durch den sich die Hamme und kleine Kanäle schlängeln, armselige Hütten der Einwohner, die hier seit Jahrzehnten mit der Scholle verwachsen sind, ein Stück Volkstum, losgelöst vom großstädtischen Leben, jeder Kultur fast bar, das war Worpswede bis vor kurzer Zeit': Köppen, *Die moderne Malerei*, pp. 56–7.

34 For the way in which 'place-myths' can be constructed, see Rob Shields, *Places on the Margin: Alternative Geographies of Modernity*, London and New York, 1991.

35 *The Letters and Journals of Paula Modersohn-Becker*, ed. J. Diane Radycki, Metuchen, NJ, and London, 1980, p. 30. For Modersohn-Becker, see also Gillian Perry, *Paula Modersohn-Becker: Her Life and Work*, London, 1989.

36 *Ibid.*, p. 29.

37 *Ibid.*, pp. 34, 247, 108.

38 *Ibid.*, p. 30.

39 Vinnen, *Protest*. See also the rebuttals of Vinnen's work: for example, Vassily Kandinsky et al., *Im Kampf um die Kunst: die Antwort auf den 'Protest deutscher Künstler'*,

Munich, 1911; and Paul Cassirer's essays in *Pan* 1 (16 May 1911), 457–69 and (1 July 1911), 558–73.

40 'Aber die Eigenart unseres Volkes liegt … auf … Vertiefung, Phantasie, Empfindung des Gemütes, man versteht mich vielleicht besser, wenn ich nur Namen nenne, deren Träger bereits in das Land der Geschichte eingegangen sind, Rethel, Menzel, Leibl, Boecklin, Marées': Vinnen, *Protest*, p. 8.

41 'keine Kunst hat sich entwickeln können in ihrer Gesamtheit, ohne die geistige und materielle Mithilfe ihres Volkes': *ibid.*, p. 13.

42 *Ibid.*, p. 1 and A. Goetze, 'Was ist deutsch?', in *ibid.*, pp. 52–3.

43 Heinrich Pudor, *Ein ernstes Wort über 'Rembrandt als Erzieher'*, Göttingen, 1890, p. 31.

44 'Man halte sich doch einmal die Eigenarten der Volksstämme vor Augen: der Franzose hat "Esprit" (Voltaire); der Engländer hat "common sense" (Thomas Reid); der Oberdeutsche hat Phantasie (Schelling); der Norddeutsche hat Verstand (Kant); der Deutsch hat Gemüth (Luther). England ist das Kopf, Deutschland das Herz, Oesterreich der Unterleib von Europa. Was soll nun die Richt schnur geben? Das Herz. Was soll also obsiegen? Europas Herz, Deutschlands Herz, das wahrhaftige Deutschland, Thüringen, Niederdeutschland ist das Land der Ebene und des Meeres. Oberdeutschland is das Land der Wälder und Berge. Im Herzen von Deutschland findet man Wiesen, Auen, Triften, fanstansteigende Berge, Thäler und Höhen': *ibid.*, p. 37.

45 'Trotz Eisenbahnen und Kunstausstellungen müssen die Deutschen großen Kunstzentren verschwinden, kein Düsseldorf, Stuttgart, Karlsruhe, Dresden, vor allem kein München mehr! Von Holland bis Polen müssen wir in jedem Krähwinkel eine besondere "lokale" Kunst haben. – Nicht nur eine westfälische hannö-märkische, nein! Eine Kunst von Meppen, Dalldorf, Sonnenstein, Itzehoe und so weiter!': Anon., *Der heimliche Kaiser oder der Dampfbau oder der wildgewordene Bleimchenkaffee. Unheimliches Geheimnis*, Stuttgart, 1891, pp. 5–6.

46 See Walter Laqueur, *Young Germany: A History of the German Youth Movement*, 2nd edn, New Brunswick and London, 1984; and Peter D. Stachura, *The German Youth Movement 1900–1945: An Interpretative and Documentary History*, London, 1981.

47 Reinhold Heller, *Brücke: German Expressionist Prints from the Granvil and Maria Specks Collection*, Evanston, 1988, p. 7, makes an important case for dropping the definite article 'die' (the) before Brücke. This is a subsequent art historical habit, rather than the formulation used at the time.

48 Quoted in *ibid.*, p. 15.

49 Studies of Brücke and their work include Jill Lloyd, *German Expressionism: Primitivism and Modernity*, New Haven, 1991; Horst Jähner, *Künstlergruppe Brücke: Geschichte einer Gemeinschaft und das Lebenswerk ihrer Repräsentanten*, Stuttgart, 1984; Barry Herbert, *German Expressionism: die Brücke and der Blaue Reiter*, London, 1983; Donald Gordon, *Expressionism: Art and Idea*, New Haven and London, 1987; Wolf-Dieter Dube , *Expressionism*, London, 1972; and Dietmar Elger, *Expressionism: A Revolution in German Art*, Cologne, 1989.

50 Peter Lasko, 'The student years of die Brücke and their teachers', *Art History*, 20:1 (1997), 61–99.

51 See Lloyd, *German Expressionism*; and Robin Reisenfeld, 'Cultural nationalism, Brücke and the German woodcut: the formation of a collective identity', *Art History*, 20:2 (1997), 289–312. Reisenfeld points out the way in which critics like Wölfflin and Worringer identified the print as a specifically German product.

52 Quoted in Heller, *Brücke*, p. 16.

53 See the argument of Patricia Berman, 'The invention of history: Julius Meier-Graefe, German modernism and the genealogy of genius', in Forster-Hahn, *Imagining Modern German Culture*, pp. 91–105.

54 See Gunther Thiem and Armin Zweite (eds), *Karl Schmidt-Rottluff: Retrospektive*, Munich, 1989.

55 This term was used by Kirchner in his 1913 Chronik der Künstlergemeinschaft Brücke.

56 Friedrich Nietzsche, *Thus Spoke Zarathustra*, Eng. trans., Harmondsworth, 1969, pp. 43–4.

57 'Die Deutschen haben schon jetzt die politische mastership of the world; ihre sonstigen Anlagen befähigen sie, sich dieselbe auch geistig zu erringen; jene werden sie sich durch starke Kriegsbereitschaft erhalten und diese durch echte Kunstgesinnung erwerben. Um diesen hohen Zweck zu erreichen, bedarf es eines vermitteln den Organs, eines Bindeglieds, einer Brücke – zwischen Deutschland und der übrigen Welt': Langbehn, *Rembrandt als Erzieher*, p. 223.

58 See Lloyd, *German Expressionism*, and Gill Perry, ' "The ascent to nature" – some metaphors of "nature" in early Expressionist art', in Shulamith Behr, David Fanning and Douglas Jarman (eds), *Expressionism Reassessed*, Manchester, 1993, pp. 53–64.

59 Georg Simmel, *The Philosophy of Money* (1900), Eng. trans., London and New York, 1990, pp. 432–3. See also David Frisby, *Fragments of Modernity: Theories of Modernity in the Work of Simmel, Kracauer and Benjamin*, Cambridge, 1985.

60 For Kirchner, see especially Donald Gordon, *Ernst Ludwig Kirchner*, Cambridge, Mass., 1968; Rosalynd Deutsch, 'Alienation in Berlin, Kirchner's street scenes', *Art in America* (January 1983), pp. 65–72; Magdalena Moeller, *Ernst Ludwig Kirchner: die Strassenszenen 1913–1915*, Munich, 1993; and Françoise Forster-Hahn and Kurt W. Foster, 'Art and the course of empire in nineteenth-century Berlin', in *Art in Berlin*.

61 Charles Haxthausen, ' "A new beauty": Ernst Ludwig Kirchner's images of Berlin', in Haxthausen and Suhr, *Berlin Culture and Metropolis*, pp. 58–94.

62 Ulrich Luckhardt, *Lyonel Feininger*, Munich, 1989.

63 See Carol Eliel, *The Apocalyptic Landscapes of Ludwig Meidner*, Munich, 1989; Gerda Breuer and Ines Wagemann, *Ludwig Meidner 1884–1966. Maler, Zeichner, Literat*, 2 vols, Stuttgart, 1991; Dorothea Eimert, *Der Einfluß der Futurismus auf die deutsche Malerei*, Cologne, 1974; and Jost Hermand, 'Das Bild der "großen Stadt" im Expressionismus', in Klaus Scherpe (ed.), *Die Unwirklichkeit der Städte: Großstadtdarstellung zwischen Moderne und Postmoderne*, Reinbek, 1988.

64 This is from an article in the art magazine *Kunst und Künstler*, quoted in Charles Haxthausen, 'Images of Berlin in the art of the Secession and Expressionism', in *Art in Berlin*, p. 26.

65 *Die Schönheit der großen Stadt*, Stuttgart, 1908. This is discussed by Lothar Müller, 'The beauty of the metropolis: toward an aesthetic urbanism in turn-of-the-century Berlin', in Haxthausen and Suhr, *Berlin Culture and Metropolis*, pp. 37–57. See also Ira Katznelson, 'The centrality of the city in social theory', in Rogoff, *Divided Heritage*, pp. 253–64.

The spiritual in art

The epoch of the Great Spirit can now peacefully begin. (August Macke to Bernhard Koehler, 22 January 1912)[1]

T HE nationalist undercurrents in rural and urban representations drew strength from a persistent emphasis on the spiritual, intellectual and philosophical aspects of visual culture. Throughout Europe in the late nineteenth and early twentieth centuries, artists and writers began to reject what they saw as a superficial and materialistic way of life, associated with the growth of middle-class culture and its perceived cultural philistinism.[2] In avant-garde artistic circles, middle-class taste was associated with mimetic representations of daily life or idealised, even propagandist, scenes of history – painting and sculpture that would not tax the eye or the mind and which could be understood at a glance. The artist was felt to be a servant or sales-man whose purpose was to provide furniture for his customers. As Kandinsky put it, the nineteenth century was 'an era of the deification of matter'.[3]

The artistic rejection of this middle-class taste was pan-European, but in Germany it took on a distinct philosophical and aesthetic form.[4] Through new movements in art – from Symbolism to Brücke and the Blaue Reiter (Blue Rider) – this philosophical bent found a distinct set of manifestations. The philosophical and aesthetic foundations of a new emphasis on the spiritual were strongly established by the end of the nineteenth century, and early twentieth-century Expressionist artists expanded the spiritual possibilities of art through a variety of means.

The development of the visual arts in Germany owed a great debt to philosophy from the Romantic movement onwards,[5] but philosophical con-nections were consolidated in the 1890s, when the works of Nietzsche inspired the avant-garde throughout Europe.[6] Nietzsche was a violent opponent of materialism, and he produced a brilliant series of aphoristic tracts between 1870 and 1889, when insanity prevented him from writing further. Although Nietzsche's early publications were hardly noticed, by the beginning of the First World War his work had cult status, especially among German avant-garde artists and writers. Nietzsche vilified the superficiality of nineteenth-century life, its moral pretences, its artistic desolation, the safety of its parliamentary democracies. His *Birth of Tragedy* (1871) polarised an Apollonian concept of the world with a Dionysian one – the former was based on knowledge, order and intellect, the latter on ecstasy, violence and raw emotion. Although he recognised the significance of his own Apollonian model, Nietzsche favoured

Dionysian violence and looked forward to a time of apocalypse, when a new order would be created out of the total destruction of the old. In *Thus Spoke Zarathustra* (1883–91) he expressed his desire for an *Übermensch* – a 'higher man' or 'superman' in the form of an artist who would be able to cut through the morass of modern morality, laws and conventions to produce work that had genuine spiritual intensity.[7] Nietzsche's passion for a bloody solution, and his contempt for the immigration and racial mixing that characterised modern society have been isolated as harbingers of Nazi jingoism and eugenics, but to the artists of the early part of the twentieth century it was his spiritual emphasis that was most important.[8]

Nietzsche's complex views of morality, the impoverishment of the bourgeoisie and the need for a violent solution to a stagnant society became especially potent when mingled with other philosophical and aesthetic theories that held equal appeal for artists. Nietzsche owed much to the ideas of Arthur Schopenhauer's *The World as Will and Representation*.[9] Schopenhauer saw the world as a division between the way things appeared and the way they really were, with the human will as an interventionary force between. To Schopenhauer the will was a primary life force, more important than the intellect, but will engendered constant struggle and consequent suffering when the object of desire was not reached. Aesthetic contemplation was an important way of transcending the power of the will, but ultimately human beings could only rise above the will's power through a sort of asceticism – a renunciation of individuality and desire. In the hands of the art historian Alois Riegl, Schopenhauer's will was transformed into the *Kunstwollen* (artistic intention or volition). According to Riegl, artists were not merely mechanical and utilitarian, but their production grew from a will to create – what Kandinsky later called an 'inner necessity'.[10] By 1909 these ideas were commonly known – if sometimes in their most basic form – by German artists, and their authority was fuelled by the publication of the Frenchman Henri Bergson's *Creative Evolution* (1907), a book that emphasised the importance of intuition, rather than objectivity, as the basis of artistic creation.[11] What these aesthetics shared was a stress on the spiritual life, a rejection of the material (and, by implication, middle-class) world, and a belief in the power of art to effect a transformation of society. German artists were able to draw on these texts – often selectively or indiscriminately – to justify their rejection of the visible material world as the foundation for representation. None of these works was easy or straightforward, and each was open to a variety of interpretations and potential misconstructions. It is thus problematic to attempt to trace the ways in which these ideas had an impact on German visual culture, and how artistic practice transformed the implications of philosophy and aesthetic theory.

In this intellectual environment, artists certainly began looking for a more profound means of representing human experience, but the first of these efforts – Symbolism – did little more than parallel Schopenhauer's and Nietzsche's rejection of materialism. Although what has been known as Symbolism was a characteristic of all European countries in the last two decades of the nineteenth century, German-speaking nations were particularly attracted to its emphasis on spiritual, intellectual or emotional states. Symbolism was as much

a phenomenon as an art movement, and it is difficult to pinpoint an unqualified definition for it.[12] However, many Symbolist artists used mimetic, at times academic, styles with subject matter that hinted at a spiritual, religious or emotional life lying beneath the visible world. Artists who worked in this mode often adopted traditional religious or mythological iconography but used it in unusual, vague or suggestive ways. Symbolism, in its widest sense, was directly opposed to the positivist emphasis of Impressionism. Impressionist artists claimed to be looking at the world and reproducing the optical effects of light, colour and landscape; Symbolist artists, on the contrary, did not reproduce the phenomenal world, but looked at nature through the haze of their emotions and spirit. Symbolism received a strong boost in Germany through the presence of the Norwegian artist Edvard Munch, who lived for a time in Berlin and whose works created a scandal, and later a sensation, when exhibited there in 1892 and 1902.[13] Many examples of European Symbolism – including, for example, the works of Gauguin or Odilon Redon – had potentially disturbing or pessimistic implications, but Munch's works were distinguished by their especially gloomy obsessions with death, lust, jealousy, sickness and anxiety. These emotional extremes appealed to the German avant-garde as a testimony to the way in which art could transcend mere representation of the outer world.

However, Munch was problematic because his intense negativism rested uneasily with any desire to see a more positive legacy of the German tradition of representing the inner life. A more palatable example of Symbolism for German nationalists was Max Klinger, whose works were equally unsettling but perhaps not so unequivocally pessimistic as those of Munch. Klinger's work rested easily within the nationalist stereotype of Germany as a place of imagination. Well before his death, monographs on Klinger extolled the artist as a 'pure German', whose works carried on the traditions of German Romanticism and idealism, while heralding a new era of fantasy.[14] Such labelling represented a prevailing attitude that the Germanic imagination was more idealist, more spiritual, more imaginative than that of other European countries. The distinctiveness of German art and literature was perceived to lie in this aspect of the national character. Between 1879 and 1915 Klinger produced a series of imaginative etchings, which he labelled with opus numbers to reinforce musical associations. These works, along with the paintings of Böcklin, were classed as part of the German idealist heritage and were seen to be in opposition to the observational naturalism of artists like Menzel and Liebermann.

One of the most bizarre of Klinger's works was *A Glove, Opus VI* (figure 16).[15] This series of ten etchings and aquatints has a narrative framework, but it does not tell a story in the conventional sense. Plate 1 begins the narrative harmlessly in a crowded room with Klinger himself observing a woman as she enters. In the second plate Klinger and the anonymous woman are in a skating rink and he retrieves a glove that she has dropped. The rest of the series plunges into fantasy. The artist dreams of the glove, which takes on a life of its own. Klinger rescues the glove from shipwreck, it undergoes a sort of deification, becomes associated with a string of nightmarish images and, by the end of the series, it has grown to a monstrous size. Klinger's series does

not have an obvious theme or narrative, and like much Symbolist painting, it is fruitless to pursue a single explanation for it. However, the central motif of the suffering artist and the anonymous woman evokes the pain and tortures of unrequited love.

Both Munch and Klinger were still concerned primarily with worldly relationships and human emotions and, in this sense, their works were firmly within the tradition of German Romanticism. By the early years of the twentieth century, this focus on the human side of the inner life was beginning to change. The deep philosophical roots of this growing fascination with the inner life were reinforced by the linguistic peculiarities of the German language. In German, the term '*Geist*' refers not just to the spirit, but to emotion, intellect and all aspects of human existence that are not purely corporeal. Artists in the early years of the twentieth century extended their ambitions and attempted to express the whole of the '*Geist*', rather than merely an outward impression of their own emotions. This focus on the *Geist* was initiated by Kandinsky and fellow artists of the Munich-based group, the Blaue Reiter. The artists of the Blaue Reiter and its predecessor – the Neue Künstlervereinigung (New Artists' Association) extended their expression of the inner life by adopting new ideas about primitivism, fuelling predictions of a coming apocalypse and, ultimately, renouncing materialism entirely by recourse to purely abstract art.

Kandinsky is often seen as the centre of this tendency, and it is important to begin with his contribution to it before considering the broader implications of the spiritual for the German avant-garde.[16] He was born in Moscow in 1866 and grew up in Odessa. He studied law and economics at Moscow University, ran a printing firm and later had the opportunity of becoming a lecturer. But he abandoned his own professional success and turned down a professorship in 1896 to go to Munich and study painting. His unusual career pattern partly accounts for his later rejection of positivistic values: his own training was in the rigorous statistical methods of social science, but he embraced art as a radically different alternative. However, he never entirely

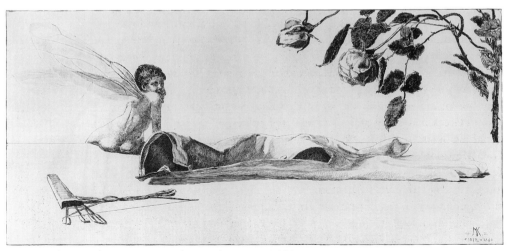

16 Max Klinger, *Glove, Opus VI*, etching and aquatint, 1881

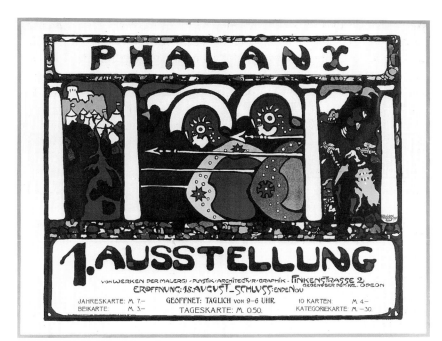

17 Vassily Kandinsky, poster for Phalanx exhibition, 1901

shed his social science training: even his later writings veer between legalistic language and pseudo-religious obscurity.[17]

Kandinsky's associations with *fin-de-siècle* Symbolism gives an important context for the development of the spiritual emphasis in his art.[18] When Kandinsky moved from Russia to Munich, he began his artistic training with the Secessionist and Symbolist, Franz von Stuck. The particular artistic climate of Munich, with the dominance of Jugendstil decorative art and theatrical reformism, exposed the artist to the possibilities of both the value of abstraction and the blurring of boundaries between painting, applied arts and performance.[19] Kandinsky's formation of his own school and exhibition society, the Phalanx, bore a direct relationship with the practices of Jugendstil artists, particularly those who were involved with the Munich Secession. The poster for the first Phalanx exhibition of 1901 (figure 17) pays homage to this heritage. Here Kandinsky showed an interest in the relationship between image and text and in the purely linear qualities of representational art. The very title of the exhibition society was also significant. 'Phalanx' refers to an ancient Greek battle formation in which the hoplites, or infantry, drew together in parallel lines with their lances extended. The word came to have connotations of firmness, solidarity and determination, attributes which he felt characterised a rebel society functioning in the midst of static and conservative forces of art. The use of a symbol from a remote period of history further pinpoints another of Kandinsky's interests that would be very important for the role of the spiritual in German art. The fairy-tale quality of the title 'Phalanx' relates to Kandinsky's fascination with archetypes and universal myths. From the beginning, Kandinsky was interested in the psychological and spiritual

resonance of symbols, and his choice of the name 'Phalanx' reveals the way in which this early obsession found its way into a public forum.

This interest in Symbolism, mythology and fairy tale was strongly related to Kandinsky's Russian heritage, and the impact of Russian spiritualism and Symbolism on German art in the early years of the twentieth century should not be overlooked.[20] Kandinsky maintained contact with the Russian art world and published articles in contemporary Russian art journals until the First World War. He was well aware of Russian aesthetic developments such as the World of Art, which favoured a pluralist approach and integration of all arts through theatre and ballet, but he also had direct contact with the Russian Symbolist movement. In the early years of the twentieth century, the Russian avant-garde 'rediscovered' its nation's folk heritage, and peasant woodcuts (*lubki*) were no longer ignored as insignificant but valued for their spiritual sincerity. Kandinsky certainly was aware of these avant-garde interests, but he later claimed that he had long been concerned with peasant traditions. While a student, he had travelled to the Vologda region of Russia to conduct research on peasant legal systems and had been struck by the beauty and power of peasant home decoration. With this background, he carried to Germany an interest in fairy tales and decorative art and a repulsion for the often conventional and spiritually bereft forms of much contemporary painting.[21] He also saw himself as a sort of ambassador, with a goal to infiltrate his adopted culture with the virtues of his native land. As he wrote to his partner and fellow artist, Gabriele Münter, 'My mission was ... to sow the seed of freedom among artists here & to strengthen the bond between Russia & Germany.'[22]

Kandinsky was not the only Russian artist in Munich, which attracted many aspirant Russians in the early years of the twentieth century. In Munich, Kandinsky met Alexei Jawlensky and Marianne von Werefkin, and he maintained contact with fellow countrymen such as David Burliuk and Mstislav Dobushinsky when they visited the Bavarian capital. Kandinsky's early works show the impact of his heritage. In works such as *Riding Couple* (1906/7, Munich, Städtische Galerie im Lenbachhaus), he chose fairy-tale subject-matter which he represented in an exaggerated version of the French pointillist style. But unlike the works of French artists such as Seurat, Kandinsky's use of colour was not scientific. Instead, it contained echoes of the mosaics that decorated Russian orthodox churches. He used the dot technique of French Neo-Impressionism without attaining any of the detachment characteristic of works by Seurat and Signac. The combination of subject and style indicates the way he was attempting to achieve a realisation of the inner life through the limitations of form and colour.

Kandinsky was arguably the central figure in the major German avant-garde group, the Blaue Reiter (Blue Rider).[23] This group had a bumpy genesis and a shorter life than Brücke. In 1909 Kandinsky founded the Neue Künstlervereinigung (NKV). This was a Munich exhibition society designed to compete directly with the increasingly predictable Secession exhibitions. Kandinsky became its first president, and he was joined by Jawlensky, Werefkin and Münter and, in 1911, Franz Marc whose friendship with another artist, August Macke, brought him to the group's attention. The second exhibition of the NKV, held at Heinrich Thannhauser's gallery in Munich, was especially

important as it announced their advocacy of recent movements in French art and artists such as Braque, Picasso, Rouault, Derain and Vlaminck.

The NKV was professedly avant-garde and internationalist – qualities the Munich Secession had already abandoned. However, in 1911 Kandinsky's semi-abstract canvas, *Composition V* was rejected by the jury of the NKV on the grounds that it was 'too large'. The rejection was seen as a mere pretence, as factions within the NKV, like the once radical Secession movements, had become increasingly factionalised and members of the exhibition jury were scornful of Kandinsky's attempts to find a new means to represent spiritual values. After this rejection, Kandinsky, Marc and Münter resigned in protest from the NKV, and Jawlensky later followed suit. They quickly mobilised themselves and launched their own exhibition, which opened on 18 December 1911 at the Gallery Thannhauser – the same gallery that had hosted the NKV exhibitions.

The speed with which this ground-breaking exhibition was launched indicates that the artists had been thinking about the possibility of such an exhibition for some time. Its title – 'The First Exhibition of the Editors of the Blaue Reiter' – pointed to a programmatic aim, but letters between Marc and Kandinsky make it clear that secrecy was essential to the success of their endeavour, particularly given the savage and competitive climate in which the artists worked. The Blaue Reiter began in an aura of freemasonic mystery, but its exhibition brought it rapidly and successfully to public attention. It soon eclipsed its rival. Secrecy was only necessary for the brief period in which the exhibition was being organised, for only a few months elapsed between the resignations from the NKV and the launch of the new society.

As Brücke and the Blaue Reiter were equally important Expressionist groups, it is essential to understand the ways in which their aims overlapped and diverged, as well as the more fundamental differences between them. Both groups shared a rejection of materialism and a desire to change society. Both groups also used publications to spread their ideas and gain public recognition, although Brücke's annual portfolio of prints was a purely artistic piece of advertising, while the Blaue Reiter's one publication, the Almanac, was replete with programmatic essays. In each case, the groups professed a belief in artistic freedom, although the Blaue Reiter did not associate this quality with youth, as Brücke had done. However, it is the differences between the groups that highlight the clearer spiritual agenda of the Blaue Reiter.

First of all, the host cities were significant in each case. Brücke's abandonment of Dresden's provincialism for the metropolitan modernity of Berlin contrasted with the Blaue Reiter's associations with the older *Kunststadt* (art city), Munich, and the Bavarian countryside nearby. Second, while Brücke artists created implicitly nationalist works focused on an insular German audience, Blaue Reiter artists trumpeted their internationalism. Certainly Brücke drew much inspiration from contemporary French painting, but they did what they could to underplay this link. Instead, they concentrated on the legacy of German Renaissance woodcuts as a fundamental source for their art. The Blaue Reiter, by contrast, made a point of highlighting both the prevalent Russian membership of the group and their admiration for contemporary French culture. Several NKV artists were involved in contributing to *The Struggle for*

Art: An Answer to the Protest of German Artists, which countered Vinnen's attack on the ubiquity of French influence in contemporary German art.[24] Macke was especially Francophile. In a letter of 1910 to his uncle, the collector Bernhard Koehler, Macke wrote 'What Rome was once, Paris is today',[25] and he made several pilgrimages to Paris to absorb the work of the Impressionists, and later of the orphist Robert Delaunay. Delaunay's interest in the prismatic effects of light on solid objects, and his vibrant colourism, had a decisive impact on Macke. Macke's scenes of contemporary bourgeois life, such as *Woman with an Umbrella before a Milliner's Shop* (figure 18), valorised modern consumer culture through his focus on the display of shop windows, but this also gave him the opportunity to explore Delaunay's ideas about light and colour. Although Macke's output was varied and experimental, his core group of modern life genre works falls firmly within the French colourist heritage of Impressionism and Post-Impressionism.

Jawlensky and Münter also used their Paris experience to good effect. Jawlensky's early landscapes reveal his use of awkward, simplified forms and stark primary and complementary colours which were borrowed directly from the French Fauves and Van Gogh. There is little to distinguish Jawlensky's flattened Murnau landscapes from some of the slightly earlier works of Vlaminck and Derain. Münter too adopted Fauvist simplification, but despite the fact that she was subsequently characterised as a 'follower' of Jawlensky, her distinctive use of large patches of colour was more improvisatory. She concentrated on still lifes and portraits, and managed to endow the latter with psychological implications that went beyond the more purely aesthetic criteria of Matisse and the Fauves.[26] Her portraits were a somewhat unusual contribution to the Blaue Reiter circle, whose other members focused primarily on landscape and genre scenes. In 1909 she painted a series of portraits of her fellow artists in Murnau, each of which reveals something essential about the individual or their relationships with each other. Her portrait of Jawlensky, *Listening* (1909, Munich, Städtische Galerie im Lenbachhaus), relying on a caricatural simplification of his features and a striking use of line, presents a light-hearted image of bewilderment and surprise. Her depiction of Werefkin with a dirty green face and a flamboyant hat characterises a woman known for her extrovert personality and seems to make a punning reference to Matisse's portrait of his wife with a green stripe down her nose of 1905.

The passion for things Russian and French which dominated the Blaue Reiter and their circle was anathema to those Germans who felt that any foreign influence was a dilution of national character and a betrayal of the recently unified country.

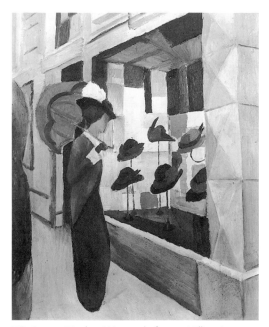

18 August Macke, *Woman before a Milliner's Shop*, 1914

Kandinsky recognised this difficulty, and many of his early writings tackle the problem of nationalist consciousness, which he saw as a particular obsession of the Germans. Kandinsky felt that not only were the Germans contemptuous of the cultural products of their perennial enemies, the French, but they were also suspicious of Russians, whom they saw as anarchistic and barbaric. Through the NKV and the Blaue Reiter, Kandinsky and his circle hoped to break through such nationalism, but unlike the artists of the *fin-de-siècle* Secession movements, they did not seek mere internationalism, but universalism. This was apparent from the opening statement in the catalogue of the first NKV exhibition of 1910:

> Our point of departure is the belief that the artist, apart from those impressions that he receives from the world of external appearances continually accumulates experiences within his own inner world. We seek artistic forms that should express the reciprocal permeation of all those experiences – forms that must be freed from everything incidental, in order powerfully to pronounce only that which is necessary – in short, artistic synthesis.[27]

The emphasis on the inner life was very important for Expressionism generally, but it became the rallying cry for the artists of the NKV.

The Blaue Reiter furthered this spiritual/universalist rhetoric. The name 'blue rider' allegedly arose from a discussion between Kandinsky and Marc, both of whom were interested in the spiritual resonances of colour, and both of whom saw in the horse a potent symbol of elemental forces. The spiritual emphasis of the Blaue Reiter was in many ways apolitical. They looked forward to a coming revolution, but they did not conceive of this revolution in the historical materialist terms of Karl Marx. Instead, like Nietzsche, they hoped that a violent spiritual cleansing would lead to an era of art. When they spoke of war, they did so in vague, idealistic terms, rather than in relation to particular contemporary political circumstances. Marc's description of their purpose, 'We fight like disorganised "savages" against an old, established power',[28] reveals the sort of unspecific linguistic formulations that led to an apparently jingoistic language. Rejecting the social regenerative aims of Brücke, the artists of the Blaue Reiter wanted people to turn inward and learn to recognise the universal signs that linked them together, to see beyond the visible surface of things, to grasp the archetypes.

This inwardness relates to a third major distinction between Brücke and Blaue Reiter artists, and that is the way in which, and the purposes for which, they employed primitivist sources in their art. The concept of primitivism was one of the most important ones for both groups, but it is also the most problematic. In the early years of the twentieth century 'primitivism' became associated with non-European cultures, artefacts and ways of life. An interest in the art of non-Western cultures had grown in Germany with the increase in overseas colonisation during the 1880s and 1890s. Germans flooded into new colonies in south-west Africa and the South Seas, and they responded with either distaste or excitement to the unusual life of the peoples who inhabited those countries.[29] Not surprisingly, the colonies themselves changed rapidly with the encroachment of German trade and tourism, but enthusiasts often found that they could ignore the changes and concentrate on what they

perceived to be the essential characteristics of the other cultures. German exhibitions of material culture from 'primitive' societies became the focus of much debate, as more and more artefacts were imported from Germany's overseas colonies.[30] In response to this growing interest, some German artists, such as Nolde and Max Pechstein, journeyed abroad to explore alternative ways of life, although they also went with preconceived notions of what they would find when they got there. Kandinsky and Münter travelled together to Tunis in 1904–5, and Macke and Paul Klee also spent three weeks there in 1914.

The deeper aesthetic implications of 'primitive' art also became a matter of concern for artists. A turning point in this development was the publication in 1908 of a Ph.D. thesis by the art historian Wilhelm Worringer. Worringer's *Abstraction and Empathy* compared the abstract art of 'primitive' peoples to the representational art of 'civilised' nations. Worringer's thesis centred on a distinction between empathy, 'a happy, pantheistic relationship of confidence between man and the phenomenon of the external world', and abstraction, 'the outcome of a great inner unrest inspired in man by the phenomenon of the outside world'. He claimed that civilised peoples who felt in control of the natural world produced imitative art that revealed their empathy with their environment; whereas less advanced or more decadent cultures expressed their fear of the natural world through a retreat into abstraction – 'the only possibility of repose'.[31] Worringer saw contemporary European society as having reached the end of its empathetic period, and artists were consequently turning back to abstract forms. Worringer's work was well known by Blaue Reiter artists, and its significance lay in the way it justified a link between abstract art and the inner life. Worringer's rather abstruse aesthetic formulations had a certain historical foundation, but pointed directly to the concerns of contemporary German art, particularly its veering towards abstract forms. His linking of abstract art to 'less advanced' societies provided a philosophical justification for the appropriation of primitivist art by the avant-garde.[32]

German artists responded to notions of primitivism in somewhat different ways, and it is important to understand their reactions in order to develop a full picture of the primitivist strand in early twentieth-century German art. The Brücke artists had been fascinated by objects from Palau in western Micronesia, and had decorated their studios with such artefacts, while altering their style and subject-matter to evoke associations with the otherness of this foreign culture. The most notable proponent of primitivist influence was Emil Nolde, who was involved with Brücke for only a short time, but whose works were admired by Blaue Reiter artists, and members of the NKV such as Jawlensky. In 1911, Nolde became interested in primitive artefacts which he observed and sketched at the Berlin Ethnographic Museum, and in that year he began his uncompleted study *Artistic Expression Among Primitive Peoples*. His interest led him to travel to New Guinea in 1915. Nolde's fascination with primitivism stemmed partly from admiration and partly from repulsion: he appreciated the spiritual force of non-Western cultures, but he had a racist disgust of cultural intermixing.[33] His later membership of the Danish branch of the National Socialist party, and his four-volume autobiography written in the 1930s show the ways in which this uneasy fascination with other cultures

developed. Nolde translated his interest in primitivism into works that had both Christian and Jewish overtones. His infamous painting *Pentecost* (figure 19 and colour plate 1) was rejected by the 1910 jury of the Berlin Secession, and it so aroused the hostility of Liebermann that he threatened to resign if it were accepted. Nolde's adoption of a modernist style with a traditional subject caused strong reaction among his contemporaries, who felt that he was both desecrating religion through his blazing impasted style and caricatural representations of holy figures, and refusing to adhere to new canons of subject-matter in his reliance on the Old Testament for inspiration.

As Jill Lloyd has pointed out, Brücke artists decorated their studios with artefacts from the Palau islands and cultivated a bohemian lifestyle and naturist practices which gave them the fantasy of living in an unsophisticated, pre-modern society.[34] To Brücke artists, primitivism offered a form of vitalism, a way of rebelling safely against the complacency of contemporary society and a means of rationalising their sexual libertinism. For this purpose, they concentrated their attention on tribal cultures, just as the primitivism of early German woodcuts provided a national heritage for their contemporary practice.

Conversely, Blaue Reiter artists used many more primitivist sources – not simply old German and tribal artefacts, but international folk art, as well as the art of children and the insane. This universality can be seen in their published Almanac of 1911, as well as their choice of subject matter and in their mode of painting. The Blaue Reiter Almanac was the culmination of their ambitions. It was published by Reinhard Piper in Munich, who was known for his support of avant-garde activity, but the artists who contributed to the Almanac were forced to fund it themselves. The financial assistance of Macke's uncle by marriage, Bernhard Koehler, made this possible, and once published, the Almanac was popular enough to go into a second edition.

The Almanac included a variety of essays by artists and musicians, such as Kandinsky, Marc, Macke, Schoenberg and David Burliuk, and over 150 illustrations of works by Brücke and contemporary French artists, as well as Russian folk art, Japanese art, Bavarian glass painting and art by anonymous children.[35] Its apparent pluralism was deceptive, for underlying each essay and illustration was the general theme of the inner life, or what Marc called the 'mystical inner construction'.[36] According to Marc and Kandinsky, works of art from all times and places could possess spiritual power or 'an inner sound', and their intention was to help their readers recognise this power. Kandinsky referred to 'the veiling of the spirit in matter' and claimed a desire to strip away this veil so that the 'inner necessity' of form would become clear.[37] The work of the French naive artist, 'Le Douannier' Henri Rousseau, in many ways encapsulated some of the ideas of the Blaue Reiter. Rousseau's work was shown in the first exhibition and illustrated in the Almanac: its deliberate evocation of

19 Emil Nolde, *Pentecost*, 1909 [see also colour plate 1]

child-like simplicity, its jungle themes and its substantive visual efficacy gave it the qualities most valued by Kandinsky and his circle.

This juxtaposition of old and new, national and international, amateur and professional, work was carried out more cautiously in the first Blaue Reiter exhibition of December 1911. Aside from works by Kandinsky, Marc and Münter, artists such as Rousseau, Vladimir Burliuk and Delaunay were included. Taken as a whole, most of the works represented a cultivated naiveté – a deliberate lack of sophistication and representational simplicity, but genuinely primitive or naive work was not included.[38] The second and last exhibition of the Blaue Reiter took place in the Munich Goltz gallery in March 1912, and it consisted solely of international graphic work by artists such as Picasso, Vlaminck, Arp, Klee, and Kubin. Again, there was a coherence here, but the genuine pluralism of the Blaue Reiter Almanac was eschewed for a safer selection of the bastions of the avant-garde.

Nevertheless in their quest for the spiritual in art, Blaue Reiter embraced what they felt to be the essential simplicity and spiritual power of 'primitive' societies. In many ways, their attitudes to other cultures could be considered patronising, as they certainly never fully understood the societies that inspired them. But unlike many of their contemporaries who saw non-European cultures as atavistic and savage, Kandinsky's circle preferred to interpret them as non-materialistic and spiritually purer than contemporary European ones. While late nineteenth-century social theories relegated non-Western peoples to the same lowly status as women and children and equated all as inferior to white male Westerners, Kandinsky and his fellow artists reversed the priority and favoured the 'atavism' of women, children and tribal societies. These groups were, in turn, compared with the peasantry, and this whole spectrum of outsiders was given a privileged status in the Blaue Reiter canon.

The place of women and the feminine in Blaue Reiter theory and practice represents another distinction between their art and that of Brücke.[39] There is no doubt that women had an important role in the Brücke circle – but as lovers, models and inspirations, rather than as fellow artists. Brücke's bohemianism and advocacy of liberated sexuality gave sexually uninhibited women a powerful, yet subordinate, place in their ideology. Although Schmidt-Rottluff shied away from the more lubricious representations of female nudity, Heckel, Kirchner and Pechstein all specialised in depictions of both mature and pubescent nude women which they used to define and consolidate their masculine artistic identity.[40] The Blaue Reiter group had a very different attitude to women and the feminine – but one that was no less problematic. At first glance, the role of women in the ambience of the Blaue Reiter appears to be a positive and enabling one. Kandinsky expressed distaste for the proliferation of female nudes in art, as well as sympathy for the problems faced by women artists.[41] Münter and Werefkin worked with the male artists of the group, rather than for them. However, when looking closely at the way notions of gender infiltrated both Blaue Reiter ideology and art, a more ambivalent attitude seems apparent. On the one hand, the stereotypical qualities associated with women in turn-of-the-century Germany – intuition, altruism, emotion – appeared to be advocated by the spiritual emphasis of the Blaue Reiter. In nationalistic art criticism, the feminine had come to have pejorative

connotations and was associated with the optical passivity of French Impressionism.[42] However, the Blaue Reiter reversed this by advocating aesthetic principles that could be construed as feminine. The spiritual, the primitive and the naive were associated with femininity, and these connections formed the foundation of much Expressionist art criticism both before and during the First World War.[43] However, while the Blaue Reiter reversed the normally pejorative or patronising connotations of the feminine, their affinity with anti-feminist philosophers such as Nietzsche and Schopenhauer led critics to demean women as part of their praise of Blaue Reiter spirituality. This combination of admiration for, and denunciation of, the feminine, continued both during and after the war. These conflicting ideas permeated the periodical *Der Sturm*, which included many programmatic essays on Expressionism (see chapter 4).[44] One *Sturm* writer, Paul Hatvani, referred to the abstract 'element' that comprised Expressionism as feminine. He wrote: 'The Element knows no compromise; it stands for itself.' He then went on to develop an analogy that both advocated his abstract 'element' and reduced women to passive creatures: 'Only the Element is caused by naked existence, so fulfilled is it by the idea of womanliness. Man creates – Woman is . . . so the Element receives its spiritual reflex from women.'[45] Even as late as 1928, Hans Hildebrandt continued to argue that feminine instinct and emotion was good for the arts, even while he referred to woman as a 'lebendes Kunstwerk' (living art work) who was only fit for 'ein Welt des Spiels' (a world of games).[46] Hildebrandt recalls here the idea that women are childlike, and this trope of inspired naiveté and creative play was one that permeated Blaue Reiter discourse.[47]

This ambivalence is especially apparent in the work of Marc, whose conception of the primitive equated women, naiveté and tribal peoples with animals. Marc's *Red Woman* (1912, Leicester Museum and Art Gallery) represents a nude, tattooed woman whose body blends with the abstracted jungle foliage that surrounds her. In some respects the work rather conventionally equates woman with nature, but in tone and approach, Marc has not followed the unthinking subordination of women advocated by many of his predecessors and contemporaries. Marc's savage woman represents a feminine principle, but that principle was seen as superior in its spiritual power to the male-dominated ethos of a materialistic bourgeois society. But when Marc attempted to explain his theories, his verbalisation of gender fell back on predictable stereotypes. In a letter to Macke of 12 December 1910, Marc expressed his colour theories most coherently:

> Blue is the *male* principle, severe and spiritual. Yellow is the *female* principle, gentle, cheerful and sensual. Red is *matter*, brutal and heavy, the colour that has to come into conflict with, and succumb to the other two. For instance, if you mix blue – so serious, so spiritual – with red, you intensify the red to the point of unbearable sadness, and the comfort of yellow, the colour complementary to violet, becomes *indispensable* (woman as comfort-giver, not as lover!).[48]

Marc's ideas were never as developed as Kandinsky's (see below), but they differed from Kandinsky in their emphasis on the associations between colour and gender. Marc carried these ideas into his work, and what could be

20 Gabriele Münter, *Still Life with St George*, 1911

considered stereotypes about men and women were transformed into genu-inely effective commentaries on nature and the spirit. *Large Blue Horses* (1911, Minneapolis, Walker Art Center) and *Yellow Cow* (1911, New York, Guggenheim Museum) reveal the ways in which he attempted to express male and female principles through both colour and form. The blue horses are represented as solid and 'severe', while the yellow cow is 'gentle' and 'cheer-ful'. However, Marc's theories should not be read so literally. He was more interested in the forces of nature than in specific symbolic associations between colour and content.

Marc claimed that he wished to engender an 'animalisation of art', and his most striking works represent the spiritual world of animals, which he saw as superior to that of human beings. He spent several years studying animal anatomy to enable him to learn a system of anatomical rules in order to understand the essential harmony of nature. He hoped that this would allow him to construct artistic animal-like forms according to nature's rules. His interest in animals combined with a belief in the spiritual power of colours – a conviction he shared with Kandinsky.

This equation of women with animals, the spiritual and the primitive gave a distinct tenor to the artistic production of the Blaue Reiter. The most notable woman practitioner of the group, Münter, equally contributed to the perpetuation of these ideas.[49] She specialised in still lifes rendered in a deliberately archaising style. Like her portraits, her still lifes are calculated to appear childlike. A work such as *Still Life with St George* (figure 20) draws on Christian religious associations, as well as Bavarian and Russian peasant artefacts, and indeed all of the objects represented in the work were part of Münter's or Kandinsky's private collections. Münter gives these artefacts a

life of their own, and her vital composition recalls the uneasy perspectives of Cézanne's still lifes. The inanimate objects assume an almost talismanic force through the power of her vitalist style. However, this powerful feminisation of art was oddly contradicted by her own life and behaviour. Although immensely important for the Blaue Reiter circle, she was also timid, chronically depressed and jealously possessive of Kandinsky. Her one written reference to feminism, in a letter of 12/13 December 1910 suggests a combination of interest and resignation: 'Wanted to read in the afternoon – the philosophy of the feminist Lessing – a new book 'Weib, Frau, Dame' but the phonograph was going across the street with the window open – so I did some sewing and ironing.'[50]

Of the many facets of this spiritual emphasis in Blaue Reiter theory and practice, perhaps the most distinctive was the group's exploration of the relationships between the arts, especially music and painting. This was a final aspect of their work that distinguished it pronouncedly from the aims of Brücke. The idea that visual arts and music were interrelated was not a new one. Klinger had used musical analogies both in the titles of his graphic works and in his aesthetic treatise *Malerei und Zeichnung* (Painting and Drawing) of 1891.[51] Also, by establishing a relationship between music and other arts, contributors to the Blaue Reiter Almanac looked back to Richard Wagner's idea of a *Gesamtkunstwerk*, or total work of art, but their interpretation of Wagner's theories was rather liberal. Wagner hoped to incorporate all forms of art into an ultimately representational form of opera, in which each component played a part but did not lose its identity. However, Kandinsky, Schoenberg and others were attracted to the idea of an intermingling in which one art form merged with another.[52] Their attraction to synaesthesia, or the experience of simultaneous sensations of taste, sound, touch and smell, ultimately led them towards a non-representational form of theatre art. Kandinsky attempted to put his synaesthetic theories into practice in a play published in 1911 in the Blaue Reiter Almanac. The title of the play, *Der gelbe Klang* (The Yellow Sound) indicates the way in which Kandinsky was attempting this fusion of different art forms. The cast of characters in *The Yellow Sound* included Five Giants, Vague Creatures, a Tenor (backstage), A Child, A Man, People in Flowing Robes and People in Tights. Kandinsky's play was really a series of 'pictures' laid out as stage directions. It is difficult to imagine how the play might have been performed without the technical sophistication of post-war animation, and indeed it was not staged in pre-war Germany. However, it offered an important argument for the Blaue Reiter Almanac's theme of synthesis between different arts and the art of different nations and peoples.[53]

Music had many levels of association for Blaue Reiter artists. In the wake of Bergson's ideas about intuition, music became important for its rhythmic – rather than harmonic – features, as the use of form and colour in art were seen to be analogous to the rhythms of music, and both were seen to arise from intuitive, rather than intellectual, forces.[54] This idea was particularly prevalent in the work of Paul Klee, a Swiss artist who was briefly associated with the Blaue Reiter group. Klee's theory and practice were riddled with musical analogies and associations, and his deep knowledge of music theory gave him the most rigorous background for applying musical concepts to artistic composition, colour and form.[55]

Ultimately, the analogy with music was superseded by various rationa-lisations for purely non-representational art. In many ways the move to abstraction was the logical conclusion of the quest for the spiritual in art. By removing references to the natural world from paintings and engravings, all associations with matter and worldly things could, at least in theory, also be obliterated. Kandinsky has been most prominently associated with the development of abstract painting in Germany, through both his paintings and his art theory. His reminiscences of 1913 deliberately gave the impression that all of his work was moving inexorably towards total abstraction, and in it he described his 'revelation' one day in Murnau when he returned home to see one of his works turned on its side. He did not recognise the subject, but he felt it to be 'an indescribably beautiful picture pervaded by an inner glow'.[56] According to Kandinsky, this painting was more effective when it was no longer an obvious representation of the external world. But Kandinsky's move towards abstraction was much more halting and riddled with uncertainty than his retrospective assessment would suggest. His paintings were certainly, from an early stage in his career, abstractions in the literal sense, that is schematised representations of reality, but it was only after the foundation of the Blaue Reiter that he began to renounce the object altogether to achieve total 'non-objectivity', although his work continued to have representational undercurrents.

Between 1909 and 1913 Kandinsky developed his abstract style partly by means of a musical analogy. During this time, he concentrated on painting three series of pictures, each titled according to his intended aims. His 'impressions' were not meant to provide the optical sensations of French Im-pressionist art, but were 'direct impressions of "external nature" expressed in linear-painterly form'. In this sense, they were his most representational works. However, his 'improvisations' were 'chiefly unconscious . . . expressions of events of an inner character', while his 'compositions' were 'expressions of feelings that have been forming within me . . . over a long period of time'.[57]

Kandinsky was determined to activate the 'inner sound' of his paintings by divesting them of as much material baggage as he was able. A work such

as *Improvisation 19* (figure 21) contains only the slightest hints of reality. Through his use of bold black lines, Kandinsky has outlined what appear to be hooded figures: in his own personal/Biblical symbolism these are the wise men or elders, who reside in a blue haze – the blue of Kandinsky's spir-itual ideals. Kandinsky's path to abstraction was facilitated by the popularity of his own art theory, which he began to formulate in 1910 and published in 1912. The result, *Über das Geistige in der Kunst* (On the Spiritual in Art) became a veritable mani-festo for abstraction, and after publishing the work, Kandinsky's own art began to follow his theories more rigorously.

21 Vassily Kandinsky, *Improvisation 19*, 1911
[see also colour plate 2]

The book's title emphasised the German idea of the *Geist*, of the whole inner life and all its components, which was privileged above the external world of appearances. However, the crux of his manifesto was a discussion of the spiritual properties of colour, which Kandinsky developed in enormous detail. In his lengthy section on colour, Kandinsky isolated two major qualities of colour: their relationship with musical tonality and their psychological power. The latter was a particularly revealing aspect of his theory. In some ways, his ideas of colour were conventional and owed much to Johann Wolfgang Goethe's romantic tract 'on colour' *Zur Farbenlehre* (1810).[58] Like Goethe, Kandinsky divided up colours into warm and cool. Warm colours approached yellow and cool colours approached blue. However, Kandinsky extended this theory by suggesting that there were additional properties inherent in colours. Yellow, for instance, was eccentric (spreading out), whereas blue was concentric (turning inwards). Yellow was an earthly colour 'pricking, upsetting'. The 'acid taste' of lemons and 'shrill sound' of a canary were both yellow. Blue, on the other hand, was a 'heavenly colour', representative of the spiritual, 'an infinite self-absorption'. White was a positive colour that 'affects our psyche like a great silence, which for us is absolute . . . corresponding in many cases to pauses in music', whereas black was nothingness, or 'an eternal silence'. Red was intense, violet morbid and green inert.[59] Kandinsky's theory anthropomorphised the colours in an attempt to explain their psychological effect on the observer. Despite his own attempts to cloak his theory in the generalities of Symbolist aesthetics, Kandinsky obviously felt that colours had specific properties, and he used them in his paintings accordingly.

Kandinsky's colour theory relied heavily on synaesthetic associations – the idea that colours could sing, or stink or have flavour. The spiritual weight was carried less by these theoretical notions than by the religious associations cultivated by Kandinsky and the Blaue Reiter artists. In an age of scepticism and atheism, religious revelation and belief were not so much abandoned as reconfigured.

Nietzsche's search for a spiritual alternative was only one of many earnest attempts to find a way to recover aspects of religious experience that had been undermined by nineteenth-century scepticism and materialism. The monolithic status of Christianity had long been lost, but philosophers, scientists and artists sought to regain something of Christianity's attention to the human soul. Some of these efforts were based upon a new attitude towards science – the new secular religion of the modern age. The biologist Ernst Haeckel, for example, attempted to reconcile science with religion. He postulated a monist view of the universe, in which all things physical and spiritual were seen to be part of one organic whole.[60] While science moved closer to religion, religion also moved closer to science: the ideas of theosophy, adopting a pluralist approach to Eastern and Western religions, were wildly popular in the 1890s. In Germany, Rudolf Steiner invented a new form of theosophy, called anthroposophy, which was more solidly Christian in its base, or at least saw Christianity as a foundation for all religions. Kandinsky was especially influenced by Steiner's ideas.

Religious themes appeared in Blaue Reiter works in just such an ambiguous, pluralist or metamorphosed form. Marc, for example, studied theology

at university and attempted in his writings to reconcile Nietzsche's chiliastic ideas with Christian theology.[61] Marc's primitivist emphasis fed into a series of apocalyptic scenes which responded indirectly to contemporary European conflicts and the approach of the First World War.[62] This does not suggest that he and his fellow artists were prophetic but, like the rest of Europe, they were aware that the two Balkan wars of 1913 were in danger of erupting into something larger and more devastating. Marc's *Unfortunate Land of Tyrol* (New York, Guggenheim Museum) makes one of the few allusions to the current political situation. The gloomy colour tones of this painting enhances the mood of coming disaster which is hinted at by the presence of a cemetery and a bird of prey. An Austro-Hungarian border sign at the left of the painting gives the work a direct reference to the Balkan conflict. Here, Marc's enthusiasm for the end of a materialistic Europe is rather muted, as he stresses the coming devastation, rather than the eventual peace. The eagerness with which Marc looked forward to a cleansing of European materialism drew inspiration from the messianic rhetoric of Nietzsche, and even after the First World War began, Marc could write from the battlefield, 'I dream of a new Europe'.[63]

Marc's fascination with the apocalypse took on new artistic forms as the First World War approached, when he began to move away from nature itself and towards an increasingly abstract vision, which he felt was more evocative of the real forces of nature underlying the external world. The decisive change in Marc's style came in 1912, when he and Macke visited Delaunay in Paris. Marc began to see abstraction as a means of expressing a more powerful nature than the superficial forms of animal life he had been painting between 1910 and 1912. Apocalypse and abstraction came together in one of his most important works, *Animal Destinies* (1913, Basel, Kunstmuseum), in which deer, horses, boars and foxes flee wildly from what appear to be flashes of lightning. In this painting, Marc unified the formal rhythm of the picture plane to create an interpenetration of animals and nature. The image is ambiguous and apocalyptic, and Marc's inscription on the back of the painting 'And all being is flaming suffering' has a chilling premonitory tone. Shortly before the war, Marc moved further away from representation and relied on depicting the elemental battles of nature in terms of pure colour. A plan to consolidate apocalyptic themes in a genuine spiritual context led Marc to produce several woodcuts intended for illustrations to the Bible.

Many of Kandinsky's semi-abstract paintings contain similarly apocalyptic themes, also with a direct Christian source, the biblical book of Revelation. Kandinsky's allusions to the final apocalypse, as described by St John the Evangelist, is significant for his spiritual concerns. The recurrence of riders, trumpets, mountains and prophets continue to be recognisable long after all other associations with the world of appearances were removed. Kandinsky's fascination with the Revelation of St John and its apocalyptic themes appears most obviously in works such as *All Saints II* (c. 1911, Munich, Städtische Galerie im Lenbachhaus) which, on one level, represents the raising of the dead at the time of the second coming of Christ. The painting contains identifiable saints, such as Walburga, the patron saint of Bavaria, and other conventional medievalising religious imagery, such as headless men (who represent

the dead rising). Although Kandinsky's painting is in no way intended to be a narrative, his fascination with fairy tales and with archetypal motifs such as those in Revelation continually forced him back to a narrative framework from which he rarely escaped during the pre-war years.

The start of the First World War was in some ways the conflagration that the Blaue Reiter artists desired. But their eagerness for destruction aroused the scorn of more politically sophisticated commentators, who realised that a contingency of artists were as guilty of agitating for bloody conflict as the most nationalistic of pan-German groups. It is notable that the desire for apocalypse did not continue after the war, nor did the artists feel that they had achieved the 'new Europe' they desired. Both Macke and Marc died in action, the latter having first been disillusioned by his own false premises about war. Kandinsky and Münter, who were lovers when the war began, separated in Sweden, the latter remaining there and the former returning to his native Russia, putting aside canvases and art theories until after the war was over. The war did not provide them with the spiritual alternative they sought, and once the war was over, they no longer seemed to seek it.

However, intimations of Christianity, apocalypse and the spiritual were strong throughout the first three decades of the twentieth century in German art, but often the spiritual signals that Kandinsky and his fellow artists sought to activate were replaced by a stronger non-Christian set of associations. It is no surprise that Expressionist sculpture was used for church decoration up until the time of Hitler's ascendancy to power. It was considered an appropriate means of expressing Christian revelation and emotion, but was designed for a functional context, rather than the avant-garde environment of an exhibition on dealer's gallery.[64] However, other examples of German Expressionism – such as the continued prominence of Crucifixion scenes in works by, for instance, Max Beckmann and Lovis Corinth (figure 22) – had a more complex set of associations with Christian heritage. Beckmann's statements about art's spiritual mission could have come from Kandinsky. He wrote, for instance, 'I assume . . . that there are two worlds: the world of spiritual life and the world of political reality.'[65] Like Kandinsky, it was the former 'world' he sought. However, when Beckmann produced Christian subjects, he did so through the lens of his own complex Schopenhauerian pessimism, representing his personal state of angst and despair, rather than the transcendent universalism of the Blaue Reiter.[66] Corinth's Crucifixion scenes likewise translated Christian texts into self-scrutiny; like Beckmann, Otto Dix too approached pseudo-Christian imagery through philosophy, this time the apocalypse of Nietzsche, rather than

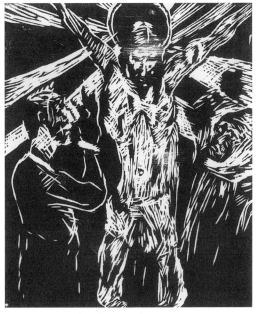

22 Lovis Corinth, *Christ on the Cross*, woodcut, 1919

that of St John the Evangelist.[67] In each case, these artists also paid homage to the German tradition of Grünewald's tortured vision of Christ crucified in the Isenheim altarpiece (figure 23). Hence their 'spiritual' quests served the multiple functions of self-fashioning through the lens of philosophy, paying homage to a specifically German artistic tradition and rejecting the faith systems of Christianity. Although different in motivation from the spiritual emphasis of the Blaue Reiter, the religious pluralism of these three individualist artists was no less modern in its effect.

Perhaps the final step away from a specifically Christian religious tradition in German art was taken by a philosopher, rather than an artist. Carl Einstein, an advocate and admirer of both French and German avant-gardism, published a book on African sculpture in 1915 in which he both rejected evolutionary theories of tribal societies and attributed spiritual, rather than purely decorative, value to African art.[68] Einstein's work served as a post hoc justification for Cubist sculpture in particular, but it was also used to consolidate the spiritual significance of art employing primitivist sources.

On one level, the spiritual legacy of Romanticism and idealist philosophy appeared to give German avant-garde art a certain moral superiority to its counterparts in other European countries. The contemporary French Fauvist concentration on sensual properties of colour and form, and the Italian Futurists' relentless modernity could be said to colonise less fundamentally spiritual

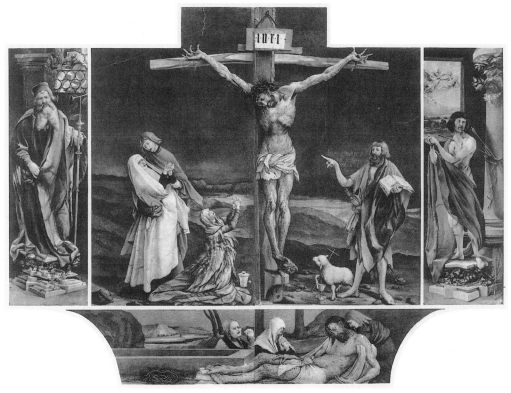

23 Grünewald, *Isenheim Altarpiece*, oil on wood, 1515

territory. However, underlying even the most universal pronouncements of the Blaue Reiter was a consistent attention to the workings of a modern marketplace without which these ideas would have remained unknown.

NOTES

1 'Die Epoche des großen Geistigen kann wegen ruhig anfangen': August Macke, *Briefe an Elisabeth und die Freunde*, ed. Werner Frese and Ernst-Gerhard Güse, Munich, 1987, p. 278.

2 See Robin Lenman, *Artists and Society in Germany 1850–1914*, Manchester, 1997.

3 This was stated in a letter to an Odessa newspaper published in January 1911, quoted in Kenneth Lindsay and Peter Vergo (eds), *Kandinsky: Complete Writings on Art*, 2 vols, London, 1982, vol. 1, p. 98.

4 On the problems that Germany's philosophical heritage has created for its visual culture, see Hans Belting, *The Germans and Their Art: A Troublesome Relationship*, New Haven and London, 1998.

5 See especially Keith Hartley, Henry Meyric Hughes, Peter-Klaus Schuster and William Vaughan (eds), *The Romantic Spirit in German Art 1790–1990*, exhibition catalogue, London, 1994.

6 For the importance of Nietzsche to German art, see Richard Hinton Thomas, *Nietzsche in German Politics and Society 1890–1914*, Manchester, 1983; Jürgen Krause, '*Märtyrer*' *und 'Prophet': Studien zum Nietzsche-Kult in der bildenden Kunst der Jahrhundertwende*, Berlin, 1984; Seth Taylor, *Left-Wing Nietzscheans: The Politics of German Expressionism 1910–1920*, Berlin and New York, 1990; Steven E. Aschheim, *The Nietzsche Legacy in Germany 1880–1990*, Berkeley and Oxford, 1992; and Riccardo Dottori, 'Expressionism and Philosophy', in Stephanie Barron and Wolf-Dieter Dube (eds), *German Expressionism: Art and Society*, London, 1997, pp. 69–74.

7 See Friedrich Nietzsche, *The Birth of Tragedy and other Writings*, ed. Raymond Geuss and Ronald Speirs, Cambridge, 1999; and *Thus Spoke Zarathustra*, Harmondsworth, 1969.

8 A clear and admirably readable explanation of Nietzsche's style and ambiguity is Michael Tanner, 'Nietzsche', in *German Philosophers*, Oxford, 1997, pp. 344–434.

9 Arthur Schopenhauer, *Die Welt als Wille und Vorstellung*, 2 vols, Leipzig, 1844, Eng. trans., New York, 1969.

10 See Margaret Iversen, *Alois Riegl: Art History and Theory*, Cambridge, Mass., 1993.

11 Henri Bergson, *Creative Evolution* (1907), London, 1911. For an excellent analysis of Bergson in context, see Mark Antliff, *Inventing Bergson: Cultural Politics and the Parisian Avant-Garde*, Princeton, 1993.

12 Symbolism was an established literary movement in France, but its artistic manifestations and programme were less sharply defined in the rest of Europe. See Jean Clair, *Lost Paradise: Symbolist Europe*, exhibition catalogue, Montreal, 1995.

13 There is a huge literature on Munch. Useful sources in English include Reinhold Heller, *Munch: His Life and Work*, London, 1984; and *Edvard Munch: The Frieze of Life*, exhibition catalogue, London, 1992.

14 See, for instance, Max Schmid, *Klinger*, Bielefeld and Leipzig, 1899, p. 1.

15 This series is thoroughly discussed by Christiane Hertel, 'Irony, dream and kitsch: Max Klinger's *Paraphrase of the Finding of a Glove* and German modernism', *Art Bulletin*, 74:1 (1992), 91–114.

16 There is an impressive literature on Kandinsky's life and work. Useful general studies include Jonathan David Fineberg, *Kandinsky in Paris 1906–1907*, Ann Arbor, 1984; *Kandinsky in Paris 1934–1944*, exhibition catalogue, New York, 1985; Paul Overy, *Kandinsky: The Language of the Eye*, London, 1969; Hans K. Roethel and Jean K. Benjamin, *Kandinsky: Catalogue Raisonné of the Oil Paintings*, 2 vols, London, 1984; Felix Thürlemann, *Kandinsky über Kandinsky: Der Künstler als Interpret eigener Werke*, Bern, 1986; Annette Vezin, *Kandinsky and the Blaue Reiter*, Paris, 1992; and Rose-Carol Washton-Long, *Kandinsky: The Development of an Abstract Style*, Oxford, 1980.

17 For another disciplinary source for Kandinsky's ideas, see Carol McKay, '"Fearful dunderheads": Kandinsky and the cultural referents of criminal anthropology', *Oxford Art Journal*, 19:1 (1996), 29–41.

18 See Dee Reynolds, *Symbolist Aesthetics and Early Abstract Art*, Cambridge, 1995.

19 For Kandinsky's associations with Munich, see Peg Weiss, *Kandinsky in Munich: The Formative Jugendstil Years*, Princeton, 1979; and *Kandinsky in Munich 1896–1914*, exhibition catalogue, New York, 1982.

20 John Bowlt and Rose-Carol Washton-Long (eds), *The Life of Vasily Kandinsky in Russian Art: A Study of 'On the Spiritual in Art'*, Newtonville, Mass., 1980.

21 See Carol McKay, 'Kandinsky's ethnography: scientific fieldwork and aesthetic reflection', *Art History*, 17 (1994), 182–208; Peg Weiss, *Kandinsky and Old Russia: The Artist as Ethnographer and Shaman*, New Haven, 1995; and Rose-Carol Washton-Long, 'Kandinsky's abstract style: the veiling of apocalyptic folk imagery', *Art Journal*, 34 (1975), 217–28.

22 Letter of November 1912, quoted in Annegret Hoberg (ed.), *Wassily Kandinsky and Gabriele Münter: Letters and Reminiscences 1902–1914*, Munich, 1994, p. 141.

23 Sources on the Blaue Reiter, include Annegret Hoberg and Helmut Friedel (eds), *Der Blaue Reiter und das neue Bild: von der 'Neuen Künstlervereinigung München' zum 'Blaue Reiter'*, Munich, 1999; Andreas Hüneke (ed.), *Der Blaue Reiter. Dokumente einer geistigen Bewegung*, Leipzig, 1989; *Der Blaue Reiter: Kandinsky, Marc und ihre Freunde*, exhibition catalogue, Hannover, 1989; Barry Herbert, *German Expressionism: die Brücke and der Blaue Reiter*, London, 1983; Magdalena Moeller, *Der Blaue Reiter*, Cologne, 1987; Hans Christoph von Tavel (ed.), *Der Blaue Reiter*, exhibition catalogue, Bern, 1986; and Armin Zweite, *The Blue Rider in the Lenbachhaus, Munich*, Munich, 1989. The paranoia is particularly apparent in Kandinsky's and Marc's letters to each other of the summer 1911. See Vassily Kandinsky and Franz Marc, *Wassily Kandinsky, Franz Marc. Briefwechsel*, ed. Klaus Lankheir, Munich, 1983.

24 Vassily Kandinsky et al., *Im Kampf am die Kunst: Antwort auf den 'Protest deutschen Künstler'*, Munich, 1911.

25 Macke, *Briefe an Elisabeth*, p. 242: letter of 26 April 1910.

26 For Münter, see Reinhold Heller, *Gabriele Münter: The Years of Expressionism 1903–1920*, Munich and New York, 1998.

27 Kandinsky, *Complete Writings*, vol. 1, p. 53.

28 Franz Marc, 'The "savages" of Germany', in Vassily Kandinsky and Franz Marc (eds), *The Blaue Reiter Almanac*, Eng. trans. and ed. Klaus Lankheit, London, 1974, p. 61.

29 For insightful sources on primitivism and German artists, see Jill Lloyd, *German Expressionism: Primitivism and Modernity*, New Haven, 1991; and Colin Rhodes, *Primitivism and Modern Art*, London, 1994.

30 See Lloyd, *German Expressionism*. An illuminating case study on the English passion for ethnography, which raises similar issues, is Annie Coombes, *Reinventing Africa: Museums, Material Culture and Popular Imagination in Late Victorian and Edwardian England*, New Haven, 1994.

31 Wilhelm Worringer, *Abstraction and Empathy: A Contribution to the Psychology of Style* (1908), Eng. trans. Michael Bullock, London, 1953, pp. 15, 44. For some excellent essays on Worringer's aesthetics, see Neil H. Donahue (ed.), *Invisible Cathedrals: The Expressionist Art History of Wilhelm Worringer*, University Park, 1995.

32 Kandinsky echoes Worringer in, for instance, an article he wrote for the Russian journal *Apollon* in April 1910. See *Complete Writings*, vol. 1, pp. 65–6.

33 See Jill Lloyd, 'Emil Nolde's "ethnographic" still lifes: primitivism, tradition and modernity', in Susan Hiller (ed.), *The Myth of Primitivism: Perspectives on Art*, London and New York, 1991, pp. 90–112; Peter Vergo, *Emil Nolde*, exhibition catalogue, London, 1995; and William Bradley, *The Art of Emil Nolde in the Context of North German Painting and Volkisch Ideology*, Evanston, 1981.

34 Lloyd, *German Expressionism*.

35 Kandinsky and Marc, *The Blaue Reiter Almanac*.

36 Franz Marc, 'Spiritual treasures', in *The Blaue Reiter Almanac*, p. 59.

37 Vassily Kandinsky, 'On the question of form', in *The Blaue Reiter Almanac*, p. 147.

38 This is despite the fact that Kandinsky and Münter had private collections of children's art, *lubki* and Bavarian glass painting. See Jonathan David Fineberg, *The Innocent Eye: Children's Art and the Modern Artist*, Princeton, 1997, chapter 3.

39 There have been a number of considerations of women artists within the Expressionist circles, but the wider issue of gender in the ideologies of the groups has not received the same systematic attention. Among important works on women Expressionists are Alessandra Comini, 'Gender or genius? The women artists of German Expressionism', in Norma Broude and Mary Garrard (eds), *Feminism and Art History: Questioning the Litany*, New York, 1982; Rosemary Betterton, 'Mother figures: the maternal nude in the work of Käthe Kollwitz and Paula Modersohn-Becker', in Griselda Pollock (ed.),

Generations and Geographies in the Visual Arts: Feminist Readings, London and New York, 1996, pp. 159–79; and Shulamith Behr, *Women Expressionists*, Oxford, 1988.

40 See Irit Rogoff, 'The anxious artist – ideological mobilisations of the self in German modernism', in Irit Rogoff (ed.), *The Divided Heritage: Themes and Problems in German Modernism*, Cambridge, 1991, pp. 116–47.

41 Kandinsky seemed to find painting nudes distasteful. See his comments in 'Letters from Munich', published in the Russian journal *Apollon* in January and April 1910, as well as his Reminiscences of 1913: *Complete Writings*, pp. 62, 69, 374.

42 Magdalena Bushart, 'Changing times, changing styles: Wilhelm Worringer and the art of his epoch', in Donahue, *Invisible Cathedrals*, pp. 69–85. Herman George Scheffauer in his defence of German avant-gardism, *The New Vision of the German Arts*, London, 1924, interestingly equated the feminine principle with 'the mystic nature of the Russians' (pp. 23–4), making explicit the connection between the feminine, the spiritual and the Russian components of the Blaue Reiter.

43 See Andreas Huyssen, 'Mass culture as woman: modernism's other', in idem, *After the Great Divide: Modernism, Mass Culture, Postmodernism*, Bloomington, 1986, pp. 44–62.

44 See the discussion of this in Maurice Godé, *Der Sturm de Herwarth Walden: l'utopie d'un art autonome*, Nancy, 1990, pp. 77–83.

45 'Das Element kennt keinen Kompromiß; es besteht für sich ... Nur das Element ist durch bloßes Dasein wirkend: so erfüllt es sich in einer *Idee der Weiblichkeit*. Der Mann schafft – das Weib ist ... So erhält das Element einen geistigen Reflex vom Weibe': Paul Hatvani, 'Versuch über den Expressionismus', *Aktion* (17 March 1917), quoted in Paul Raabe (ed.), *Ich schneide die Zeit aus: Expressionismus und Politik in Franz Pfemfert's 'Aktion' 1911–1918*, Munich, 1964, p. 273.

46 Hans Hildebrandt, *Die Frau als Künstlerin*, Berlin, 1928, especially pp. 13, 157.

47 See Fineberg, *The Innocent Eye*, p. 68, who points out that although Blaue Reiter artists advocated the work of children, only Jawlensky and Klee had any children at this time.

48 August Macke and Franz Marc, *Briefwechsel*, Cologne, 1964, p. 28, quoted in Frederick S. Levine, *The Apocalyptic Vision: The Art of Franz Marc as German Expressionism*, New York, 1979, p. 57.

49 In addition to Johannes Eichner's *Kandinsky und Gabriele Münter: von Ursprüngen der modernen Kunst*, Munich, 1957, there has been a great deal of good recent research on Münter's life and work. See, for instance, Hoberg, *Kandinsky and Münter*; Annegret Hoberg and Helmut Friedel (eds), *Gabriele Münter*, exhibition catalogue, Munich, 1992; Gisela Kleine, *Gabriele Münter und Wassily Kandinsky: Biographie eines Paares*, Frankfurt-am-Main, 1991; Anne Mochon, *Gabriele Münter: Between Munich and Murnau*, Cambridge, Mass., 1980; Karl-Egon Vester, *Gabriele Münter*, exhibition catalogue, Hamburg, 1988; and Sabine Windecker, *Gabriele Münter: eine Künstlerin aus dem Kreis des 'Blauen Reiter'*, Berlin, 1991.

50 Hoberg, *Kandinsky and Münter*, p. 99.

51 Max Klinger, *Malerei und Zeichnung* (1891), 5th edn, Leipzig, 1907. See Thomas K. Nelson, 'Klinger's *Brahmsphantasie* and the cultural politics of absolute music', *Art History*, 19:1 (1996), 26–43. Klinger also produced the statue of Beethoven, which formed the centrepiece of the ground-breaking Vienna Secession exhibition of 1902. See Peter Vergo, *Art in Vienna 1898–1918*, 2nd edn, Oxford, 1981.

52 See David Large (ed.), *Wagnerism in European Culture and Politics*, Ithaca, 1984; and Peter Vergo, 'The origins of Expressionism and the notion of the *Gesamtkunstwerk*', in Shulamith Behr, David Fanning and Douglas Jarman (eds), *Expressionism Reassessed*, Manchester, 1993, pp. 11–19.

53 For the relationship between Kandinsky's theatrical work and the Munich theatrical community, see Peter Jelavich, *Munich and Theatrical Modernism*, Cambridge, Mass., 1985; for the Russian sources, see Shulamith Behr, 'Deciphering Wassily Kandinsky's *Violet*: activist Expressionism and the Russian Slavonic milieu', in Behr, Fanning and Jarman, *Expressionism Reassessed*, pp. 174–88.

54 This emphasis on rhythm was expressed most directly not by the Blaue Reiter artists themselves but by their later advocates – most notably the contributors to Herwarth Walden's *Der Sturm* magazine (see chapter 4). See, for instance, Rudolf Blümner, 'Das Harmonische in der Musik', in Herwarth Walden, *Expressionismus: Die Kunstwende* (1918), Berlin, 1973, p. 90. The idea of 'rhythm' as a basis for art was a common interpretation of Bergson's theories and was particularly prevalent in France, where there was a short-lived avant-garde journal called *Rhythm*. I am grateful to my Ph.D.

student Catherine Heathcock, who drew my attention to the importance of the 'rhythm' phenomenon.

55 See Andrew Kagen, *Paul Klee: Art and Music*, Ithaca and London, 1983; K. P. Aichele, 'Paul Klee's operatic themes and variations', *Art Bulletin*, 68 (1986), 450–66; and Paul Bauschatz, 'Paul Klee's Anna Wenne and the work of art', *Art History*, 19:1 (1996), 74–101.

56 Vassily Kandinsky, 'Reminiscences' (1913), in *Complete Writings*, vol. 1, p. 369.

57 Vassily Kandinsky, 'On the spiritual in art' (1912), in *Complete Writings*, vol. 1, p. 218.

58 See John Gage, *Colour and Culture: Practice and Meaning from Antiquity to Abstraction*, London, 1993.

59 Kandinsky, *Complete Writings*, vol. 1, pp. 180–5.

60 Among Haeckel's more influential works was *The Riddle of the Universe at the Close of the Nineteenth Century*, Eng. trans., London, 1900. See Christoph Kockerbeck, *Ernst Haeckel's Kunstformen der Natur und ihr Einfluss auf die deutsche bildende Kunst der Jahrhundertwende*, Frankfurt am Main, 1986.

61 This is discussed in Frederick S. Levine, *The Apocalyptic Vision: The Art of Franz Marc as German Expressionism*, New York, 1979, p. 21. Marc's debt to Nietzsche comes forward most clearly in his Nietzchean aphorisms. See Franz Marc, 'Die 100 Aphorismen', in *Franz Marc Schriften*, ed. Klaus Lankheit, Cologne, 1978, pp. 185–213.

62 Marc's apocalyptic imagery is discussed most thoroughly by Levine, *Apocalyptic Vision*, and in Frederick Levine, 'The iconography of Franz Marc's *Fate of the Animals*', *Art Bulletin*, 58 (1976), 269–77. See also Claus Pese, *Franz Marc: Life and Work*, Stuttgart, 1990.

63 Franz Marc, *Briefe aus dem Felde*, Munich, 1966, p. 60.

64 See Erich Ranfft, 'German women sculptors 1918–1936: gender differences and status', in Marsha Meskimmon and Shearer West (eds), *Visions of the 'Neue Frau': Women and the Visual Arts in Weimar Germany*, Aldershot, 1995, pp. 42–61; Erich Ranfft, 'Expressionist sculpture *c.* 1910–30 and the significance of its dual architectural/ ideological frame', in Behr, Fanning and Jarman, *Expressionism Reassessed*, pp. 65–79. See also Stephanie Barron, *German Expressionist Sculpture*, Chicago, 1983.

65 Max Beckmann, 'On my painting' (1938), quoted in *Max Beckmann: Self-Portrait in Words*, ed. Barbara Copeland Buenger, Chicago and London, 1997, p. 302.

66 For Beckmann, see for example, Hans Belting, *Max Beckmann: Tradition as a Problem in Modern Art*, New York, 1989; Reinhard Spieler, *Max Beckmann 1884–1950: The Path to Myth*, Cologne, 1995; Peter Beckmann, *Max Beckmann: Leben und Werk*, Stuttgart and Zurich, 1982; and for Beckmann and Dix, Matthias Eberle, *World War I and the Weimar Artists: Dix, Grosz, Beckmann, Schlemmer*, New Haven, 1985.

67 For Dix and Nietzsche, see Eva Karcher, *Otto Dix 1891–1969: His Life and Works*, Cologne, 1988. I am grateful to Jonathan Casely and Gemma Blackshaw whose undergraduate dissertations on works by Dix and Corinth in the Barber Institute collection brought out the inventive ways in which these artists used the Crucifixion theme.

68 Carl Einstein, *Negerplastik* (1915), Munich, 1920. The clearest discussion of Einstein's work is contained in Liliane Meffre, *Carl Einstein et la problématique des avant-gardes dans les arts plastiques*, Berne, 1989.

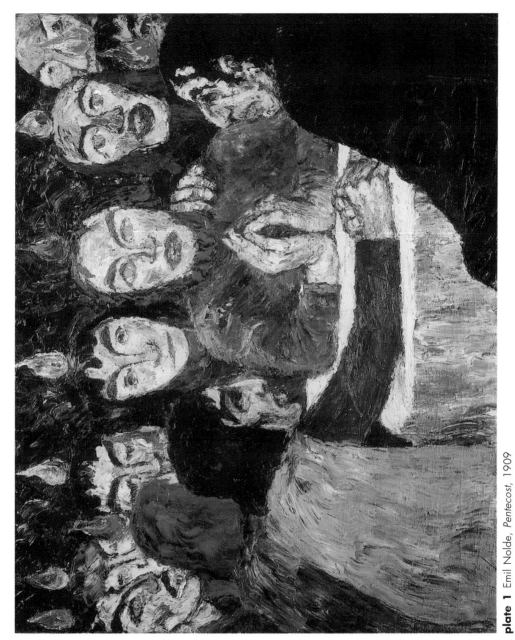

plate 1 Emil Nolde, *Pentecost*, 1909

plate 2 Vassily Kandinsky, *Improvisation 19*, 1911

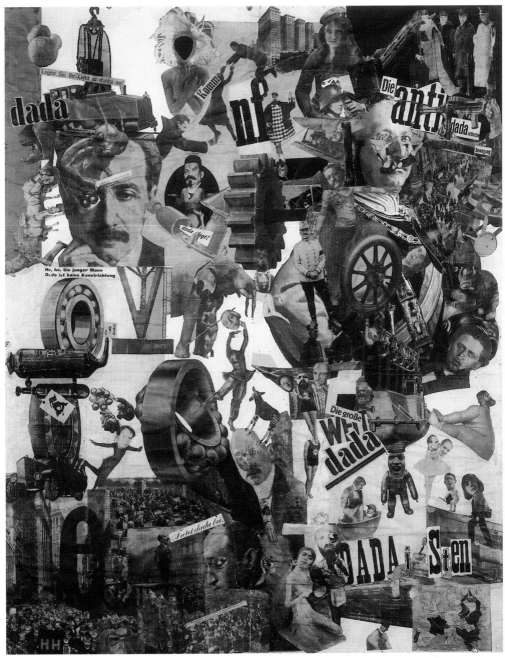

plate 3 Hannah Höch, *Cut with the Kitchen Knife: Dada through the Last Weimar Beer Belly Culture Epoch of Germany*, 1919, collage

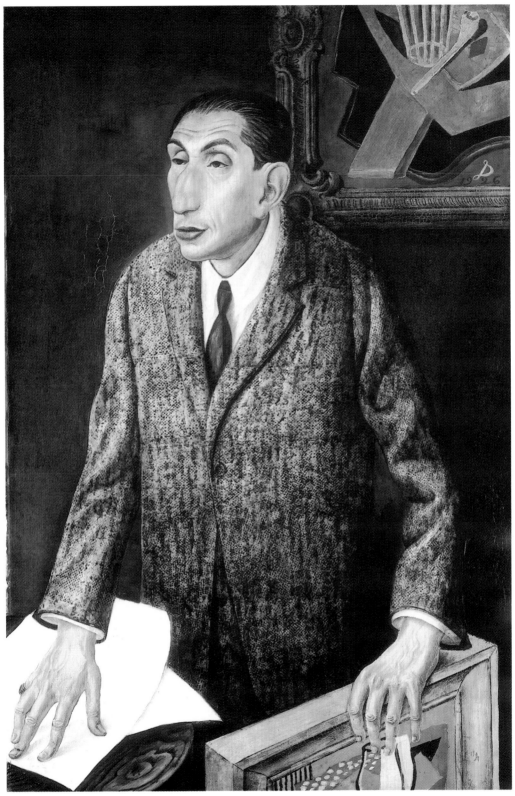

plate 4 Otto Dix, *The Art Dealer Albert Flechtheim*, 1926, oil on canvas

The invention and dissemination of Expressionism

4

all artists significant for Expressionism have one thing in common. That is 'Der Sturm'. (Rudolf Blümner, *Der Sturm: Einführung*, 1917)[1]

. . . the catchprase Expressionism with which the smart art dealers and smooth art critics practise their propaganda . . . (Paul Westheim, 'Das Ende des Expressionismus', 1920)[2]

THE artists of the Blaue Reiter, like those of Brücke, have been labelled 'Expressionists', and the term is now commonly used to distinguish early German modernism from that of other European countries. However, while these groups did share certain fundamental characteristics, Expressionism was never a unified movement like Cubism or Futurism, and it retained within its boundaries both intellectual and aesthetic polarities. Expressionists were either pacifists or vocal exponents of war; they extolled art for its own sake, or they embraced only art which had a distinct political purpose; their rhetoric was either feverishly excited or grimly despairing. Furthermore, Expressionism as a term was used frequently only after both the groups discussed earlier had come to public prominence. The protean nature of the label gave it a value to artists, critics and dealers eager to recognise something distinctive in Germany's contribution to modernism. The invention of the term Expressionism, its wide application, and the dissemination of its vague principles to art forms as diverse as film and theatre provided a special direction for German art immediately before, during and after the First World War.

It is worth recognising, for a start, how the term 'Expressionism' came into common usage and the balance between accident and design in its popularisation.[3] Although as demonstrated by the activities of Secessionist artists, as well as the Blaue Reiter and Brücke groups, Germany had an important role to play in the international avant-garde, by the time of the first Blaue Reiter exhibition in 1911 there was still no clear way of characterising these tendencies as German. Cubism, for instance, had French associations; Futurism was linked with the Italians. Germans had no 'ism' of their own. By bringing the idea of 'inner necessity' into the theoretical domain, Kandinsky and his Blaue Reiter colleagues unwittingly provided art critics with a way of seeing German art as distinct from its foreign counterparts. German art was about expression ('*Ausdruck*'), while Germany's major rival, France, was still concerned with the '*Eindruck*' (impression) that characterised the optical bias of Impressionist art.

This set of oppositions was not articulated clearly for some years. The first notable usage of the term Expressionism to stand for an art of inner expression came in 1911 – at the time of Brücke's dissolution and after the Blaue Reiter had launched both of its exhibitions. In that year, the 22nd exhibition of the Berlin Secession included works by French artists such as Derain and Vlaminck who were labelled 'Expressionists' by contemporary critics. It is significant at this early stage that this art was classified using a Germanised version of the French *'expressionistes'* – *Expressionismus* – rather than a neologism using *'Ausdruck'* as a root.[4] The following year, the Berlin art dealer Herwarth Walden launched an exhibition which included the word 'Expressionisten' in its title, although he employed the phrase even more generally, as a synonym for modernism. The important Sonderbund exhibition in Cologne in 1912 consolidated the association of the term 'Expressionism' with contemporary German art.[5] By 1914 when the first monograph on Expressionism, Paul Fechter's *Expressionismus*, was published, the diverse ideals of Brücke and the Blaue Reiter were blended into a single coherent entity, and they were given a patrimony that was traced back to Van Gogh.[6] What had begun as a diverse range of artistic theories became a serious commercial concern and, by the end of the First World War, a genuinely 'popular' style. However, it is important to realise that as late as the 1920s critics still spoke of the 'movement' as something pan-European, although Expressionism was more frequently associated with German art by this stage.[7]

The connotations of 'Expressionism' were only gradually separated from those of other modern movements, but as the German associations were strengthened through critical reception, the distinctiveness of the Expressionist programme was also stressed. Expressionism came to stand for anti-materialism and pure abstraction. In a world of objects and egotism, Expressionism sought spirit, depth and community. Although these aims came to be articulated only gradually, the importance of Expressionism for the understanding of Germany's move in the direction of cultural unity should not be underestimated. All of the abortive attempts to discover a genuinely 'German' style and culture were in some ways compensated by the ubiquity and influence of Expressionist art. Expressionism was in many ways an answer to the problem of cultural unity: it drew on Germany's idealist and romantic heritage; its styles often relied on German medievalism; unlike Impressionism, it did not become pan-European, but remained firmly rooted in German-speaking countries. But the unity of such a 'spiritual' style was achieved through the agency of dealers, newspapers and magazines. One of the most violently anti-bourgeois and anti-materialist art movements of the early twentieth century owed its success to the market conditions that its artists openly reviled. Thus it is important to stress that Expressionism was not a creation of the artists but of the dealers and critics who promoted them. The most significant of these figures was the Berlin writer, editor and dealer, Herwarth Walden.[8]

A number of contemporary avant-garde tendencies found a common home in Walden's various enterprises. He was a musician and a writer, as well as a lover of both theatre and painting, and he was married for a time to the poet

Else Lasker-Schüler. His interests led him to become involved with various experimental societies and journals in pre-war Berlin. Especially important was the Verein für Kunst (Society for Art) founded in Berlin in 1904. The Verein sponsored evenings in which experimental poetry, music and drama were brought together and ideas were exchanged. Several artists were among the members, but it was only later that Walden became committed to contemporary art. The turning point in his association with the art world was the founding of a weekly arts journal *Der Sturm* in March 1910. Collaborating with the renowned Austrian journalist Karl Kraus, Walden devoted *Der Sturm* to a polemical defence of modern tendencies in culture and art. The journal lingered on in various forms until 1932 and, over the course of this period, it gradually became a propaganda organ for the dissemination of Expressionist ideas.

Walden's focus on art benefited from the circumstances in Berlin in 1910. At that time a split in the Berlin Secession led Max Pechstein and 27 other artists to hold their own exhibition. After this, Pechstein founded a rival organisation, the Neue Sezession, which lasted only a year in the face of the more powerful Berlin Secession. It was clear that there was dissent in the art world, and that some of the younger artists no longer felt that the Berlin Secession was representative of their interests. The failure to create an alternative institution led dissenting artists to turn to the private sector for help. By 1912 many of these artists were seeking the assistance of Walden, who had the funds, energy and willingness to help finance essential exhibitions of their work. Walden was prepared to take risks and to compensate for the relative obscurity of some of his pet artists by aggressive marketing and public relations strategies. Perhaps more importantly, Walden was a foil for Paul Cassirer, whose firm association with Liebermann and the Berlin Secession was anathema to the rebels who turned against the conservatism of that institution. In 1912 Walden sponsored exhibitions of Blaue Reiter artists and the Italian Futurists. In 1913 he held his first autumn salon (*Herbstsalon*), modelled on the Paris Salon d'Automne and including the work of 75 artists from 12 different countries. By 1921, despite the intervention of the First World War, he had sponsored more than 200 exhibitions, many of which travelled to countries as far away as America or Japan.[9] In fact, the war appeared to enhance, rather than hinder, his success: by the time it was over, his commercial empire had expanded to include involvement in theatre, as well as art and literature.[10] The *Sturm* school which opened in 1916 and included such distinguished staff as Klee and Münter, reflected the vastness of Walden's cultural enterprise, as its brief was to provide 'lessons in Expressionist art of the stage, acting, performance, painting, poetry, music'.[11]

But it was *Der Sturm* magazine and Walden's other publications that – combined with his activities as a dealer – did the most to give Expressionism an international profile. Although *Der Sturm* was only one of many German journals that offered support for avant-garde tendencies, Walden's was the only one that developed a coherent aesthetic.[12] The early numbers of *Der Sturm* lacked this coherence, but by 1912, Walden's interest in art was more apparent. However, it was not until the war years of 1914–18 that *Der Sturm* renounced its pluralist approach for a wholesale validation of Expressionist

aesthetics.[13] The war years witnessed a temporary diminishment of artistic production with the conscription, exile, or death of many prominent artists, and the art market, not surprisingly, collapsed for a time. However, the war provided an opportunity for aesthetic consolidation. Walden and *Der Sturm* did not actively support the war, as many propagandist journals did, but the journal promoted an aesthetic escapism that was particularly susceptible to the Expressionist idea of an inner life.

Walden's view of Expressionism was vague enough to encompass all the movements and artists he admired. To Walden Expressionism was not simply a style but a *Weltanschauung* (world view).[14] Frequently relying on word play and repetition as much for effect as meaning, Walden's various statements on art gave a spurious programme to Expressionism.[15] To consolidate this illusion of homogeneity, Walden gave the promotion of Expressionism visual reinforcement by gradual alterations in the visual emphasis of *Der Sturm*. Before the war, he had included a heterogeneous selection of illustrations, from caricatures to Futurist painting, but the immediate pre-war and wartime issues of *Der Sturm* included greater attention to the graphic styles associated with Brücke and the Blaue Reiter circles. The persistence of the stark woodcut technique associated with Brücke was accompanied by their characteristic subject-matter of nudes and cabarets. Such themes were gradually superseded by the childlike creations of Kandinsky, Münter, Klee and Marc. Walden favoured a small group of artists, both German and non-German, whose works he promoted unfailingly. Among these were Marc, Macke, Marc Chagall, Fernand Léger and Alexander Archipenko.

This attempt to provide a theoretical unity for such a diverse range of artists was an effective marketing ploy. While Walden promoted individuals through his gallery,[16] he perpetuated a notion of aesthetic homogeneity – a kind of corporate identity – through his journal. Many later (often disparaging) references to the 'Sturm style' show the extent to which Walden's strategy was an effective one. Among the artists who were part of his circle at the beginning and end of the *Sturm* years were Oskar Kokoschka and Kurt Schwitters, two very different artists whose works reveal the diversity encompassed by Walden's aesthetic theories. Kokoschka was part of an initial clique of Austrians, including Karl Kraus, Adolf Loos and Paul Scheerbart, who were heavily involved in *Der Sturm* during its early years. Kokoschka came to Berlin in 1910, having failed to make a success of his art in his native Vienna. In many ways, he was an ideal candidate for the cultural pluralism of *Der Sturm*, as his work to date comprised theatre and poetry, as well as applied art through his association with the Wiener Werkstätte (Vienna Workshops). He had exhibited designs for his book *Der träumenden Knaben* (*The Dreaming Youths*) at the Vienna Kunstschau exhibition of 1908, and the distortions of his figures and violent colours led one critic to dub his room 'The Chamber of Horrors'.[17]

The Dreaming Youths was, to a point, a reflection of the decorative emphasis of the Austrian art nouveau movement, which sought reforms in typography and book design, as well as in furniture and home decoration. But what began as an illustrated children's book became a psycho-history with a text full of sexual longing and adolescent anxieties – hardly children's reading.

Indeed, *The Dreaming Youths* is a very powerful Expressionist poem, complemented by images of boats, red fish, naked men and women, water, forests, dark nights and pubescent figures sleeping (and presumably dreaming). The imagery directly recalls that of Kokoschka's Viennese contemporary, Sigmund Freud, whose *Interpretation of Dreams* was first published in 1899. The sensuous language of the poem enhances the stunning images which accompany them. The poem is full of colours, sounds and smells. It leaps back and forth between mind and body with barely disguised sexual metaphors and a prevailing sense of nostalgia.

But it was disgust, rather than nostalgia, that inspired Kokoschka's second major early work, *Murder, Hope of Woman*, a play performed at the second Vienna Kunstschau of 1909, and it was this very violent work that first brought Kokoschka to the attention of Walden. By Kokoschka's own account, the play was performed by amateur student actors, who made up in intensity for what they lacked in talent. As there was no budget for costumes, the students wore rags and painted their bodies. The more the audience heckled the actors, the more vehemently they performed their roles. The play itself is anti-naturalistic: the characters ('Man' and 'Woman') fight each other physically and verbally, until the masculine force violently murders the feminine force, and the Nietzschean battle is over. The obscurity of the play, its seemingly gratuitous violence, its extremes and extravagance offended the Viennese public, and the reaction to it was partly responsible for Kokoschka's escape from Vienna in 1910. He made his way to Berlin, and introduced himself to Walden who agreed to publish his play in *Der Sturm*.[18]

Kokoschka's contributions to *Der Sturm* clearly came several years before Walden promoted the Expressionism that was to be associated with the journal, but aspects of Kokoschka's approach to art seem to have influenced Walden's views. Kokoschka's interest in poetry and theatre complemented Walden's own concerns, as well as those of one of his most loyal *Sturm* contributors, Lothar Schreyer. However, in visual terms, it was Kokoschka's portraiture that seemed to have the most pronounced associations with the spiritual emphasis of Walden's avant-garde.

As one of the most staid and predictable of genres, portraiture in some ways was an odd choice for an avant-garde artist.[19] In Vienna, a conventional and flattering form of society portraiture prevailed at the turn of the century, and there was no shortage of rich patrons to commission such works for their bourgeois homes. Kokoschka's associations with portraiture were initially accidental. While still working for the Wiener Werkstätte, Kokoschka was discovered by the radical architect Adolf Loos, who was shocked at the waste of Kokoschka's talent. Loos offered Kokoschka a stipend that allowed him to abandon his job at the Werkstätte to pursue painting. In order to justify this intervention, Loos arranged a number of portrait commissions for the artist. Although Kokoschka initially loathed the discipline of portraiture, he came to see it as the most appropriate means of tapping into the psyche of other individuals. By the time he came to Berlin, his portrait of Walden (figure 24) shows just how far Kokoschka had developed a genre from a tired vehicle of the socially aspirant to an expressive medium in itself. Kokoschka's later assessment of the role of portraiture reveals his purpose most clearly:

When I paint a portrait, I am not concerned with the externals of a person – the signs of his clerical or secular eminence or his social origins. It is the business of history to transmit documents on such matters to posterity. What used to shock people in my portraits was that I tried to intuit from the face, from its play of expressions, and from gestures, the truth about a particular person, and to recreate in my own pictorial language the distillation of a living being that would survive in memory.[20]

In some ways, Kokoschka's attitude towards portraiture is very traditional, as it recalls Renaissance theories of physiognomy in which the soul was seen to speak through the face and body. But he transformed a tradition into something quite unique. The combination of poses and gestures that he adopts, his exposure of bones, sinews and blood vessels through his use of colour, and the expressive distortions of his painterly style all contribute to create portraits which make 'statements' about the inner life of those individuals he chose to represent. Kokoschka presented a number of his portrait drawings to early editions of *Der Sturm*, and as many of them represented individuals associated with the journal, they helped create *Sturm*'s distinct identity. Portraiture thus contributed to some early ideas about the inner life that fed Walden's later development of an Expressionist theory of the spirit.

However significant Kokoschka may have been for Walden's evolving aesthetics, the two severed relations by 1916, and Kokoschka transferred his allegiance to Cassirer. In total contrast, but equally appropriate for the *Sturm* world view was Walden's much later promotion of the Hanoverian Dada artist, Kurt Schwitters, who became involved with the journal in 1918. Although different in many ways, Kokoschka and Schwitters shared certain tendencies. Both artists were poets, and Schwitters, like Kokoschka, initially contributed literary work to *Der Sturm*. Both artists were also firmly rooted in a Romantic tradition; and both were concerned with the ways in which art could transcend material and visual reality.[21] However, Schwitters's art developed in a very different way, and it is instructive to see how Walden's world view could incorporate into Expressionism a type of art that came to be associated with the later movements of Dada and Constructivism.[22] Schwitters was initially linked with the politicised Berlin Dada movement, through his acquaintance with the artist Richard Huelsenbeck. However, Huelsenbeck very quickly became disillusioned with what he saw as Schwitters's lack of social critique. Schwitters's ideas about art paralleled the resolutely apolitical stance

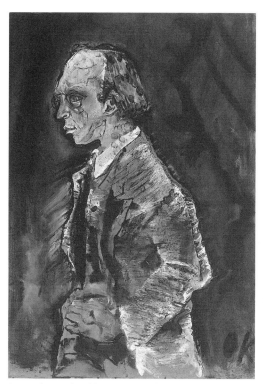

24 Oskar Kokoschka, *Portrait of Herwarth Walden*, 1910

of *Der Sturm* during the war years, and his statements show that he veered towards the concept of 'art for art's sake':

> Art is a spiritual function of man, which aims at freeing him from life's chaos. Art is free in the use of its means in any way it likes, but is bound to its own laws and to its laws alone; the minute it becomes art it becomes much more sublime than a class distinction between proletariat and bourgeoisie.[23]

Schwitters' public feud with the Berlin artists led to his retreat into an alternative form of Dadaism which he called 'Merz'. Schwitters claimed that the name 'Merz' was chosen by accident, when he cut out these letters from a newspaper clipping with the words 'Kommerz- und Privatbank', but the meaningless term soon took on a series of important associations. Although Merz was not Expressionism, it shared many things with the older art movement. Schwitters was concerned with the transcendent and spiritual power of art and the priestly nature of the artist. He sought to create a *Gesamtkunstwerk*, or total work of art, which had been a goal of other Expressionist artists, such as Kandinsky. Schwitters was also, in some ways, a utopian, as he believed that art could provide a solace from the pedestrianism of the world. Merz was a form of art which involved a metamorphosis of inanimate objects. Schwitters collected items of 'rubbish' such as tram tickets, stamps, fragments of newspaper, sweet wrappers, and he transformed these individual items by incorporating them into a larger, crafted collage or assemblage. To Schwitters, every object had a special essence (*Eigengift*), and it was the artist's job to combine or juxtapose objects in such a way that they would undergo a metamorphosis (*Entformung*).[24]

Although there was an Expressionist tendency in Schwitters's art, Merz developed into a distinct form of art that owed little to its Expressionist roots. As the 1920s progressed, Schwitters became more and more interested in the abstract qualities of Merz, and some of his assemblages were similar in effect, if not in intention, to the works of Picasso and the French Cubists. But unlike the largely formal experiments of the Cubists, Schwitters's decisions about the combination of forms was linked with his ideas about the transcendent power of art. His work also differed from that of the Expressionists in its incorporation of punning or satirical language. The titles of Schwitters's Merz compositions are not always logical, but there is sometimes an ironic resonance or association underlying them. His Merz composition *Merzbild 32A: Das Kirschbild* (1921, New York, Museum of Modern Art), for example, is so named because it is a near homonym of 'Kurtchen' – an affectionate diminutive of Schwitters's first name.

Schwitters's most distinctive Merz contribution also owes something to Expressionism and to the Expressionist megalomania of Walden. This is the Merzbau, or Merz building, which Schwitters constructed in his Hanover studio between *c.* 1923 and 1931. The Merzbau was destroyed when Schwitters left Germany in the 1930s and, although he built another one during his exile in England, the original is known only through photographs and (often conflicting) contemporary descriptions. It appears that the Merzbau was the ultimate realisation of the *Gesamtkunstwerk* – a work of art that was literally everything and anything that Schwitters wanted it to be. In some respects it was a

utopian environment, but unlike previous total environments, such as the artists' colony in Darmstadt, it was satirical, anti-aesthetic and non-functional. It was a personal statement, not a public monument, and it was constantly evolving, as Schwitters's ideas and aesthetics changed. The Merzbau began as a slightly expanded version of one of Schwitters's assemblages. The first manifestation of the Merzbau was a Merz column which consisted of a collection of objects placed in a series of 'grottoes'. This column, also known as 'The Cathedral of Erotic Misery', contained objects which were ironic or without apparent meaning. Schwitters constructed grottoes that were both biographical and topographical, and he designed a number of these as homages to his artist friends, such as László Moholy-Nagy, Sophie Täuber and Hannah Höch. When friends came to stay at his house, Schwitters would often confiscate their personal items and add them to his Merzbau. The grottoes included an array of bizarre and often disturbing objects: a bottle of Schwitters's own urine, Persil adverts, an effigy of a mutilated corpse, a dog kennel with its own lavatory, and a reproduction of the Mona Lisa, whose face was replaced by that of the Dada artist Raoul Hausmann. Many of the objects were fetishistic or otherwise associated with sexual pathology and, in this respect, the Merzbau was a dim echo of Expressionist self-seeking, as translated through the theories of Freud.

However, the evolution of the Merzbau reveals just how far Schwitters had moved away from his Expressionist roots. By the end of the 1920s, the Merzbau was no longer so self-referential, nor was it so based on the resonances of individual components. At some stage during the 1920s, the Merzbau became a sculptural object rather than a Dada construction. Schwitters gradually placed geometric designs over the grottoes and caves and created a piece of abstract sculpture that people could walk into. The effect of the Merzbau was meant to be one of peace and repose, while its aesthetic formula had moved into the realm of abstract Constructivism and away from the literary references of Dada and the spiritual implications of Expressionism. The emphasis here is important, for whereas Kandinsky had hoped to create an abstract Expressionist art that would convey spiritual meaning, his concern had always been for the spiritual, with colour and form as merely the tools for this kind of expression. In Schwitters's Merzbau, the reverse seems to be the case. The abstract image evolved out of his spiritual and aesthetic concerns, but then the object itself took precedence over its spiritual or emotional significance.

By the time he created his Merzbau, Schwitters had moved away from Walden's circle, ironically, just as Walden was becoming increasingly political in his associations. Walden's eventual emigration to Moscow in 1932 was a culmination of his political sympathies, as well as the end of his *Sturm* enterprise, but in the long period of his ascendancy Expressionism was consolidated as the most notable example of German modernism. Despite his success, Walden was rarely characterised as a man of vision and accomplishment. The artists whom he patronised had mixed feelings about him; both Klee and Kokoschka, for example, associated him with a pernicious commercialism that was infecting the art world.[25] Macke painted a disparaging watercolour (1913, Munich, Städtische Galerie im Lenbachhaus) showing his fellow Blaue Reiter artists sitting in a cart being pulled by Walden as a way of demonstrating their passivity amidst his less elevated aims.[26] Walden's commercial

acumen was necessary for avant-garde artists in a climate no longer controlled by the discipline of an academy, but the artists themselves were reluctant to acknowledge their need for anything that seemed to hamper their freedom. Brücke, for instance, prided itself on relieving the individual of 'commercial considerations', although Kandinsky's exchange of letters with Marc and Münter reveal how obsessed his group was with the power of the marketplace.[27]

In forming such judgements, even liberal-minded artists were not free from the verdict of Vinnen's *Protest* and other public statements that saw the art world as controlled by a conspiracy of Jewish dealers and critics, and the fact that Walden was a Jew reinforced attacks on him.[28] Defensiveness about commercialism and the anti-Semitic uses made of it certainly characterised Lothar Schreyer's brief history of *Der Sturm*, in which he defined Walden's enterprise by a series of negatives:

> It is contemporary opinion that holds the Sturm to be a swindling private limited company through which Europe's celebrated artists will be exploited; others take it to be a clique of Jews who will contaminate the spirit of the people [*Volksgeist*], contrary to those who see it as a mere dance club with an artistic culture.[29]

Walden's role in the creation and perpetuation of an Expressionist ethos should not be underestimated, but there were other factors at work that led to a consolidation of Expressionist ideas during the First World War. Perhaps one of the most effective aspects of Walden's missionary campaign was using prints as a way of disseminating Expressionist stylistic features. This was clearly not a new idea, as Brücke had built their group identity partly on their annual graphics portfolios and the Blaue Reiter had embarked upon the Bible project. But the juxtaposition of prints with programmatic texts was employed by Walden as well as other journal editors during the war period. While the frequency and breadth of painting exhibitions were checked by the economic conditions of wartime, the production of prints for a dispersed and inconsistent market provided better opportunities for artists. Furthermore, although there was relatively little art bought and sold during the early years of the war, artists continued to produce works, and their responses to the war, whether positive or negative, attracted public attention and opinion. It is important to remember that the First World War – with its exceptionally wide conscription – for the first time involved a large number of artists, who did not all give up their practice entirely, even while serving in the trenches.[30] Given the limitations of their environment, conscripted artists turned largely to small-scale drawing to maintain their practice. The war inspired the sort of extreme reactions that were characteristic of Expressionism from the beginning; it also stimulated spiritual and religious feelings, and its ineffable misery demanded some attempt at articulation. Marc, who died in battle, and Beckmann, who survived, both sent letters from the field in which they included sketches of landscapes, fellow soldiers and other aspects of their new life. In both instances, drawing provided a way of recording and coming to terms with their experiences.[31] Marc's initial enthusiasm and increasing disillusionment with the war eventually suppressed his artistic instincts. Beckmann, on the other hand, retained something of his enthusiasm even

while undergoing the horrific duties of a medical orderly. His letters to his wife, Minna Tube, during the war, veer wildly from detachment to manic excitement. On 10 March 1915, he could write: 'What haven't I seen since last I wrote? I saw people dying of typhus and pneumonia',[32] and then, two months later, on 11 May: 'This war is wholly right: what I did before now was all apprenticeship; I am always learning and enlarging myself'.[33]

Beckmann's letters were accompanied by his drawings of fellow soldiers, and indeed his productivity was not quelled by his involvement with the casualties of battle: 'I have such a passion for painting! I am always working on form. In drawing and in my head and while sleeping. Sometimes I think I must be deranged, so fatiguing and tormenting to me is this painful sensuousness. All else is engulfed, time and space.'[34] His observations of fellow soldiers in the refectory or in the hospital itself indicate the way in which the visual side of the war obsessed him. Only barely beneath the surface of this visual fascination is a combination of ecstasy and disgust, which his descriptions of death, graves, explosions and injured soldiers does little to hide. Given his situation, it is perhaps surprising that he held on to his pre-war theories of art and could write to his wife 'No arabesques, no calligraphy, rather depth and form' (*keine Arabesken, keine Kalligraphie, sonder Fülle und Plastik*). His disgust with 'decorative' art prevailed, even while his intense feelings about the human condition were enhanced: 'It is wonderful for me, the coming together of men. I have a mad passion for this species.'[35]

The importance of drawings and prints during the war gave further fuel to the dissemination of distorted graphic forms that came to be associated with Expressionism, but other media also contributed to the ubiquity of this invented concept. One of the most notable effects of the war on visual culture was to inspire a greater interest in sculpture as an expressive medium.[36] Although monumental sculpture was a strong propagandist force throughout the Wilhelmine period, monuments tended to be idealised, predictable and didactic in their functions.[37] The war created a need for commemorative monuments and memorials, and given the spiritual and transcendent aims of Expressionism, there were attempts to apply these ideals to sculpture as well.

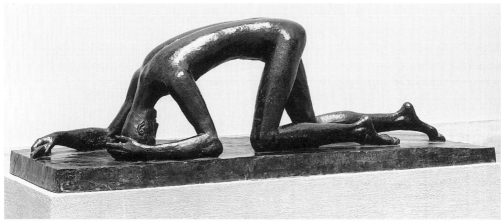

25 Wilhelm Lehmbruck, *Fallen Man*, bronze, 1915/16

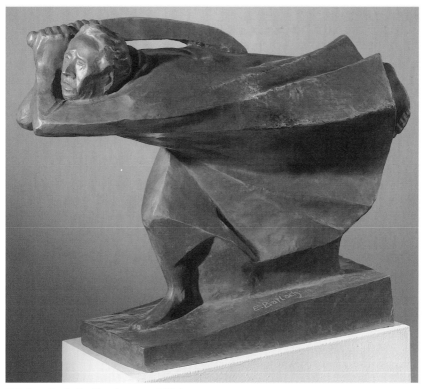

26 Ernst Barlach, *The Avenger*, 1914

Although the Brücke artists had experimented with wood carving, the German avant-garde had not previously devoted the same attention to sculpture that characterised their French contemporaries, such as Matisse and the Cubists.

The two most famous sculptural exponents of Expressionism, Wilhelm Lehmbruck and Ernst Barlach, in many ways represented the polarities of reaction to the war itself. Lehmbruck's famous *Fallen Man* (figure 25) has been contrasted with Barlach's *The Avenger* as two powerful responses to impending war. *The Avenger* (figure 26) is a stark, dynamic woodcut, whose body is poised for destruction; while the *Fallen Man* is an almost classical image of defeat and despair. The difference between the sculptures of Lehmbruck and Barlach is mirrored by a contrast between their careers and artistic orientations. Lehmbruck was the son of a labourer; Barlach's father was a bourgeois doctor. Lehmbruck was influenced by Rodin and his Parisian followers; Barlach was inspired by the crude popular carving of Russian peasants that he saw on a trip to Russia in 1906. Lehmbruck succumbed to despair during the war and committed suicide in 1919; Barlach became commercially successful and continued to produce art until he was gagged by the Nazis in the 1930s. Ironically, perhaps, Lehmbruck's humble origins were countered by an almost aristocratic grace of sculptural form, while Barlach's self-consciously *volkisch* figures were a denial of his comfortable bourgeois background.[38]

Their differences aside, both sculptors, like Beckmann, had a respect for and even love of, the art of the past. Neither artist was attracted to the experiments in abstract sculpture that were becoming common in the wake of

Cubism and Futurism. Although he was associated with Expressionism, Barlach eschewed this label because of its connotations of abstraction. In a letter to the art publisher Reinhard Piper of 1911, Barlach attacked Kandinsky's *On the Spiritual in Art* for its abstract emphasis and insisted:

> We must agree on a language in order to know anything at all: someone could say the most beautiful, most marvellous things in Chinese and I wouldn't pay attention. Therefore, if I want to share someone's spiritual experiences that person must speak a language in which I can experience the deepest and most secret things . . .

and he disparages abstraction, calling it 'an Esperanto art'.[39] Ironically, abstractionists such as Kandinsky claimed that their language of colours and forms was a universal one, but Barlach still adhered to the importance of the human form.

The rejection of abstraction did not lead to a 'realistic' alternative, but to sculptural forms that used recognisable images for spiritual ends. Lehmbruck's sculptures are not naturalistic representations: his figures are attenuated and their features are schematised, but their gestures are both simple and theatrically evocative. Barlach's works were also exaggerated, but their thick stumpy awkwardness contrasts with the poignant grace of Lehmbruck's sculpture. Whereas Lehmbruck never achieved fame and respectability, Barlach's election to the Prussian Academy of Arts in Berlin in 1919, and a series of commissions for war memorials throughout the 1920s indicate the extent to which he became professionally and commercially successful. His desire to 'give sensuous form to the mystical' also made him an appropriate choice for religious commissions, including sculptural decoration of churches.[40] His contemporary, Käthe Kollwitz, achieved similar respectability and likewise undertook sculptural commissions that demonstrated both mourning for the dead and an Expressionist spiritual transcendence. For example, Kollwitz's *The Mothers* uses monumental simplified forms and a dramatic motif of mourning women in a circle to create a poignant statement on the ultimate effects of the war's horrors.[41]

Barlach represented an additional element in the newly created Expressionist canon. Like many artists who were labelled Expressionist, Barlach worked in literary as well as visual forms, and the dramatic power of his figures was complemented by his special interest in the theatre. Among his Expressionist plays, *The Dead Day* was published in 1912 accompanied by 28 lithographs which translated Barlach's sculptural style into a graphic medium. Barlach's *Dead Day* shares with Kandinsky's *Yellow Sound* and, to a lesser extent, Kokoschka's *Murder, Hope of Woman* its unproducibility, and it was not performed until 1919.[42] As with other Expressionist plays, it contains obscure 'everyman' figures; in this case, the cast of characters includes 'Mother', 'The Son, who yearns for his Father', 'Hole, a blind seer', 'Hairybottom, an invisible gnome', 'Broomleg, a house spirit' and a 'Horse, which has been killed by the Mother'. It also shares with Kokoschka's play an intrinsically misogynist subtext, as the 'plot' centres on a mother's attempt to hinder her son's desire to follow his deified father. However arcane, *The Dead Day* was a valuable commodity because of the lithographs Barlach produced for it, and Bruno Cassirer had no hesitation about publishing the work

in 1912. Barlach's easy relationship with the publishers Cassirer and Piper even
before the war show just how accessible his art could be to a cultured public,
and, like many Expressionists, he became a respectable member of the estab-
lishment during the 1920s. As with many artists, Barlach's success was not
challenged until the National Socialist purges of modern art during the 1930s.
In a brave stand, he made a public radio statement in 1933 attacking the
expulsion of the leftists Heinrich Mann and Käthe Kollwitz from the Prussian
Academy of Arts, and afterwards, he increasingly became the target of persecu-
tion by right-wing forces. In 1933 a sculpture he had produced for Magdeburg
Cathedral was removed from that site at the request of the congregation; soon
after that his plays were banned and many of his works were removed from
public museums. By 1937 he was forbidden the right to exhibit his work.

Before the Nazi intervention, Barlach's success helped make Expressionist
sculpture the public and commercial voice of both patriotic and religious
sentiment during the 1920s. The ubiquity of Expressionist sculpture in public
life is only one of the many indications of the way in which Expressionism
had been transformed from an avant-garde art movement into a popularly
accepted mode of representation. But in the years after the war, this widespread
dissemination of Expressionism soon countered its revolutionary potential
and weakened its spiritual power. The expansion of media that loaned them-
selves to Expressionist treatment is best demonstrated by the new technology
of film. More than prints, drawings and sculpture, film helped make Expres-
sionism an ubiquitous form of visual representation in Germany. Walden had
started the commercial ball rolling with his *Sturm* empire before the First
World War, but it was the populist nature of film which would finally pop-
ularise, and then neutralise, the power of Expressionism as a concept.[43]

The cinematic turn to Expressionism was made simpler by the prevalence
of Expressionist language and set design in theatre both before and during the
First World War. The involvement of artists such as Kandinsky and Kokoschka
in theatrical activity complemented the experiments with theatre design by
performers and directors such as Max Reinhardt.[44] *Der Sturm*'s engagement
with theatrical Expressionism bore fruit through Lothar Schreyer's theoretical
texts and his instruction in the *Sturm* school. The natural early associations
between theatre and film made an appropriation of Expressionist ideals, styl-
istic qualities and even artists a natural one. Although some early films had
visual elements that could be considered Expressionist, it was not until Robert
Wiene's *The Cabinet of Dr Caligari* (figure 27) in 1919 that Expressionism
was embraced fully by the cinema.[45]

Significantly, *Caligari*'s odd sets, with their distorted angles, painted
shadows and deliberately unnatural lighting effects, were designed by three
regular contributors to *Der Sturm*, Hermann Warm, Walter Roehrig and Walter
Reimann. But it was not simply the sets that made *Caligari* an Expressionist
film. The acting methods and the extremes of plot also contributed to the
Expressionist ambience. The plot of the film is characteristically exaggerated,
romantic and complex. Caligari, having discovered the secret of sleepwalking,
hypnotises Cesare, a patient in a mental hospital. Caligari disguises himself as
a fairground performer, with Cesare as his main attraction. Two students,
Francis and Alan, come to the fair with Jane, with whom both of them are

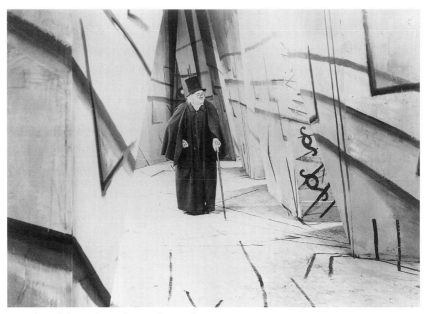

27 Film still from *The Cabinet of Dr Caligari*

in love. Alan is stabbed, and Francis and Jane's father suspect that Caligari has something to do with it. Francis spies on Caligari and sees Cesare in a box, but this Cesare is only a mannequin. Meanwhile, the real Cesare kidnaps Jane, and dies of exhaustion while carrying her away. Caligari escapes to a lunatic asylum. When Francis enters the asylum to find Caligari, he discovers that Caligari himself is the director of the institution. Caligari had read a story of an eighteenth-century showman who practised hypnosis, and in his madness, he believed that he was this man. When confronted with this, Caligari raves and is put in a strait jacket.

It is difficult to make narrative sense out of such a confusing jumble, but, like many early films, the effect relied more on sensation than clarity. But there was an additional element to the plot that inspired a great deal of controversy both then and since. The plot was actually inserted into a framing device. At the beginning of the film, Francis and Jane are patients in the lunatic asylum, and the 'story' is thus told through the perspective of Francis's madness. It transpires that Caligari is actually the benign director of the mental institution, and the rest of the events are Francis's sick fantasy. This may all seem very harmless, but the contemporary critic, Siegfried Kracauer, later accused the director of the film of undermining its revolutionary potential through this framing device. To Kracauer, Caligari represented 'unlimited authority that idolises power as such, and to satisfy its lust for domination, ruthlessly violates all human rights and values'.[46] According to Kracauer, although the main plot of the film showed a revolutionary spirit by emasculating Caligari, the framing device functioned to disable this radicalism. Kracauer's assessment was published after the Second World War, when he had had time to digest the cultural effects of insidious right-wing forces during the 1920s in Germany. His retrospective judgement may, certainly, be exaggerated, but there is little doubt that the Expressionism of the film was as much cosmetic as ideological.

Indeed, although *Caligari* is now seen as high culture, when it was made the film was designed to appeal to both 'high' and 'low' audiences through a reconciliation of various elements. Perhaps only the initiated would have noticed the way the sets deliberately recalled the distorted imagery of Expressionist painting, but the twists, turns and extremes of the plot were designed to appeal to a much wider audience. The two most outrageous characters – Caligari himself and Cesare – were made up extravagantly as a contrast with the more 'normal' figures of Francis and Jane, and their stylised and exaggerated mode of acting gave them a larger-than-life quality designed both to shock and delight. The film had all the appeal of Gothic horror, and indeed it was this quality of the horrific and the supernatural that became the trademark of Expressionist cinema during the 1920s.

A grasp of Expressionism in cinema relies on seeing film as a kind of *Gesamtkunstwerk*. Expressionist film was more than simply the painted shadows and distorted angles of set designs; it was a performance mode as well as a choice of genre. The transcendent and vitalist ideals that permeated *Sturm* aesthetics were transformed through the cinema into a more populist form. The universal message of Expressionist transcendence appeared to remain, giving a specious seriousness to the Gothic frivolities of the horror genre.[47] The spiritual became spiritualism or the supernatural, packaged for a mass audience. It is no surprise, then, that various versions of both the Frankenstein and the Dracula myths dominated the screen during this period. Expressionist films contained monsters, madness, hypnosis and fantasy settings.

Among these films was the 1920 version of Paul Wegener's *The Golem*, in which a Rabbi of Prague in the Middle Ages creates a creature to divert disaster from the Jews. As with Frankenstein, this creature loses control and begins to destroy everything in its path. Like *Caligari*, *The Golem* included stylised sets, and in this case, medievalising architecture, designed by Hans Poelzig, contributed to the effect of the film.[48] The excessive reliance on indoor sets enhanced the artificiality of these early films, as did the prevailing use of a still camera, which fixed the vision of the audience, while the performers moved in and out of the camera space. *The Golem* also shared with *Caligari* a contrast between the 'natural' acting style of the human characters and the stylised and exaggerated gestures of the monster.

The most famous cinematic monster of the 1920s was Nosferatu – the rat-like vampire of Fritz Murnau's film of that name.[49] Based loosely on Bram Stoker's *Dracula*, *Nosferatu* (figure 28) carried the Expressionist idiom a step further in its

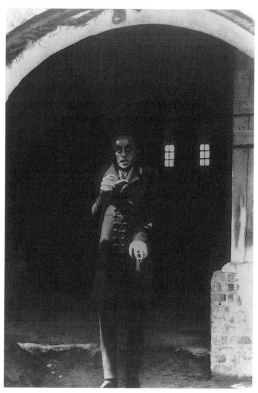

28 Film still from *Nosferatu*

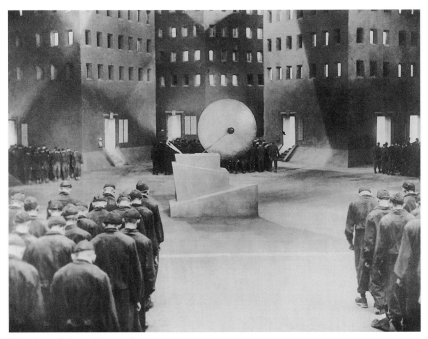

29 Film still from *Metropolis*

evocative use of outdoor settings and cameras lingering on significant inanimate objects. The vampire was a strong presence in Expressionist film until the 1930s, when Carl-Theodor Dreyer adapted two short stories by the nineteenth-century writer Sheridan Le Fanu for his film *Vampyr* (1931). Unlike *Nosferatu*, *Vampyr* does not include any artificial creations or distorted characters. The 'vampire' in this case is an old woman, who looks like an old woman, but performs the usual horrors on her victims. Here we can see the Expressionist aesthetic having run its course, but surviving in a new form in a series of 'subjective' shots which put us – the observers of the film – in the place of the protagonist, David Gray. The unsettling effects of the film derive from the uncertainty of the situations and the artistry of the camera, rather than make-up, set, surprise or theatrical exaggeration. *Vampyr* used Expressionist plot formulas, but pulled away from the aesthetic exaggerations of Expressionist film sets.

In fact, Expressionist cinema had run its course by the mid-1920s, although some of its more superficial manifestations were exported to Hollywood and even maintained by the Nazis. One of the last bastions of Expressionist exaggeration was Fritz Lang's *Metropolis* (1926), derided at the time for the absurdities of its plot and for the naiveté of its political perspective. The Expressionism of *Metropolis* lay primarily in its elaborate futuristic sets (figure 29) and in the character of a female robot, created by a mad genius, Rotwang. The film is set in an imaginary city of the future in which workers toil underground, while the wealthy ruling classes desport themselves in pleasure gardens and Olympic stadia up above. Freder, the son of the city's leader goes underground and meets the beautiful Maria, with whom he falls in love. Freder is persuaded of the plight of the workers and tries to convince

his father to ameliorate their situation. Meanwhile the evil genius Rotwang creates a robot that looks just like Maria and is sent below to incite the workers to revolt. The real Maria helps quell the revolt, and she and Freder live happily ever after in a reconciled world. The film seems to indicate not only that the 'masses' can be easily fooled, but that all they need is a good leader to put them right. The mechanisation of the crowd scenes and the massive sets went only a small way to making up for the vacuous plot.

Metropolis is one symptom of the way in which Expressionism, which was initially intended to unveil the human spirit, became an ornamental device by the mid-1920s. Expressionism became decorative, rather than spiritual, or even psychological, and Expressionist distortion became an end in itself, rather than a clue to something deeper. As with painting, graphic art and sculpture under the influence of *Der Sturm*, the features of Expressionist film were codified by 1926 with the publication of Rudolf Kurtz's *Expressionismus und Film*.[50] The fact that Expressionism – as well as conveying the aesthetic rhythms of nature and the transcendent power of art – could be embodied in the long fingernails of Nosferatu, shows the extent to which an invented term could be stretched to the point of becoming meaningless. By the mid-1920s, when Franz Roh published his monograph *Nach-Expressionismus* (*Post-Expressionism*), the style was seen to have been superseded by a 'new objectivity' (see chapter 7). But Roh's work also, significantly, represented Expressionism in abstract, stylistic terms, rather than in relation to its utopian objectives. To Roh, Expressionist art was dynamic, schematic, monumental, heavily impasted and full of diagonals.[51] What had begun as a rebellion against the bourgeois domination of society had degenerated into a decorative art. The commercialisation of Expressionism had led to the success and dissemination of the movement but, ultimately, a popular commodity proved unable to achieve the philosophical objectives of Expressionism's originators.

But even before Roh's work declared the limitations of Expressionism, problems with its usage were becoming apparent. It was especially difficult to classify who was an Expressionist and who was not. Artists such as Barlach, Corinth and Beckmann found the concept distasteful, although each of them was labelled Expressionist at one time or another. Given the vagueness of Expressionism's meaning, and its application to anything that veered towards abstraction or aimed to represent the inner life rather than the outer world, this is hardly surprising. Corinth's work is a case in point. Corinth, the Impressionist, was deeply opposed to the Expressionist tendencies in contemporary art, and he did his best to block its advancement in Berlin. But by the time the war was over, his own style had undergone a transition to an Expressionist mode which was clear not only in his academic nudes but also in his portraits of friends and acquaintances. The fact that an opponent of Expressionism used the tools and techniques of the movement shows how a vague concept could ultimately be rendered meaningless.

Beckmann's anti-Expressionism was part of an even more strongly expressed opposition to what he saw as the passing fashions of the avant-garde. Beckmann began his art studies in the Weimar Academy, and this early academic training was to remain an important factor in his subsequent development. After a brief flirtation with Impressionism, Beckmann turned

away from modernist influences and towards the extravagant paintings of French Romantic artists such as Delacroix and Géricault. His rejection of modernism was more than simply a pose. In a famous written exchange with Franz Marc in the art magazine *Pan* of 1912, Beckmann replied to Marc's praise of new art by criticising the works of Gauguin, Matisse and Picasso as too 'decorative'. Referring to 'Gauguin's wallpapers, Matisse's fabrics, Picasso's chess boards, and Siberian-Bavarian folk-icon posters', he lamented the decline of real significance in art, and argued for a return to the monumentality, three-dimensionality and spiritual power of works by old masters.[52] Beckmann's critique was certainly polemical in an age in which such traditionalism was associated firmly with conservative values and bourgeois philistinism. But despite Beckmann's admiration of the past, his approach to old masters was very much that of an Expressionist, and it is significant that he was particularly attracted to Romantic art with grand themes and striking compositions. He also shared the Expressionists' loathing for modern technology and for the mechanised souls of modern individuals. His attack on French Post-Impressionism and the work of Picasso revealed just how averse he was to an art which he felt was based on colour and form, rather than ideas and emotions.

In his pre-war works he tried to realise his ambitions to become a modern history painter and, in doing so, he combined elements from art of the past as well as more recent influences. These were large, violent paintings with pessimistic themes and an emphasis on natural disaster. His *Great Death Scene* of 1906 (Munich, Staatsgalerie moderner Kunst) owes a great deal to Munch in its use of colour and theme, but Beckmann's 'death' is not the Symbolist self-absorption of Munch, but a disaster on a massive scale. In his work, Beckmann responded to his feelings about his own mother's death from cancer, but, unlike Munch, the autobiographical element is subsumed within the universal theme. Beckmann's early works were physically, as well as thematically, on a grand scale. He not only tackled such contemporary events as the sinking of the cruise ship *Titanic*, but he also veered into religious painting with his two versions of the *Resurrection*, the latter of which measured 11 × 16 feet. What unified all of these early works was a desire to use representational art to express something beyond the objective reality of contemporary existence. By introducing himself into many of his works (including the Resurrection), Beckmann added a further message about the place of the artist within the confused and confusing hell of modern existence.

During the 1920s, Beckmann read various tracts on mysticism, theosophy and gnosticism and gradually formulated a view of the world and of individuals within it that continued to give his art an Expressionist flavour long after Expressionism had lost its impetus. Beckmann spoke through his art, so it is perhaps misleading to be too specific about his philosophy or theory of art, but his attitude to the world centred on a dualistic perspective, borrowed from Schopenhauer, in which the evolving soul of individuals was polarised against their earthly 'self'. The 'self' in this case was not just the body, but the whole way in which people are forced to play roles in the modern material world. Beckmann's pessimistic outlook on the world saw the soul as trapped by the worldly self and attempting, always abortively, to escape the chains of

this confinement. He expressed this response in several series of lithographs which he produced from 1916, and which include *Hell*, *Night in the City* (1920) and *Trip to Berlin* (1922).

If this was Beckmann's view of the world, it appears at first glance to suggest an irredeemable world, but it must be remembered that Beckmann's faith in the individual human soul was as strong as his disgust with the world that entrapped it. His art was a constant attempt to express his frustration with the shackles that tied the individual creative soul to a decayed and corrupted reality. To Beckmann, human beings in the world were constantly trapped in roles, which frequently changed and were rarely of any substance. His numerous self-portraits, and his various images of carnival, masquerade and *commedia dell'arte* were expressions of the artificiality that he felt permeated modern life. His pre-war interest in the representational art of old masters returned again after the war with his new concern for spatial effect. Works such as *Night* or *Carnival* draw their emotional impact in part from the way in which Beckmann used space, but space to him was a meaningful thing, not just a formalist trick. His *Carnival* also reveals his growing interest in German medieval art, in which human pain and suffering was given a strongly spiritual meaning. The vertical composition of *Carnival* makes it appear to be the wing of an altarpiece, with Beckmann himself posing as the ersatz Christ in the guise of a sad clown.

In considering Beckmann as a key figure in the dissemination of Expressionism, it is necessary to make some provisos. Beckmann's work was always representational, and during the 1920s he was considered to be part of the 'New Objectivity' – a 'realist' reaction to the painterly emphasis and distortions of Expressionism (see chapter 7). Beckmann rejected the label 'Expressionist', seeing Expressionist works as part of the same category of 'decorative' art as Cubism and Post-Impressionism. Beckmann also recognised that the popularity of Expressionism was fuelled by the marketplace, rather than by genuine spiritual concerns. He felt that the artist should have a special privileged position in modern society as a translator and conveyor of inner spiritual truths, but that the 'spiritualism' of many modern artists was specious.

If Corinth and Beckmann, despite their rejection of the label, reveal the possibilities of an Expressionist ideal outside the commercial label, Max Ernst exemplifies the limitations of the term in a changing post-war artistic climate. Unlike Beckmann and Corinth, Ernst began his career as a contributor to *Der Sturm* and clearly recognised his affinity with Walden's theories. Like Beckmann, Ernst admired Grünewald and German medieval art, and in 1913 he contributed to the Cologne exhibition of Rhineland Expressionists, indicating his early affiliation with the movement. Ernst fought in the First World War, but like many of his artist contemporaries, he turned against the war and became involved with the Dada reaction to it. Through the Sonderbund exhibitions, Cologne, Ernst's birthplace, had become associated with the pre-war avant-garde, and the Expressionist movement in particular, but its relationship with Dada was enhanced when Hans Arp came to Cologne straight from Zurich and the Cabaret Voltaire in 1919.[53] With Ernst and Johannes Baargeld, he formed the Dada organisation 'Zentrale W/3', which, like most Dada phenomena, was very short-lived. Ernst was also involved in the notorious

Dada Early Spring (*Dada-Vorfrüling*) exhibition, which was launched in the courtyard of a Cologne beer hall in 1920. Visitors were expected to enter through a men's latrine, and then they were encouraged to destroy the works of art on display. Ernst became associated with the Cologne-based group 'Das junge Rhineland' ('Young Rhineland'), which congregated around the eccentric art dealer Johanna ('Mutter') Ey in 1919. Although the artists in this group were really advocates of Dada nihilism, the 'junge' of their title indicates that they had inherited some of Expressionism's emphasis on the cultural power of the younger generations.[54]

Although quite early in his career Ernst moved towards the nihilist extremism of the Dada movement, his Expressionist heritage did not desert him immediately. In 1919 he saw a copy of the Italian journal *Valori Plastici* (*Plastic Values*), which included reproductions of illustrations by the 'metaphysical' artist Giorgio de Chirico. Ernst was fascinated by the way De Chirico used space and the juxtaposition of unrelated objects to create an effect or a mood. Some of Ernst's early works, such as the enigmatic *Aquis Submersis* owe their mystery and mood to De Chirico, but their very detachment lacks the intensity and ecstasy of Expressionism.

Ernst developed this detachment through a series of collages, which he began to produce in 1919–20. Although the generalities of Expressionism made it suitable for multi-media appropriation, collage and photomontage were never associated with the movement in the same way that drawings, woodcuts and lithographs were. It is conceivable that the use of real objects and photographs as part of collage experimentation was too literal for the Expressionist vision of spiritual aristocracy, or perhaps collage was too firmly associated with its Cubist and Futurist proponents.[55] Certainly Ernst's collage experiments lacked the ecstatic engagement of the *Sturm* style. Rather than attempting to evoke a mood or a dream-like state through his use of objects, Ernst's collages were ironic, wry and frequently irritating. His *The Hat Makes the Man* (1920, New York, Museum of Modern Art) was put together entirely from hat advertisements, while his *Design for a Manifesto* juxtaposed biological drawings of plants with a photograph of Ernst himself, pictures from sporting magazines and a pair of tassels.[56] Like Schwitters, Ernst used whatever he could find in his collages, but, unlike Schwitters, he did not seek to create a calm aesthetic space but an art of 'chaos and disruption', according to his contemporary Hugo Ball. Ernst's interest in scientific drawings, diagrams and zoological models invested his works with an aura of empirical detachment which was utterly disrupted by the absurd juxtapositions of unlike objects. In a very un-Expressionist way, Ernst also tried to move away from the idea of the individual creative artist by producing with Hans Arp a series of collages under the absurd title 'Fatagaga' (Fabrication of pictures [tableaux] guaranteed gazometric).

Ernst left Germany in 1922 for Paris, and there he became associated with the Surrealist movement. His fascination with psychological states, his use of Freudian sources, and his employment of irony and disturbing juxtaposition of objects all went against his earlier Expressionist orientation, even though it could be said that an Expressionist obsession with the inner life dominated his thinking throughout his career. Ernst's work shows the limits

of Expressionism, even in its vaguest *Sturm* definitions. However, the impoverishment of Expressionism was seen in more than just its visual limitations. In 1918 Ernst Bloch wrote his *Spirit of Utopia* – a typically Expressionist cry of ecstasy but with a strong underlying political purpose. Bloch was one of many Marxists who felt that the regenerative desires of Expressionist art were most appropriate for the new world left behind when the war was over. For the few short weeks when the German revolution of 1918 appeared to have succeeded, Expressionist excitement seemed the most appropriate cultural response to the coming of a new order. In retrospective assessments, Bloch's ideas appeared to other leftists to be foolish or misguided. A famous debate in the 1930s between Bloch and the Hungarian Marxist Georg Lukács reopened the argument about the political value of Expressionism. This time, however, Lukács initiated the debate with his idea that post-war Expressionist art was mere posturing by bourgeois centre-left ideologues. Lukács claimed that the Expressionists had no genuine political commitment, while Bloch declared their very utopianism as revolutionary.[57] The debate between Bloch and Lukács was an important manifestation of the polarities that had dogged Expressionism from the beginning. From 1911 the art magazine *Die Aktion* provided a left-wing alternative to Walden's tame *Sturm*, although both journals patronised Expressionist artists and writers. After the war there were artists who harnessed Expressionism to their leftist aspirations, but Expressionism became more and more firmly a commercially inspired movement. Ultimately, *Sturm* escapism overcame *Aktion* engagement, but the politicisation of Expressionism was a significant moment in the history of German modernism and one which deserves separate attention.

NOTES

1 Rudolf Blümner, 'Einführung', *Der Sturm: Einführung*, Berlin, 1917, p. 1.
2 Paul Westheim, 'Das Ende des Expressionismus', *Das Kunstblatt*, 4:6 (June 1920), 188, quoted in Iain Boyd Whyte, *Bruno Taut and the Architecture of Activism*, Cambridge, 1982, p. 216.
3 There are several important discussions of Expressionism's evolution as a term and a 'movement'. See, for example, Donald Gordon, 'On the origin of the word "Expressionism"', *Journal of the Warburg and Courtauld Institutes*, 29 (1966), 368–85; Ron Manheim, 'Expressionismus: Zur Entstehung eines Kunsthistorischen Stil- und Periodenbegriffes', *Zeitschrift für Kunstgeschichte*, 49:1 (1986), 73–91; John Willett, 'Expressionism: bonfire and jellyfish' and David Elliot, 'Expressionism: a health warning', in Shulamith Behr, David Fanning and Douglas Jarman (eds), *Expressionism Reassessed*, Manchester, 1993, pp. ix–xii and 40–9.
4 Gordon discusses the 'semantic confusion' between Expressionism and *Ausdruckskunst*. See also the discussion of *Eindruck* and *Ausdruck* in Franz Landesberger, *Impressionismus und Expressionismus: eine Einfuhrung in das Wesen der neuen Kunst*, Leipzig, 1920, p. 11. See also Patrick Bridgwater, *The Expressionist Generation and Van Gogh*, Hull, 1987, pp. 16–20; and Maurice Godé, *Der Sturm de Herwarth Walden: l'utopie d'un art autonome*, Nancy, 1990, p. 91.
5 Gunter Aust, 'Die Ausstellung des Sonderbundes 1912 in Köln', *Wallraf-Richartz Jahrbuch*, 22 (1961), 276–9; Magdalena Moeller, *Der Sonderbund*, Cologne, 1984; and Jill Lloyd, *German Expressionism: Primitivism and Modernity*, New Haven, 1991, pp. 8–12.
6 Paul Fechter, *Der Expressionismus*, Munich, 1914, 3rd edn, 1919. By the third edition, a number of other important books had been published on Expressionism, including Herwarth Walden's *Expressionismus: Die Kunstwende* (1918) Berlin, 1973, and Hermann Bahr's *Expressionism*, Munich, 1916, Eng. trans., London, 1925.

7 See the discussion of the unstable associations of the term 'Expressionism' in Dennis Crockett, *German Post-Expressionism: The Art of the Great Disorder 1918–1924*, University Park, 1999.

8 The fullest discussion of *Der Sturm* is contained in Godé, *Der Sturm*, but much useful information can also be found in M. S. Jones, *Der Sturm: A Focus of Expressionism*, Columbia, 1984; and Georg Brühl, *Herwarth Walden und 'Der Sturm'*, Leipzig, 1983.

9 For a full list, see Brühl, p. 109.

10 For a fascinating discussion of Walden's wartime activities and their political implications, see Kate Winskell, 'The art of propaganda: Herwarth Walden and "Der Sturm", 1914–1919', *Art History*, 18:3 (1995), 315–44.

11 'Unterricht in der expressionistischen Kunst der Bühne, der Schauspielerei, der Vortragskunst, der Malerei, der Dichtung und der Musik': Brühl, p. 111. In a number of ways, the Sturm school anticipates the holistic approach of the Bauhaus: see chapter 6.

12 For other journals, see Paul Raabe, *Die Zeitschriften und Sammlungen des literarischen Expressionismus*, Stuttgart, 1964. The only other journal with a similar level of success during this period was Franz Pfemfert's political *Die Aktion* (1911–32) (see chapter 5).

13 Godé, *Der Sturm*, divides the journal's early history into periods: the first, 1910–12, he sees as polemical and pluralist; the second, 1912–14, as breaking away from Viennese influence in the group and with greater attention to art; and the third, 1914–19, in which a clear programme for Expressionism was created.

14 Walden popularised his ideas in his compilations of short essays: *Expressionismus: Die Kunstwende*; *Einblick in Kunst. Expressionismus, Futurismus, Kubismus*, Berlin, 1917, 2nd edn, 1924; and *Die neue malerei*, Berlin, 1919.

15 On Walden's often irritating repetition of keywords, see Jones, *Der Sturm*, p. 23. On Schreyer's theory of *Wortkunst* (word art), see Brühl, *Herwarth Walden*, pp. 94–5, and Godé, *Der Sturm*, p. 114.

16 See Robert Jensen, *Marketing Modernism in Fin-de-Siècle Europe*, Princeton, 1994, p. 199. Jensen sees Walden's enterprise as a culmination of the growing fragmentation in the art market perpetuated by competition amongst dealers. The realities of the marketplace thus worked against unifying ideals of Expressionism.

17 Oskar Kokoschka, *My Life*, London, 1974, p. 21.

18 For Kokoschka's early work and his relationship with *Der Sturm*, see Werner Schweiger, *Der junge Kokoschka. Leben und Werk 1904–1914*, Vienna, 1983; Oskar Kokoschka, *Oskar Kokoschka: der Sturm: die Berliner Jahre 1910–1916*, Pochlarn, 1986; Frank Whitford, *Oskar Kokoschka: A Life*, London, 1986; and Oskar Kokoschka, *Briefe*, ed. Olga Kokoschka and Heinz Spielmann, 4 vols, Düsseldorf, 1985–88, and the selected version in English, *Oscar Kokoschka Letters*, London, 1992.

19 I discuss this in Shearer West, 'Portraiture in the 20th century: masks or identities?', in Christos M. Joachimides and Norman Rosenthal (eds), *The Age of Modernism: Art in the Twentieth Century*, exhibition catalogue, Berlin, 1997, pp. 65–71. See also Frank Whitford, *Expressionist Portraits*, London, 1987.

20 Kokoschka, *My Life*, p. 33.

21 Schwitters's Romanticism led him to be disparaged as the 'Caspar David Friedrich of the Dada Revolution'. For Schwitters's work, see especially John Elderfield, *Kurt Schwitters*, London, 1985; and Dorothea Dietrich, *The Collages of Kurt Schwitters: Tradition and Innovation*, Cambridge, 1993. Schwitters' literary works are contained in *Kurt Schwitters. Das literarische Werk*, ed. Friedhelm Lach, 5 vols, Cologne, 1973–81.

22 Godé, *Der Sturm*, p. 226. Wilhelm Worringer saw Expressionism as a unified style even in the 1920s, although apparently he was one of the few who did not recognise the movement's pluralism. See Charles W. Haxthausen, 'Modern art after "the end of Expressionism": Worringer in the 1920s', in Neil H. Donahue (ed.), *Invisible Cathedrals: The Expressionist Art History of Wilhelm Worringer*, University Park, 1995, pp. 119–34.

23 Kurt Schwitters, 'Manifest Proletkunst', in *Kurt Schwitters. Das literarische Werk*, vol. 5, p. 143, quoted in Elderfield, *Kurt Schwitters*, p. 42.

24 *Ibid.*, pp. 51–2.

25 For Kokoschka's comment on the commercialisation of the art world, see *My Life*, p. 24. Kokoschka did not refer directly to Walden, but his allusion is clear.

26 This unusual watercolour is discussed in Armin Zweite, *The Blue Rider in the Lenbachhaus, Munich*, Munich, 1989, p. 48.

27 The Brücke reference is in a letter from Schmidt-Rottluff to Nolde of 4 February 1906, quoted in Reinhold Heller, *Brücke: German Expressionist Prints from the Granvil and Marcia Specks Collection*, Evanston, 1988, p. 15. In Brücke, Heckel took on the role of

entrepreneur for the whole group. For the Blaue Reiter obsession with commercialism, see for instance, Kandinsky's letter to Münter of July 1911, quoted in Annegret Hoberg (ed.), *Wassily Kandinsky and Gabriele Münter: Letters and Reminiscences 1902–1914*, Munich, 1994, p. 120, and Kandinsky and Marc's exchange of letters at the time of the founding of the Blaue Reiter. See Vassily Kandinsky and Franz Marc, *Wassily Kandinsky, Franz Marc. Briefwechsel*, ed. Klaus Lankheit, Munich, 1983.

28 Jensen, *Marketing Modernism*, discusses the importance of the art market to myths of the avant-garde and modernist art. In his introduction to the book, he alludes to the ways in which the Jewish heritage of many dealers became the excuse for Hitler's later persecution of the entire avant-garde art world, but he does not develop this delicate theme in his otherwise exemplary discussion. See also Catherine M. Soussloff (ed.), *Jewish Identity in Modern Art History*, Berkeley, 1999.

29 'es gibt Zeitgenossen, die halten den Sturm für eine Hochstapler-G.m.b.H., durch die Europas arme und berümte Künstler ausgebeutet werden, andere wieder für eine Judenclique, durch die bewußt der Volksgeist vergiftet werden soll, wider andere für einen Ballklub mit künstlerischen Allüren': Lothar Schreyer, 'Zur Geschichte der Sturm', in Walden, *Einblick*, pp. 168–9 (quotation on p. 168).

30 Here I am focusing on the war's impact on artists, but Nicola Lambourne has offered a cogent corrective to the propensity of art historians to see the First World War solely in terms of the creative processes of the avant-garde. See her 'Production versus destruction: art, World War I and art history', *Art History*, 22:3 (1999), 347–63. For a more conventional view of art and war, see Richard Cork, *A Bitter Truth: Avant-Garde Art and the Great War*, New Haven and London, 1994.

31 See Franz Marc, *Briefe aus dem Felde*, Munich, 1966, and Max Beckmann, *Max Beckmann: Self-Portrait in Words*, ed. Barbara Copeland Buenger, Chicago, 1997.

32 'was sah ich nicht alles letzter Zeit. Sah Leute an Typhus und Lungenenzüdung sterben': Max Beckmann, *Briefe im Kriege 1914/15* (1916), Munich, 1984, pp. 26.

33 'Es ist mir ganz recht, daß Krieg ist, was ich bis jetzt gemacht habe, war alles noch Lehrjahre, ich lerne immer noch und erweitere mich': *ibid.*, p. 60.

34 'Ich habe eine solche Passion für die Malerei! Immer arbeite ich an der Form. Im Zeichnen und im Kopf und im Schlaf. Manchmal denke ich, ich muß verrückt werden, so ermüdet und quält mich diese schmerzliche Wollust. Alles versinkt, Zeit und Raum': *ibid.*, p. 58 (letter of 11 May 1915).

35 'Wundervoll ist mir immer das Zusammenkommen mit Menschen. Ich habe eine wahnsinnige Passion für diese Species': *ibid.*, p. 27 (letter of 16 March 1915).

36 See especially Stephanie Barron, *German Expressionist Sculpture*, Chicago, 1983; and Erich Ranfft, 'Widening contexts for German Expressionist sculpture before 1945', *Art History*, 16:1 (1993), 184–90.

37 See Karen Lang, 'Monumental unease: monuments and the making of national identity in Germany', in Françoise Forster-Hahn (ed.), *Imagining Modern German Culture 1889–1910*, Washington, DC, 1996, pp. 275–99.

38 For Lehmbruck, see August Hoff, *Wilhelm Lehmbruck: Life and Work*, London, 1969, and Dietrich Schubert, *Die Kunst Lehmbrucks*, Worms, 1981. For Barlach, see *Ernst Barlach*, exhibition catalogue, 3 vols, Berlin, 1981; and Kent W. Hooper, *Ernst Barlach's Literary and Visual Art: The Issue of Multiple Talent*, Ann Arbor, 1987.

39 Ernst Barlach, *Die Briefe 1888–1924*, Munich, 1968, vol. 1, quoted in Victor Miesel (ed.), *Voices of German Expressionism*, Englewood Cliffs, 1970, p. 95.

40 Ernst Barlach, 'Aus einem Taschenbuch 1906', in Elmar Jansen (ed.), *Prosa aus vier Jahrzehnten*, Berlin, 1963, quoted in Miesel, *Voices of German Expressionism*, p. 92.

41 Kollwitz's son Peter died fighting in the First World War, so her response to the idea of dying in battle had a poignant personal aspect. See Käthe Kollwitz, *Aus meinem Leben. Ein Testament des Herzens*, Freiburg, 1992; and *Briefe an den Sohn 1904 bis 1945*, Berlin, 1992. For Kollwitz, see, for example, *Käthe Kollwitz, Schmerz und Schuld*, exhibition catalogue, Berlin, 1995, and Nina Klein and H. Arthur Klein, *Käthe Kollwitz: Life in Art*, New York, 1972.

42 See *Seven Expressionist Plays: Kokoschka to Barlach*, 2nd edn, London, 1980.

43 Siegfried Kracauer's *From Caligari to Hitler: A Psychological History of the German Film*, Princeton, 1947, remains an important source on Expressionist film. Other studies include John Barlow, *German Expressionist Film*, Boston, 1982; Michael Hierholzer, *Zeitfragen im Spiegel der Künste: Beispiele aus Literatur, bildender Kunst und Film vom Kaiserreich bis zum vereinten Deutschland*, Bonn, 1996; Paul Coates, *The Gorgon's Gaze: German Cinema, Expressionism and the Image of Horror*, Cambridge, 1991; and J. Kasten, *Der expressionistische Film*, Münster, 1990.

44 For a discussion of the links between theatre and early film, see Lotte Eisner, *The Haunted Screen: Expressionism in the German Cinema and the Influence of Max Reinhardt*, London, 1965. See also Peter Jelavich, *Munich and Theatrical Modernism*, Cambridge, Mass., 1985; and David Kuhns, *German Expressionist Theatre: The Actor and the Stage*, Cambridge, 1997.

45 *Caligari* is a much discussed film. Apart from histories of Expressionist cinema, see S. S. Prawer, *Caligari's Children: The Film as Tale of Terror*, New York, 1980; Mike Budd (ed.), *The Cabinet of Dr Caligari: Texts, Contexts, Histories*, New Brunswick, 1990; Werner Sudendorf, 'Expressionism and film: the testament of Dr Caligari', in Behr, Fanning and Jarman, *Expressionism Reassessed*, pp. 91–100; and Carol Diethe, 'Beauty and the beast: an investigation of the role and function of women in German Expressionist film', in Marsha Meskimmon and Shearer West (eds), *Visions of the 'Neue Frau': Women and the Visual Arts in Weimar Germany*, Aldershot, 1995, pp. 108–23.

46 Kracauer, *From Caligari to Hitler*, p. 65.

47 For the way 'the fantastic both represents conflicts and disguises them', see Thomas Elsaesser, 'Social mobility and the fantastic German silent cinema', in James Donald (ed.), *Fantasy and the Cinema*, London, 1989, pp. 23–38 (quotation on p. 23).

48 Julius Posener, *Hans Poelzig: Reflections on His Life and Work*, New York, 1992.

49 See Ernst Prodolliet, *Nosferatu: Die Entwicklung des Vampirfilms von Friedrich Wilhelm Murnau bis Werner Herzog*, Olten, 1980.

50 Rudolf Kurtz, *Expressionismus und Film*, Berlin, 1926.

51 Franz Roh, *Nach-Expressionismus, magischer Realismus: Probleme der neuesten europäischen Malerei*, Leipzig, 1925, pp. 119–20. Crockett, *German Post-Expressionism*, p. 145, tracks Roh's tendency to see art in terms of stylistic comparisons to his teacher Heinrich Wölfflin, whose *Principles of Art History* (1915) established a comparative stylistic basis for visual art.

52 Max Beckmann, 'Gedanken über zeitgemäße und unzeitgemäße Kunst', *Pan*, 2 (1912), 499–502, translated as 'Thoughts on timely and untimely art', quoted in *Max Beckmann: Self-Portrait in Words*, p. 117.

53 Jörgen Schäfer, *Dada Köln: Max Ernst, Hans Arp, Johannes Theodor Baargeld und ihre literarischen Zeitschriften*, Wiesbaden, 1993.

54 Shulamith Behr, 'Anatomy of the woman as collector and dealer in the Weimar period: Rosa Schapire and Johanna Ey', in Meskimmon and West, *Visions of the 'Neue Frau'*, pp. 96–107; and Ulrich Krempel (ed.), *Am Anfang 'das junge Rheinland': zur Kunst und Zeitgeschichte einer Region 1918–1945*, Düsseldorf, 1985.

55 See Christine Poggi, *In Defiance of Painting: Cubism, Futurism and the Invention of Collage*, New Haven and London, 1992; and Dawn Ades, *Photomontage*, 2nd edn, London, 1986.

56 Werner Spies, *Max Ernst Collages: The Invention of the Surrealist Universe*, London, 1991.

57 See Ernst Bloch, *The Utopian Function of Art and Literature: Selected Essays*, Cambridge, Mass., 1988; and Georg Lucáks, '"Große und Verfall" des Expressionismus' (1934), in *Werke*, Neuwied and Berlin, 1971, vol. 4, pp. 109–49.

Community and personality: art on the left 5

There were no conflicts among us; we had all left our native lands, we all hated war, we all wanted to accomplish something in the arts. I really felt that dada grew out of friendship, congenial love and congenial hate. (Richard Huelsenbeck, *Memoirs of a Dada Drummer*)[1]

Unlike those artists' associations which are only based on various styles and the slogan *l'art pour l'art*, the ARBKD intends to promote the class struggle and will correspond in style and content to the needs of the workers. (Statutes of the Association of Revolutionary Artists, 1928)[2]

I long for the kind of socialism that lets people *live*. (Käthe Kollwitz, *Diaries*, 1920)[3]

THE Bloch/Lucáks debate, like the rivalry between *Der Sturm* and *Die Aktion*, arose in part because of a growing acknowledgement that art could or should have a political purpose. While the *Sturm* circle became increasingly involved in escapist aesthetics as the more brutal aspects of the war impinged, *Die Aktion* took a different route and became increasingly tendentious.[4] Although Expressionism remained a powerful force in the art world, by the end of the First World War in 1918, even artists who might once have been sympathetic to Expressionism's aims could refer snidely to '*Der Waldenismus*'.[5] Walden's view of art as a sort of game ('*Spielerei*') was rejected in favour of a more serious conception of art as a 'duty' ('*Pflicht*').[6] The events in Germany immediately after the war fuelled this change of emphasis and shifted the focus of avant-garde artists from a purely aesthetic to an actively political sphere.[7]

However, certain aspects of Walden's empire proved remarkably tenacious. His attempt to encompass all the arts within a *Sturm* aesthetic proved a particularly beneficial model for both Dada and the more political wing of post-war Expressionism. The interlinking of the arts, as well as the many ways in which ideas could be disseminated – through performances, exhibitions and journals – became important mechanisms for leftist artists during this period. The club ethos that permeated the *Sturm* circle was transformed from a convenient commercial interchange to an important mode of creation for the avant-garde. As Kandinsky put it as early as 1910, 'a club is a spiritual force',[8] and in the hands of post-war Expressionist and Dada artists, this community ideal was balanced against a sometimes contradictory focus on the individual artistic personality.

Although many artists before the First World War had had political inclinations, their politics were often vaguely expressed and frequently non-partisan. The war and its aftermath changed the relationship between politics and art: no matter how staunchly apolitical before the war, artists found it difficult to avoid some kind of political affiliation after the war was over. The crucial turning point came in 1918, when the November Revolution altered the political landscape of post-war Germany. The revolution, and the subsequent uncertainty, created a situation in which artists felt that they could genuinely contribute to an altered society. The pre-war spiritual values of Expressionism seemed at first to be the answer to the new society that revolution had created, but even while idealistic artists extolled the values of art for the people, another, more disillusioned, group of Dada artists renounced all fine art as a bourgeois invention. Many Expressionists and Dada artists found that they were most sympathetic to the various left-wing political ideologies that grew from the revolution, although there were a variety of attitudes adopted by leftist sympathisers. Artists began to question the role of the masses and sought to create an art that was most appropriate for the urban proletariat. What began as an artistic issue quickly evolved into a political one. Art came to be seen to be in the service of various political ideologies, and by the end of the 1920s, left-wing art was associated with communist propaganda.[9]

The shift from artistic to political values was primarily a matter of terminology and emphasis, as these values were interwoven from the very beginning of the revolutionary period. The German revolution followed the more famous Russian revolution by less than a year. As Germany began to suffer from its losses of the First World War, a series of incendiary actions served to bring down the old monarchy. The turning point was a naval mutiny in Kiel of 1918. This sparked off riots throughout Germany which led to street fighting in early November, and the abdication of Kaiser Wilhelm II on 9 November. At that time, Germany was proclaimed a republic, but this rather frantic proclamation did not specify what form the new republic would take. For the next six months, various factions fought, lobbied and argued about the most appropriate direction for post-war Germany. In this heated and often bloody controversy, left-wing sympathisers gained much ground. However, even these groups did not agree. The pre-war Socialist party (SPD) wanted a parliamentary democracy, while a new splinter party, the USPD (Independent Socialists) wanted a more accountable government. By late December, a radical fringe of the USPD, the so-called Spartacists, formed the first German communist party (KPD). The KPD favoured a form of government known as a *Räterepublik* (council republic), in which councils of proletarian interest groups would hold the balance of power within the government. By December, a number of these workers' and soldiers' councils had been formed, and it was the council system that first drew artists into the revolutionary fray.[10]

The avant-garde artists who had survived the First World War, or who had managed to avoid the bloody conflict, shared a number of essential complaints about the art world as it existed. They particularly disliked the hegemony of the academy and the bourgeois dominance and commercialisation of the art market. It is important to recognise that these shared goals are not, in themselves, political, but because of the political interventionism of the previous

monarchical government, artists hoped to wrest themselves free of the old order. In this respect, they were aesthetic revolutionaries, and it is perhaps to be expected that they should have supported the political revolution, however briefly in some cases. These few shared goals did not disguise the disagreements between individual artists and new artistic organisations. Two of the most prominent of these post-revolutionary groups, the Arbeitsrat für Kunst (Workers' Council for Art) and the Novembergruppe were diametrically opposed in both political and aesthetic tendencies. These two Berlin societies symbolised the confusion that followed after the fall of the Kaiser.[11]

The Arbeitsrat für Kunst was founded in December 1918. The Expressionist emphasis was clear from its original programme, which stressed the spiritual importance of art to the new German society. The Arbeitsrat was meant to be a liberating organisation, just as the revolution had intended to liberate German society. Its purpose was to 'free art from the guardianship under which it has existed for decades' by contributing to the dissolution of moribund art academies, reforming art education systems and enhancing the pedagogic function of museums.[12] However, the controlling spirits of the Arbeitsrat were not the Expressionist painters, but the architects, including Walter Gropius (who became president of the organisation), Hans Poelzig and especially Bruno Taut.[13] The stress on architecture was clear from the initial programme. The first of the Council's six demands was the 'recognition of the public nature of all building activity', which would include a more rigorous programme of town planning as well as a stipulation for *Volkshäuser*, or arts centres for the general population, and 'permanent experimental sites, for assessing and improving architectural effects'. The utopian programme also stipulated 'the removal of all artistically worthless monuments and the demolition of all buildings whose artistic value is disproportionate to the value of their raw materials', thus allowing the new breed of architects to recreate the world afresh by removing what they saw as the eyesores of the past.[14]

The programme of the Arbeitsrat was well intentioned but virtually unworkable in the chaotic post-war climate. However, before disillusion set in, members felt that they could make a genuine contribution to a new type of society through the propagation of architectural ideals. By Christmas 1918 Taut had produced the first of the group's pamphlets, an 'Architecture Programme' which insisted on the significance of architecture to a spiritually enlightened life. Architecture became a sort of synonym for the positive revolutionary spirit and, over the next two years, Taut promoted his notion of an ideal architecture that would maintain the messianic enthusiasm of the revolution and contribute to a better quality of life. Even before the war, Taut had presented his first glass house at the 1914 Werkbund exhibition in Cologne. The house was shaped like a beehive and had no obvious function. What began as an experiment in new materials evolved into a complete theory of art, which Taut first articulated in his 1919 book, *Alpine Architecture*.[15]

Alpine Architecture was an odd, ecstatic document of Taut's belief in the symbolic importance of buildings. The book included drawings of vast, symbolic crystal towers perched on top of the Alps and joined together by bridges. These buildings were not houses or hospitals or schools or art galleries. They were not intended to have any practical purpose, but they were to contribute

to the beauty of life and thereby act as a balm for a beleaguered population. Taut expanded his theories in his futuristic book, *The Dissolution of Cities: The Path Towards Alpine Architecture*, published the following year.[16] In this work he predicted the collapse of skyscrapers and the destruction of ugly modern urban spaces. In their place would be erected a series of star-shaped, communal garden cities in which people would live happily without ownership of property and without marriage, but in a bond of socialistic brotherhood. His belief in all forms of freedom including sexual freedom was realised through symbolic shapes such as the 'phallus and rosette', one of many building forms in his new garden city. In the centre of each garden city would be 'the city crown', a functionless, but beautiful building, that would symbolise the spiritual ecstasy of a new religion of socialism.

Taut's utopian socialism underlay his formation of another post-revolutionary artistic grouping, the Politischer Rat geistigen Arbeiter (the Political Council of Spiritual Workers) in 1918. This short-lived experimental group was dedicated to changing the whole political structure of Germany by reorganising parliament to allow a large contingent of artistic representatives. Taut's unrealisable programme postulated that the politicians should comprise only the 'lower house' of the new legislature, while the 'council of the spirit' should control the upper house. While the lower house was elected, the upper house was to consist only of those who had the 'right' to be there. The artist, or, more specifically, the architect, would be the spiritual leader of the new Germany.

Taut's ideas were an odd mixture of Expressionist ecstasy and political ideology, ruralist utopianism and modernist architectural principles. Although he avoided discussion of functionalism in favour of the religious or spiritual purpose of buildings, his own futuristic ideals depended upon the inventions of the modern world, such as the aeroplane, which he saw as the primary form of transportation in his crystal cities. This mingling of futurism and nostalgia, spiritualism and ill-defined socialism was a strong undercurrent in the agenda of the Arbeitsrat, and Taut's ideals were linked with the work of the Arbeitsrat through the Exhibition for Unknown Architects, which opened in Berlin at I. B. Neumann's Gallery in March 1919. This exhibition was intended to break down artistic hierarchies by including works of architects who did not have public practices, and many of the abstract drawings shown here represented buildings which, like Taut's, had no obvious function. The exhibition promoted the Arbeitsrat's demand that architects be allowed to build 'experimental' structures, but in the end none of the exhibited designs was realised.

Certainly very few such utopian designs ever came to fruition. One of the rare examples is Hans Poelzig's conversion of the Grosses Schauspielhaus in Berlin. The vast interior space of this theatre appears like a cave hung with stalactites, but what must have been an impressive effect was little more than that. The crystalline structures favoured by Taut here appear to be little more than a cosmetic addition, and the fact that this Expressionist building was a theatre emphasises the fantasy aspects of such architecture. The Arbeitsrat produced exhibitions and publications, but the failure of its ideals coincided with the collapse of revolutionary enthusiasm. On 30 May 1921, the society voted to dissolve itself.

Although Expressionist fervour proved to be an inappropriate direction for the Arbeitsrat, the architects in the group went on to contribute to a massive building boom in Germany during the 1920s. Taut, whose impractical ideas about crystal cities may have appeared to disqualify him from tackling the dull realities of daily life, was appointed chief designer for the Berlin building society, Gehag, in 1923. Gehag was one of many building societies that emerged during the 1920s, each of which was founded to address the critical housing shortage that was particularly apparent in urban working-class districts. Although the early 1920s was blighted by rampant inflation, a stabilisation of the currency after 1924 led to greater investment in housing. A new rate of 15 per cent on previously built houses was collected by the government and invested through building societies in new housing developments.[17]

Taut's contribution to Gehag was a symptom of the way in which his revolutionary passion had been tempered. One of the directors of Gehag was Martin Wagner, a member of the SPD, whose politics were conciliatory and compromising, rather than radical and revolutionary. But Wagner and other building society directors supervised the erection of over 14,000 new buildings in Berlin between 1924 and 1933, many of which were working-class apartment blocks and houses. A similar experiment was being conducted in Frankfurt, where the architect Ernst May directed the design of over 15,000 new buildings. The new buildings in Berlin and Frankfurt were not 'crystal cities', but some of the ideals of Taut were put into practice in these urban centres. The new workers' housing was centrally heated and included communal laundry and recreation facilities as well as, in some instances, access to parks or gardens, following the principles of the turn-of-the-century garden city. What began as a socialist ideal became a social reality.

The Arbeitsrat was not the only organisation to explore the political possibilities of Expressionist aesthetics. Its rival, the Novembergruppe, was also founded after the November Revolution in 1918.[18] The aims of the Novembergruppe resembled those of the Arbeitsrat in only a superficial way. Both organisations included Expressionists who argued for the regenerative potential of art. Both groups advocated a socialism based on a vague 'brotherhood of man'. Both groups supported the revolution, and desired revolutionary changes in the structure of the art world. However, the programme of the Novembergruppe was more decisively aesthetic than that of the Arbeitsrat. In their first public statement of December 1918, the Novembergruppe addressed itself to 'revolutionaries of the spirit (Expressionists, Cubists, Futurists)'.[19] This classification indicated that the artists of the group felt that their work was distinct from that of politicians and revolutionaries. They were artists, not ministers, and their goal was to revise outdated aesthetic formulas, rather than to change the world.

While some members of the Arbeitsrat joined the KPD and became solid supporters of the Communist party, the dominant membership of the Novembergruppe supported the majority Socialist (SPD) government. This included the group's president, Max Pechstein. Pechstein was a former member of Brücke who had been expelled from that association in 1912 when he refused to remove his works from the Neue Sezession exhibition. Pechstein was certainly an establishment figure, and his muted form of Expressionism offered

no threat to the old art establishment and no real challenge to the new avant-garde. Expressionism appeared to be the dominant aesthetic mode of the group, which included such artists as Heckel and Schmidt-Rottluff. Their first publication *An alle Künstler!* (To all artists!) included an Expressionist frontispiece by Pechstein.

The political association of the Novembergruppe was more complicated than this stereotype suggests, however, and the very cover of *An alle Künstler* highlights this ambiguity. In some respects, the cover and the title of the pamphlet are statements of revolutionary support. A shouting figure, his body consumed in flames, races away from the smoking chimneys of a big city. This man is the spirit of revolution, and the title 'To all artists' is a direct allusion to Lenin's rallying cry to the workers 'To all!'. The pamphlet also included essays reprinted from speeches by the Bavarian Independent Socialist minister, Kurt Eisner, and the Prussian culture minister Konrad Hänisch, indicating that the Novembergruppe sought a direct relationship with government forces who could contribute to radical changes in art practice. The most notable symptom of the group's apparent political affiliation was a debate in the Prussian provincial parliament of December 1919, in which the right-wing nationalist parties attacked Expressionism as a symptom of cultural degeneration and one that was associated with the worst excesses of the revolution. The Novembergruppe's advocacy of Expressionism thus placed it in the political firing line, despite the group's own commitment to spiritual and aesthetic values, rather than political reformism.

These factors do not indicate that the Novembergruppe was a politically subversive organisation, but that the Expressionism its members practised had come to be associated with political radicalism. In fact, the group avoided such associations, and extolled individualism above the needs and ideals of the masses. The cover of *An alle Künstler*, with its single, enflamed revolutionary figure, is as much a paean to individualism as an incitement to revolution. The text of *An alle Künstler* is littered with allusions to Nietzsche and world catastrophe, and a pseudo-religious language – replete with references to Bethlehem and the Holy Ghost – configures politics through Christian metaphor.[20] Despite the grandiosity of its stated ideals, the Novembergruppe was primarily an exhibition society, and in 1920 some of its more radical members resigned in fury when paintings by Otto Dix and Rudolf Schlichter were removed from one of its exhibitions. In an 'Open Letter to the Novembergruppe', signed by Raoul Hausmann, Hannah Höch, George Grosz, Dix and Schlichter, these artists accused the organisation of pandering to bourgeois tastes by pursuing pure artistic values, rather than political radicalism.[21] In this criticism, they were to an extent mirroring contemporary Russian debates about the status of easel painting and the need for a proletarian art. But these dissident artists recognised that the revolutionary sentiments of the Novembergruppe were only superficial, while they threw themselves more directly into politics through their involvement with the KPD and Dada.

Despite the complexities, contradictions and shades of political difference between the Arbeitsrat and the Novembergruppe, they both drew strength from a post-revolutionary idea of group solidarity and commitment. In many ways, the adoption of Expressionist aesthetics was a convenient way of representing

this community ideal, just as Brücke artists had echoed each other's primitivist woodcut techniques in their graphics portfolios. Like Brücke, too, both the Arbeitsrat and the Novembergruppe explicitly drew upon Tönnies' notion of a *Gemeinschaft* – a small community based on shared values – rather than the more disparate *Gesellschaft* (see chapter 2).[22] Here, as well, their formation and common aims recalled Expressionist values perpetuated by wartime journals.

This emphasis on community was frequently addressed in Expressionist criticism which considered the extent to which art was the reflection of an individual temperament or of a more universal set of ideas. Walden, and many of his adherents, associated artistic temperament and cults of personality with the aims of Impressionism – 'a piece of nature seen through a temperament'.[23] As Heiner Schilling, a post-war Expressionist in Dresden, put it: 'It is therefore fundamentally wrong to say that the Expressionist slices out his object with his temperament ... "with temperament" already suggests a subjectivity that excludes the pure being of the object.'[24] Temperament, then, represented connotations of literalness, subjectivity and perhaps even triviality that many Expressionists considered anathema to their more universal views of art. Nevertheless, Expressionist critics had to reconcile this rejection of temperament or personality with their wholesale admiration for Nietzsche – whose work preached the need for a cultural *Übermensch* to sweep away the detritus of bourgeois order.[25] A partial reconciliation of these opposing views appeared in the clever philosophical writings of Carl Einstein, who saw an affinity, rather than a rupture, between the individual and the world.[26] Einstein published some of his writing in *Die Aktion*, and these ideas were stated more strongly in that journal than in *Der Sturm*. For example, an article of March 1917 again used the contrast between Impressionism and Expressionism to indicate the more elevated vision of the Germans, but here the individual is reconciled with the cosmic vision: 'In Impressionism the World and I, Inner and Outer, form a harmonious alliance. In Expressionism the I is inundated by the World.'[27] This idea represented a significant change from the point of view expressed by Arthur Drey in a pre-war edition of *Die Aktion*. Writing about the Neue Sezession exhibition in Berlin before Expressionism had evolved as a label for German modernism, he insisted that 'Art is the expression of a personality'.[28] This change of emphasis is significant. During the war, *Die Aktion* became increasingly political. In the pacifist and left-wing ideology of *Aktion* writers, a reconciliation of the individual with society was necessary. Although individual freedom of expression was essential, the individual artist should not just create for himself or herself, or even for the nation, but for the world, the society, the *Volk*.[29] Walden had given this idea an implicitly nationalist inflection, when he wrote of art as 'belonging to the whole people [*Volk*]', but by 1918, *Die Aktion* had politicised this *Volk* into the proletariat.[30]

Building on this theoretical legacy, politicised artists' organisations like the Arbeitsrat and Novembergruppe were thus communal in two ways – in their own sense of shared values, and in their desire to create systems and aesthetics that would speak to the masses. The *Gemeinschaft* mentality was particularly prevalent, as many of these 'brotherhoods' of artists were regionally based and worked with local adherents, rather than on a national or

international level. In Dresden, for instance, a series of Expressionist evenings ('Abende'), modelled on Walden's Sturm soirées, became by October 1917 an 'Expressionistischen Arbeitsgemeinschaft' ('Expressionist work community').[31] When this group did not provide enough radical alternatives, some artists broke away from it and formed the 'Secession Group 1919'. The statutes of the Dresden Secession had specified its goals as 'Truth-Brotherhood-Art', and although the second group may have been more politically radical than the first, the Gemeinschaft ideals were maintained.[32] The leader of this new group was Conrad Felixmüller, who was a committed communist with a true pro-letarian heritage.[33] Like many members of the Novembergruppe, Felixmüller was sympathetic to Expressionism, as he felt this was the most appropriate manifestation of revolutionary utopianism. Felixmüller's passionate political commitment was countered by his establishment success. The contradictions in his life and art are highlighted by his marriage to an impoverished aristo-crat, and by his winning of the Saxony State Rome Prize in 1920. The prize, intended to fund a conventional Grand Tour to Italy, was used subversively by Felixmüller to support a sketching trip to the mining community in the Ruhr valley. He later renounced politicised Expressionism in favour of the more subdued colours and realist mode of the Neue Sachlichkeit (see chapter 7). Like Dresden, Kiel also had an Expressionist 'Gemeinschaft', and other centres, such as Munich and Düsseldorf, possessed similar post-revolutionary groupings.[34]

The Gemeinschaft sensibilities of these regional Expressionist organisa-tions were sustained temporarily because of the events immediately following the November Revolution. The declaration of a republic in November 1918 left Germany with a vacuum which various political factions sought to fill. In December 1918 a Reich Congress of Councils met to decide whether or not Germany should be governed by parliament or workers' councils, and this question unleashed furious factionalism and debate between right-wing tradi-tionalists, communists and the SPD, the latter of which sought a compromise between the two extremes. Ultimately, the compromise proved the successful alternative, and a National Assembly in Weimar of July 1919 established the Weimar Republic on constitutional lines. In some ways the Weimar constitu-tion was a model of reason and fairness, and included clauses which respected equal rights of individuals regardless of class or gender. However, what appeared an excellent solution on paper was ineffective, or even dangerous, in practice, as from the time of the revolution until the early 1920s, Germany was racked by discontent, anguish and bloodshed.

The year 1919 began with a general strike in Berlin and the Spartacist uprising, when communist factions attempted to gain control of the govern-ment. The government made emergency compromises with a mercenary army, the Freikorps, to quell the upheaval, but the Freikorps, under the guidance of the SPD minister Gustav Noske, took the opportunity to exact violent revenge on the revolutionaries. The bloodshed, intimidation and murder that followed was technically sanctioned by the government, and it served to dampen the leftist enthusiasm that had followed the November Revolution. Political coups led to Räterepubliks in Hungary and Bavaria, but these were rapidly quelled by the Freikorps. Political assassinations included the murder of the Dresden

war minister and the Bavarian Prime Minister Kurt Eisner. The alliance between the Socialist government and the newly formed Freikorps has been seen to be one of the reasons for the failure of revolutionary ideals. The artists suffered too from these events, and Expressionist groups were particularly singled out and attacked for their support of the revolution.

Artistic sympathies were marshalled by one of the most brutal events of the counter-revolutionary period, the murder of the communists Karl Liebknecht and Rosa Luxemburg on 15 January 1919. These two individuals had quickly become figureheads of the communist party and, by extension, they were associated with the Spartacist uprising. Their ability to stimulate revolutionary spirit and rouse Berliners against a compromise parliamentary government provoked fear in the socialist government and anger in the right-wing Freikorps. When the Freikorps rampaged through the streets of Berlin, silencing the communist opposition, they took the opportunity to murder Luxemburg and Liebknecht in the most brutal way possible. Luxemburg was beaten, shot and thrown into the Landwehr canal. No one was seriously punished for this assassination.

Their violent deaths led Liebknecht and Luxemburg to be canonised by the besieged leftist factions, and several artists produced memorials to them. Walter Gropius designed a monument in their memory, while Käthe Kollwitz and George Grosz both published prints representing their sacrifice (figure 30). The difference between Kollwitz's and Grosz's memorials is indicative of the variety of ways in which individuals responded to the event. Kollwitz's woodcut is very much in a elegiac mode: the dead Liebknecht becomes like a funeral effigy, surrounded by proletarian mourners. The caption 'From the living to the dead' suggests the commemorative nature of the print. Although

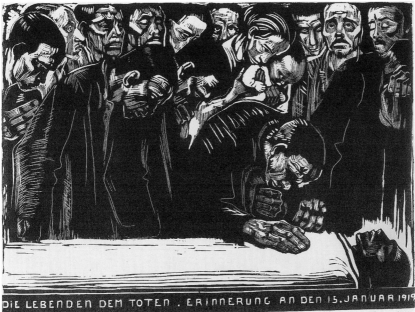

30 Käthe Kollwitz, *Memorial to Karl Liebknecht*, woodcut, 1919–20

Kollwitz was deeply ambivalent about her own political commitment (see below), she was horrified by the murder of the two communists and offered her work as a regretful memorial to all victims of violent conflict. Grosz's work, by contrast, is a bitter satire, which shows the two heroes dominated by the faceless figure of the church – one of the institutions despised by Grosz. Grosz's angry reaction to the deaths was indicative of his own post-revolutionary political commitment, and it also underlay the politically tendentious work of his fellow Dada artists.

This moment of artistic conjunction was brief, just as the *Gemeinschaft* ideology of the artistic workers' groups could not be sustained under an Expressionist banner. A more powerful and lasting force came through the nihilistic and revolutionary attitude of Dada in Berlin. With Dada, the political spirit remained, but communal ideals were transformed into the sometimes baffling behaviour of a predominantly male subculture and a renewed cult of the individual personality. The Berlin branch of Dada, normally construed as the 'political' wing, was actually, like all post-war groups, an eclectic band of individuals with variant views. The origin of Berlin Dada was in the anarchist behaviour of a group of writers and artists who congregated in neutral Zurich during the war. Among these, the writers Hugo Ball, Richard Huelsenbeck and Tristan Tzara, poet and performer Emmy Hennings, and the artist Hans Arp met and performed at the Cabaret Voltaire, created by Ball and Hennings as a site of alternative theatre.[35] While in Zurich, these writers and artists – many of them pacifists – expressed their disgust with the war and with the state of modern society through a series of performances, which included simultaneous poetry readings, insulting the audience, belches, moos, cacophonous music and other spontaneous outpourings of discontent. The group declared the death of art and the pointlessness of existence; the very name 'Dada' was intended to be an international nonsense word.

However, even from this early stage, Dada demonstrated some affinity with Expressionism. Ball's admiration for Kandinsky led to a strong spiritual emphasis in the group's early writing and performances, and Nietzsche's ideas of personal freedom and the impoverishment of the bourgeoisie underpinned much of their protests.[36] They also used a mixture of art forms, modes of performance and exhibition to disseminate their ideals. To an extent, Dada was also a club, but this was less prominent in their rebellious ideals than a sense of the importance of the individual. Huelsenbeck stressed this strongly in his later memoirs: 'Dada … was a revolt of the personality that was threatened on so many sides.'[37] To the Zurich Dada artists, the individual had been suppressed by the authoritarianism of modern social and political systems. Conformity was rampant and it suffocated the personality of the creative artists.[38] Although united and friendly, the group prided itself on the individuality of its members and their capacity for disagreement.[39] Ball turned this belief in the personality into a peculiarly German problem, one that he saw as originating in the Protestant Reformation of the sixteenth century. To Ball, Martin Luther's success had ensured that the authority of Church and state were synonymous and unassailable, and this authoritarianism had suppressed the individual.[40] The rebellion against this suppression of the individual formed the cornerstone of Dada theory during the Zurich period,

and it explains their predilection for extremes such as offensive or nonsense performance, sexual libertarianism and the virtues of insanity.[41]

It is therefore useful to trace the way in which the nihilist and rebellious strands of Dada were appropriated for politically tendentious purposes once members of the group moved to Berlin. The most significant of the Zurich artists to make this move was Huelsenbeck, who went to Berlin in January 1917 and became part of a new Dada circle comprising Grosz, Johannes Baader, Wieland and Helmut Herzfelde, Raoul Hausmann, Hannah Höch, Franz Jung and Erwin Piscator. Helmut Herzfelde later Americanised his name to John Heartfield as an anti-German protest. This group met in the Café des Westens and exchanged ideas and shared attitudes about contemporary social and political corruption. In later life, Huelsenbeck denied any commitment to communism, and his coy stance was echoed by Grosz, who dismissed the uniqueness of Dada: 'In those days we were all "Dadaists". If that word meant anything at all, it meant seething discontent, dissatisfaction and cynicism.'[42] It is important, however, to remember, that when Huelsenbeck made his first Dada speech early in 1918, the post-revolutionary climate was at its most heated. What is more, Grosz and the Herzfelde brothers brought a different perspective to Dada from their own wartime protests.

The potent collection of individuals who comprised Berlin Dada devoted themselves to a series of actions designed to gain public recognition. Although at times clearly political in spirit, the performances, publications and art works produced by Dada artists in Berlin were more nihilistic than tendentious.[43] First of all, many of their activities were performative, and involved role playing, improvisation and other activities which required an audience.[44] The male members of the group gave themselves special names. Raoul Hausmann was the Dadasoph; Grosz the Dadamarshal or Propagandada; Heartfield was Dadamonteur and Baader was Oberdada. They began infiltrating public spaces by placing stickers with subversive captions all over Berlin. They dressed in parodies of military uniform and wore monocles as an ironic echo of ruling class pretensions. They published notices in the newspaper, claiming that Dada was going to take over the world. Baader was the most extreme member of the group, and his activities ranged from declaring himself 'President of the Globe' to interrupting a church service with a proclamation that God was dead. These seemingly spontaneous anarchic activities certainly gained attention for the group, but they very soon began to organise their activities. The formation of a 'Club Dada' in 1918 crystallised their purpose, and they held a series of 'soirées' which superficially resembled the performances of the Cabaret Voltaire, acting as ironic foils to Walden's *Sturm* evenings. They charged admission to these performances, and spent much time insulting the audience. Police often had to be in attendance, as fighting frequently broke out. Their use of the word 'club' suggested a closed male community, and despite important women such as Hennings, Höch, Sophie Täuber and Lasker-Schüler, who were, or had been, on the fringes of the group, the maleness of Dada was apparent from the beginning.[45]

Their public performances were complemented by their second major activity: the publication of a series of short-lived incendiary journals. The use of journals to express anti-war feeling began when Wieland Herzfelde took

charge of an art journal, *Neue Jugend* (*New Youth*), and founded a publishing company, Malik Verlag. As wartime censorship inhibited pacifist sentiment, and new journals were carefully monitored, Herzfelde used the old journal as a cover for spreading anti-war propaganda. Grosz became involved with this enterprise, and began publishing satirical graphics in *Neue Jugend*.[46] The Berlin Dada group carried on their publications with Malik. The first, and most sensational of these was *Jedermann sein eigner Fussball* (*Every Man his own Football*) (figure 31), the one issue of which was sold out, then immediately banned by the authorities. This virulent four-page satire on the counter-revolution included contributions by Grosz and Heartfield. It was one of the earliest journalistic uses of the technique of photomontage, which was to become a trademark of the Berlin Dada artists. Photomontage involved cutting and pasting photographs in such a way that juxtapositions of images could produce trenchant or ironic comment. It was a particularly useful art form for satire, and its ambiguities were appropriate in an age of censorship when subversive messages could be delivered obliquely, rather than directly. *Every Man his own Football* utilised this technique most effectively. The very title of the book was intended to indicate that people should not allow others to 'kick them around', but that they should be in charge of their own destiny. However, this sentiment was accompanied by a ludicrous image of a man with a top hat and cane whose body has been transformed into a football. The humour of the image lies in its absurdity.

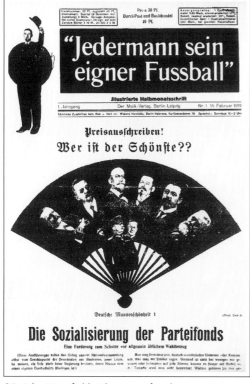

31 John Heartfield, title page of *Jedermann sein eigner Fußball*, 1919

Absurdity dominates the text and images in the remainder of the magazine, but underlying the humour are very serious points about the current political crisis. The cover includes a fan spread out to reveal the faces of government dignitaries, including the Chancellor (later President) Friedrich Ebert, Noske and the army general Erich Ludendorff. The caption above the fan 'Who is the most beautiful??' ('Wie ist der Schönste??') sets up a beauty contest, while the caption below 'German male beauty' ('Deutsche Mannesschönheit') undermines these government figures and military men. The deliberate association of militaristic 'pillars of society' with a feminine beauty contest was intended to be the worst possible slur on the dignity of resolutely masculine officials. But the absurdity of the magazine only thinly disguised a political message. Each of the images and articles in *Every Man his own Football* is an attack on the suppression of revolution – the so-called 'White Terror' which resulted when Noske unleashed Freikorps troops to quell the Spartacist uprising. This pointed political

attack is indicative of the way in which the nihilist Dada group was becoming more firmly committed to a political party. Much of their subsequent activity included some form of support for communist ideology.

Communist ideas appeared, for example, in the sequels to *Every Man his own Football*, *Die Pleite* (*Bankruptcy*) and *Der blutige Ernst* (*Bloody Serious*). Each time a journal was censored, Malik changed the name and produced a different one. *Die Pleite* was a similar bitter assault on Weimar political corruption, but it also contained an advertisement inviting readers to attend the first Congress of the Communist International. This was a sign of the political orientation of its contributors. Certainly party politics had not been in the mind of Huelsenbeck, when he made his first Dada speech in Berlin in 1918. His speech in fact was very much directed towards failures in the art world and, in his Dada manifesto, he stressed this with a direct allusion to Expressionism: 'Have Expressionists fulfilled our expectations for . . . an art which is a public vote on our most vital concerns? NO! NO! NO!'[47] What began as an anti-art movement and a destructive dismantling of contemporary convention, soon became, in Berlin at least, a vehicle for communist propaganda.

The political orientation of the Berlin Dada artists also came to the fore in the climax of the Berlin Dada movement, the First International Dada Fair of July and August 1920 (figure 32). This large and controversial exhibition included works by Dix, Grosz, Schlichter, Baader and Höch, but each of the works shown was some form of attack on the 'pillars' of Weimar Society. The most effective of these attacks was a pig-like creature dressed in a military uniform which was attached to the ceiling and given the title 'Prussian Archangel'. This unequivocal slur on the military led the participating artists to be prosecuted for offending the Germany army, although they were let off the charge lightly. The opposition to militarism and to the corruption of post-war society was not the only signal of the political sympathies shared by the Dada artists. Included in the exhibition was a placard which read 'Art is Dead, Long Live the New Machine Art of Tatlin'. By declaring art as dead, the artists of the group were aligning themselves with the anti-art tendencies of the wartime Dada movement. But their allusion to Tatlin indicates that they rejected only the bourgeois forms of art favoured by the old regime. Vladimir Tatlin was a Russian artist whose commitment to the communist party led him to contribute to the formation of Constructivism, a new form of art which was seen to be an appropriately utilitarian for the proletariat. Constructivism favoured abstraction and the creative use of materials such as glass and iron. Its successor, Productivism, was an even more technologically-oriented cultural tendency, which favoured only useful art and rejected illusionism and easel painting as toys of the bourgeoisie. By referring directly to Tatlin, the Berlin Dada artists were reinforcing their communist credentials, but although their own art also embraced the new 'machine age', it was always more representational than anything produced by Tatlin or the Russian Constructivists.[48]

The Dada Fair brought to the fore a final activity of the group, and the one that represented its most lasting contribution to German visual culture, that is the production of individual paintings, prints and especially photomontage. Through these works, various members of the Dada group both

reinforced communist ideology and revealed its limitations. Grosz's paintings were explicit demonstrations of Dada anti-authoritarianism.[49] As with many of his contemporaries, Grosz's disgust with the German political system began with the First World War. Although apolitical and suspicious of the masses before the war, Grosz threw himself behind the communist revolutionaries when the war was over. But he was not a utopian. He later wrote of the war that 'the promise of great adventure had made way for filth, lice, monotony, disease and deformity', and his characterisation of the Weimar Republic equally stressed its repulsive aspects: 'All moral restraints seemed to have melted away ... The streets were wild ravines haunted by murderers and cocaine peddlers, war cripples, real or sham, hung around every street corner.'[50] Grosz's pessimism was of a different order to that of Beckmann. While Beckmann's metaphysical view of the world saw the German condition as a human condition, Grosz pointed a finger at specific offences in the German political and social system. He rejected the conventional artistic training he had received at the Dresden Academy and the Berlin Kunstgewerbeschule, and produced paintings which combined the techniques of Cubism, Futurism and the metaphysical art of Giorgio de Chirico, with violent and satirical subject matter.

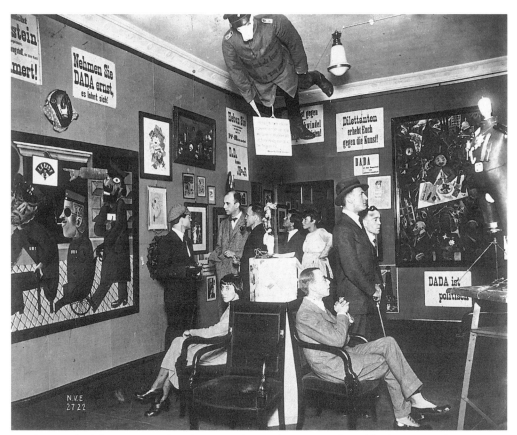

32 Photograph of the International Dada Fair, Berlin, 5 July 1920, Berlin, Bildarchiv Preussischer Kulturbesitz. From left to right: Raoul Hausmann, Otto Burchard, Baader, Wieland and Margarete Herzfelde, George Grosz, John Heartfield. Sitting: Hannah Höch, Otto Schmalenhauser

Grosz viciously attacked representatives of the church, the government and the education system – which he held responsible for the dreadful conditions of modern Germany. His *Pillars of Society* (1926, Berlin, Staatliche Museen Preußischer Kulturbesitz, Nationalgalerie) includes a monocled student swilling a glass of beer, an ineffectual politician wearing a chamber pot and holding an olive branch, an academic whose head is full of burning rubbish, an inebriated priest opening his arms to a gullible population, and a soldier with a sword. Grosz's hatred of established institutions was thus individualised, while he represented the victims of this society as anonymous, faceless and emasculated. Grosz's disgust with the Germans, whom he depicted as fat and stupid, led him to obsessive pro-Americanism and an official change of his name from Georg to George.

But Grosz made a more effective contribution to both the political and anti-authoritarian aspects of Dada through his prints and series which employed both satire and caricature as a clearly legible and effective means of attack.[51] Many of these works were produced for Malik. By the early 1920s, Grosz was publishing his own collections, which combined caricature with bitterly satirical captions. The most famous of these were *The Face of the Ruling Class* (1921) and *Ecce Homo* (1922–23), both of which were published by Malik. Grosz's satire ranged from the general to the particular, but in each case he viciously denounced the remnants of the old Wilhelmine monarchy which he saw as continuing to dominate life in the Weimar Republic. The army and the Freikorps were the target of some of his most savage attacks. His representations ranged from bald, monocled and moustached generals with cigarettes and ugly scowls to violent and inhumane actions on the part of these same ugly generals. The proletariat were shown as sad, tired, thin and beleaguered, while the 'ruling class' was fat, avaricious and sadistic. His captions ironically highlighted the atrocities of the ruling class. His image of two financiers toasting their own success, while workers are massacred on the street was given two different captions: 'The Communists fall and the exchange-rates rise!' and 'Blood is the best sauce', both of which targeted the selfishness and inhumanity of these men. His series *Ecce Homo* concentrated more specifically on the licentiousness and sexual depravity of this same class, using these means to highlight their essential moral corruption and their inhuman actions, even in private life. Grosz was also not averse to attacking specific targets. His famous depiction of Hitler captioned 'Siegfried Hitler' for the cover of the journal *Die Pleite* (figure 33) was first

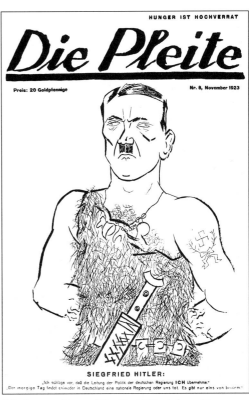

33 George Grosz, 'Siegfried Hitler', from *Die Pleite*, 1923

printed after Hitler's abortive attempt to take over the Bavarian government in 1923, but it was reissued in 1930 when the Nazis had a more prominent profile in German politics.

The satirical aspects of Grosz's work caused some problems for his relationship with the KPD, who appreciated his demonisation of the bourgeoisie but could never fully reconcile themselves to the negativism of his world view or his unwillingness to idealise the proletariat.[52] Even more ambivalent was the art form most closely associated with Dada in Berlin, photomontage. This was practised by Hausmann, Höch and Heartfield and was used in all the Dada journals. In contrast to the clarity of graphic satire, photomontage was potentially a problematic medium for the conveyance of political messages. While Dada practitioners like Höch and Hausmann used familiar popular imagery from such sources as trashy magazines, their juxtaposition of these sources was too ambivalent to serve an obviously political function. The works of Hannah Höch in many ways epitomise this media but also reveal its complexities. Although Dada artists prided themselves on their openness about sex and gender, they marginalised Höch, who was not given a Dada nickname or full participation in the group's various activities.[53] However, her work, particularly her experimentation with photomontage, made her one of the most creative and original artists of the group. Höch worked for the magazine empire Ullstein, and she collected scrapbooks of photographs from Ullstein journals as raw material for her art. She launched her strongest attacks against consumer society, and her works highlight the ambiguous role of women in the Weimar Republic (see chapter 7). But her most famous, and most politically engaged, work was *Cut with the Kitchen Knife: Dada Through the Last Weimar Beer Belly Culture Epoch* (figure 34) which was exhibited at the International Dada Fair in 1920.[54]

Cut with the Kitchen Knife is replete with references to both Wilhelmine society and Weimar culture, and it includes hundreds of photographs carefully juxtaposed for ironic or satirical effect. To make her satire most effective, Höch included mechanical illustrations, architecture, words cut out from newspapers, animals and photographs of over 50 individuals, many of them recognisable. The odd title of the work outlines its agenda. Höch chose the image of a 'kitchen knife' as a way of giving herself, as a woman, the power to expose the male-dominated society of Weimar Germany. She metaphorically used a domestic implement to cut open the 'beer belly culture' of Weimar. Beer, both a German drink and an integral part of male society, was chosen as a way of emphasising the bloated and heavy quality of German militarism; the word 'culture' (*Kultur*) is used in its fullest sense to indicate the society's whole artistic, political and educational profile. In order to stress the failings of Weimar culture, and to praise implicitly the experimentation of Dada, Höch divided her photomontage into 'Dadaist' and 'anti-Dada' sections, although these divisions are not exact nor are they mutually exclusive. Her anti-Dada group dominates the upper half of the work, and includes government officials, such as Ebert, Hindenburg and Noske, as well as members of the former monarchy, such as Wilhelm II and Crown Prince William of Prussia. The Dada section, by contrast, contains photographs of Hausmann, Grosz, Baader, Herzfelde and Höch herself, significantly juxtaposed with political figures such

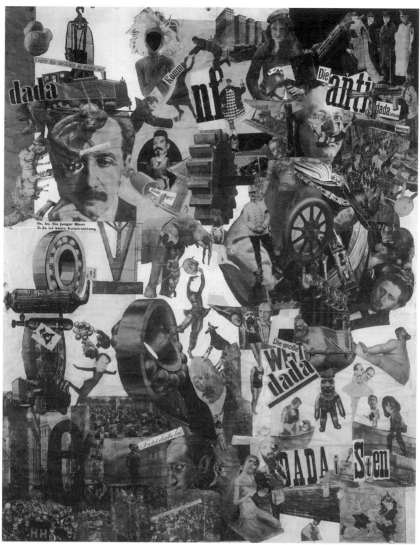

34 Hannah Höch, *Cut with the Kitchen Knife: Dada through the Last Weimar Beer Belly Culture Epoch of Germany*, collage, 1919 [see also colour plate 3]

as Marx and Lenin. However, these divisions are not without ambiguity. In the very centre of the photomontage is the head of the artist Käthe Kollwitz, being tossed upwards by the headless body of the dancer Nidda Impekoven. The feminist undercurrent of *Cut with a Kitchen Knife* is here made explicit, as Höch opposes feminine creativity with male militarism.

Höch's unique combination of feminism and politics was distinct from the more psychological orientation of her colleague and erstwhile lover, Raoul Hausmann, despite some superficial similarity in their works.[55] Hausmann's most famous works share with Höch's photomontages the use of advertising imagery, machine parts, familiar faces and newsprint. Hausmann's *Tatlin at Home* (1920, lost) makes another reference to the famous Russian artist, but the juxtaposition of mechanism and anatomy seems to ridicule Tatlin's

emphasis rather than praise it. Hausmann earned his nickname 'Dadasoph' because of his interest in philosophical and psychological issues. During the war, he recognised the importance of Freud's work on the unconscious, and he was influenced by ideas of sexual freedom developed by his fellow Dadaist Franz Jung. Hausmann began to evolve his own theory about the relationship between communism and the unconscious. Hausmann believed in a 'natural' law of communism that was repressed by a patriarchal capitalist society. He felt as if people's brains were loaded down with material things that suppressed their true orientation and denied them sexual and personal freedoms. His three-dimensional assemblage, *Mechanical Head: Spirit of Our Times* (1921, Paris, Musée d'art moderne) realises this theory. Hausmann began with a wooden head and glued various objects to it, such as a collapsible cup, a wallet, a ruler and a jewel box. The purpose of this head was to reveal the way in which people's thoughts were imposed from the outside, rather than developed from within. The accumulation of insignificant ideas was anathema to Hausmann, and he used the photomontage and assemblage technique to attack this form of mental materialism.

A third member of Berlin Dada circle, John Heartfield, produced the most politically committed and consistent work of all the Dada artists.[56] Like Höch and Hausmann, Heartfield found photomontage the most sympathetic means of expressing his ideas, but he used the new technique in a radically different way. Unlike the chaotic and fragmented forms of his colleagues, Heartfield assembled his photomontages using only a small number of images which he compiled to make a united whole. He first developed his distinctive style in a series of book jackets he produced for novels published by Malik Verlag during the early 1920s. These novels were works by leftist writers, including Ilya Ehrenburg and Upton Sinclair, and they tended to highlight the exploitation by the ruling classes and the poverty and despair of the proletariat. Heartfield's dust jackets were intended to have an immediate impact on the observer, and their legibility was a far cry from the often arcane and confused imagery of Höch and Hausmann.

Heartfield's dust jackets for Malik Verlag were only the beginning of what was to be a lifelong commitment to communism. Of all the Dada artists, Heartfield was the one who continued to devote himself unquestioningly to art in the service of party politics, although for a time Grosz had a similar commitment. During the early 1920s, Grosz contributed directly to the KPD journal *Der Knüppel* (*The Cudgel*), and took a trip to Russia in 1922 with the Danish novelist Martin Andersen-Nexö in order to produce an illustrated book on the present state of the Soviet Union. Grosz's involvement with the latter project grew from his participation in the International Workers' Aid (IAH), an organisation founded by Willi Münzenberg to raise money for famine relief in the Soviet Union. Although ostensibly non-partisan, the IAH was the first operation of what would become a vast communist propaganda empire, headed by Münzenberg.[57] Münzenberg worked for the Soviet government to help disseminate and encourage an international communist culture. His activities were the first clear symptom of the way state communism resulted in a closing down of aesthetic freedom, in contrast to the ways in which revolutionary communism had opened it up immediately after the November

Revolution. Grosz's involvement with Münzenberg's activities underlined his political commitment, but, like many of his contemporaries, his enthusiasm for communism was soon tempered, and later in his life, when in exile in America during the cold war period of the 1950s, he deliberately understated his involvement with the movement and stressed instead his disillusionment with the Soviet Union when he travelled there.

Heartfield, by contrast, did not experience this disillusionment, and his development of photomontage shows the way in which he strove for greater clarity in the service of propaganda. His contribution to propaganda of the communist movement came to a head in the late 1920s, when political extremism destroyed the temporary stability of the Weimar Republic. Although various coalition governments had eased the tensions resulting from post-revolutionary violence, both left- and right-wing extremists continued to wage their propaganda battles throughout the 1920s. During this period of consolidation, the political battles were conducted in the theatre, in film and through the press, rather than on the street. Both Erwin Piscator and Berthold Brecht popularised left-wing theatre, and Brecht contributed to the making of the only communist fiction film *Kuhle Wampe* (1932), which included a cast of over 4,000 supernumeraries.[58] *Kuhle Wampe* is exclusively concerned with proletarian life: at the beginning of the film, the suicide of an unemployed man leads a passer-by to make the resigned comment, 'one less unemployed', while the heroine of the film, Anni, raises money for an abortion from a communist sports club. Kuhle Wampe is the name of a tent colony for the unemployed that forms a central setting of the film. In the most famous scene, a worker reads aloud a newspaper story about Mata Hari, while his wife frets over how to balance the household budget so that the family will have enough to eat. The distance between the fantasy of the newspapers and the grim reality of working-class life is here highlighted with great efficacy.

Communist culture was also spread through the expansion of Münzenberg's publishing empire, and he formed the Prometheus film company to finance the import of Soviet films, while the rival publishing/film empire of Alfred Hugenberg catered to right-wing biases. The widespread support for the communist party is evidenced by the popularity of one of Münzenberg's journals, the *Arbeiter Illustrierte Zeitung* (*Workers' Illustrated Newspaper, AIZ*), to which Heartfield contributed over 237 full page photomontages. Political extremism erupted violently again after the collapse of the New York stock market in 1929 and the subsequent economic depression. In the period between 1929 and the ascendancy of Hitler as Chancellor in 1933, art became increasingly politicised, while artists sided more openly with one faction or another.

The relationship between art and communist propaganda was a complicated one, which extended back to the beginning of the 1920s and the writings of the Berlin Dada artists. Part of the Dada agenda was the abolition of what they considered 'bourgeois art', but because of their occupations as artists, they could not completely dismiss the commercial practice of art. Instead, they put forward what they considered the alternatives for an artist in the post-war world. Their first hint of this perspective was in a negative spirit. In 1920 the failed attempt of right-wing forces to take over the government

(the Kapp Putsch) stimulated a series of riots and the usual Freikorps repression throughout Germany. One of the cities to suffer from the ensuing violence was Dresden, where Oskar Kokoschka lived and worked as Professor of the Dresden Academy. Kokoschka made a public appeal to the people of Dresden to avoid rioting near the Dresden museums, as they were in danger of damaging the 'holy possessions' (*heiligsten Güter*) of the German people. Kokoschka's reverence for art of the past aroused the disgust of Grosz and Heartfield, who called such art a 'swindle' in their swingeing attack 'Der Kunstlump' ('the Art Rogue'), which was published in various left-wing journals during the spring of 1920.[59] According to Grosz and Heartfield, all art was tendentious, and bourgeois art was the most pernicious form of this *Tendenzkunst*.

More positive suggestions were offered in a later essay *Die Kunst ist in Gefahr* ('Art is in Danger'), which Grosz wrote with Heartfield's brother, Wieland Herzfelde, and which was published in the latter's Malik Verlag in 1925. Their premises were overtly left-wing:

> Art is in danger. Today's artist, unless he wants to be useless, an antiquated misfit, can only choose between technology and class war propaganda. In both cases he must give up 'pure art.' Either he joins the ranks of architects, engineers and ad men who develop industrial strength and who exploit the world, or he, as depictor and critic of the face of our time, as propagandist and defender of the revolutionary idea and its followers, enters into the army of the oppressed who fight for their just share of the worth of the world.[60]

Grosz's and Herzfelde's assessment highlighted the problems for all artists in the post-revolutionary period. The question of whether or not art should have an overt political purpose, or whether it should be some sort of escape or panacea was one that most avant-garde artists confronted in the period immediately after the war. The conclusion that Grosz and Herzfelde reached was that all art was political in some way or another, whether it was a luxury of the ruling class or a relief to the workers. If all art was political, Grosz and Herzfelde suggested that it should therefore be marshalled for the purpose of improving society. Therefore, in their view, an art that propagated the ideals of communism was the most forgivable.

This ideology led a number of Dada artists, including Grosz, to form the Red Group in 1924. This was intended to be a union of communist artists in Germany, whose goal was to work directly with the KPD to produce the most appropriately political art. The relationship between the KPD and communist artists was solidified by the formation in 1928 of a more openly propagandist organisation, the Association of Revolutionary Artists of Germany (ARBKD), a pro-Soviet group, whose purpose was to stimulate class war by enlightening the workers to their oppression. The ARBKD was the most party political of these artistic groupings, and its members worked to produce an art that would be immediately accessible to the mass of workers.

The formation of the ARBKD highlighted the question of what was the most effective form of art for the proletariat. At the beginning of the revolutionary period, some artists, like Felixmüller and Pechstein, saw Expressionism as the most appropriate proletarian art. The ideal underlying Expressionist art

was a communal brotherhood of the spirit, which did not exclude individuals on the basis of class or economic position. Just as Pechstein and Felixmüller saw their expressive woodcut technique as universally appealing, so Taut thought that his utopian crystal city was the answer to the despair of the people. The passionate commitment of some of these artists somewhat blinded them to the aesthetic taste of the very mass of workers they meant to lure. Others despised what they saw as the debased taste of the proletariat and, despite their stated position, appealed directly to a bourgeois market by exhibiting their art in fashionable sections of town and selling it for high prices. Increasingly, artists began to feel that the often ambiguous spiritual art of the Expressionists was inaccessible to the majority of the population, and they began to develop instead a form of art that was eye-catching and immediately legible to everyone. This form of realist art was increasingly advocated by Soviet communists, who looked to the aesthetic theories of Leo Tolstoy's *What is Art?* (1898) and Alexander Bogdanov's *Art and the Proletariat* (1919) as a basis for a defence of art that was totally accessible to the people.

Heartfield's photomontages answered most appropriately this perceived new need, and the admiration for his work in the Soviet Union attested to its appeal to communist ideology. Heartfield not only contributed to Münzenberg's *AIZ*, but he also produced covers for the communist party newspaper, *The Red Flag*. One of his most striking images for that newspaper was a single hand with all five fingers spread apart, which has the clarity and stark appeal that was expected of communist artists in the late 1920s. Heartfield's hand also referred directly to forthcoming elections, in which the communist party was item five on the voting paper. Heartfield's efficacy as a propagandist appeared in a book he published with the satirist Kurt Tucholsky in 1929. The book, ironically entitled *Deutschland, Deutschland über Alles* was a caustic attack on the economic and social inequalities of Weimar Germany. On one two-page spread, for example, a series of photographs of impoverished proletarians living in filthy conditions and obviously starving, are accompanied by the following lines: 'In Prussia alone we have 28,807,988 Mark for horse-breeding and little to eat, but 230,990 Mark for the spiritual welfare of the army'.[61] In 1933 Heartfield continued his work for the *AIZ* in Prague, where the journal was forced into exile by the Nazi regime. Like many other artists, Heartfield fled from central Europe during the Second World War, but he returned to the German Democratic Republic afterwards, where he continued to devote himself to art in the service of communism. His long struggle for acceptance under the new East German communist regime indicates just how ambiguous the position of pre-war communist artists could be once the Second World War was over.

The ambiguity of Heartfield's position was not unique. Although it is perhaps easy to caricature artists on the left as communist propagandists, an examination of any one case history shows just how problematic the relationship between art and left-wing politics could be. The individualist ethos of Dada remained even in the extremist period of the late 1920s. Ironically the ideals of community, art for the masses and individual artistic freedom came together not in Dada art or in Expressionist circles, but in the work of Käthe Kollwitz, whose career was exceptional, and who never became part of the

ubiquitous club culture of the 1920s.[62] Kollwitz's prints and sculptures had the potential to serve the purpose of communist propaganda, but her attitude to politics was cautious. She was born in 1867, and was therefore a product of an older generation of artists, but her fairly consistent style had a universal appeal which led to its acceptance by both traditionalists and avant-garde artists in the 1920s. Kollwitz was exposed to socialist politics from a very early age through her father and grandfather, and her marriage to a doctor Karl Kollwitz resulted in her moving to a working-class district of Berlin. Her early works embodied the naturalist obsessions of French contemporaries such as Zola, and her first major series of prints, *The Weavers' Revolt* (1897) represented a solidly political theme.

The series was based on Gerhard Hauptmann's play, *The Weavers*, which Kollwitz saw in 1893. Hauptmann originally represented the story of the Silesian weavers' strike of 1844 using detailed sets and Silesian dialect, although the latter was forbidden by the censor. Kollwitz's series consisted of three etchings, *Need*, *Death* and *Deliberation*, and three lithographs, *The Weavers on March*, *Riot*, *The End*, which did not so much narrate Hauptmann's tale as visualise its more universal themes. She returned to another historical political series in 1908, when she produced the *Peasants' Revolt*, seven lithographs representing an uprising of the 1520s. In both series she concentrated on the oppression of the workers, their rebellion against it and the subsequent failure of their attempt.

The themes of insurrection and rebellion seemed to place Kollwitz firmly within Marxist ideology, but, from the beginning, she was more interested in oppressed individuals than in the politics of the class struggle. However, her appealing graphic techniques and her stark use of imagery led her to become involved in producing publicity and propaganda for left-wing interest groups. Even as early as 1906, her poster for the German Home Workers Exhibition aroused the ire of Kaiser Wilhelm's wife and, after the revolution, she produced similarly pessimistic posters for the IAH highlighting the needs of starving children in Russia (figure 35). In many ways, her work answered the communist desire for an accessible and 'realist' form of art that had immediate appeal and significance for the proletariat. But Kollwitz's sympathies with starving families in working-class districts did not exemplify a firm commitment to the communist party.

Indeed, in a number of respects, Kollwitz was the sort of bourgeois traditionalist despised by Dada artists. Her series, *The Peasants' Revolt* may have had a Marxist theme, but its aesthetic qualities merited an award of the Villa Romana Prize, which allowed Kollwitz to spend a year studying in Italy. In 1919 Kollwitz was the first woman elected to the Prussian Academy of Arts, and she later earned the honour of a Professorship and a stipend from that institution. In 1929 she received the Prussian award for merit. Although she joined the Arbeitsrat für Kunst at the beginning of the revolution, she withdrew from that organisation when its party-political perspective became apparent. Although she published lithographs in the communist journal *AIZ*, she never joined the communist party, and she seemed to have sympathy for the socialist coalition government. Although her posters were used by the communist AIH, the communist newspaper *The Red Flag* was critical of her

35 Käthe Kollwitz, *Help! Russia is Hungry*

emphasis on the hopeless state of the proletariat. Her diaries rarely referred to her political perspective; her diary entry of 21 June 1921 is one of these rare revelations. After seeing a revival of Hauptmann's play *The Weavers* in 1921, she was overcome with the same political fervour she had felt when she first saw the play many decades before. But she admitted

> In the interim I have lived through the revolution and that has convinced me that I am no revolutionary. My childhood dreams to fell the barricades could not be carried out, because I will not go to the barricades, since I know how it really is there. So I know now what kind of illusion I lived through all those years ago, believing that I was revolutionary when I was only evolutionary. Yes, once in awhile, I don't know whether I am, above all, a socialist, or merely a democrat.[63]

Kollwitz opposed senseless bloodshed and the war which was responsible for the death of her son Peter, but she did not see political factionalism as the answer to Germany's problems.

Because she never joined a party and because of her own honesty about her political position, her work has been classified as universal, rather than partisan. Certainly her recurrent themes of mother-love and the death of children seem to have little obvious political function, despite their representation of working-class poverty and despair. But Kollwitz's works were political, if not partisan, and they were seen to be so by the Wilhelmine conservatives, who condemned them as 'ugly', as well as the Nazis, who decried what they saw as her negative representation of the German people.

Kollwitz was also one of the few famous left-wing artists who did not leave Germany, or commit suicide or die during the worst of the Nazi oppression, although her works were confiscated and she lost her academic position.

The Nazis attacked her work, but they also used it (without acknowledgement) in their own journals and publications. Its universality made it equally accessible to right-, as well as left-wing factions. She tolerated the oppression under which she lived, but she and her husband formed a suicide pact in the event that they were arrested by the Gestapo.

Kollwitz's work highlights the difficulty of creating a sympathetic but non-partisan art between the two world wars. The political situation in Germany made it virtually impossible for artists to detach themselves from politics, and the vague utopian socialism of post-war Expressionism and rebellious anarchism of Dada soon gave way to art directly in the service of propaganda. Throughout this period, avant-garde artists banded together for group action, even while they promoted their individual theories and personalities. They also made increasingly creative use of both traditional and new media, performance and the growing possibilities of a culture for the 'masses'.

NOTES

1 Richard Huelsenbeck, *Memoirs of a Dada Drummer* (1969), ed. Hans J. Kleinschmidt, Berkeley and Los Angeles, 1991.
2 Quoted in Charles Harrison and Paul Wood (eds), *Art in Theory 1900–1990*, Oxford, 1992, p. 392.
3 Diary entry of October 1920, quoted in Elizabeth Prelinger, *Käthe Kollwitz*, New Haven, 1992, p. 80.
4 See Paul Raabe (ed.), *Ich schneide die Zeit aus: Expressionismus und Politik in Franz Pfemfert's 'Aktion' 1911–1918*, Munich, 1964.
5 This pejorative use of Walden's name was made in the Cologne Dada journal, *Bulletin D*. See Jörgen Schäfer, *Dada Köln: Max Ernst, Hans Arp, Johannes Theodor Baargeld und ihre literarischen Zeitschriften*, Wiesbaden, 1993, p. 94.
6 See *An alle Künstler*, Berlin, 1919, p. 19: 'Kunst ist keine Spielerei, sondern Pflicht dem Volke gegenüber'.
7 For the most comprehensive account of left-wing artistic activity during the Weimar Republic, see W. L. Guttsman, *Art for the Workers: Ideology and the Visual Arts in Weimar Germany*, Manchester, 1997.
8 See the letter from Kandinsky to Münter of 18 November 1910, in Annegret Hoberg (ed.), *Wassily Kandinsky and Gabriele Münter: Letters and Reminiscences 1902–1914*, Munich, 1994.
9 This transformation is traced most clearly in Barbara McCloskey, *George Grosz and the Communist Party: Art and Radicalism in Crisis 1918 to 1936*, Princeton, 1997. See also Martin Kane, *Weimar Germany and the Limits of Political Art: A Study of the Work of George Grosz and Ernst Toller*, Tayport, 1987.
10 The complex history of the German revolution and its impact on art is outlined in more detail in Detlev Peukert, *The Weimar Republic: The Crisis of Classical Modernity*, London, 1991; Bärbel Schräder and Jürgen Schebera, *The Golden Twenties: Art and Literature in the Weimar Republic*, New Haven, 1988; John Willett, *The New Sobriety: Art and Politics in the Weimar Period 1917–33*, London, 1978; and Richard Bessell and E. J. Feuchtwanger (eds), *Social Change and Political Development in Weimar Germany*, London, 1981.
11 Joan Weinstein, *The End of Expressionism: Art and the November Revolution in Germany 1918/19*, Chicago and London, 1990.
12 'Arbeitsrat für Kunst – programme, December, 1918', in *Mitteilungen des deutschen Werkbundes*, 1918, no. 4, pp. 14–15, quoted in Iain Boyd Whyte, *Bruno Taut and the Architecture of Activism*, Cambridge, 1982, pp. 232–3.
13 See *Ja! Stimmen des Arbeitsrates für Kunst in Berlin*, Berlin, 1919.
14 'Arbeitsrat für Kunst – programme, December, 1918', quoted in Whyte, *Taut*, pp. 232–3.
15 See the excellent analysis of Taut's theory and practice in *ibid*. See also Regine Prange, *Das Kristalline als Kunstsymbol: Bruno Taut und Paul Klee*, Hildesheim, 1991; and

Rosemarie Haag Bletter, 'The interpretation of the glass dream – Expressionist architecture and the history of the crystal metaphor', *Journal of the Society of Architectural Historians*, 40:1 (1981), 20–43.

16 Bruno Taut, *Die Stadtkrone*, Jena, 1911; and idem, *Die Auflösung der Städte oder die Erde eine gute Wohnung oder auch: der Weg zur Alpinen Architektur*, Hagen, 1920.

17 For a full discussion of the Expressionist theories in their architectural context, see especially Barbara Miller Lane, *Architecture and Politics in Germany 1918–45*, 2nd edn, Cambridge, Mass., 1985; Timothy Benson, *Expressionist Utopias: Paradise, Metropolis, Architectural Fantasy*, exhibition catalogue, Los Angeles, 1993; and Wolfgang Pehnt, *Expressionist Architecture*, London, 1973.

18 For the Novembergruppe, see Weinstein, *End of Expressionism*, and Helga Kliemann, *Die Novembergruppe*, Berlin, 1969.

19 Quoted in Weinstein, *End of Expressionism*, p. 27.

20 *An alle Künstler*, especially pp. 5, 9.

21 'Offener Brief an die Novembergruppe', *Der Gegner*, 1921, pp. 297–301, extract in English quoted in Rose-Carol Washton-Long (ed.), *German Expressionism: Documents from the End of the Wilhelmine Empire to the Rise of National Socialism*, Berkeley and Los Angeles, 1995, pp. 220–21.

22 For a discussion of the importance of the *Gemeinschaft* for Expressionist ideology, see M. S. Jones, *Der Sturm: A Focus of Expressionism*, Columbia, 1984, pp. 220–1.

23 Herwarth Walden, *Einblick in Kunst. Expressionismus, Futurismus, Kubismus*, Berlin, 1917, 2nd edn 1924, p. 37. For a discussion of Walden's view of personality, see Jones, *Der Sturm*, p. 17. The individuality associated with Impressionism was related by Franz Landesberger to the visibility of their brushstrokes (*Impressionismus und Expressionismus: eine Einfuhrung in das Wesen der neuen Kunst*, Leipzig, 1920, p. 9). Robert Jensen discusses the way in which Impressionist 'temperament' became part of the myth of the modernist artist, although the temporal limits of his study do not enable him to discuss how Expressionist critics dealt with the issue: Robert Jensen, *Marketing Modernism in Fin-de-Siècle Europe*, Princeton, 1994, p. 81.

24 'Es ist deshalb grundfalsch, zu sagen ... dass der Expressionist die Wesenheiten seines Objects [sic] haarscharf und mit Temperament herausschäle. "Mit Temperament" begreift schon eine Subjectivität in sich, und schliesst somit das rein Wesenhafte der Objecte aus': 'Expressionismus', quoted in Peter Ludewig (ed.), *Schrei in die Welt: Expressionismus in Dresden*, Zurich, 1990, p. 40.

25 This problem is alluded to by Maurice Godé, *Der Sturm de Herwarth Walden: l'utopie d'un art autonome*, Nancy, 1990, p. 207.

26 See the discussion of this in Liliane Meffre, *Carl Einstein et la problématique des avant-gardes dans les arts plastiques*, Berne, 1989, p. 20.

27 'Im Impressionismus hatten sich Welt und Ich, Innen und Außen, zu einem Gleichklang verbünden. Im Expressionismus überflutet das Ich die Welt': Paul Hatvani, 'Versuch über den Expressionismus', *Die Aktion* (17 March 1917), 146–50 (quotation on p. 146).

28 'Kunst ist der Ausdruck einer Persönlichkeit': Arthur Drey, 'Kunst: Neue Sezession (Vorbericht)', *Die Aktion* (27 Feb 1911), pp. 52–3 (quotation on p. 52).

29 Both Kandinsky and Marc hedged round this issue before the war, but neither gave it a party-political inflection. See Franz Marc, 'Two pictures', in Wassily Kandinsky and Franz Marc (eds), *The Blaue Reiter Almanac* (1912), Eng. trans., ed. Klaus Lankheit, London, 1974, p. 66; and Kandinsky's essay 'On the question of form', p. 153 in the same source.

30 Walden, *Einblick*, p. 36. Cf. Iwan Goll, 'Kommunistisch Kunst', quoted in Ludewig, *Schrei in die Welt*, p. 50.

31 Ludewig, *Schrei in die Welt*.

32 Weinstein, *End of Expressionism*, p. 112.

33 See Shulamith Behr and Amanda Wadsley (eds), *Conrad Felixmüller: Between Politics and the Studio*, exhibition catalogue, Leicester, 1994; Shulamith Behr, *Conrad Felixmüller: Works on Paper*, London, 1994; *Conrad Felixmüller: Werke und Dokumente*, exhibition catalogue, Nürnberg, 1981; and Dieter Gleisberg, *Conrad Felixmüller Leben und Werk*, Dresden, 1982.

34 For Munich, see Helmut Friedel (ed.), *Süddeutsche Freiheit: Kunst der Revolution in München 1919*, exhibition catalogue, Munich, 1993. For post-revolutionary groups in the Rhineland, see Schäfer, *Dada Köln*; and Ulrich Krempel (ed.), *Am Anfang 'das junge Rheinland': zur Kunst und Zeitgeschichte einer Region 1918–1945*, Düsseldorf, 1985.

35 See Hans Richter, *Dada: Art and Anti-Art*, New York, 1965; and Alan Greenberg, *Artists and Revolution: Dada and the Bauhaus, 1917–1925*, Ann Arbor, 1979.

36 For a discussion of this, see John Elderfield, 'Introduction', in Hugo Ball, *Flight Out of Time: A Dada Diary*, ed. John Elderfield, Berkeley and Los Angeles, 1996.

37 Huelsenbeck, *Memoirs*, p. 52. See also Richard Huelsenbeck, *Dada: ein literarische Dokumentation*, Hamburg, 1964; and Karin Fullner, *Richard Huelsenbeck: Texte und Aktionen eines Dadaisten*, Heidelberg, 1983.

38 Huelsenbeck, *Memoirs*, p. 79.

39 Ball, *Flight Out of Time*, p. 63.

40 Ball expanded on this idea in his *Zur Kritik der deutschen Intelligenz*, Bern, 1919.

41 See McCloskey's interesting discussion of the insanity issue in *Grosz and the Communist Party*, p. 19. For the nineteenth-century sociological origins of the links between insanity and artistic 'genius', see Shearer West, *Fin de Siècle: Art and Society in an Age of Uncertainty*, London, 1993, pp. 64–6.

42 Huelsenbeck's *Memoirs* contain a number of denials of communist affiliation. See also George Grosz, *The Autobiography of George Grosz: A Small Yes and a Big No* (1955), London, 1982, p. 103.

43 For Berlin Dada, see Hanne Bergius, *Das Lachen Dadas: Die Berliner Dadaisten und ihre Aktionen*, Giessen, 1989; Hanne Bergius and Karl Riha, *Dada Berlin: Texte, Manifeste, Aktionen*, Stuttgart, 1977; and Walter Mehring, *Berlin Dada: eine Chronik mit Photos und Dokumenten*, Zurich, 1959.

44 See Peter Jelavich, *Berlin Cabaret*, Cambridge, Mass., 1993.

45 For gender issues in the Dada circle, see especially Maud Lavin, *Cut with the Kitchen Knife: The Weimar Photomontages of Hannah Höch*, New Haven and London, 1993; and Renée Riese Hubert, 'Zurich Dada and its artist couples', in Naomi Sawelson-Gorse, *Women in Dada: Essays on Sex, Gender and Identity*, Cambridge, Mass., 1998, pp. 516–45. It was clear that the Dada artists themselves realised the gender implications of their activities. See, for instance, the comments of Huelsenbeck, *Memoirs*, p. 23, who claims that his Zurich girlfriend found the Cabaret Voltaire distasteful because it was the enactment of masculine wildness. The Dada belief in sexual freedom and liberty would seem to imply a greater openness to women's participation and, as with Surrealism, gender became entrenched in the ideology of the group, but theory was not necessarily complemented by practice. See Whitney Chadwick, *Women Artists and the Surrealist Movement*, London, 1985.

46 Harald Maier-Metz, *Expressionismus-Dada-Agitprop: Zur Entwicklung des Malik-Kreises in Berlin 1912–1924*, Frankfurt am Main, 1984.

47 Richard Huelsenbeck, 'First German Dada manifesto', in Raoul Hausmann, *Am Anfang war Dada*, Giessen, 1980, p. 22.

48 For the distinctions between Tatlin's art and the theories of the Constructivists in Russia, see Christina Lodder, *Russian Constructivism*, New Haven and London, 1983.

49 See especially Beth Irwin Lewis, *George Grosz: Art and Politics in the Weimar Republic*, 1971, 2nd edn, Princeton, 1991; M. Kay Flavell, *George Grosz: A Biography*, New Haven, 1988; and Hans Hess, *George Grosz*, London, 1974, reprint New Haven, 1985.

50 Grosz, *Autobiography*, pp. 79, 95.

51 I discuss the importance of humour to German visual culture more thoroughly in chapter 7.

52 See McCloskey's discussion of the KPD's problems with satire: *Grosz and the Communist Party*, pp. 80–3.

53 See Lavin, *Cut with the Kitchen Knife* and Dawn Ades, *Photomontage*, 2nd edn, London, 1986.

54 This is discussed thoroughly in Lavin, *Cut with the Kitchen Knife*, pp. 30–5. All the photographs are identified in Gertrud Dech, *Schnitt mit dem Kuchen-Messer: Dada durch die letzte Weimarer Bierbauchkulturepoche Deutschlands*, Münster, 1981.

55 For Hausmann, see Michael Erlhoff, *Raoul Hausmann, Dadasoph: Versuch einer politisierung der Ästhetik*, Hanover, 1982; Timothy Benson, *Raoul Hausmann and Berlin Dada*, Ann Arbor, 1987; and Hausmann, *Am Anfang war Dada*.

56 For Heartfield, see John Heartfield, *Schnitt entlang der Zeit: Selbstzeugnisse, Erinnerungen, Interpretationen*, ed. Roland März, Dresden, 1981; Peter Pachnicke and Klaus Honnef (eds), *John Heartfield*, New York, 1992; and Wieland Herzfelde, *John Heartfield: Leben und Werk*, Dresden, 1971.

57 See Helmut Gruber, 'Willi Münzenberg's German communist propaganda empire 1921–1933', *Journal of Modern History*, 38:3 (1966), 278–97; and for Münzenberg's

changing relations with Stalin, see Stephen Koch, *Double Lives: Stalin, Willi Münzenberg and the Seduction of the Intellectuals*, London, 1995.

58 For Kuhle Wampe, see especially Bruce Murray, *Film and the German Left in the Weimar Republic: From Caligari to Kuhle Wampe*, Austin, 1990; and Stephen Lamb, 'Woman's nature?: images of women in "The Blue Angel", "Pandora's Box", "Kuhle Wampe" and "Girls in Uniform"', in Marsha Meskimmon and Shearer West (eds), *Visions of the 'Neue Frau': Women and the Visual Arts in Weimar Germany*, Aldershot, 1995, pp. 124–42.

59 George Grosz and John Heartfield, 'Der Kunstlump', *Der Gegner*, 1:10–12 (1919/20), 48–56.

60 George Grosz and Wieland Herzfelde, *Die Kunst ist in Gefahr*, Berlin, 1925, quoted in Lewis, *George Grosz*, p. 118.

61 'Wir haben 28,807,988 Mark allein in Preußen für pferdezucht übrig und aber 230,990 Mark für die Seelsorge in der Reichswehr': Kurt Tucholsky, *Deutschland, Deutschland über alles. Ein Bilderbuch von Kurt Tucholsky und vielen Fotografen montiert von John Heartfield*, Berlin, 1929, pp. 48–9.

62 For Kollwitz, see Prelinger, *Kollwitz*; *Käthe Kollwitz, Schmerz und Schuld*, exhibition catalogue; and Nina Klein and H. Arthur Klein, *Käthe Kollwitz: Life in Art*, New York, 1972. Various editions of Kollwitz's writings are available in German and English: see Hans Kollwitz (ed.), *Tagebuchblätter und Briefe*, Berlin, 1948, Eng. trans. as *The Diary and Letters of Käthe Kollwitz*, Evanston, 1988; Käthe Kollwitz, *Aus meinem Leben. Ein Testament des Herzens*, Freiburg, 1992; and Käthe Kollwitz, *Briefe an den Sohn 1904 bis 1945*, Berlin, 1992.

63 'Inzwischen hab ich eine Revolution mit durchgemacht und hab mich davon überzeugt, daß ich kein Revolutionär bin. Mein Kindertraum, auf die Barrikade zu fallen, wird schwerlich in Erfüllung gehen, weil ich schwerlich auf eine Barrikade gehen würde, seitdem ich in Wirklichkeit weiß, wie es da ist. So weiß ich jetzt, in was für einer Illusion ich die ganzen Jahre gelebt habe, glaubte, Revolutionär zu sein und war nur Evolutionär, ja, mitunter weiß ich nicht, ob ich überhaupt Sozialist bin, ob ich nicht vielmehr Demokrat bin': Kollwitz, *Aus meinem Leben*, pp. 109–10.

6

Commodity and industry: from the Werkstätte to the Bauhaus

> Together let us conceive and create the new building of the future, which will embrace architecture and sculpture and painting in one unity and which will rise one day toward heaven from the hands of a million workers like the crystal symbol of a new faith. (Walter Gropius, Programme of the Bauhaus, 1919)[1]

> Art is not only an aesthetic, but at the same time, a moral power, both, however, leading in the final analysis to the most important of powers: economic power. (Fritz Schumacher's address to the first conference of the Deutscher Werkbund, 1907)[2]

THE tensions between community and individuality that erupted in the post-war circles of the German avant-garde were not confined to artists alone. Just as freedom and community became catchwords for the artistic avant-garde, so individuality competed with standardisation among the practitioners of 'applied' arts. The art and performances of Expressionism and Dada, however diverse in their forms, had only a limited audience when compared to the everyday products of the consumer culture that characterised modern Germany. Furthermore, Dada and Expressionism both appealed in different ways to an elite group of intellectuals with largely socialist inclinations. Expressionism's appropriation by the film industry gave it a brief mass popularity, but the majority of the German population were more concerned with the commodities of everyday life – clothes, furniture, houses – than with the exhibitions, publications and performances of the avant-garde. The change in the forms of, and attitudes towards, these commodities represent a crucial aspect of any history of modern German visual culture. The aesthetic experiments of the Secessionists, Expressionists and Dada artists occurred alongside debates about the role of style in objects produced for a modern capitalist society. These separate developments echoed each other, and despite their differences, showed sets of common concerns about the nature and value of the visual in modern life, but their outcomes were very different.

During the period of unity, consumerism also came to be considered by new movements, institutions and organisations. Just as Secessionism and Expressionism sought to reconcile tradition and innovation as a way of creating an especially German form of art, so more commercial enterprises and government-sponsored educational institutions were formed to direct artistic attention towards the problems of a new machine age. Beginning with the

United Workshops for Art in Craftwork, which was founded in Munich in 1897, and ending with the collapse of the art school, the Bauhaus, in 1933, a series of craft and design organisations mingled utopian ideas about art with economic realism. Through these developments, a desire to take advantage of Germany's modernisation was yoked to the persistent German cultural mission. Unity was sought in 'applied' art and craft, but this goal was dogged by the tensions between commercial and aesthetic concerns and between artistic individuality and mechanised standardisation. Overriding these dichotomies was a persistent political interventionism that was not just a conflict between left-wing and right-wing factions but involved a more complex appropriation of visual culture for both political commercial ends. The idea prevailed that an improvement in machine manufacturing would bring about both a better quality of life and exportable commodities which were readily identifiable as 'German'. These cultural aspirations deeply involved artists but also implicitly consigned them to the role of servants of industry.

Modern commodity culture made the consumer infinitely more important in the processes of aesthetic change, just as the manipulations of the market affected the success or failure of art movements. The most ubiquitous consumers were members of the German middle class. Like the fragmented nation itself, the middle class was not a single entity, and Germans themselves used different terms for 'middle class', from *Bildungsbürgertum* (educated middle class) to *Mittelstand* (petit bourgeoisie).[3] Looking back to the first decades of German political unity, the conservative taste that led to middle-class disdain for the internationalism of the Secessionists was accompanied by a wholesale embrace of the possibilities of modern consumer capitalism. The bourgeoisie – regularly derided by avant-garde artists for their philistinism – were nevertheless just as concerned with ways of responding to the social changes wrought by modernisation. But their primary focus was on how to improve Germany's international situation and how to reconcile the explosion of consumer goods with a sense of German cultural identity.

The attempts to reconcile art and industry were not wholly divorced from the goals and desires of Expressionist artists, and throughout the movement for cultural reform through industry, Expressionist ideas continued to appear, even in the most unlikely places. Despite their seemingly escapist stance, many Expressionist artists were fully aware of the importance of design, and a number of them (including nearly all the Brücke group) were trained in an arts and crafts or technical school, rather than a conventional academy.[4] Indeed the arts and crafts schools (*Kunstgewerbeschulen*) were the first places where the importance of design to modern life became apparent. These schools began to appear throughout Germany in the 1860s. They were set up as a foil to art academies, and the training in *Kunstgewerbeschulen* avoided the life drawing and copying of old masters which still prevailed as the dominant pedagogical mode in the academies. Crafts training was based more directly on the development of manual skills which would, ultimately, be used to contribute to the design of new consumer goods, particularly furnishings and textiles. This was especially important during the *Gründerzeit*, when middle-class prosperity meant an enhanced desire for consumer goods, as well as a greater ability to afford them.[5]

As Germany in the years after unification was in the middle of a cultural rivalry with France, the *Kunstgewerbeschulen* represented Germany's affinity with England. The idea of an 'arts and crafts' school was borrowed from English design schools and was based partly on the ideas of William Morris and the English Arts and Crafts movement.[6] Morris was a socialist who lamented the way in which the machine had alienated the worker. His desire for a beautiful world in which all objects were hand-made to a high standard was more than simply an aesthetic dream, as he felt that such a world would also inspire better behaviour and greater happiness. Morris and his European followers felt that art could ameliorate society – not just visually, but morally as well. In addition, Morris's desire to revive a medieval way of living resonated for German nationalists who valorised the nation's medieval past. Morris's utopianism partly underlay the ideals of the German *Kunstgewerbeschulen*, but these schools also functioned with a strong dose of pragmatism. The 'Gewerbe' in their titles refers strictly to trade and industry, rather than craft, and intrinsic in their formation was a desire to improve German design thus enabling Germany to compete profitably in an international marketplace. The terminology of developments in German applied arts was multivalent: terms like 'Handwerk' (craft) and 'Werkstatt' (workshop) were used to evoke the medieval tradition, but 'Gewerbe' (industry) underpinned the modernity of applied arts and design. Frequently, these connotations were coupled, rather than separated.

However, Morris's medievalism was not far from the minds of German designers at the turn of the century. Among Morris's admirers was the Belgian architect, Henry van de Velde, who was called to Weimar in 1902 to take charge of crafts training and act as government adviser to the Grand Duke there.[7] Van de Velde's presence in Germany indicates one of the principal ways in which Germany's approach to design differed from that of England. From the early years of unification, the German government, at both national and local level, became involved in attempts to improve design training by contributing both attention and funds. The intervention of the government was one of the reasons that Germany's efforts to foster a modern design were so much more successful than those of their European counterparts, but it would be wrong to suggest that Germany moved inexorably towards a 'modern' style. Indeed, even while the association between designer and machine led to items which appeared flawlessly modern, other manufacturers were producing period furniture in many different historical styles.[8] Ironically, attempts to achieve cultural unity through the agent of the machine resulted only in greater pluralism. The very capabilities of machine manufacture militated against standardisation and, in some cases, modernisation. If consumers wanted a Biedermeier desk or a Louis XIV chair, a machine was able to produce it for them.

The situation in Germany at the turn of the century was, therefore, very complex. On the one hand, utopian ideas about the role of the craftsman had filtered over from England to create a sense of idealism about applied arts which had been lost through the hegemony of 'fine art' training. However, working in counterpoint to this tendency was a rapid industrialisation which carried everything else in its wake. Morris had been opposed to any sort of

machine-made goods, but German artists looked to the machine as a necessary tool of the trade. Finally, the movement for cultural reform after unification gave the new emphasis on applied arts a further urgency; the arts were felt to be a way to achieve this unity, and the government was willing to turn its attention to a reconciliation of art with modern commercialism that would help facilitate it.

However, as with many other artistic changes during this period, the beginnings of design reform were localised, rather than pan-German, and the shift from a regional to a national agenda characterises the growing importance of design to German visual culture. Throughout Germany and Austria small companies formed, based in part on the model of Morris & Co., and, more recently, another English company, Ashbee's Guild of Handicraft, begun in 1888. But the political idealism of Morris's and Ashbee's companies was distinct from the combination of economic realism and social reformism that characterised their German equivalents. The first German association with this function was the Vereinigte Werkstätten für Kunst im Handwerk (United Workshops for Art in Craftwork), which was founded in Munich in 1897.[9] The origins of this association lay in part in the prevalence of Jugendstil applied arts at Munich exhibitions, but the Jugendstil acted as both a positive and negative stimulus. As the 'floral' or 'serpentine' style became more recognised, manufacturers began using variations of it in bastardised products which were despised by Jugendstil artists. The United Workshops were formed in part to protect artists against this sort of design plagiarism, but they also sought to veer consumers away from historicist styles of furniture. The main aim of the organisation was to promote good design, and its means of doing this were varied. First of all, the company acted as a mediator between 'artists, craftsmen and customers'; it attempted to introduce 'fine' artists with ideas about design to craftsmen who could carry out those designs most efficiently, and to sell these products to enlightened members of the public.[10] Its second means of disseminating good designs was through educating not just artists but consumers as well. Its statutes contained a provision for an 'information centre' which could be consulted by artists, manufacturers and buyers. This sort of educational initiative was prevalent in all the later versions of the United Workshops. Underlying it was the sense that the middle classes, the principal consumers of modern products, were ultimately ignorant about design quality and needed to be guided towards developing good taste. Pedagogic values also persisted beyond the bounds of the Workshops themselves, as one of the members, Hermann Obrist, founded the Teaching and Research Studio for Applied and Free Art in 1902.[11] This school, which was later headed by Wilhelm Debschitz, attempted to guide its students to realise their own potential for self-expression, rather than restricting them to the ideals and styles of their teachers. Such didacticism directed to the public, in the case of the Workshops, and the craftsmen, in the case of the Debschitz school, was one of the ways in which private enterprise sought to shape public taste.

The third way in which the United Workshops promoted good design was by giving the initiative to the artists themselves. The United Workshops was a limited liability company (G.m.b.H.), in which each shareholder contributed a risk-free amount of money and benefited from both the commercial

and the educational aspects of the organisation. Although shareholders included artists, craftsmen and enlightened 'buyers', the artists were in control of the organisation from the beginning, as they felt themselves to be the most appropriate arbiters of modern taste. The idea of a coalition of artists and consumers was one that Brücke had cultivated through its 'passive members', and even the Blaue Reiter was built on a less formal relationship between the artists and the entrepreneur Bernhard Koehler. But in the context of the United Workshops, the presence of non-artists began to take on a significant role. Among the artists involved with the United Workshops were Peter Behrens, Otto Eckmann, August Endell (figure 36), Hermann Obrist, Bernhard Pankok (figure 37) and Richard Riemerschmid – most of whom had been previously associated with the Munich Secession. Their furniture, tapestries, typography and *objets* did not perpetuate a single style, but attempted to bring quality to modern design. The emphasis on 'crafts' did not, as in the case of William Morris, exclude the importance of the machine. Several of these artists found the machine an essential tool for producing affordable goods for a modern public. Riemerschmid in particular valued the machine as a way to improve the conditions of the working class. A cheap, but well-designed, machine-made product was, to him, superior to the most carefully-crafted, but prohibitively expensive, luxury item.[12]

By 1907 the success of the United Workshops was clear. They had transcended their regional origins by opening branches in Hamburg, Bremen and Berlin, and their works had been acclaimed at the international exhibitions in Paris (1900) and Turin (1902). There were also a number of imitators, including, most notably, the Dresdener Werkstätten für Handwerkskunst (Dresden Workshops for Handwork Art), founded in 1898 by Karl Schmidt, and the Wiener Werkstätte (Vienna Workshops), formed by Carl Moser and Josef Hoffmann in 1903. The success of the Workshops also helped inspire the founding of several applied arts museums, modelled on the London South Kensington Museum. These museums formed an odd link between art and industry, in that contemporary designs were exhibited as if they were artefacts, thus elevating the craft to an art while providing propaganda for new designs. The various workshops also served to erode the distinctions between 'fine art' and design, as craftsmanship was no longer considered an inferior

36 August Endell, chest, 1899

practice. This disruption of artistic hierarchies temporarily created a space for women in the art world. Just as Expressionism and Dada later opened up an ideological space for the feminine, so early design debates renegotiated the place of design – previously considered an inferior, mechanistic and hence feminised mode of creation. But while women were more easily and frequently trained as designers than as academic artists, the design reform movement quickly became a strictly masculine preserve.[13]

In most respects, then, the Munich United Workshops and its successors seemed to provide a potential way forward for design in a modern industrialised Germany. However, the enthusiasm for these new organisations, as well as their commercial success did little to disguise a number of underlying tensions. Although artists appeared to be taking control of the new machine age through their own initiative and desire for excellence, the machine still threatened to supersede the artists themselves. The critic, Meier-Graefe, rather cynically suggested that artists were turning to interior decoration because of this rivalry with industry. They were forced to produce chairs, tables, lamps and cutlery to halt their own obsolescence.[14] Perhaps to avert this suspicion, the artists were the first to insist on the moral and cultural excellence of their projects. The manifesto of the Dresdener Werkstätten contains a typical mixture of aesthetics and cultural politics:

> We want to create furniture which is so formed, that each piece . . . directly serves best its purpose and gives expression in its form to its purpose. And further, people shall see in our furniture, that it is prepared from German materials, created by German artists, and is the expression of German emotions and feelings.[15]

Furniture thus became a means of cultural improvement, rather than something to fill a house, and this sort of language persisted in the rhetoric of such profit-making organisations throughout the first two decades of the twentieth century. While artists were trying to justify themselves in the face of industrial change, they took on the language of both German nationalism and commercial propaganda. They began to speak of art both as a means of improving society and as a commodity in the narrowest sense of the word. Through its more general cultural associations, art became one of the means in which industrialists valorised their products in the early years of the twentieth century, although the artists themselves did not allow their 'product' to be kidnapped by the capitalist marketplace without some opposition.

These tensions were brought to the surface after the founding of the Deutscher Werkbund,

37 Bernhard Pankok, cupboard, 1899

the most powerful and important society devoted to design and commodity culture in early twentieth-century Germany.[16] The Werkbund differed from the crafts-based Werkstätte in a number of ways. First of all, it turned its attention more clearly to contemporary economic problems, whereas the Werkstätte, organised and administrated by the artists, were focused more strongly on purely aesthetic issues.[17] Second, the Werkbund served to amalgamate more fully the pedagogic aspects of the Werkstätte, as its educational reforms were directed more rigorously towards artists, consumers and 'middlemen' such as salesmen. Third, it differed from the Werkstätte in that it was politically motivated and associated throughout its 16-year existence with government initiatives for cultural reform. Finally, it can be contrasted with the Werkstätte in its more clearly national agenda. The Werkbund was not intended to be a local organisation but a German one, with a mission to improve design as a way of promoting German economic interests in the international marketplace. In this respect, it followed in the wake of nineteenth-century cultural reform movements such as the Bund Heimatschutz and the Dürerbund, but unlike these predecessors the Werkbund wanted to achieve unity within a modern capitalist consumer culture.[18] In the years before the First World War, debates within the Werkbund about how to achieve this aim were wide-ranging and heterogeneous. Like the Secession movements earlier and Dada later, the Werkbund comprised individuals whose approaches to aesthetics and economics was dialectic, rather than monolithic.[19]

The economic and political dimensions of the Werkbund were present even before the official foundation of the organisation, largely through the activities of one of its founder members, Hermann Muthesius.[20] Muthesius was a civil servant, who began his career as architectural attaché to London, and returned to Berlin in 1903 to take up a post in the Prussian ministry of trade. Like many of his contemporaries, Muthesius was attracted to reforms in English architecture, and with his own architectural practice he had unique insights into both contemporary aesthetics and government attitudes to design. While in the ministry of trade, he contributed to the reformation of art schools and used his influence to secure the appointment of Peter Behrens to the Art Academy in Düsseldorf and Bruno Paul to the Berlin School of Applied Arts. Muthesius's ideas about architecture and its role in contemporary German life owed a great deal to the speeches of the centre-right Christian Socialist Friedrich Naumann. Naumann advocated a sort of anti-Marxist socialism which appealed to the middle classes as a unifying force in German life. His ideology was a mixture of bourgeois prejudices and socialist ideals, and this odd combination fuelled the cultural aspirations of contemporary industrialists. Naumann did not pay homage to the machine, nor did he condemn machines as alienating human labour. He felt that machines could be 'spiritualised' to serve the needs of modern society. And it was the artist who would provide the spiritual force for the materialistic machine. This interesting mixture of the Nietzschean language of cultural reform with the rationalism of middle-class values was to persist in Werkbund debates.

Naumann's ideas had already gained a strong following amongst cultural reformers, including the founder of the Dresdener Werkstätten, Karl Schmidt,

but it was Muthesius who first gave Naumann's theories a real impetus in the art world. At his inaugural lecture at the Berlin School of Commerce of 1907, Muthesius praised the Third German Arts and Crafts Exhibition which had been held in Dresden in 1906. In his controversial speech, he hinted that German manufacturers were contributing to the degeneration of society by producing cheap, trashy goods. Taking the excellent work of the Arts and Crafts movement as an inspiration, contemporary industrialists needed to 'act morally' and pursue 'quality'.[21] Muthesius played upon the nationalist and religious sentiments of his audience, but he offended the Trade Association for the Economic Interest of Applied Arts, which saw his attack as damaging to the reputation of contemporary designers. Nevertheless, his mixture of economic pragmatism and nationalist romanticism proved attractive enough to inspire the foundation of the Werkbund – an organisation designed to improve the quality of modern German industry.

Muthesius's tone was echoed in the first meeting of the Werkbund, which took place in Munich in October 1907. The first president of the organisation, the architect Fritz Schumacher, claimed that Germany needed to become modern, but it had to avoid the amoral materialism that often accompanied modernisation. The task of the Werkbund was therefore, on one level, to ensure the success of German industry through the production of good design, and, on another level, to contribute to national unity and raise Germany's profile in Europe and other parts in the world. The latter aim was perhaps the strongest thread throughout the early Werkbund propaganda. Modern design and modern technology would not simply make life better for the citizens of Germany but would result in the production of exportable commodities which would be desired by the outside world. The idea that Germany should be recognised and admired was never far from the minds of the Werkbund members, and, in this respect, the organisation was initially unified in its aims.

The Werkbund membership steadily increased from 492 in 1909 to nearly 3,000 by 1929, despite the intervention of the First World War. This membership consisted of both individual artists and industrialists, although the success of the Werkbund led to the addition of corporate membership in 1912. After its foundation, it quickly grew through local branches and greater bureaucracy, and its annual conferences became essential events for aspirant industrialists. The Werkbund was responsible for educating the consumer as well as the designer through courses, exhibitions and a yearbook. Through the agency of one of its members, Karl Ernst Osthaus, the Werkbund was responsible for founding the Deutsches Museum für Kunst im Handel und Gewerbe (German Museum for Art in Commerce and Industry), which was opened in Hagen in 1908 and sponsored a range of travelling exhibitions.[22] It advocated 'quality' in design but, from the beginning, the needs of the manufacturer were privileged over those of the artist.

Indeed, it was the tension between the often conflicting requirements of aesthetics and consumer culture that led to open controversy within the Werkbund as the First World War approached. The fact that the dissident artists did not secede from the Werkbund was due in part to the distraction of the war, but also indicated the power that a national government-sponsored and industry-based organisation had over all those who worked within it.

Artists formed Secessions by breaking away from academies and exhibition societies, but they remained with the Werkbund, despite their opposition to its principles. The disagreements within the Werkbund were as much a matter of ideology as practice. Those who strongly objected to what the Werkbund was doing did not join in the first place and undoubtedly agreed with the economist Werner Sombart that a machine-based culture would never result in genuine 'quality' items. However, most artists within the Werkbund wanted to find a way to reconcile the production of quality commodities with the need to cultivate a modern German culture, but they could not agree on how this could be achieved.

The vast Werkbund bureaucracy prevented the mutterings of dissident artists from becoming an issue until the annual conference in July 1914. Shortly before this conference, Muthesius circulated ten theses in which he argued for standardisation (*Typisierung*) in modern industrial design.[23] His argument was that such standardisation would not only ensure the quality of design, but it would give a distinctive face to German industrial products. To a certain extent, standardisation was already in force in German industry. The Werkbund architect Peter Behrens, for example, was hired by the electricity company AEG as a 'cultural adviser', but his real job was to help create a corporate identity for that rapidly expanding organisation.[24] Also, German manufacturing was so dominated by syndicates and cartels that managers had less need to be concerned about price wars and could concentrate on the luxuries of product design. The communal nature of manufacturing led more often to cooperation between large industries, rather than attempts to introduce competing products and product design, and branding became an important means of establishing a product's individuality.[25]

But despite these industrial realities, the pre-circulation of Muthesius's theses aroused the ire of a group of architects and designers who still believed in the importance of individualism. Among this group, the architects Gropius, Behrens, van de Velde, Poelzig and Taut exchanged a series of letters in which they rehearsed the arguments for breaking away from the Werkbund. Poelzig felt that they had created a 'monster' in the Werkbund, while Taut argued passionately for a creative elite with an architect as 'dictator'. This was the conspiratorial opposition, but their ideas were presented publicly by van de Velde, who circulated ten counter-theses at the conference which argued the case for artistic individualism. Van de Velde's passionate advocacy of the artist's rights may not have been the most powerful counter to Muthesius's arguments for standardisation. In reality, German industry was still dominated by a pluralism of styles, as the modern consumer realised that he or she could have whatever they wanted. Taste became more individualistic, despite the efforts to achieve cultural unity. Muthesius probably intended his attack against this sort of eclecticism, rather than against individuality *per se*, but whatever his intention, he was forced to tone down his recommendations, and the advent of the First World War steered the Werkbund away from ideological feuds.

The war helped unify the Werkbund and even brought about its ideals for standardisation. During the war, the need for usable modern weaponry focused the Werkbund's attention while intensifying the organisation's nationalistic undercurrents. After the war was over, the Werkbund flourished, and it

continued to maintain a membership which consisted of some of the most renowned architects and industrial designers. However, with changes in economic conditions brought about by the destruction of the war, theoretical debates gave way to an ostensibly more unified approach to design. The zenith of the Werkbund's activities was the 1927 housing exhibition in the Weissenhof district of Stuttgart, which included 60 buildings by various architects, all devoted to the theme of low-budget mass housing.[26] Despite the success of this exhibition, the Werkbund was not immune to the severe economic recession and government funding cuts of the late 1920s. It was also subject to attacks from both the political left – who found its approach to housing shortages half-hearted – and the political right – who felt that its emphasis on modernisation made it dangerously international. The Nazis appropriated what they could of the Werkbund in 1933, but they developed the organisation's emphasis on standardisation to the detriment of its modernity. In the meantime, the Werkbund had succeeded in exporting and gaining recognition for modern German design, but it had in no way inspired the cultural unity desired by its founders.

One of the Werkbund's major roles throughout its 16-year existence was educational. Although the Werkbund did contribute to the reform of art schools, its major educational initiatives were geared towards consumers, managers, shopkeepers and industrial designers. The reform initiatives of the Werkbund did not really find their way into the art curriculum until the foundation of the Bauhaus in 1919, but the approach and focus of the Bauhaus was essentially different from that of the Werkbund. For the Werkbund, a reconciliation of consumers and producers was the purpose and motivation behind the organisation's activities; in the Bauhaus, it was the reform of art education combined with the utopian ideals of its founder and staff. Ironically, where the Werkbund failed to make a lasting stamp on German consumer culture, the Bauhaus – through its innovations in product design – left a decisive impression on both Germany and elsewhere.[27]

The Bauhaus was founded in Weimar in 1919, but like the Weimar Republic itself, it was not so much a new organisation as a coalition of existing institutions and reformers. The Grand-Duke of Sachsen Weimar-Eisenach, whose domain included the historic city of Weimar, had already been seeking a means to unite art education and industry in the town, and he had hired Henry van de Velde for just that purpose. At van de Velde's suggestion, the architect Walter Gropius was selected to head a new art academy which was composed of the old School for Fine Arts and the more recent *Kunstgewerbeschule*. The idea behind this new academy was an amalgamation of fine arts and crafts, with an emphasis on design skills as a necessary concomitant to developments in technology. The students of the new school would learn both 'fine art' and craft, and they would, ideally, be able to make a direct contribution to modern industry. Ultimately, the school was intended to manufacture its own products to sell and make money to finance other activities. This combination of Werkstatt and Werkbund ideals permeated Bauhaus theory and practice for the first few years of its existence. On the one hand, the Bauhaus looked back to the medievalising tendencies of Morrisonian design reform, but on the other hand, it had to confront the Werkbund's

desire for a reconciliation of aesthetics with modern consumer culture. In the beginning, utopian idealism was most apparent in the theory and practice of the Bauhaus. The very decision to open the new school shortly after the devastation of the war was part of this post-revolutionary idealism.

For a start, the choice of Walter Gropius as first director complemented the post-war utopianism experienced when the Kaiser was deposed and Germany was declared a republic.[28] On a practical level, Gropius was an apt choice. He was an architect, and he had already proved his ability to work creatively with modern materials. In early buildings, such as the Fagus Factory of 1910–11 and the model shoe factory for the Cologne Werkbund exhibition of 1914, Gropius produced the sort of designs that balanced individuality with a use of modern materials. He used steel and glass, and dispensed with the old-fashioned load-bearing wall in favour of a steel frame. In these buildings, Gropius showed that he could bring something of the skill and uniqueness of craftsmanship to the employment of modern materials. His involvement with the Werkbund further qualified him for the job, despite his reservations about the organisation's practices.

It was not, however, Gropius's practical experience but his artistic idealism that helped mould the character of the early Bauhaus and injected it with a vision that persisted for many years. Gropius's involvement with the Arbeitsrat für Kunst, fuelled his fervent belief in the importance of architecture to a fulfilled life – a value which he shared, at least in principle, with the pre-war Werkbund. In a memorandum for the programme of the Arbeitsrat, Gropius wrote that he wanted to 'Unite all the arts under the wings of great building [Baukunst]', a sentiment which he later echoed in the programme for the Bauhaus: 'The ultimate aim of all visual arts is the complete building'.[29] Gropius's early Bauhaus speeches are full of phrases about war, unity, chaos, spirit and synthesis, all of which resound with the Expressionist utopianism of the post-war period. He always came back to the idea of architecture as the ultimate unifying force for all the arts, and he reiterated this visually in his 'syllabus' for the Bauhaus course.

The organisation of the school and the structure of its course represented Gropius's belief that the Bauhaus would contribute to a renewal of post-war society, that it would help consolidate the values of the new republic. Gropius introduced the taxonomy of the medieval guild system: the teachers were 'masters'; first-semester students 'apprentices'; second-level students were 'journeymen'. The school was also divided into 'workshops', each of which was devoted to a different material. Furniture, metal, carpentry, sculpture, pottery, mural and stained glass workshops at Weimar were in later years joined by typography and photography workshops. In a true spirit of the unity of the arts, there was also a theatre workshop, where some of the most innovative ideas of the Bauhaus were realised. In order to reconcile the need to integrate arts and crafts, each workshop had two masters, a Master of Form (the artist) and the Workshop Master (the craftsman). The Master of Form was to teach the students how to use their creativity, whereas the Workshop Master was to instruct them in the qualities of materials and the techniques of craft.

The progression of the student from apprentice to master seemed at first a logical one. The syllabus wheel of the Bauhaus reveals how this training was

intended to function. First of all, there was a preliminary course (*Vorkurs*) which lasted six months, and which the student had to pass in order to continue to the next stage. During the *Vorkurs*, the student was allowed to familiarise him or herself with various materials, textures and colours. During the next stage of the course, the student was assigned to a specific workshop and received technical instruction for three years, leading to a more sophisticated understanding of the properties and possibilities of individual materials like stone, wood, and glass. A small number of gifted students were allowed to extend their instruction and to aspire to the title of Master. Ultimately, all of this training was intended to lead the student to create the 'Bau', or the building towards which the Bauhaus course was theoretically aimed. But what was true in theory was flawed in practice.

The school itself was seen as a sort of *Gemeinschaft*, in which masters and apprentices worked side by side towards a common goal. This evocation of medieval society was not simply a game; it was a serious attempt to undercut the hierarchies that made conventional academies such authoritarian institutions. The acceptance of a number of women on to the Bauhaus course was further evidence of these democratic tendencies, and the programme of the course emphasised that admission was allowed to 'any person of good repute, without regard to age or sex',[30] thus counteracting the exclusivist tendencies of the old art academies. The association of women with the maintenance of craft traditions such as weaving was, in theory at least, important to the Expressionist medievalism of the early Bauhaus.[31]

The gendered nature of craft was reinforced by other aspects of early Bauhaus teaching practice that picked up on the feminised undercurrents of Expressionist theory – especially the emphasis on intuition and primitivism. These qualities appeared in the pedagogical methods of the Swiss painter Johannes Itten.[32] Gropius met Itten in 1918, where he was making a name for himself in Vienna through his innovative approach to teaching art. Like Kandinsky, Itten's own paintings and graphics reveal his interest in the relationships between colour and form, and he carried these ideas into his teaching at the Bauhaus. He initiated the *Vorkurs*, in which he stressed the liberation of the students' creative potential. Following a general tendency in German educational reform, Itten believed that education should be used to free hidden talents, rather than imposing dogma on sensitive minds. His unorthodox methods were non-authoritative, non-methodical and based on intuition, rather than instruction (figure 38). His sympathies with Eastern religions led him to encourage the students to meditate and practise breathing exercises before they began their artistic activities. There was always a sound purpose in Itten's improvisatory tactics. To understand rhythm, he asked students to dance and gesture with their arms, and then draw what they had done and seen. He set them exercises in 'analysing' old master paintings by reducing complex works of art to geometric or colour patterns. His introduction of physical exercises and tendency to lecture on subjects from everyday life were all designed to relax the student so that he could get the best efforts from them. He later claimed 'imagination and creative ability must be first of all liberated and strengthened. Once this has been achieved, technical and practical demands and finally commercial considerations may be introduced.'[33] Itten's low placement of 'commercial

38 Student exercises from Johannes Itten's preliminary course

considerations' was in line with the idealism of the early Bauhaus, but it did not help the institution realise its ultimate pragmatic goal of selling the items produced in the workshops. His introduction of religious mysticism and vegetarianism into his teaching also upset or offended some of his students and fellow teachers. He waged a tense battle with Gropius over the purpose of the workshops, and when they could not reach an agreement, he resigned in 1923.

Itten's methods brought together qualities that had become associated with the wartime *Sturm* culture, but the early Bauhaus also showed inclinations towards the Expressionist version of the *Gesamtkunstwerk*. To an extent, this idea was located in Gropius's building – the '*Bau*' – which was intended to be the ultimate goal for all students and masters. Painting, furniture, pottery, textiles, typography were component parts of the building, just as music, epic poetry, set design and performance comprised the Wagnerian *Gesamtkunstwerk*. But the Bauhaus also undertook to become involved in experimental theatre, and in this sense, carried on a legacy that began with the Jugendstil and became an essential part of both Walden's empire and the Zurich/Berlin Dada circles. The master most involved in this facet of Bauhaus work was Oskar Schlemmer, who joined the institution in 1921.[34] Like Itten, Schlemmer came to the Bauhaus as a painter, but his own work had a figurative quality that was lacking in the abstract productions of the others. Schlemmer's

representational inclinations were barely disguised by the puppet-like figures that dominated his paintings, and his involvement with the theatre became the most appropriate way to express this humanity in an increasingly abstract age. Schlemmer felt that a purely abstract theatre was impossible, and that the stage depended on the human form. However, his own stage productions stressed the 'mechanisation' and 'abstraction' of the human form, and veered away from any sort of naturalistic representation.[35] His attempt to people the stage with the *Kunstfigur* (artificial human figure) was realised in his *Triadic Ballet*, which was first performed in Stuttgart, and then at a theatre in Weimar in 1923.[36] The *Triadic Ballet* contains three scenes, twelve dances and eighteen costumes, and it was performed by only two men and one woman. The three parts of the piece correspond to colours and moods: scene one is in a burlesque mode, and is dominated by yellow; scene two is in a solemn mode and is dominated by rose; scene three is serious, even gloomy, and is dominated by black. The unusual costumes of the ballet were all designed by Schlemmer to represent spiritual values. The movement in the ballet was stylised and artificial. The ballet was surprising, humorous and compelling, and it succeeded in realising Gropius's desire for unity of the arts.

As the activities of the early Masters reveal, the Bauhaus was a creative institution, which encouraged some of the Expressionist enthusiasms that prevailed immediately after the First World War. These Expressionist elements in Bauhaus theory and practice seem to distinguish it from the more pragmatic economic concerns of the Werkbund, but throughout the early years of the Bauhaus revolutionary idealism competed with the knowledge that the economy had collapsed and rejuvenation of Germany through the latest technology was felt to provide one answer to this problem. Thus, underlying Gropius's idealism were strands of practicality which eventually suppressed the initial spirit of the Bauhaus. In a retrospective assessment of his contribution to the Bauhaus, Gropius insisted that his idea was always to reconcile art and industry and find ways of using machines to make modern life easier and more civilised:

> Were mechanisation an end in itself it would be an unmitigated calamity, robbing life of half its fullness and variety by stunting men and women into sub-human, robot-like automatons . . . But in the last resort mechanisation can have only one object: to abolish the individual's physical toil of providing himself with the necessities of existence in order that hand and brain may be set free for some higher order of activity.[37]

This seemed to appear strongly in Gropius's attitude towards the Bauhaus from 1923, when he invented a slogan 'Art and Technology – A New Unity' which did not meet with the approval of all his colleagues. The artist Lyonel Feininger joked about this slogan in several letters to his wife, Julia, but ultimately he expressed the dissatisfaction that many of the Bauhaus Masters felt about this concession to industry:

> This misinterpretation of art is . . . a symptom of our times. And the demand for linking it with technology is absurd from every point of view. A genuine technologist will quite correctly refuse to enter into artistic questions; and on the other hand, the greatest technical perfection can never replace the divine spark of art.[38]

Despite Feininger's objections, the association between art and industry was implicit in the programme of the Bauhaus from the beginning. Not only would the Bauhaus allow painters and craftspeople to work together, and thereby elevate design to the level of fine art, but it would also serve 'to make contacts with industry'. Ultimately, the links between art and industry would promote an architecture that used modern methods, materials and aesthetics and would aim to improve quality of life.

Gropius's stance of compromise also characterised the teaching of some of the other Masters of the Weimar Bauhaus, most notably Kandinsky and Klee. Itten's emphasis on art as a spiritual activity was fully in line with Kandinsky's pre-war theories of art. Kandinsky had left Germany during the First World War and made his way, via Sweden, back to Russia, where he painted very little. When the Russian Revolution of 1917 resulted in sweeping changes in public art institutions, Kandinsky became involved in educational reform through his association with INKHUK (The Institute of Artistic Culture) in Moscow. Although he was asked to contribute a plan for the organisation of a new kind of art school, Kandinsky's emphasis on the spiritual in art was not received sympathetically in the utilitarian climate of post-revolutionary Russia. He therefore came to Weimar in 1921 and joined the Bauhaus, taking his ideas about art education with him.

Kandinsky was named Master of Form for Murals, and, with Klee, he took charge of the formal training of students who had just completed the *Vorkurs*. His own painting during this period was both related to, and distinct from, his pre-war work. Although he still wished to retain the transcendental resonances of abstract form, his paintings of the 1920s reveal a refinement of style that indicates some tendency towards the 'rationalism' of Constructivism that was beginning to gain authority in communist Russia. He still claimed to believe in the spiritual value of colour, but he concentrated his attention more decisively on form. He expressed these ideas in a book he published in 1926 through the Bauhaus, *Point and Line to Plane*.[39] Kandinsky's new interest in the effects of form, combined with his old ideas about colour, affected his teaching at the Bauhaus. He still insisted on the emotional effects of colour and form, but his ideas crystallised into a greater rigidity. He insisted that certain colours were directly analogous to certain forms in their spiritual associations: thus blue was the equivalent of a circle, red of a square and yellow of a triangle. He set students exercises in which they were required to mix and match various colours and forms to create different emotional effects. Kandinsky hoped to make students aware of the transcendent properties of colour, and, like Itten, he set analytical drawing exercises in which students had to 'translate' still lifes into geometric forms.

Complementary to his teaching, but nevertheless distinct, was the approach of his colleague, Paul Klee.[40] Like Kandinsky, Klee had been associated with pre-war Expressionism, and he had been involved briefly with the Blaue Reiter. His art was thus essentially concerned with universal spiritual values, but, like many of his Expressionist contemporaries, Klee veered towards an abstract expression of his views of nature and man. Klee believed that nature was 'reborn' in a picture and that the artist should not copy nature, but he should learn to create a different kind of nature on his canvas: 'Pictures have their

skeleton, muscles and skin like human beings'.[41] Klee's musical training inspired the symbiosis between mathematical law and intuition that characterised his work. His ideas about the internal nature of a picture were expressed in his teaching at the Bauhaus and in his Bauhaus publication *The Pedagogical Sketchbooks*.[42]

The combination of spiritual and rational elements in the teaching of some Bauhaus Masters also characterised the practice of the American expatriate Lyonel Feininger, who, like Gropius, was associated with both Walden's *Sturm* magazine and with the Arbeitsrat für Kunst.[43] Feininger began his career producing satirical cartoons for journals such as *Simplicissimus*, but his contact with Walden led him to explore the possibilities of painting. In 1913 he discovered village church architecture on a trip around villages near Weimar. His subsequent series of scenes of the church at Gelmeroda become increasingly abstract and visionary. He produced the frontispiece for the initial programme of the Bauhaus, representing Gropius's utopian 'cathedral of the future', modelled unashamedly on a Gothic cathedral, but with the emphasis on the abstract shapes of the building. However, underlying Feininger's visionary representations of medievalising buildings was a concern with form and the structural properties of painting.

Although painters like Kandinsky, Klee and Feininger moved towards a reconciliation of idealism with a kind of mathematical formalism, the Bauhaus mission to improve design was being achieved more in the realm of theory than practice in the first few years after its foundation. During these early years, the institution was frequently criticised for its lack of sound technical instruction. The accusation that the Bauhaus was not fulfilling its initial purpose came largely from other artists and architects. Gropius had intended that the Bauhaus should be linked with industry from the beginning, but his idealism was undermined by lack of funds and rampant inflation. In order to promote the links with industry, students were allowed to use the materials in the workshops free of charge, providing the Bauhaus had control of the final product. The emphasis on painting in the teaching methods of the Bauhaus worked against this, and very few sales were made in the first few years. Gropius tried to improve the situation by involving students in one of his own architectural commissions, a house he designed for the timber industrialist Adolf Sommerfeld in Berlin. Gropius and his architectural partner, Meyer, built the house, and they drew in some of the Bauhaus's best students, including Marcel Breuer and Joost Schmidt, to do the interior decoration. The final result was an Alpine cottage in the vernacular tradition, rather than a product of modern technology, but it certainly served to liberate the medievalising 'craft' instincts of the Bauhaus students, and it was a positive beginning for their entrepreneurial ambitions.

However, there were still critics of the Bauhaus's perceived failures. One of the most vehement of these was the Dutch artist Theo van Doesburg, who came to Weimar in 1921, initially full of enthusiasm about the Bauhaus. Doesburg was one of the initiators of the Dutch movement De Stijl, which shared some of the values of Germany's cultural reform movement. The artists of De Stijl were attempting to unite the fine artist and the designer, with the ultimate aim of creating a unified and universal modern style which

incorporated developments in modern technology. Doesburg found the lack of tangible results in the Bauhaus an offence, and he proceeded to attack the institution for its pseudo-mystical didactic methods. It was partly due to the pressure of Doesburg that Gropius chose to replace Itten with a Master from a very different artistic background, the Hungarian artist László Moholy-Nagy.[44]

It has become commonplace to polarise Itten's mystical approach to art with that of Moholy-Nagy, whose art theories were based strongly on his own political activism, but such a polarisation fails to take account of the fact that both artists, in their own ways, were idealists who retained utopian visions about the possibilities of art in modern society. Itten's mysticism and colourful and rhythmic paintings appear to provide a more escapist response to modernity than Moholy-Nagy's activism and austere controlled abstracts, but both represented strongly held ideas about the necessity of a developed visual culture in the modern world. Moholy-Nagy had become involved with cultural politics while still in Hungary, when he helped found the avant-garde group MA (Today) in 1918. He travelled to Vienna in 1919 and Berlin in 1921, and he absorbed the ideas of the contemporary Russian art movements, Constructivism and Suprematism. Both of these tendencies favoured abstraction, and Constructivism was being adopted in Russia as a practical style for the contemporary proletariat. The Russian Constructivists and especially the Productivists rejected the hegemony of easel painting, which they found to be a useless bourgeois art form, and although Moholy-Nagy produced a number of easel paintings throughout his career, he avoided representation and focused on abstract geometric form. Because of his activist instincts, he was a strong advocate of art's role in society. When he came to the Bauhaus in 1923, he took over the preliminary course and adopted a more practical approach that helped lead towards the unification of art and craft. His impact on the Bauhaus was seen most obviously through his role in producing the series of fourteen Bauhaus books, and in his introduction of a photography workshop in 1929. His interest in the possibilities of light and sound led him to become involved in the theatre and photography, and later, when he left the Bauhaus, film.

But the real turning point in the Bauhaus's attempts to associate with the realities of modern consumer capitalism could perhaps be dated to the exhibition of 1923 when, for the first time, the work of the Bauhaus was shown publicly. The exhibition was a big event, staged to attract both public and industrial attention. It consisted not only of displays of art and craft, but also performances and lectures. It drew 15,000 people and, more importantly, it was a propaganda victory for the Bauhaus beyond the confines of Weimar. One of the most important parts of the exhibition was a model house, the Haus am Horn (figure 39), designed for the 'modern' family. The inclusion of model buildings as part of large exhibitions had been one of the practices of the Werkbund, but the Haus am Horn was distinct from these in that it was intended as a domestic residence for a modest middle-class family. The house and all its fittings were designed by staff and students of the Bauhaus with the purpose of making life as easy and convenient as possible. It consisted of a high-ceilinged living room, lit by clerestory windows and surrounded by other, smaller, rooms. The living room was designed for the whole family, and its

positioning meant that it was the warmest and most communal room of the house. The subsidiary rooms included perhaps the first fitted kitchen and a children's bedroom with chalkboard covers on the walls and toy boxes which could also serve as tables and chairs. The laundry room and other utilities were located in the basement. The house was intended to be compact and convenient, and each design element was planned with the practicality of daily living in mind. The idea of a house without ornament, built solely with function in mind offered a nod to Muthesius's *Typisierung* which became transformed from an aesthetic philosophy to a label for modern mass-produced housing.[45]

The success of the 1923 Bauhaus exhibition served to enhance the reputation of the school and to draw interest in its products from industry with the possibility of an enhanced market for its work. But these reconciliations within the institution did not prevent attacks from outside it. Throughout its existence in Weimar, local opposition to the Bauhaus and all its activities was strong. A contingent of members of the right-wing National People's Party claimed that the Bauhaus repressed artistic freedom and promulgated a doctrine of uniformity, while imposing suspect Expressionist ideals on gullible students. This was deeply ironic, given that pre-war Werkbund debates about uniformity grew from the desire to find a way to regulate and conciliate a conservative and patriotic middle-class. The equally vociferous complaints about the rush of bohemian students into the quiet city of Weimar led to a petition in December 1919 asking the state ministry to close the Bauhaus. Local citizens made several accusations against the Bauhaus, all of which pointed to right-wing suspicion of ostensibly left-wing activity. The Bauhaus was said to harbour Spartacist elements and to be responsible for disseminating communist propaganda. Its emphasis on design above 'fine' art was claimed to be to the detriment of German cultural values. Gropius was accused of 'unilaterally favour[ing] elements alien to the race at the expense of German nationals', and it was alleged that a patriotic student had been harassed for defending Germanness at a Bauhaus meeting.[46] Certainly the Bauhaus did contain a large share of staff who had, at some time in their lives, been sympathetic to socialism or communism, but very few of the staff or students were foreign, and even fewer were Jewish (which was what the petitioners really meant when they referred to 'alien' elements). The idea that the Bauhaus was too devoted to the lowly crafts was equally wrongheaded, as its very lack of attention to crafts and architecture led to attack from artists like Doesburg.

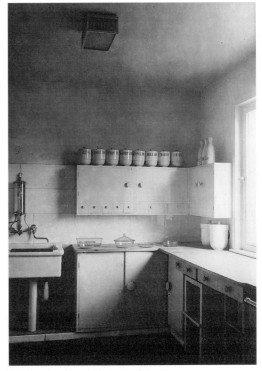

39 Interior (fitted kitchen) of the Haus am Horn, 1923

Just as the school began to become successful, political change in Weimar brought the right-wing nationalist parties firmly into power, and the prejudices against the Bauhaus led to political action. Gropius's home was searched by Reichswehr (army) soldiers in November 1923, and the Landtag (regional parliament) withdrew their funding of the institution in 1924. Despite bitter letters from Gropius, his colleagues and his students, the Bauhaus was forced to find another home. Several cities offered to take on the project, but Gropius chose to move the Bauhaus to Dessau in 1925. The move to Dessau was one of the most obvious signals that the old idealistic days of the Bauhaus were over and that Gropius's slogan 'Art and Technology – a New Unity' was in force. Although it was, like Weimar, a historical city, Dessau had a larger population and more industry, including the Dessau Sugar Refinery, the German Continental Gas Company, the Polysius Machine Factory and the massive Junkers works, which consisted of aircraft and rail-car factories. Dessau was the sort of industrial city that conformed to the more modernising ideology of the Bauhaus, and the first opportunity to demonstrate this ideology came with the building of a new school in Dessau.

The new Bauhaus building (figure 40), designed by Walter Gropius and opened in the autumn of 1926, represented a sort of monument to his slogan about the unity of art and technology. The building used modern materials and it was practical. It had an L-shaped design which spanned a road, and students could go everywhere in the building without having to venture out of doors. On one side of the road, the building housed a technical school; the bridge across the road contained administrative offices; and the other side of the street consisted of workshops, the stage, the dining hall, and 28 self-contained studio flats for the students. The 'Masters' (who were now called Professors) had separate houses nearby, which had also been designed by Gropius and the Bauhaus students.

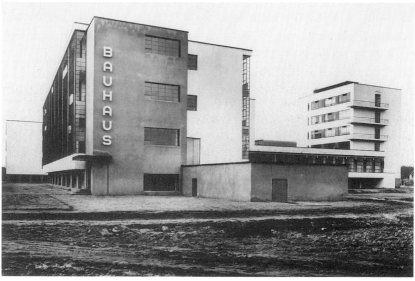

40 Exterior of the Dessau Bauhaus

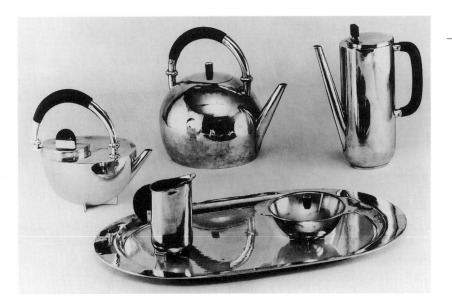

41 Marianne Brandt, coffee and tea service

The new building signalled the new aims of the Bauhaus, and these were also reflected in changes in the structure and methods of the course. The dual teaching method, in which each workshop contained both an artist and a craftsman, was abolished, and now one Professor in each workshop inculcated skills of both 'fine' art and design. This was made possible by the fact that several of the better Bauhaus students, such as Josef Albers and Marcel Breuer, had graduated and had become 'Masters' themselves. With their training in both art and industry, they were able to combine these skills in teaching other students.

Another major change in the new Bauhaus was its greater orientation towards the market. At the time of its opening in Dessau, a 'Bauhaus corporation' was formed to oversee the business enterprises of the school. The school began to produce lamps, tables, kettles, chairs and other items to order (figure 41). The furniture, tapestry and typography workshops were among the most successful in the institution. For the furniture workshop, the former student Marcel Breuer produced the first tubular steel chairs, and another former student, Gunta Stölzl, headed a very successful tapestry workshop, which encouraged consumers to adorn their walls with textiles, rather than easel painting. The typography workshop published a series of Bauhaus books between 1925 and 1930 which introduced typographical changes. Under Moholy-Nagy's direction, the typography workshop dispensed with the fussy lettering of German Gothic script, and they favoured lower-case letters against the grain of the German system of capitalising all nouns. The smooth, clinical appearance of their typography helped create a distinctive Bauhaus style which was soon adopted by other publishers in Germany and Europe. The Bauhaus books also promulgated the school's own art theories. Among the works published were writings by Klee, Schlemmer, Moholy-Nagy and Kandinsky, as well as other avant-garde art treatises, such as Piet Mondrian's *Neo-Plasticism* (1925) and Albert Gleizes' *Cubism* (1928).

But while the Dessau Bauhaus represented a greater fusion of the aesthetic and economically pragmatic interests of the Weimar period, other aspects of their earlier ideology were obliterated. The Expressionist medievalism that had motivated Gropius and Feininger, for example, faded away, as did Morrisonian ideals about craft. The new Bauhaus worked primarily with the machine, and this had the additional impact of marginalising Bauhaus women, many of whom were practitioners of traditional handcrafts like weaving.[47]

Instead, this deeper relationship with technology led to a new architectural workshop, which opened in 1927. With the opening of this workshop, the Bauhaus seemed to have achieved its early ambitions, but at the cost of the enthusiasm and idealism of the original school. Gropius selected the Swiss Hannes Meyer as the new Professor of Architecture, as he believed that Meyer's principles were in keeping with those of the Bauhaus. Meyer's speciality was the use of modern materials for mass housing. This was a particularly important issue, given a perpetual housing shortage in Germany during the 1920s. But as with many other contemporary architects, Meyer's enthusiasm for mass housing was part of a larger political commitment. He had strong Marxist leanings and felt that art and technology should work together to ameliorate the debased conditions of the proletariat. Meyer's presence at the Bauhaus as a Professor did not cause a problem in itself, but problems did arise in 1928 when Gropius resigned the directorship due to pressure of his private architectural practice. Meyer was appointed as his successor, and this contributed to the eventual collapse of the institution.

Meyer's contribution to the ruptures within the Bauhaus was not deliberate or premeditated. Given Gropius's hope that the Bauhaus would work to improve standards of architecture, Meyer was a logical choice. But the appointment was unpopular with the other staff at the Bauhaus for a number of reasons. First of all, he was opposed to the emphasis on painting in the workshops, and he sought to undermine its importance. This was in part a legacy of his own cultural politics, as he had the Russian productivist's disdain for the bourgeois status of easel painting, but it did not serve to assuage the ire of Professors such as Kandinsky and Klee who had remained on the staff and were still teaching colour and form. Second, Meyer had been at the school for only a year when he was elevated to directorial status, and this naturally aroused professional jealousy and was represented as a thoughtless mistake on the part of Gropius. Finally, Meyer's unpopularity went beyond the bounds of the school itself, and was rooted firmly in his strong political commitment. At a time of political turmoil in Germany, when right-wing factions were gaining greater power in government, and when Marxism and communism were seen to be extremist and incendiary, Meyer's candid political commitment was dangerous. His introduction of political ideology into the school curriculum brought him quickly to the attention of local authorities, who forced his resignation in August 1930.

Subsequent histories of the Bauhaus have often stressed that the school was intended to be apolitical and that Gropius had made great efforts to avoid introducing any form of political propaganda into the school. This seems to be confirmed by the fact that the petition against the Spartacist tendencies of the Weimar Bauhaus in 1919 was rejected by the state government on the

grounds of lack of evidence. Certainly, Gropius's cultural mission was a universalist one and, in principle, politics should have been excluded from this. But it is also true to say that from the beginning, the staff of the Bauhaus veered more towards the left than towards the right, and that their principles and practices were commensurate with the ideals of Expressionist socialism and Russian Constructivism. Given the political climate of the late 1920s, it would also have been difficult to quell student activism, whether or not Meyer fuelled potential Marxist tendencies in the student body. It is thus hardly surprising that in the tense political climate of the early 1930s the Bauhaus would come under attack.

After Meyer's resignation, the architect Mies van der Rohe was appointed director of the Bauhaus, and he proceeded to introduce extreme measures to inhibit political discussion within the school. But Mies van der Rohe's authoritarian tactics did little to help the Bauhaus, for when the Nazis gained control of the Dessau parliament in 1931, they rescinded the generous grant previously allowed to the Bauhaus. Mies took over what was left of the school and reopened it as a private institution in Berlin in 1932.[48] It lasted only a year after that. Although there was a period of compromise with Nazi authority soon after Hitler was elected Chancellor in 1933, the Bauhaus was deemed a refuge of 'Jewish-Marxist' ideology, and the school's products, with their anonymous modernity, were condemned as anti-German. The dispersal of former Bauhaus teachers to America carried the principles abroad, but the Bauhaus's contribution to German cultural unity was abruptly halted.[49]

What the cases of the Werkstätte, Werkbund and Bauhaus revealed was just how important it was for Germans to reconcile modern consumer capitalism with their own sense of national identity, as well as the larger issues of style, quality, unity and sense of higher purpose. These organisations, like the avant-garde art movements of German modernism, sought a reconciliation of old values with a new world. It could be argued that the desire for unity, the efforts to join modern technology with the excellence of medieval crafts traditions, the overriding wish to make a better society were all lost with the closure of the Bauhaus. But the collapse of the Bauhaus was only one symptom of the larger cultural problems that resulted from the encroachment of modernity, the shocks of the war and the instability of the German government after the fall of the Kaiser. The clash of old and new was to find particularly fertile ground in the mass culture of the Weimar Republic.

NOTES

1 Quoted in Hans Wingler, *The Bauhaus – Weimar, Dessau, Berlin, Chicago 1919–1944*, Cambridge, Mass., 1978, p. 31.
2 Quoted in John Heskett, *German Design 1870–1918*, New York, 1986, p. 119.
3 For a discussion of the different middle classes and their relationship with culture, see Robin Lenman, *Artists and Society in Germany 1850–1914*, Manchester, 1997, pp. 8–9; and Frederic Schwartz, *The Werkbund: Design Theory and Mass Culture Before the First World War*, New Haven and London, 1996, p. 15.
4 See Peter Lasko, 'The student years of die Brücke and their teachers', *Art History*, 20:1 (1997), 61–99, who gives details of the syllabus of the Brücke group and reveals that there was an element of 'fine' art training even in technical schools.

5 See Mark Jarzombek, 'The *Kunstgewerbe*, the *Werkbund* and the aesthetics of culture in the Wilhelmine period', *Journal of the Society of Architectural Historians*, 53:1 (1994), 7–19.

6 This connection was most famously and classically made by Niklaus Pevsner, *Pioneers of Modern Design: From William Morris to Walter Gropius* (1960), Harmondsworth, 1974. See also Reyner Banham, *Theory and Design in the First Machine Age*, Cambridge, Mass., 1981; and Joan Campbell, 'Social idealism and cultural reform in the German arts and crafts 1900–1914', in Gerald Chapple and Hans Schulte (eds), *The Turn of the Century: German Literature and Art 1890–1915*, Bonn, 1981, pp. 311–25.

7 See Henry van de Velde, *Die Renaissance im modernen Kunstgewerbe*, Berlin, 1901; and idem, *Geschichte meines Lebens*, Munich, 1962.

8 This point is made clearly by John Heskett in his excellent introduction to the subject, *German Design*.

9 For a discussion of this, see Kathryn Bloom Hiesinger (ed.), *Art Nouveau in Munich: Masters of Jugendstil*, exhibition catalogue, Munich, 1988.

10 The Statutes of the Vereinigte Werkstätten, quoted in Hiesinger, *Art Nouveau*, p. 169.

11 Nina Parris, 'Van de Velde, Obrist, Hoelzel: the development of the basic course', in Chapple and Schulte, *The Turn of the Century*, pp. 327–46.

12 See Sonja Günther, *Interieurs um 1900. Bernhard Pankok, Bruno Paul und Richard Riemerschmid als Mitarbeiter der Vereinigten Werkstätten für Kunst im Handwerk*, Munich, 1971; and Winfried Nerdinger (ed.), *Richard Riemerschmid: Vom Jugendstil zum Werkbund. Werke und Dokumente*, Munich, 1982.

13 For a discussion of women and craft, see Anthea Callen, *Angel in the Studio: Women in the Arts and Crafts Movement 1870–1914*, London, 1979.

14 Julius Meier-Graefe, *Modern Art: Being a Contribution to a New System of Aesthetics*, 2 vols, New York, 1968, vol. 2, p. 299.

15 Manifesto of the Dresdener Werkstätten, 1899, quoted in Heskett, *German Design*, p. 45.

16 There are several very useful sources on the Werkbund. Schwartz, *Werkbund* provides the most subtle and suggestive analysis of the group and its theory, but very clear introductions can be obtained from Heskett, *German Design*; Joan Campbell, *The German Werkbund: The Politics of Reform in the Applied Arts*, Princeton, 1978; Lucius Burckhardt (ed.), *The Werkbund: Studies in the History and Ideology of the Deutscher Werkbund 1907–33*, London, 1977; and Wend Fischer, *Zwischen Kunst und Industrie: Der Deutscher Werkbund*, Munich, 1975.

17 This is discussed most fully by Schwartz, *Werkbund*, who links Germany's cultural mission to contemporaneous economic theory.

18 Joachim Petsch, 'The Deutscher Werkbund from 1907 to 1933 and the movements for the "reform of life and culture"', in Burckhardt, *Werkbund*, pp. 85–93.

19 For the view of the Werkbund as a group of heterogeneous individuals, see Julius Posener, 'Between art and industry in the Deutscher Werkbund', in Burckhardt, *Werkbund*, pp. 7–8. For an opposing view of the Werkbund as a network of individuals whose more consensual views were formed before the foundation of the movement, see Mark Jarzombek, 'The discourses of a bourgeois utopia 1904–1908 and the founding of the Werkbund', in Françoise Forster-Hahn (ed.), *Imagining Modern German Culture 1889–1910*, Washington, DC, 1996, pp. 127–45.

20 See Hans-Joachim Hubrich, *Hermann Muthesius: die Schriften zu Architektur, Kunstgewerbe, Industrie in der 'Neuen Bewegung'*, Berlin, 1980; and Muthesius's own *Das englische Haus*, 3 vols, Berlin, 1904–5, and his *Die englische Baukunst der Gegenwart*, 2 vols, Leipzig and Berlin, 1900.

21 Schwartz, *Werkbund*, points out the way in which vague notions like 'quality' and 'style' were debased by repetition and became problematic in the Werkbund's attempt to develop its reformist theory.

22 See Herte Hesse-Frielinghaus, *Karl Ernst Osthaus: Leben und Werk*, Recklinghausen, 1971.

23 See the fascinating discussion of the implications of the term *Typisierung* and its changing meaning in Schwartz, *Werkbund*, pp. 122–5.

24 See Alan Windsor, *Peter Behrens: Architect and Designer 1868–1940*, New York, 1981; and Gisela Moeller, *Peter Behrens in Düsseldorf: Die Jahre von 1903 bis 1907*, Weinheim, 1991.

25 For a study of German advertising and marketing practices in the pre-war period, see Henriette Väth-Hinz, *Odol: Reklame-Kunst um 1900*, Giessen, 1985; and Frederic

Schwartz, 'Commodity signs: Peter Behrens, the AEG, and the trademark', *Journal of Design History*, 9:3 (1996), 153–84.

26 Richard Pommer, *Weissenhof 1927 and the Modern Movement in Architecture*, Chicago and London, 1991.

27 The documentation and history of the Bauhaus has received extensive attention in previous publications. Among these are Wingler, *The Bauhaus*; Frank Whitford, *Bauhaus*, London, 1984; Gillian Naylor, *The Bauhaus Reassessed: Sources and Design Theory*, London, 1985; Anna Rowland, *Bauhaus Source Book*, Oxford, 1990; Marcel Franciscono, *Walter Gropius and the Creation of the Bauhaus in Weimar: The Ideals and Artistic Theories of its Founding Years*, Urbana, 1971; Karl-Heinz Huter, *Das Bauhaus in Weimar*, Berlin, 1982; and Eckhard Neumann (ed.), *Bauhaus and Bauhaus People: Personal Opinions and Recollections of Former Bauhaus Members and Their Contemporaries*, New York and London, 1993.

28 See Herbert Bayer, Walter Gropius and Ise Gropius (eds), *Bauhaus 1919–1928*, London, 1975; Reginald Isaacs, *Gropius: An Illustrated Biography of the Creator of the Bauhaus*, Boston, 1991; and Sigfried Giedion, *Walter Gropius* (1954), New York, 1992.

29 Gropius's memorandum for the programme of the Arbeitsrat für Kunst, quoted in Franciscono, *Walter Gropius*, p. 255; and Walter Gropius, *The Programme of the Bauhaus*, quoted in Wingler, *Bauhaus*, p. 31.

30 *Programme of the Bauhaus*, quoted in Wingler, *Bauhaus*, p. 33.

31 See Sigrid Weltge, *Bauhaus Textiles: Women Artists and the Weaving Workshop*, London, 1993.

32 For Ittten's theory and pedagogical ideas, see Johannes Itten, *Mein Vorkurs am Bauhaus*, Eng. trans. as *Design and Form: The Basic Course at the Bauhaus*, London, 1975. See also Willy Rotzler, *Johannes Itten, Werke und Schriften*, Zurich, 1978, and Dieter Bogner and Eva Badura-Triska (eds), *Johannes Itten: meine Symbole, meine Mythologien werden die Formen und Farben sein*, exhibition catalogue, Vienna, 1988.

33 Itten, *Design and Form*, p. 7.

34 For Schlemmer's theory, see his *Man: Teaching Notes from the Bauhaus*, London, 1971; *Idealist der Form: Briefe, Tagebücher, Schriften 1912–1943*, ed. Andreas Huneke, Leipzig, 1990; and *The Theatre of the Bauhaus*, Baltimore, 1996. See also Matthias Eberle, *World War I and the Weimar Artists: Dix, Grosz, Beckmann, Schlemmer*, New Haven, 1985; *Oskar Schlemmer: der Folkwang-Zyklus: Malerei um 1930*, exhibition catalogue, Stuttgart, 1993; and Oskar Schlemmer, *Oskar Schlemmer: Briefe und Tagebucher*, ed. Tut Schlemmer, Stuttgart, 1977, Eng. trans. as *The Letters and Diaries of Oskar Schlemmer*, Middletown, 1972.

35 Oskar Schlemmer, 'Man and art figure', in Walter Gropius (ed.), *The Theatre of the Bauhaus*, Middleton, 1961, p. 17.

36 See Dirk Scheper, *Oskar Schlemmer: das triadische Ballett und die Bauhausbuhne*, Berlin, 1988.

37 Walter Gropius, *The New Architecture and the Bauhaus*, Boston, 1965, p. 33.

38 Letter of 1 August 1923, quoted in Wingler, *Bauhaus*, p. 69.

39 For Kandinsky's work in the Bauhaus, see *Kandinsky: The Russian and Bauhuas Years 1915–1933*, exhibition catalogue, New York, 1983; Clark Poling, *Kandinsky's Teaching Theory at the Bauhaus*, New York, 1986; and Beeke Sell Tower, *Klee and Kandinsky in Munich and the Bauhaus*, Ann Arbor, 1981.

40 See Tower, *Klee and Kandinsky*; and also Christian Geelhaar, *Paul Klee and the Bauhaus*, Greenwich, 1973; and Mark Roskill, *Klee, Kandinsky and the Thought of Their Time: A Critical Perspective*, Urbana, 1992.

41 *The Diaries of Paul Klee 1819–1918*, ed. Felix Klee, Berkeley and Los Angeles, 1968, p. 231.

42 See Paul Klee, *Pädagogisches Skizzenbuch*, Eng. trans by Sibyl Moholy-Nagy as *Pedagogical Sketchbook*, London, 1953.

43 See Ulrich Luckhardt, *Lyonel Feininger*, Munich, 1989.

44 For Moholy-Nagy, see Victor Margolin, *The Struggle for Utopia: Rodchenko, Lissitzky, Moholy-Nagy 1917–46*, Chicago, 1997; Eleanor Hight, *Picturing Modernism: Moholy-Nagy and Photography in Weimar Germany*, Boston, 1995; and Louis Kaplan, *László Moholy-Nagy: Biographical Writings*, Durham, 1995.

45 See Schwartz, *Werkbund*, pp. 122–5 on the evolution of the term's meaning.

46 Quoted in Wingler, *Bauhaus*, p. 39.

47 Weltge, *Bauhaus Textiles*, especially pp. 42, 99, argues that women were pushed to traditional feminine spheres like weaving and pottery in the early Bauhaus, and despite

the economic success of the weaving workshop, they were further marginalised in Dessau by the bias against handcraft.

48 See Peter Hahn (ed.), *Bauhaus Berlin . . . eine Dokumentation*, Weingarten, 1985.
49 See Peter Hahn, 'Bauhaus and exile: Bauhaus architects and designers between the old world and the new', in Stephanie Barron (ed.), *Exiles and Emigrés: The Flight of European Artists from* Hitler, exhibition catalogue, Los Angeles, 1997, pp. 211–23; and *The Blue Four: Feininger, Jawlensky, Kandinsky and Klee in the New World*, New Haven and London, 1998.

> The general characteristics to be found in contemporary German painting cut
> across all . . . artificial categories – they belong to the spiritual categories of a
> post-war world: despair and its concomitants – satire and irony; realism,
> matter-of-factness, *Sachlichkeit*. (Peter Thoene, *Modern German Art*, 1938)[1]

> It has become more and more subtle, more and more modern, and the result
> is that one is now incapable of photographing a tenement or a rubbish-heap
> without transfiguring it. Not to mention a river dam or an electric cable
> factory: in front of these, photography can now only say, 'How beautiful.'
> (Walter Benjamin, 'The Artist as Producer', 1934, on photography)[2]

THE Werkbund and the Bauhaus, in their different ways, struggled to
reconcile the requirements of a modern consumer society with aesthetic
coherence. Like Dada and Expressionist artists, members of these organ-
isations were concerned with the problem of maintaining artistic freedom and
individuality amidst a tacit acceptance that both producers and consumers acted
in a communal, as much as individual, capacity. The importance of the com-
munity to visual culture intensified during the period of the Weimar Republic
(1919–33). At this time, a greater urbanisation of Germany, the development
of mass culture through the immense popularity of film, radio and magazines,
and economic and political instability engendered changes of emphasis in
both 'fine arts' and popular culture. The association of these changes with the
idea of objectivity (*Sachlichkeit*) reveals an important redirection of emphasis
from the spiritual aims of Expressionism. During this post-war period,
utopianism – desire for and belief in the regenerating powers of culture – was
superseded by cynicism, sarcasm, violence and despair, although even within
this change of emphasis, vestiges of Expressionist Romanticism remained.[3]

Numerous studies have highlighted the rich cultural production of the
Weimar period and the plethora of painting, film, photography and design
which characterised what has been known rather inappropriately as the 'Golden
Twenties'.[4] Attempts to make sense of this rich and complex period have led
historians to divide the Weimar Republic into three phases.[5] The first was the
turbulent and violent period from the November Revolution in 1918 until the
end of 1924. During this time, Germans experienced hopes and disappoint-
ments in the aftermath of revolution. The expectations of a better society were
quelled by the extremist measures and anarchy of 1918–20, although the
adoption of a republican constitution in the summer of 1919 seemed to offer
some solace for a weary country. During this time, Germans also endured the

effects of the Versailles Peace Treaty, which not only stripped them of their army, but imposed crippling reparations and included a 'war guilt' clause that made Germany solely responsible for the First World War. At the same time inflation devalued the German Reichsmark to a millionth of its former worth, and financial speculation accompanied corruption, greed and black marketeering.[6] After rampant inflation and civil disorder, a relatively stabilised currency and a Centre-Right coalition government soothed the fiery emotions that had been unleashed by the defeat in the war. In addition, the Dawes Plan of 1924 helped counteract some of the more harmful effects of inflation, by bringing substantial American investment into Germany. It also ushered in American culture and American values, both of which had a major impact on the visual culture of the period.

After the period of turbulence, the second phase (1924–29) has been labelled a period of 'stability'. Certainly during this time the more progressive aspects of post-war Germany came to the fore, as the attractions of America led to an emphasis on modernity and technological innovation. The final phase (1929–33) has been identified as preparing the ground for the electoral success of the National Socialist party: the Wall Street crash at the beginning precipitated a further period of crisis, and the accession of Hitler as Chancellor in January 1933 abrogated the Weimar constitution. Historians who classify the Weimar Republic in this way have given art historians a handy set of labels as well: thus, the revolutionary years are dominated by Expressionism, while the stable years saw the growing popularity of 'Neue Sachlichkeit' or the 'New Objectivity'. The 'pre-Hitler years' are rarely seen as artistically distinct, as most manifestations of culture were overwhelmed or pushed aside by political confusion.[7] Although these divisions can be useful, they are primarily convenient labels that do little to explain the cultural diversity that characterised the Weimar period as a whole, the aesthetic continuities from the pre-war period, or the artistic pluralism that mirrored the very contradictions of the society itself.

It is perhaps more fruitful to search for a means to define the period as an entity, as the break with imperialism at the beginning, and the acceptance of a totalitarian regime at the end, serve to isolate it neatly and to contribute to its distinct identity.[8] Attempts to characterise the Weimar period lead one naturally to the stable years of the mid-1920s. Although many people continued to be obsessed with Germany's failing military strength, and revolutionary tensions remained only temporarily dormant, the demise of rampant inflation and the physical and psychological reconstruction of the country gave a different emphasis to public discourse. If this period had a dominant style, it was a particular brand of realism known at the time as 'Sachlichkeit' or 'objectivity', although the seeds of sachlich aesthetics were sown well before 1925.[9] The nuances of the term are very important in clarifying its significance and implications to the Germany of the 1920s. The word 'Sachlichkeit' signals an objective fact, as opposed to a tangible object. This tendency led to gritty realism in fiction and exposé journalism; it was a product of cynicism and was fed by the freedom of speech encouraged by the republican constitution.

The notion of Sachlichkeit was not a new one. The word had been used before the war by Muthesius as a way of characterising the greater realism he

hoped to bring into modern design through the Werkbund.[10] In its associ-
ations with fact (*Sache*), *Sachlichkeit* seemed to offer a clear contrast to the
spiritual emphasis of Expressionism. The formulation 'Neue Sachlichkeit' (New
Objectivity) gained wide circulation in art circles only after 1925, when the
dealer Gustav Hartlaub organised an exhibition with the title 'Die Neue
Sachlichkeit' in the Mannheim Kunsthalle. The subtitle of Hartlaub's show,
'Deutsche Malerei seit dem Expressionismus' ('German Painting Since Expres-
sionism') signalled the fact that proponents of the *Neue Sachlichkeit* wished
to separate themselves from the ecstatic utopianism and visual idiosyncrasies
of Expressionist art. In a letter of two years before, Hartlaub had expressed
his wish to bring together 'representative works by those artists who over the
last ten years have been neither impressionistically vague nor expressionistically
abstract'.[11]

The distinction between the *Neue Sachlichkeit* and Expressionism was
taken up on the level of theory at a very early stage by Franz Roh's mono-
graph, *Nach-Expressionismus* (*Post-Expressionism*) of 1925. Roh's work
classified the new realism as separate from both Expressionism and Impres-
sionism, although he pointed to different manifestations of this realism as a
way of indicating just how diverse the new 'movement' was.[12] Roh saw the
new realism as a sort of *Zeitgeist* which embraced satirists such as Grosz,
as well as classicists such as Georg Schrimpf (figure 42) and Christian Schad.
According to Roh, what related these disparate artists to each other was
the relationship between their work and the current age of technology,
sobriety and practicality. Roh's choice of terminology was also significant.
Eschewing Hartlaub's term 'objectivity', he more frequently referred to the
'Gegenstandlichkeit' of the new style – emphasising the physical 'object'

(*Gegendstand*), rather than the abstract
'fact'. Here he made a quite deliberate refer-
ence back to the language of *Der Sturm* that
built the principles of Expressionism on a
rejection of the object in art. In the words of
Sturm writer Lothar Schreyer, 'As the work
of art cannot represent an object (because
the painted flower is not a flower), so it
also cannot express a thought or feeling'.[13]
However, by referring to the *Gegenstand*,
Roh also muddied the waters between the
principles of *Neue Sachlichkeit* and that of
Constructivism which also concerned itself
with the object.[14] This sort of terminolo-
gical slippage was to characterise the *Neue
Sachlichkeit* from the beginning.

Semantic confusions that surrounded
the terminology abounded in discussions of
Neue Sachlichkeit art. For a start, Hartlaub
tried to define the movement in terms of
left- and right-wing factions, and although
his generalisations have become entrenched

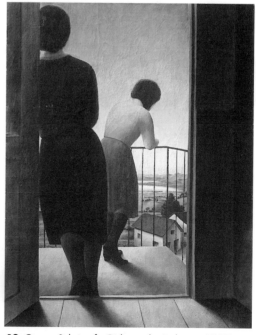

42 Georg Schrimpf, *Girls on the Balcony*, 1927

in subsequent scholarship, they do not fully explain all the variant manifesta-tions of the movement.[15] This well-intentioned effort to characterise diversity led others to adopt terms like 'verist' to refer to the realist works of Dix and Grosz, and 'magical realist' to describe the Italianate paintings of Munich artists like Schrimpf. The fragmentary nature of the *Neue Sachlichkeit* aesthetic is apparent in the fact that it was never a unified movement, and it did not therefore have a home base, as, for instance, Berlin had been for the *Sturm* circle. Manifestations of *Neue Sachlichkeit* varied widely from region to region, and its popularity resisted the metropolitan centralisation of a uni-fied Germany.[16] In Berlin, Grosz and Rudolf Schlichter, among others, launched their savage attacks on post-war bourgeois society through a mode of carica-tural 'realism'. In Dresden Dix's unflinching representations of post-war decay could be reconciled with his post as professor of the Academy there. In Munich a group of neo-romantics, including Schrimpf and Carlo Mense, were looking back to the contrived perfection of the nineteenth-century Nazarene group, while they borrowed some of their more obvious stylistic mannerisms from contemporary Italian art. The *Neue Sachlichkeit* in Cologne showed a constructivist tendency, while in Hanover it was dominated by the cool self-examination of women artists such as Grethe Jürgens and Gerta Overbeck.[17] Max Beckmann, well represented in Hartlaub's 1925 exhibition, worked alone in Frankfurt and defied any categorisation, although Hartlaub saw him as a key figure in the movement.

Nevertheless, the tendency to see *Neue Sachlichkeit* as a *Weltanschauung* was just as strong in the 1920s as the pre-war nationalist *Heimatschutz* and wartime Expressionist movements had been earlier. But whereas the earlier movements had located cultural unity in an irrational, spiritual sphere, the *Neue Sachlichkeit* rejected the inner life in favour of a greater emphasis on rationality and physical objects. In this focus on the object, the *Neue Sachlichkeit* came to be seen as the 'masculine' counterpart of the intuitive and spiritual feminine of Expressionism.[18] The objectivity of the *Neue Sachlichkeit* was that of surfaces, rather than realities. The critic Siegfried Kracauer saw this greater emphasis on physical objects as leading both artists and the public away from a critical awareness of contemporary events and political change. To him, the *Neue Sachlichkeit* served 'to drown all implica-tions in an ocean of facts'.[19] But Kracauer also believed that 'The position that an epoch occupies in the historical process can be determined more strikingly from an analysis of its inconspicuous surface-level expressions than from that epoch's judgements about itself',[20] and a study of *Neue Sachlichkeit* art does help reveal the social tensions beneath this obsession with surface during the stable years of Weimar Germany. Attempts have been made to locate an iconography of the *Neue Sachlichkeit* to correspond with the stylistic emphasis on surface and although here, too, variation is more apparent than unity, there are certain predominant themes or subjects that recur in *Neue Sachlichkeit* art and give it something approaching the status of a movement. These themes are also related to tone, mood, style and media, and it is important to con-sider these aspects together.

The first of these aspects is violence – the verism of artists like Dix, Grosz and Heinrich Maria Davringhausen. Even before *Neue Sachlichkeit* was

declared a movement by Hartlaub, these artists turned their attention to the violence and crime that characterised the post-war German metropolis. The many representations of sex murders and sex murderers is the most unsettling example of this. In these *Lustmord* paintings and drawings, the brutal, dehumanised savagery of criminal violence is linked implicitly to real serial crimes that were being tried at the time.[21] The social degeneration evidenced by such violence is mythologised by Beckmann in the urban claustrophobia of works like *Night* (1918/19, Düsseldorf, Kunstmuseum), and it is clear that however 'objective' such views were purported to be, they serve to fetishise fear, pain and murder in a deeply disturbing manner.

It is also important to note the way the city became a mythical site for this culture of violence that dominated many *sachlich* paintings and, through the visual, we can see how the pre-war ambivalence about urban life was resolved into a fairly universal condemnation of the anonymity, soullessness and capitalist money culture of the metropolis. While lapsarian associations clung to such cities as Berlin, the hellish qualities of the metropolis were as fascinating as they were repulsive. The significance of the city was one of the most important aspects of Weimar modernity, and it was one which was later fully exploited by Hitler. The city during the 1920s was not simply a social phenomenon; it was the subject of cultural investigation as well. The city was epitomised by Berlin, which, at the time, was the third largest metropolis after London and New York.[22] In representations of the city, the full impact of Germany's modernisation can be seen. But the emphasis in such representation tended to be on the negative aspects of the city – its destructive potential, its

anonymity, its inhuman scale – rather than its more positive features. However, even such pessimistic views could have their eulogistic aspects. The city was frightening and beyond human control, but it also held the fascination of a good horror movie. The city was a familiar subject for *Neue Sachlichkeit* painters; for many such artists, it replaced the countryside as a focus for 'landscape' painting. In *Neue Sachlichkeit* cityscapes, the human being was often absent, and the tedious modernity of blocks of flats, factories and shops became the focus of representation. Karl Grossberg's many cityscapes are typical of the genre, but they could be interchanged with cityscapes by other *Neue Sachlichkeit* artists. The city did have a distinct identity, but unlike landscape views of the countryside, the distinct locations were often difficult to determine. One exception to this is Karl Hubbuch's *Swimmer of Cologne* (figure 43), an ironic comment on the urbanising of modern Germany. With the spire of the medieval Cologne cathedral

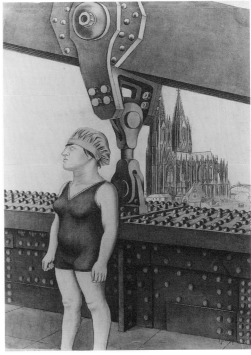

43 Karl Hubbuch, *The Swimmer from Cologne*, 1923

looming in the background, a female swimmer stands rather inappropriately on a modern suspension bridge.

These detached views of the city were as common as the more sensationalist representations of the verists, but in much *Neue Sachlichkeit* work, the city became a place of sexuality and violence most frequently conceived through the image of the prostitute. One of the most obvious examples of this is Dix's *Big City Triptych* (1927/28, Stuttgart, Stadtgalerie). Dix's hellish vision of the agonies and ecstasies of city life is set in the post-inflationary period, when suffering and prosperity prevailed simultaneously. In the centre panel, a jazz band and 'shimmy' dance reveals the ecstatic, yet empty, preoccupations of urban leisure life, while on the side panels, war cripples and prostitutes bear witness to less savoury aspects of the Weimar metropolis. The war cripples are forgotten victims, while the prostitutes represent the commercial monomania and rampant greed that Dix saw as characteristic of post-war society. Dix's representations of women in works such as these are equivocal. Despite the fact that he intended to attack capitalism, which turned women into commodities, rather than women themselves, Dix's obsessions are problematic. Dix's view of women had elements of both traditional misogyny and modern anxiety and, in this sense, it was as paradoxical as women's own position in Weimar Germany.[23]

The essential theme of sexuality in many of the more violent *sachlich* representations is an important symptom of the cultural changes that characterised the Weimar Republic and fed the new emphasis on rationalism. Unlike the idealised bohemianism of Brücke, the sexual squeamishness of the Blaue Reiter, or even the utopian ideas of sexual freedom held by some Dada artists, sexuality in its most uncompromising form was an important part of the verist strand of *Neue Sachlichkeit*. Much of this emphasis was tied up with changing attitudes to sexuality. With the spread of Freudian psychoanalysis, sexuality became not just a subject of psychological study, but also a topic of daily conversation. Magnus Hirschfield's Berlin Institute for Sexology was opened in 1919 as an advice centre, and it was only the first of a series of clinics and counselling services which ostensibly helped improve marital relations but in reality gave advice about contraception. Contraception was, throughout the period, prohibited, although the commodification of such prophylactics as condoms and pessaries made the illegality little more than a formality. In the late 1920s, communists campaigned openly for the abolition of paragraph 218 of the criminal code, which made abortion illegal and, although it was not legalised, a relaxation of the law in 1926 meant that it was no longer equated with homicide. The ambivalence towards birth control stemmed in part from a fear that the population was declining, and that the defeated nation would be further emasculated by a depletion of future generations. But whatever the propaganda, the reality was a widespread use of both contraception and abortion for personal and economic reasons.

In cultural terms, sexual openness began at the very outset of the Weimar Republic, when all censorship laws were abolished. This lifting of regulations led to a plethora of 'sex manual' films which were loosely described as 'educational'.[24] The box-office hits *Lost Daughter*, which concerned prostitution, and *Different from the Others*, about homosexuality, gained their popularity

through their explicit scenes, rather than their educational value. Films such as *Hyenas of Lust* were educational only in the broadest sense of the term. The lifting of censorship laws therefore did little to encourage truly artistic films, but their reinstatement in 1920 did much to stifle creativity. The increasingly harsh pornography laws of the 1920s caused difficulty for Dix when in 1922, he was taken to court for his painting *Girl in Front of a Mirror*. This work showed a semi-nude woman, most likely intended to be a prostitute, whose sensuous and youthful buttocks are a shocking contrast to her ageing face as seen in a mirror.

Even today, Dix's explicit imagery can be unsettling, and it was certainly alarming for contemporary observers. Dix's emphasis on physical imperfection as a sign of social ills appears in a work such as *Old Couple* (1923, Berlin, Staatliche Museen Preußischer Kulturbesitz, Nationalgalerie). This work's potency rests in its exploitation of human prejudice about the sex life of the elderly, and Dix exploits this childish disgust to its fullest extent with his emphasis on wrinkles, varicose veins, vacant eyes and discoloured rolls of flesh. But the work also looks back to the *memento mori* imagery of German sixteenth-century painting, in which young women are juxtaposed with skulls and skeletons to emphasise the evanescence of their beauty. To Dix, the decay had already set in, and the lives people were leading in his Germany were examples of the degeneration of a whole people. Similarly, his *Three Women* (1926, Stuttgart, Stadtgalerie) is both a parody of the Three Graces and a representation of contemporary prostitution. Dix's prostitutes are not alluring beauties but caricatures, whose physical appearances are on a par with their bizarre professional paraphernalia.

The caricatural aspect of the *sachlich* vision is another leitmotif that can be distinguished from violent and sexual representations, but draws force from the same kind of cynical view of society. Although it has been recognised in individual cases, the ubiquity of humour to German modern visual culture has never been fully acknowledged. Before the war visual humour had its place on the fringes of the avant-garde, in satirical journals such as *Simplicissimus*,[25] as well as the parodic mythological fantasies of Corinth and Stuck.[26] Parody, satire, the grotesque and other forms of humour also found their way into Expressionism – from the whimsical paintings of Klee to the satirical fantasies of some of the most popular contributors to *Der Sturm*, Paul Scheerbart, Mynona (Salomon Friedländer) and Albert Ehrenstein.[27]

The use of humour in both visual and literary culture came in for a number of justifications during the period of unity. The playwright Oskar Panizza defended the satirical tradition in his 1895 trial for blasphemy, claiming that his anti-Papist play, *The Council of Love* had a distinguished literary progeny.[28] Visual satire was also the subject of widespread public discussion during the 1920s when communists condemned it as indiscriminate entertainment, rather than an art form capable of embodying party ideology.[29]

However, satire as a world view came to the *Neue Sachlichkeit* through a slightly different route. Dada artists had employed it in Zurich as part of their response to social decay. According to Hugo Ball, 'The writer of comedies has a double perception of life: as utopia and as reality, as general background and as character', and he commented on the effective, but cruel, power of

laughter.[30] This view of humour as an artistic weapon, with both illuminating and destructive potential, also formed part of Beckmann's cynical attitude to the phenomenal world. It was this cynicism, rather than the uncomplicated amusement of *Simplicissimus* cartoons or the whimsy of Klee, that formed the dominant humorous mode within *Neue Sachlichkeit*. Grosz employed it to best effect in his many cartoons, which sparked bitter laughter, as their representations of a corrupt society were both apt and horrible. The work of the illustrator Jeanne Mammen equally veered towards the grotesque. Her depictions of lesbian subculture in Berlin were both wry and sarcastic.[31]

While violence and sarcasm embody the mood and tone of many *Neue Sachlichkeit* paintings and graphics, this movement also renewed the authority of traditional portraiture. Portraiture had an important place in German modernism before the 1920s through the psychological studies of Kokoschka, and Beckmann's experiments with identity and role playing, but during the 1920s a more traditional kind of portraiture emerged as part of the new movement.[32] Artists like Dix and Schad modelled their portraiture implicitly or explicitly on Italian Renaissance examples as well as their own national progenitors, Holbein, Dürer and Cranach. This led to an emphasis on an exacting physical likeness, formal, conventional posing and signals of status through objects and settings. However, Dix, especially, directed his traditional portraiture towards the most striking examples of Weimar modernity.

Dix's portrait of his friend the dancer *Anita Berber* (1925, Vaduz, Otto Dix Stiftung) is one of his most striking representations. Berber was known in Berlin for her erotic nude dancing and for her starring role in what were euphemistically called 'sexual enlightenment films', but she was also infamous among Berlin bohemian circles for her disastrous marriage, her lesbian relationships, and her opium and cocaine addiction. Dix's startling image of Berber in a red dress hints at the self-imposed decay and tawdry sexuality that characterised her life. Her calculating sensuous pose, her pale skin showing through the excessive make-up, and her transparent dress provide clues to her profession and her personality. Dix's portrait of an equally strong woman, *Sylvia von Harden* (1926, Paris, Musée national d'art moderne) also stresses the personality of the sitter. Known formerly as Sylvia Lehr, she changed her name to von Harden as a cynical bid for aristocracy. In many respects, Dix's image of her embodies the stereotype of the new woman (see below), whose bobbed hair, ubiquitous cigarette and glass of spritzer served to advertise her emancipation and fashionability. But as with Berber, Dix chose a pose which exaggerates, and thereby caricatures, the features of his sitter.

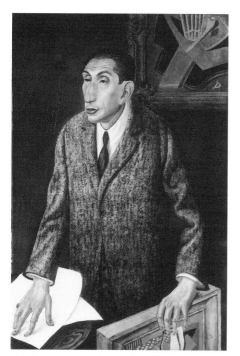

44 Otto Dix, *The Art Dealer Albert Flechtheim*, 1926, oil on canvas [see also colour plate 4]

Finally, Dix's portrait of the art dealer *Alfred Flechtheim* (figure 44) has proved so convincing

that many contemporary and subsequent observers have claimed that it is possible to detect his calculating disposition in his profile. Certainly, Flechtheim was a shrewd dealer, who made a substantial sum by selling works of contemporary French artists such as Matisse, Derain and Picasso. However, the fact that Flechtheim was a Jew has contributed to the stereotype that he was ruthless and obsessed with money. In reality, Dix was suspicious of Flechtheim, who had passed judgement on him as an artist who could only 'paint farts'.[33] Dix's unflattering representation of Flechtheim may have been coloured by his own attitude towards the dealer. In all of these portraits, Dix employed the *Neue Sachlichkeit* style, but in each case, a type peeps through the painstaking representation of the individual. Berber is the Berlin bohemian, von Harden the new woman, and Flechtheim the greedy Jew. It is this tendency towards typology that separates the *Neue Sachlichkeit* mode of portraiture from its traditional roots. This propensity to look for types, rather than individuals, was characteristic also of the Weimar portrait photographer, August Sander, and it is instructive to contrast the effect of his portraiture with that of Dix to uncover some intrinsic contradictions within the 'objective' aesthetic.

Sander conceived of the idea of an album of photographs, *Menschen des 20. Jahrhunderts (People of the Twentieth Century)*, in 1920, and although he never fully realised his intentions, his plan for the whole series showed that it was intended to be a compendium of all 'types' of people living in contemporary Germany.[34] Such typological classification bore a direct relationship to the theories of physiognomy which were particularly popular in the nineteenth century, but Sander's categories were very much moulded by the society in which he lived. His draft plan included seven sections: Farmers, Craftsmen, Women, Professions, Artists, City Types and 'Last People'. These separations of status, profession and gender do not so much mirror contemporary stereotypes as give them, for the first time, a tangible form. Although Sander was not attempting to create a hierarchy, his taxonomy was riddled with hierarchical implications. His aim was to show 'types', not individuals, but the types were those of a new age of industry and metropolis. Certainly, modernisation and political upheaval were leading to social change, and the ever growing lower middle class is one of the leitmotifs of Weimar social history. However, it is questionable whether or not Sander's *sachlich* view of Weimar typology is anything but a distortion, perhaps coloured by his own socialist interests. Sander's progressive intentions were counteracted by the eugenic implications underlying his categorisation. By presenting his 'people of the twentieth century' as types, he inadvertently reinforced a prevailing right-wing view that vestiges of class, race and profession could be read into the face and body. Conversely, it is difficult to accept his photographic portraits as types when the individuality of the sitter continues to emerge in the image.[35] Sander's contrived settings for such works as the *Unemployed Man* (figure 45) and *The Master Tiler* direct the observer towards an understanding of the class and status of the type depicted, but the real humanity of the characters themselves does not allow such an easy typological classification. Instead, Sander's typical individuals represent one of the reasons photography was such an effective medium for the *Neue Sachlichkeit*. Even more than the obsessively realistic but nevertheless mood-evoking paintings of the movement,

photography had the capacity to make the familiar strange – to both document reality and resist the interpretative clarity of documentation.[36]

Before the 1920s, the competing claims of photography and painting for the status of fine art led to a dominance of 'art photography' – photographs modelled on the aesthetics and subject matter of painting. With advancing technology, the 1920s witnessed the emergence of photography as a more appropriate art form for a modern age. Photography was used not only in journalism and photomontage, but new photographic techniques were developed which exploited the abstract potential of the medium.[37] In 1929 the Bauhaus instituted a photography course as part of its programme, and some of the most notable examples of experimental photography were produced by men and women who were associated with that institution.[38] The 1928 Film und Foto exhibition in Stuttgart and the 1929 photography exhibition in Berlin confirmed the powerful role of photography in contemporary Germany. The particularly successful Stuttgart exhibition also advocated a new type of photography which glorified individual objects for their abstract perfection and beauty. Here photography entered the realm of the *sachlich* aesthetic. Albert Renger-Patzsch's photographic album, *Die Welt ist Schön* (*The World is Beautiful*), published at the time of the Film und Foto exhibition, adopted this purely formal approach to the presentation of objects.[39] Renger-Patzsch had wanted to entitle his work *Die Dinge* ('Things'), which provides a clearer statement of his purpose. By concentrating on machinery and nature, and by juxtaposing unlike objects for purely formal reasons, Renger-Patzsch tried to lead the viewer to an uncritical appreciation of the beauty of things normally considered unworthy of attention. In his album, factory pistons and wet leaves were given equivalent status, and both were treated as part of a new canon of beauty.

This approach to photography led to the contemporary cliché – voiced by the novelists Alfred Döblin and Christopher Isherwood, among others – that there was no difference between the photographic lens and the human eye. The acceptance of such objectivity as accurate, and the idea that such accuracy should be appreciated without question, underlies this formulation. But the critic Walter Benjamin, in a retrospective analysis, saw a more sinister implication of this theory about the camera's objectivity. Benjamin's interpretation of Renger-Patzsch's *Die Welt ist Schön* claimed that 'It has succeeded in turning abject poverty itself, by handling it in a modish, technically perfect way, into an object of enjoyment', and he elaborated his criticism of 'the way in which certain modish photographers . . . make human misery an

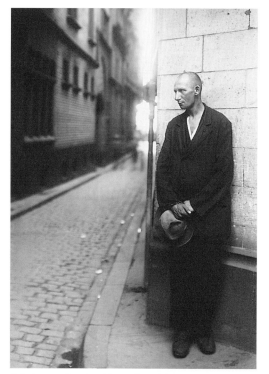

45 August Sander, *Unemployed Man*, 1928

object of consumption'.[40] Benjamin was incensed by the inclination to divest objects of their meaning and thus politically neutralise them.[41] Even signs of poverty and despair could be rendered beautiful by a camera if they were removed from their context and photographed for their purely 'abstract' values. The objectivity which was trumpeted by the new photographers and the *Neue Sachlichkeit* artists thus seemed divested of political content in what was unquestionably a political age.

Discussions about values implicit in new uses of technology were part of wider debates about the place of popular culture in the modern world of the Weimar Republic. Within these discussions, visual culture played a prominent role. The most subtle and persuasive of these ideas grew from the theories of the Frankfurt Institute for Social Research, founded in 1923 initially as part of the University of Frankfurt. Writers such as Benjamin, Theodor Adorno, Max Horkheimer and others questioned the function of mass culture in their suggestive interpretations of Marxist theory.[42] Kracauer, who worked for the *Frankfurter Zeitung* newspaper was on the fringe of this circle. At the very foundation of these writings was the question of what constituted the 'masses'. Ideas of the *Volk* which had been prevalent in German cultural debates since the nineteenth century were resurrected, but the communal German *Volk* had become transformed into the modern urban petit bourgeoisie, according to Kracauer.[43] This group – with its self-created cultural autonomy – was subsumed into a mass society whose interests and sense of purpose was not differentiated by the class or cultural background of its components.

Kracauer's examination of the composition and behaviour of the masses reconfigured the relationship between the individual and the community that had concerned both Dada and Expressionism. To him, the group was an essential component of modern culture:

> instead of being made up of fully developed individuals, the group contains only reduced selves, abstractions of people . . . But is it surprising that people who are no longer fully in control of themselves act differently from people who are still in complete possession of their selves?[44]

Kracauer supplemented this concern about the composition and behaviour of the masses with his many studies of modern ephemeral phenomena such as film, photography and pulp fiction. His stress on the quotidian aspects of modern life appeared in his most famous essay 'The mass ornament' (1927), in which he related the patterning of modern dance by groups such as the American Tiller Girls with the unthinking conformity of modern mass culture.[45] Kracauer saw all life as permeated with the rationalising methods of factory production, and the Tiller Girls as a sort of aesthetic equivalent of the streamlining that dominated factories. The formula dances of the Tiller Girls turned human bodies into mere ornaments, and, in Kracauer's view, society was focusing its attention more and more narrowly on such formal elements. As a consequence, no one could see a whole picture, because their eyes were riveted on the display of partial functions.

Kracauer was responding to the sorts of cultural changes that had resulted from modernisation in Germany, and particularly its impact during the years of stability and prosperity after 1925. The industrial and technological changes

which had contributed to a fundamental alteration in the way of life of Germans before the First World War intensified when the war was over, as Germany became one of the most advanced industrial nations in the world. The economic, political and social consequences of this industrialisation are very complex, but they help elucidate the role of visual culture in Germany during the 1920s. From a country known in the past for its agricultural production, Weimar Germany became a centre for industry. Its modernity rested partly in the fact that industry was concentrated, cartelised and rationalised into a handful of powerful concerns. These changes drove more and more people into fewer and fewer industries and concomitantly increased the need for bureaucrats, secretaries, clerks and other positions of service or middle management. Industry created employment and then drew potential employees to cities, where massive immigration altered the way people lived their lives. Most significantly for art, modernisation also led to new uses of leisure time, and centralisation and rationalisation invaded culture in the form of mass media. Each of these factors contributed to the modernity of Weimar Germany: the growth of cities, the expansion of white collar employees, the adoption of American factory assembly line techniques, the cartelisation of industry, and the presence of a mass culture which privileged film, newspapers and photography over painting and sculpture.

The modernisation of Weimar Germany was one of many shocks to the German system. Not only were the Germans defeated in the First World War and forced to bow to the reparations demands and the 'war guilt' clause of the Versailles Treaty, but they were also attempting to form a completely new government, which met opposition from both left and right throughout the 1920s and early 1930s. In the midst of these struggles, Weimar Germany became, in Walter Laqueur's words 'the first truly modern culture'.[46] Given Germany's cultural heritage, this conversion to modernity engendered more than its share of teething pains. For decades before the drafting of the Weimar constitution, Germany's rural identity dominated ideas about its culture and society. Rural youth movements such as the Wandervogel were distinct to Germany. The glorification of country life permeated both aristocratic and 'peasant' mentality. Despite the intensifying popularity of such nature movements, the First World War and its aftermath led to a weakening of the agricultural base, and government policies designed to protect Germany's industry were often to the detriment of its agricultural strength. In addition, the old rural aristocracy was effectively made redundant by the abolition of the empire. The reasons for the dramatic change from a largely rural, agrarian, aristocratic society to an urban, industrial and middle-class one are complicated and have inspired a great deal of historical debate. Regardless of the causes of change, the results were unquestionable. The American concept of rationalisation entered every aspect of life. Despite some pressure from communists and socialists, the Weimar coalition governments failed to take the step of nationalising major industries; this resulted in more monopolies and mergers of a number of large corporations, leading to powerful cartels in the hands of a few wealthy businessmen. In order to generate as much income as possible, the directors of major industries adopted streamlined factory methods which resulted in a greater volume of production, but in a demoralisation of

the workforce. More and more products were created to appeal to an ever-increasing public comprised of middle-class consumers.

Above all, the growing sophistication of mechanical reproduction led to new art forms that had mass, rather than elite, appeal. In his essay 'The work of art in the age of mechanical reproduction' (first published in 1936), Benjamin saw such technical sophistication as liberating. He claimed that although 'The presence of the original is prerequisite to the concept of authenticity', a technology that made the original obsolete would expand the audience for art.[47] No longer would an elite be able to monopolise a few expensive and precious works of art. Technology would make art accessible to everyone. The abolition of tradition would therefore bring art to the masses, creating a new 'mode of participation'. However, the mass art of the Weimar Republic was both a positive and a negative force. Certainly, film and illustrated journals had a larger audience and a greater appeal than painting or sculpture had ever achieved, but they equally had more power as tools of propaganda, and they were used as such during the Weimar Republic.

The development of the film industry is a case in point.[48] In 1916 the German government founded the Deulig Deutsche Lichtspiel Gesellschaft – a company designed to produce films that would help glorify Germany's image during the war. In 1917 the merger of this with other film companies resulted in Ufa (Universum Film A.G.), which itself became a private company in 1918. Already, an organisation formed for explicitly propagandist purposes had passed into the hands of private capitalists. The expansion of the German film industry during the early 1920s was due in no small part to the inflation which made such films cheap to foreign markets but undeniably lucrative to German entrepreneurs who wished to amass hard currency. However, inflation also led to rising production costs, and international success meant that German stars insisted on higher salaries. The increasing demands on film makers and cinema owners meant that films had to be more lucrative, and this was achieved in several ways. First of all, cinemas became larger, with a greater seating capacity designed to hold hundreds of people at once. Second, films became more escapist and superficial in a bid to attract the largest possible cross-section of the public. Finally, and most significantly, film companies began to merge with other business interests to consolidate their strength. Ufa – originally a government concern – eventually became associated with the Deutsche Bank, the Dresdner Bank and the AEG electricity company. By 1927, Hollywood film companies, including MGM, also had a stake in Ufa. By the end of the 1920s, Ufa was a large organisation consisting of 140 companies and controlling 116 cinemas in Germany. In 1929 Ufa also managed to swallow up two companies which held the German patent for sound films. From that point onwards, Ufa dominated the production of sound films, which by 1932 drove silent films off the screen.

A phenomenal amount of power was concentrated in Ufa. Millions of people each year went to the cinema, and were naturally influenced by what they saw on the screen before them. One of the stereotypes of the Weimar Republic is the image of secretaries and shop assistants gazing dreamily at the silent screen, absorbed and influenced by visions of more glamorous secretaries and shop assistants. This is certainly a cliché, but there is truth in the

representation of the disillusioned and bored bourgeoisie aspiring to a sanitised and ameliorated image of their own life. Many Ufa films were unashamedly escapist, and the emergence of 'operetta' films led to such empty gems as *Three at the Petrol Station* of 1930, which told the story of three men who purchase a derelict gas station, flirt with an attractive woman and burst into song at periodic intervals. Such superficial entertainment had its place, but in other cases, blockbuster moneymaking films had more sinister undercurrents. Among the most popular films of the 1920s and early 1930s were those which concerned the war, and those which dealt freely and eulogistically with aspects of Germany's past. Films about such historic figures as Frederick the Great were little more than nationalist newsreels, melding historical 'fact' with contemporary sentiment. According to Kracauer's retrospective analysis, these films fed the consciousness of a public bruised by defeat in the war and unable to reconcile itself to an often ineffectual new republican government.[49]

In a different way, the *Neue Sachlichkeit* contributed to the film's mass appeal. As Expressionist film drew popular audiences through its supernatural and escapist effects, so *Neue Sachlichkeit* film appealed because of its deceptive factuality.[50] During the early years of the Weimar Republic, documentary films (*Kulturfilme*) were common, and newsreels became a recognised way of feeding government propaganda to an increasingly cinema-oriented society. But by 1923 some elements of the documentary were beginning to enter fictional film drama, and a sub-genre, known as the 'street film' used new visual methods to emphasise the details of everyday life.[51] In that year, Karl Grüne's film *The Street* appeared. The film concerned a middle-class man who decides to abandon his safe but monotonous home for a more exciting life. In a matter of hours, he becomes implicated with a prostitute and a murder, but a lucky escape leads him to return happily to the hearth that he had so casually abandoned. The film was shown without intertitles, and the camera focused frequently on inanimate objects as a way of stressing the ordinary context in which the situation was meant to take place. A similar theme was characteristic of G. W. Pabst's *Joyless Streets* of 1925, and Bruno Rahn's *Prostitute's Tragedy* of 1927. Each of these 'street films' seemed to represent the tragedies of everyday life, but, like contemporaneous painting and photography, the emphasis on inanimate objects and melodramatic situations gave them a purely entertainment value which evaded the social problems they pretended to represent. Kracauer claimed that these films 'reveal the workings of the paralysed collective soul': by converting poverty and suffering into an object of visual consumption they were feeding a real social need with inappropriate nourishment.[52] The films pretended to tackle social problems, but they were doing little more than creating a dramatic gloss for genuine unhappiness. Indeed, the apparent technological progressiveness of these films did not penetrate far beneath the surface. The films used all the latest techniques of montage, close-up and elaborate camera effects to create an image of reality. But the elaborate technology, artificiality and deliberate calculation employed belied the 'realistic' effects it produced. The greater the technology, the greater the possibilities for exhibiting 'real life' on the screen, the more aesthetic and purposeful the filming became. Such detailed realism grew less from a desire to make a statement than from a purely visual interest in the world of 'things'. In addition,

the 'objectivity' of street films was counteracted by a use of melodramatic gesture and situation which captivated the cinema audiences and raised them emotionally above the visual dreariness of the situations depicted.

The masterpiece of the *Neue Sachlichkeit* film genre, Walter Ruttmann's *Berlin, die Symphonie der Großstadt* (*Berlin, the Big City's Symphony*) (figure 46), transcended these limitations, as, like photography, it defamiliarised the everyday, rather than simply validating it. *Berlin* concentrated on the daily rhythms of life in the city, including such mundanities as crowds pouring down the Kurfürstendamm and glittering shop windows. One of the film's cameramen later commented, 'I wanted to show everything. Men getting up to go to work, eating breakfast, boarding trams or walking'.[53] Significantly, a film which offered urban citizens a rather stale slice of their own life was wildly popular. Removed from reality and placed on the screen, even such dull moments could appear glamorous.

But the film was not the only art form that captivated the mass market. Illustrated periodicals became increasingly common, and they too used visual methods to allure and influence the ever-growing number of consumers. During the Weimar Republic, there were over 4,000 newspapers in Germany. Many of these were dailies or weeklies, and some of them had a distinct political affiliation. Despite this pluralism of journals, there were only a handful of large media organisations which controlled the majority of their publication. Berlin was the base for Ullstein, Mosse and Scherl, the three most powerful and influential media companies in the country, with controlling interests not just in newspapers, but in newswire and distribution services. Indeed, Alfred Hugenberg's Scherl empire managed to take control of the film company Ufa as well, so that Hugenberg became one of the most important individuals in Germany.[54] The fact that Hugenberg was a vocal and committed supporter of the far right DNVP (German National People's Party) is particularly significant in the light of this astonishing cultural influence.

On the surface, Scherl's products were diverse and appealed to different audiences. The *Berliner Illustrierte* was a general interest paper, while *Der Querschnitt* was designed for intellectuals; *Die Dame* targeted the 'modish' woman, while *Blatt der Hausfrau* appealed to a different sector of the female population. Indeed, not all writers for Hugenberg's journals were of a similar political persuasion and, to an outside observer, it could appear that this politically committed capitalist was decidedly neutral when it came to the direction of his own company. There may indeed be some truth in this, as money was obviously more important to Hugenberg than politics. But

46 Film still from Walter Ruttmann's *Berlin, die Symphonie der Großstadt*

a closer look at the Scherl journals reveals certain similarities, particularly in their visual presentation. The journals inevitably used photography and the techniques of photomontage which had been employed so subversively by the Berlin Dada artists, but this plethora of images helped create the visual clichés of the Weimar Republic, rather than engage with them, as the Dada artists had intended to do. Hannah Höch's use of advertising imagery, for example, deftly embraced and mocked the commercial obsessions of post-war culture, but the increasing acceptance of similar imagery in mainstream journals merely enhanced its commercial function. Images of movie and sport stars, 'modern' women and men manipulated consumerist consciousness and the obsessions of middle-class leisure culture. Although ostensibly neutral, such journals reinforced fashions, fads and stereotypes, while appealing aggressively to the spending power of the urban middle class. They were, therefore, political in covert and often invidious ways. There was very little to separate the visual techniques of such popular periodicals from those of communist journals like the *Arbeiter Illustrierte Zeitung*, which used photography and photomontage for political purposes.

Illustrated newspapers were mass entertainment, but, like film, they did not really justify the enthusiasm of leftist critics who glorified the new technology as a way of galvanising the masses and giving them a voice. Many communists were particularly fervent supporters of the new mass culture, and its predominance was one of the factors which led to the right-wing philosopher Martin Heidegger's disillusionment with a modernity that privileged seeing over understanding, and thus led to intellectual paralysis.[55] However, the polarity between mass and high art cannot be explained solely by reference to a political division in which the left supported change and the right resisted it. The German left may have been enthusiastic about the liberating potential of new technology, but the German right made effective use of it. Despite the suspicion with which traditionalists regarded the modernisation of Germany, these changes were incorporated into the irrational romanticism of the German right. The Nazis, for example, did not turn their back on modernity and technology, but used it in their drive to create a new Germany in an image which they had chosen (see chapter 8).[56]

Amidst all the debates about mass culture and the productions of artists, photographers and film makers, modernity was frequently configured through women. Women were more regularly the subjects, consumers and producers of popular cultural artefacts than they had been before the war, and their greater presence in cultural life led to a reconsideration of the role of the feminine to modernity.[57] Unlike the Expressionists' stereotypical equation of women with the spiritual, the visual culture of the Weimar Republic showed a more multi-faceted and engaged response to the place of women (and the concept of 'woman') within the avant-garde.

The role of women in Weimar Germany has received a great deal of welcome attention in recent years, but the contradictions which characterised their role have not yet been resolved.[58] In many respects, the place of women during the 1920s and early 1930s was as paradoxical as the role of modernity itself. Superficially, women appeared to have made great gains in terms of emancipation and equality. Article 119 of the Weimar Constitution stated,

'Marriage is based on equality of the sexes', and article 109 declared, more radically, 'men and women have fundamentally the same rights and duties'. Women gained the vote at the beginning of the period, and a handful actively entered politics. There were more and more working women, and for those women who chose to become housewives, advanced technology offered the possibility of less toilsome housework. The Weimar '*neue Frau*' (new woman) was employed, bobbed her hair, smoked cigarettes and enjoyed sexual relations either inside or outside marriage.[59]

However, these were only superficial victories, as the real position of women during the Weimar period was much more equivocal. First of all, women in work did not receive the same pay as men, and for the most part they were concentrated in low status jobs such as shop assistants and typists. There were very few professional women. After the war, married women were legally prohibited from working, if an able-bodied veteran was in a position to take the job. Towards the end of the 1920s, a fervent controversy about *Doppelverdiener* ('double earners', or both husband and wife working) raged when unemployment led men to question the hiring of cheap female labour. Second, although communists and some socialist supporters campaigned actively for women's rights, most political parties of the left and the right were more interested in the declining birth rate. This led them to an emphasis on women's role as mother, and a concomitant glorification of motherhood. Third, although women's lives were transformed by technology, new gadgets such as vacuum cleaners and washing machines set higher standards of cleanliness which, paradoxically, created more work for housewives. Bruno Taut's somewhat chilling pronouncement on the potential for rationalising women's housework represents the typically utopian response to a technology that changes superficial, rather than essential, aspects of life:

> She [the housewife] will adopt a new organisation for her work … and arrange to perform individual chores – tending the children, cooking, serving meals, washing up, cleaning, laundry, shopping, etc. according to a plan.[60]

Women became, in effect, slaves to the new machines, and working women were not exempt from the toils of modern housework. Finally, the '*neue Frau*' certainly existed, but she was at least in part a creation of the media, and she was certainly the target of the consumer leisure culture of the Weimar Republic. Advertising, journalism and film were all directed to the tastes of the new woman, who became the quintessential consumer, and whose self-creation in part rested in the imagery she was fed by such cartels as Scherl and Ullstein.

This is not to suggest that women were merely passive victims of Weimar modernity. Women assumed diverse roles, and cultural products reflected this diversity. Among the most prevalent icons of the Weimar Republic are film stars, such as Marlene Dietrich in her role as the sadistic tavern singer in *The Blue Angel* (1930). Dietrich's image of overpowering sexuality was balanced by the largely unknown stars of the controversial film, *Mädchen in Uniform* (*Young Women in Uniform*, 1932), which contained an all-female cast.[61] *Mädchen in Uniform* was both a spirited attack on Prussian militarism and an investigation of female relationships with undeniably lesbian overtones. The women in this film stood as an example of a potentially better society. Further

examples of the pluralism of women's roles come from a more traditional source. Although Dix could see women as icons of cultural decay, the president of the conservative Bund deutscher Frauenverein (Organisation of German Women), Gertrude Bäumer, felt that womanliness was the only effective foil for the harsh inhumanity of masculine rationalisation and modernity. Bäumer's view was coloured by a traditional stereotype of women as nurturing and peace-loving, but it stands as an important alternative to the male notion of women as evil and corrupt. Such contradictory symbols of womanhood manifested a confusion about femininity that characterised the Weimar period as a whole and underlay visual representations of women as well.

Women artists often used the *Neue Sachlichkeit* trademarks to experiment with their own notions of themselves as individuals, as artists, and as women.[62] The self-portraits by the Berlin painter Lotte Laserstein and the Dresden artist Käte Diehn-Bitt stress androgyny through an emphasis on unisex clothes and the fashionable Bubikopf haircut. Similarly, the Danish actress Asta Nielsen cultivated an androgynous appearance, which reconciled her role as a star and sex symbol with that of a professional woman in a man's world. Androgynous images were rife in journalism, and could be the brunt of low humour, but their ubiquity pointed to confused notions of identity and dominance which contributed to the instability of the Weimar Republic.

Such confusions are highlighted by Klaus Theweleit's account of the 'male fantasies' of members of the German Freikorps (or free army) during the 1920s.[63] Their fantasies of women either extolled them as angels beyond reach or destroyed them if they were any sort of threat to masculine dominance. Theweleit showed how right-wing militarists could view women who declared their sexuality, or dared to take on employment, or supported socialist political causes, as enemies of their masculinity and of the German state as a whole. Theweleit's sophisticated analysis used Freudian psychology to unpack a complex array of both visual and verbal imagery, but what he also showed was just how pervasive the spirit of militarism continued to be in the ostensibly pacifist Weimar Republic. One of the conditions of the Versailles Treaty was the disarmament of a large portion of the Reichswehr (German army), but the Freikorps, which was patched together to put down civil disturbance, became an invidious new force in German society. With a handful of notable exceptions, the visual culture of the Weimar Republic eschewed the representation of war, which could not be reconciled to notions of modernity.[64] Dix's work showed what artistic imagination could do with images of the war. Dix himself saw action on the battlefield, and his initial utopian enthusiasm for war was shaken by his experience. Shortly after the war, his *Skat Players* (1920, Stuttgart, Stadtgalerie) used the savage mutilations suffered by war veterans to make a bitter comment about the indifference of society to the effects of its military technology. His horrifying series of etchings *War* (1923), and his painting of *The Trench* (1920–23) equally dwelt upon the misery and suffering of the war. But Dix was an exception.[65] Images of war were less common in visual culture than views of city life and the new woman. Meanwhile, the defeat of the First World War rankled in public imagination, *Blut und Boden* (blood and soil) novels became popular in the late 1920s, and nationalistic war films gained a large following. So pervasive was the spirit of war, that the

film of Erich Maria Remarque's pacifist novel *All Quiet on the Western Front* attracted Nazi demonstrators in many cities. Despite the decade which had elapsed since the defeat of the First World War, war continued to captivate the public imagination, even while artists and film makers of the *Neue Sachlichkeit* focused their attention on the more mundane aspects of German modernity. Thus beneath the cynical and 'objective' visions of modernity, a very old spirit of resistance and national pride stirred and prepared to re-emerge.

NOTES

1 Peter Thoene, *Modern German Art*, Eng. trans. Charles Fullman, Harmondsworth, 1938, p. 9.
2 Quoted in Charles Harrison and Paul Wood (eds), *Art in Theory 1900–1990*, Oxford, 1992, p. 486.
3 Dennis Crockett argues forcefully for the ahistorical vagueness of the term '*Sachlichkeit*', and prefers 'Post-Expressionism' as a signal of the continuity of the Expressionist tradition in the early years of the 1920s. See his *German Post-Expressionism: The Art of the Great Disorder 1918–1924*, University Park, 1999.
4 Of the many important studies, see especially John Willett, *The New Sobriety: Art and Politics in the Weimar Period 1917–33*, London, 1978, and the same author's *The Weimar Years: A Culture Cut Short*, London, 1984; Peter Gay, *Weimar Culture: The Outsider as Insider*, Harmondsworth, 1968; Walter Laqueur, *Weimar: A Cultural History 1918–33*, New York, 1974; Bärbel Schräder and Jürgen Schebera, *The Golden Twenties: Art and Literature in the Weimar Republic*, New Haven, 1988; Richard Bessell and E. J. Feuchtwanger (eds), *Social Change and Political Development in Weimar Germany*, London, 1981; and Kurt Sontheimer, 'Weimar culture', in Michael Laffan (ed.), *The Burden of German History 1919–45*, London, 1988, pp. 1–10.
5 See, for example, Schräder and Schebera, *Golden Twenties*.
6 Crockett, *Post-Expressionism*, pp. 27–8 includes a fascinating discussion of the ways in which inflation stimulated the art market.
7 See, for example, Sergiusz Michalski, *New Objectivity*, Cologne, 1994, pp. 7–8.
8 The idea that the Weimar Republic should be seen as a self-contained entity is argued most eloquently in the excellent study by Detlev Peukert, *The Weimar Republic: The Crisis of Classical Modernity*, London, 1991.
9 See Michalski, *New Objectivity*; Crockett, *German Post-Expressionism*; Wieland Schmied (ed.), *Neue Sachlichkeit and German Realism of the Twenties*, exhibition catalogue, London, 1979; Wieland Schmied, *Neue Sachlichkeit und Magischer Realismus in Deutschland 1918–33*, Hanover, 1969; Helen Adkins, *Neue Sachlichkeit – Deutsche Malerei seit dem Expressionismus*, exhibition catalogue, Berlin, 1988; Hans-Jürgen Buderer, *Neue Sachlichkeit: Bilder auf der Suche nach der Wirklichkeit*, Munich, 1994; and Hans Gotthard Vierhuff, *Die neue Sachlichkeit: Malerei und Fotografie*, Cologne, 1980.
10 See Frederic Schwartz, *The Werkbund: Design Theory and Mass Culture Before the First World War*, New Haven and London, 1996, p. 41.
11 Quoted in Schmied, *Neue Sachlichkeit* (1979), p. 9.
12 Franz Roh, *Nach-Expressionismus, magischer Realismus: Probleme der neuesten europäischen Malerei*, Leipzig, 1925.
13 'Wie das Kunstwerk keinen Gegenstand darstellen kann, weil die gemalte Blume keine Blumen ist, so kann es auch keine Gedanken oder Gefühle ausdrücken': Lothar Schreyer, 'Das Gegenständliche in der Malerei', in Herwarth Walden, *Expressionismus: Die Kunstwende* (1918), Berlin, 1973, pp. 22–9 (quotation on pp. 22–4). Walden referred to the fact (*Sache*) in some of his writings. See, for example, *Einblick in Kunst. Expressionismus, Futurismus, Kubismus*, Berlin, 1917, 2nd edn 1924, p. 36: 'Die Kunst und die Tatsache sind zwei Welten, die nichts miteinander zu tun haben.'
14 Willett discusses this in *New Sobriety*, p. 112. Neue Sachlichkeit trends in Cologne were firmly related to Russian Constructivism.
15 Hartlaub used this distinction in an article published in *Das Kunstblatt* in 1922, but see also his later 'Zum Geleit', in *Ausstellung: Neue Sachlichkeit*, Mannheim, 1925, in

which he is very tentative in his use of the term 'left-wing' and does not refer to a right wing at all. For an example of the way these labels have become appropriated by subsequent scholarship, see Schmied, *Neue Sachlichkeit*.

16 See, for example, Michalski, *New Objectivity* and Schmied, *Neue Sachlichkeit*.

17 For Jürgens and Overbeck, see Marsha Meskimmon and Martin Davies (eds), *Domesticity and Dissent: The Role of Women Artists in Germany 1918–1938*, exhibition catalogue, Leicester, 1992. With the exception of prominent figures like Grosz and Dix, most *Neue Sachlichkeit* artists have been considered through exhibitions and exhibition catalogues, rather than scholarly monographs.

18 See, for instance, Max Brod, 'Die Frau und die neue Sachlichkeit', *Die Frau von Morgen, wie wir sie wünschen*, ed. Friedrich M. Huebner, Leipzig, 1929, pp. 38–48, quoted in Anton Kaes, Martin Jay and Edward Dimendberg (eds), *The Weimar Republic Sourcebook*, Berkeley and Los Angeles, 1994, pp. 205–6. See also Marsha Meskimmon, 'Politics, the Neue Sachlichkeit and women artists', in Marsha Meskimmon and Shearer West (eds), *Visions of the 'Neue Frau': Women and the Visual Arts in Weimar Germany*, Aldershot, 1995, pp. 9–27.

19 Siegfried Kracauer, *From Caligari to Hitler: A Psychological History of the German Film*, Princeton, 1947, p. 166.

20 Siegfried Kracauer, 'Mass ornament', in his *The Mass Ornament: Weimar Essays*, ed. Thomas Y. Levin, Cambridge, Mass., 1995, pp. 75–86 (quotation on p. 75).

21 See especially Beth Irwin Lewis, '*Lustmord*: inside the windows of the metropolis', in Charles Haxthausen and Heidrun Suhr (eds), *Berlin Culture and Metropolis*, Minneapolis and Oxford, 1990, pp. 111–40; and for the wider context and contemporaneous criminal trials, see Maria Tatar, *Lustmord: Sexual Murder in Weimar Germany*, Princeton, 1995.

22 For sources on Berlin and its history, see the footnotes to chapter 2. For the Weimar Republic specifically, see also *The Berlin of George Grosz: Drawings, Watercolours and Prints*, exhibition catalogue, London, 1997.

23 See Eva Karcher, *Otto Dix 1891–1969: His Life and Works*, Cologne, 1988; and *Otto Dix 1891–1969*, exhibition catalogue, London, 1992.

24 Peter Gay discusses the commonly held belief that the sexual realism of Weimar culture was an excuse for sexual licence and pornography. See his *Weimar Culture*, p. 128.

25 See Ann Taylor Allen, *Satire and Society in Wilhelmine Germany: Kladderadatsch and Simplicissimus 1890–1914*, Lexington, Kentucky, 1984; and Sherwin Simmons, 'War, revolution, and the transformation of the German humor magazine 1914–1927', *Art Journal*, 52:1 (1993), 46–54.

26 The idea that there is a parodic element to religious art in turn-of-the-century Catholic Munich is put forward very convincingly by Maria Makela, 'The politics of parody: some thoughts on the "modern" in turn-of-the-century Munich', in Françoise Forster-Hahn (ed.), *Imagining Modern German Culture 1889–1910*, Washington, DC, 1996, pp. 185–207.

27 See Maurice Godé, *Der Sturm de Herwarth Walden: l'utopie d'un art autonome*, Nancy, 1990, especially pp. 61–7.

28 Peter Jelavich discusses the Panizza trial in *Munich and Theatrical Modernism*, Cambridge, Mass., 1985, pp. 69–70.

29 The communist writer Lu Märten attempted to consider the limitations of satire for communist propaganda in her 'Geschichte, Satyre, Dada und Weiteres', published in *Die Rote Fahne*, 163 (22 August 1920). For an excellent discussion of this essay, see Barbara McCloskey, *George Grosz and the Communist Party: Art and Radicalism in Crisis 1918 to 1936*, Princeton, 1997, pp. 80–3.

30 Hugo Ball, *Flight Out of Time: A Dada Diary*, ed. John Elderfield, Berkeley and Los Angeles, 1996, pp. 61, 83.

31 For Mammen's unusual work, see Annelie Lütgens, 'The conspiracy of women: images of city life in the work of Jeanne Mammen', in Katharina von Ankum (ed.), *Women in the Metropolis: Gender and Modernity in Weimar Culture*, Berkeley, 1997, pp. 89–105; Marsha Meskimmon, *'We Weren't Modern Enough': Women Artists and the Limits of German Modernism*, London, 1999; and Louise Noun, *Three Berlin Artists of the Weimar Era: Hannah Höch, Käthe Kollwitz, Jeanne Mammen*, exhibition catalogue, Des Moines, 1994.

32 See Shearer West, 'Portraiture in the twentieth century: masks or identities?', in Christos M. Joachimides and Norman Rosenthal (eds), *The Age of Modernism: Art in the Twentieth Century*, exhibition catalogue, Berlin, 1997, pp. 65–71.

33 See Ursula Zeller, 'The reception of Dix's work', in *Otto Dix*, pp. 49–60.

34 See August Sander, *Citizens of the Twentieth Century*, ed. Günther Sander, Cambridge, Mass., 1986; and *August Sander: 'In photography there are no unexplained shadows!'*, exhibition catalogue, London, 1996.

35 This is the argument of Graham Clarke, 'Public faces, private lives: August Sander and the social typology of the portrait photograph', in Graham Clarke (ed.), *The Portrait in Photography*, London, 1992, pp. 71–93.

36 See Roland Barthes, *Camera Lucida*, Eng. trans. by Richard Howard, London, 1984.

37 For photograph in Germany during the 1920s, see David Mellor (ed.), *Germany, the New Photography*, London, 1978; for a useful summary of the different types of experimental photography in this period, see Eleanor Hight, *Picturing Modernism: Moholy-Nagy and Photography in Weimar Germany*, Boston, 1995, pp. 97–9.

38 Although photography was practised in various official and unofficial capacities by students and staff at the Bauhaus, there was no single Bauhaus photographic style. See *Photography at the Bauhaus*, exhibition catalogue, London, 1990; Paolo Costantini (ed.), *La fotografia al Bauhaus*, exhibition catalogue, Venice, 1993; Andreas Haus, *Moholy-Nagy: Photographs and Photograms*, London, 1980; and Rolf Sachsse, *Lucia Moholy: Bauhaus fotografin*, Berlin, 1995. For the opportunities photography potentially offered women, but the obstacles that inevitably had to be overcome, see Ute Eskildsen, 'A chance to participate: a transitional time for women photographers', in Meskimmon and West, *Visions of the 'Neue Frau'*, pp. 62–76.

39 See Donald Kuspit, *Albert Renger-Patzsch: Joy Before the Object*, Santa Monica, 1993.

40 Walter Benjamin, 'The artist as producer' (1934), quoted in Harrison and Wood, *Art in Theory*, p. 487.

41 For Benjamin's views, see also 'A small history of photography', in *One Way Street and Other Writings*, Eng. trans. Edmund Jephcott and Kingsley Shorter, London, 1979, pp. 240–57.

42 For a discussion of some of these cultural theories, see David Frisby, *Fragments of Modernity: Theories of Modernity in the Work of Simmel, Kracauer and Benjamin*, Cambridge, 1985.

43 Siegfried Kracauer, 'The revolt of the middle classes: an examination of the *Tat* circle' (1931), in *Mass Ornament*, pp. 107–27.

44 Sigfried Kracauer, 'The group as bearer of ideas', in *Mass Ornament*, pp. 143–70 (quotation on p. 151).

45 Sigfried Kracauer, 'The mass ornament', in *Mass Ornament*, pp. 75–86.

46 Laqueur, *Weimar*, preface.

47 Walter Benjamin, 'The work of art in the age of mechanical reproduction', in *Illuminations*, ed. Hannah Arendt, London, 1992, pp. 211–44 (quotation on p. 214).

48 See Bruce Murray, *Film and the German Left in the Weimar Republic: From Caligari to Kuhle Wampe*, Austin, 1990; and Uli Jung and Walter Schatzberg (eds), *Filmkultur zur Zeit der Weimarer Republik*, Munich, 1992.

49 Kracauer, *From Caligari to Hitler*.

50 See Lynne Frame, 'Gretchen, girl, garçonne? Weimar science and popular culture in search of the ideal new woman', in Ankum, *Women in the Metropolis*, pp. 12–40. On p. 32 she discusses the way the *Neue Sachlichkeit* aesthetic validated fiction by associating it with scientific and technical aspects of modernity.

51 Patrice Petro deals thoroughly with these films in *Joyless Streets: Women and Melodramatic Representation in Weimar Germany*, Princeton, 1989.

52 Kracauer, *From Caligari to Hitler*, p. 165.

53 Wick Evans, 'Karl Freund, candid cinematographer' *Popular Photography*, 4 (1939), p. 51, quoted in Kracauer, *From Caligari to Hitler*, p. 186.

54 See John A. Leopold, *Alfred Hugenberg: The Radical Nationalist Campaign Against the Weimar Republic*, New Haven, 1977.

55 These theories are discussed by Petro in *Joyless Streets* and in her essay 'Perceptions of difference: woman as spectator and spectacle', in Ankum, *Women in the Metropolis*, pp. 41–66.

56 See Jeffrey Herf, *Reactionary Modernism: Technology, Culture and Politics in Weimar and the Third Reich*, Cambridge, 1984.

57 For the importance of gender in constructions of modernity, see Andreas Huyssen, 'Mass culture as woman: modernism's other', in idem, *After the Great Divide: Modernism, Mass Culture, Postmodernism*, Bloomington, 1986, pp. 44–62; and for Weimar Germany specifically, see Günter Berghaus, '"Girlkultur": feminism, Americanism and popular entertainment in Weimar Germany', *Journal of Design History*, 1:3–4 (1988), 193–219.

58 There are some excellent studies on women in the Weimar period. See, for example Renate Bridenthal, Atina Grossman and Marion Kaplan (eds), *When Biology Became Destiny: Women in Weimar and Nazi Germany*, New York, 1984; Ute Frevert, *Women in German History: From Bourgeois Emancipation to Sexual Liberation*, Oxford, 1989; Richard Evans, *The Feminist Movement in Germany 1894–1933*, London, 1976; and Helen L. Boah, 'Women in Weimar Germany: the "Frauenfrage" and the female vote', in Bessell and Feuchtwanger, *Social Change*, pp. 155–73.

59 For studies of the new woman, see especially Ankum, *Women in the Metropolis*; Meskimmon and West, *Visions of the 'Neue Frau'*; Meskimmon, *'We Weren't Modern Enough'*; and Helmut Gold and Annette Koch (eds), *Fräulein vom Amt*, Munich, 1993.

60 Bruno Taut, *Die neue Wohnung: Die Frau als Schöpferin*, Leipzig, 1924, pp. 64–70, quoted in Kaes, Jay and Dimendberg, *Weimar Republic Sourcebook*, pp. 461–2.

61 See Ruby B. Rich, 'From repressive tolerance to erotic liberation: *Mädchen in Uniform*', in Mary Ann Doane, Patricia Mellencamp and Linda Williams (eds), *Re-vision: Essays in Feminist Film Criticism*, Los Angeles, 1984.

62 For women artists in the Weimar period, see especially, Meskimmon and Davies, *Domesticity and Dissent*; Meskimmon, *'We Weren't Modern Enough'*; Verein der Berliner Künstlerin (ed.), *Käthe, Paula und der ganze Rest: Künstlerinnen Lexicon*, Berlin, 1992; Verein der Berliner Künstlerin (ed.), *Profession ohne Tradition. 125 Jahre Verein Berliner Künstlerin*, Berlin, 1992; Ulrike Evers, *Deutsche Künstlerinnen des 20. Jahrhunderts*, Hamburg, 1983; and Renate Berger, *Malerinnen auf dem Weg ins 20. Jahrhundert: Kunstgeschichte als Sozialgeschichte*, Cologne, 1982.

63 Klaus Theweleit, *Male Fantasies*, volume 1: *Women, Floods, Bodies, History*, Minneapolis, 1987; volume 2: *Male Bodies: Psychoanalysing the White Terror*, Oxford, 1989.

64 Dora Apel, '"Heroes" and "whores": the politics of gender in Weimar anti-war imagery', *Art Bulletin*, 72:3 (1997), 366–84.

65 Another exception was Käthe Kollwitz, who also produced a war series in the early 1920s.

Reaction: 'degenerate' art

What the Degenerate Art exhibition means to do:
It means to give, at the outset of a new age for the German people, a firsthand survey of the gruesome last chapter of those decades of cultural decadence that preceded the great change. (Introduction to the catalogue of the 'Degenerate Art' Exhibition, 1937)[1]

Hitler's dictatorship was the first dictatorship of an industrial state in this age of modern technology. (Albert Speer's speech at the Nuremberg trial in 1946)[2]

The logical result of Fascism is the introduction of aesthetics into political life. (Walter Benjamin, 'The work of art in an age of mechanical reproduction')[3]

A FTER the political and aesthetic turmoil of the Weimar Republic, the National Socialist regime imposed an order on German art that was unimaginable during the 1920s. From the time of Hitler's assent to power in 1933, art became a political and social weapon. Kracauer's premonitory remarks about the dangers of mass culture proved all too accurate when the Nazi propaganda machine took advantage of the mechanisms of cultural dissemination already in place. The divisions that had existed in the art world before 1933 were eradicated, and an illusion of homogeneity and consensus was maintained. Arguably, the Nazis came the closest to achieving the German desire for cultural unity, but the culture that they created was not worth having and the price that was paid for it was the suicide, despair, death and exile of talented artists. The Nazis created an image of cultural unity, but only at the expense of repressing personal freedoms. The cultural pluralism of Germany before the advent of Hitler was a much healthier expression of a country striving to locate an essential or unified culture. However, the Nazis did not turn their backs entirely on the visual culture of the Weimar Republic. Instead, they borrowed selectively from styles, modes and institutions to create their own art world – a world which was in no way superior, but in many respects more effective, than that it had replaced. The Nazis systematically assembled a tight cultural bureaucracy and in many ways restored the cultural centralisation that had collapsed with the Secession movements of the 1890s. The visual arts were of immense importance to this new bureaucracy. The messages of Nazi visual culture were inevitably monolithic and propagandist, but the means and media they used showed their ability both to play on tradition and exploit innovations in visual culture.

The Nazi cultural mission was simple and alarmingly effective.[4] With the public's collaboration, they reviled and destroyed the work of the avant-garde, while extolling an academic style of art which had existed since the nineteenth century but had been superseded by the market success of modern art movements. The 'new art' was then harnessed in the service of propaganda.[5] The meagre artistic successes of the Nazis were extolled at home and abroad as 'evidence' of their cultural achievements, and the rhetoric of nationalism and racism was employed to endow such works with the qualities that also characterised Hitler's view of the world. Much of the cultural unity of the Nazi period was an illusion: for several years after they came to power, the art world continued to be beset by tensions, but these were suppressed or minimised with the help of propaganda. The significance of visual culture to the Nazi regime should not be underestimated. When Walter Benjamin spoke of fascism as aestheticising politics, he pointed to the way in which use of the arts permeated National Socialist methodology. This was not simply their attitude to the arts, or to culture in general, but the way in which the party lured the people to follow or accept a totalitarianism that was, at best, irrational, and at worst, murderous. In order to understand how the Nazis achieved their goals, it is important to see how they infiltrated institutions, systematically destroyed the German avant-garde, appropriated the tools of mass culture, and used what was left to create an art that supported Hitler's totalitarian regime.

During the 1920s, while the Weimar Republic was undergoing its numerous political and social trials, the Nazi party briefly thrived, was suppressed and then re-emerged more powerful during the period of economic depression after the 1929 Wall Street stock market crash. When Hitler joined the party in 1919 it was called the German Workers' Party, and it advocated a strong central government and a proactive anti-Semitism. In 1920, the party changed its name to the National Socialist German Workers' Party (NSDAP), and Hitler's own role within the party increased dramatically. Aside from their ubiquitous anti-Semitism, the Nazis hoped to appeal to the working people (hence the 'Socialist' in their title), but they derided the Marxist emphasis on the repressed proletariat. They aspired to a sort of paternalistic government which unified all the population under a nationalist and racist agenda. The Nazis attempted to seize power in an abortive putsch of 1923. After this, Hitler was imprisoned and their party was banned. In the uncertain political climate of the late 1930s, many anxious and miserable voters turned back to the Nazi party as an answer to their problems. In 1930 the Nazis had only 12 seats in the Reichstag, but by 1932, they had 230.

Their rise to power was partly the result of internal disputes within the Weimar coalition government, and the inability of that government to solve the economic problems created by the world depression. Between 1930 and 1933, parliament was dissolved three times, there were three different Chancellors and a presidential election was held in which Hindenburg regained his seat. Hitler came second in the 1932 presidential election, and he drew an increasing contingency of voters to his platform, which was based on anti-Semitism, the unification of Germans with German blood and the exclusion of foreigners from Germany. In Hitler's rhetoric, the financial dealings of the

Jews were responsible for the present disastrous situation in Germany, and popular despair welcomed such a simple explanation for a very complex political problem. On 30 January 1933, after many negotiations with the government, Hitler was named Reich Chancellor. The changes he made over the next few months were breathtaking in their rapidity and harshness. In March, he passed an Enabling Act which gave him power by decree (effectively creating a dictatorship); in April, the Gestapo was founded; in May, all unions were abolished; in June the SPD was banned; and in July all other political parties, including right-wing nationalist parties, were also abolished. The National Socialist party, with Hitler at its head, controlled the whole of Germany, and there was no longer any effective opposition.

One of the most remarkable aspects of Hitler's assumption of power was how quickly he began to intervene in the arts, and the extent to which he initially focused his attention not on manifestations of mass culture like films, design and journalism, but on 'fine' art forms, such as painting, sculpture and architecture. Despite a number of other pressing matters, his first artistic reforms came just over a month after his appointment as Chancellor. Hitler's obsession with the arts was not a new one, and he had long hinted that if he obtained power, a restructuring of culture was one of his major goals. It has become commonplace to attribute Hitler's interest in the arts to his own failure to succeed in the Vienna Art Academy when he was there in 1907. Hitler's revenge on the art world has been seen as a vendetta against the sort of artists who refused to recognise his own talents at that time. Although there may be some truth in this assertion, it is perhaps less feasible that his artistic failures led to a sort of Freudian over-compensation than that his interest in art made him realise how effective a weapon it could be in the hands of a dictator. It is also important to realise that Hitler's decision to pursue academic training in turn-of-the-century Vienna had run directly counter to the avant-gardism that had prevailed successfully in the powerful Secession movement there, which had state support.[6]

Even as early as 1920, one of the 25 'points' in Hitler's Programme of the German Workers' Party included a reference to art: 'we demand the legal prosecution of all tendencies in art and literature of a kind likely to disintegrate our life as a nation'.[7] This punitive reference was certainly a taste of things to come, as Hitler later launched an artistic pogrom designed to eradicate any art which went against his own world view. But Hitler's understanding of the function of art also appeared in his own early writing. In *Mein Kampf*, which he wrote in 1924 while in prison, he made several comments about art that reveal the significance it had for him. First of all, he attacked any form of art that supported left-wing ideology. He was writing several years after the November Revolution, when he had had the opportunity to see the relationship between revolutionary ideology and art production:

> Artistic Bolshevism is the only possible cultural form and spiritual expression of Bolshevism as a whole. Anyone to whom this seems strange need only subject the art of the happily Bolshevized states to an examination and, to his horror, he will be confronted by the morbid excrescences of insane and degenerate men, with which, since the turn of the century, we have become familiar, under the collective concepts of Cubism and Dadaism.[8]

His emphasis on Cubism and Dadaism persisted in the speeches about art which he made after his ascent to power, and these references reveal the lack of nuance in his views on avant-garde art, as well as reflecting the tendency to see all modernism as a single phenomenon.[9] To Hitler, Cubism encompassed all art of an abstract tendency, and Dada art was synonymous with the KPD. Although Hitler's later speeches also referred to Futurism and even Impressionism, he made no reference to Expressionism, which was a style of art he particularly disliked. These points of detail reveal much about Hitler's own ideas. Art was firmly associated with the people who produced it, and any works by left-wing or Jewish artists were, in his eyes, evidence of conspiracy or insanity. The fact that many of the artists whose work he most reviled were neither Jews nor communists did not stop him from associating abstraction, Cubism and the nihilism of Dada with what he claimed to be a Jewish/Bolshevik conspiracy.

In *Mein Kampf*, Hitler saw all art as political, but he also showed an understanding of the ways in which culture could have an impact on a mass population. Despite the ideological distinction, this emphasis on mass culture had also been the goal of communist art during the 1920s and early 1930s. Many of their productions, including Heartfield's attacks on Hitler in the early 1930s, were intended to be unambiguous and legible to a large population. But despite the shared legibility of left- and right-wing propaganda art, Hitler saw such mass art as imposed firmly from above, while the communists hoped to inspire an indigenous proletarian art that would allow creative freedom to the workers. Hitler made his perspective clear in *Mein Kampf*, where he wrote:

> The capacity of the masses for perception is extremely limited and weak. Bearing this in mind, any effective propaganda must be reduced to the minimum of essential concepts . . . Only constant repetition can finally bring success in the matter of instilling ideas into the memory of the crowd.[10]

If art was to influence the masses, it needed to be simple and obvious. Hitler later put his theories into practice in his own cultural programme. Although he gave a total of only six speeches about culture, his words were repeated, reprinted and reproduced so many times and in so many different places that it seemed as if he were making constant pronouncements about the role of art in contemporary life. In truth, his cultural ideas were simplistic and appealed to popular prejudice. His condemnation of modern art movements touched an empathetic cord with the many people who did not understand esoteric avant-gardism, and his assignment of evil intentions to these 'incomprehensible' works provided a simple explanation which appealed to the public's desire for enlightenment. His attack on the Jewish conspiracy in the art world may have seemed plausible to the ignorant. Although there were very few Jewish artists in Germany, there were many Jewish dealers and art critics, and the very association of Jews with the money side of art fuelled Hitler's tendency to blame the Jews for the desperate economic state of contemporary Germany.[11]

Hitler did not invent these ideas. He appropriated them from a number of publications that began appearing from the mid-1920s which assigned racial qualities to art and architecture. The most notable of these works were published by the neo-Biedermeier architect Paul Schultze-Naumburg, whose

books played out his grudge against the success of the Bauhaus style. His *ABC of Building* (1926), *Art and Race* (1928) and *The Face of the German House* (1929) represented a theory of contemporary architecture that was increasingly extreme and irrational. Although Schultze-Naumburg was perfectly capable of making pronouncements about the technical, structural and engineering aspects of architecture, his focus on facades – which he conceived of as the 'physiognomy' of a building – reinforced his racist emphasis.[12] According to Schultze-Naumburg, the urban architecture of the 1920s embodied an internationalist style that reflected its proletarian, nomadic and Jewish roots. Because buildings of the new style did not possess a distinct cultural association, they were seen to be offending against the heritage of the German people. In contrast, Schultze-Naumburg praised his own mode of architecture as racially correct; his pastiches of the Biedermeier style became the way forward for German architecture.

Schultze-Naumburg's tracts were self-publicising attempts to denigrate a more successful opposition, but they were dressed up in a grand theory that had appeal for similarly philistine contemporaries.[13] Schultze-Naumburg's success and influence was consolidated when he was appointed director of the new United Institutes for Art Instruction, which replaced the Weimar Bauhaus in 1929. In that year, the Nazis achieved their first victory in local elections when a coalition of Nazis and other right-wing parties was formed after the Thuringian Landtag elections. Under the Minister of the Interior, the Nazi Wilhelm Frick, Schultze-Naumburg's artistic policies gained strength, while films by Eisenstein and Brecht were banned and, in 1930, frescoes by Oskar Schlemmer in the former Weimar Bauhaus were deliberately destroyed.

Schultze-Naumburg was not the only proponent of these new cultural theories. One of the most influential books in the Nazi ideological weaponry was Richard Darre's *The Peasantry as the Life Source of the Nordic Race* (1929) which first proposed the ideas of 'blood and soil' that would form the foundation of the Nazi cultural perspective. According to Darre, it was important that the Germans realised their true racial potential and that this 'Germanness' rested in the countryside, in the soil and in the peasantry. The ideas were not new (they had been percolating since the turn of the century), but the way in which this theory was mobilised by the Nazi government for cultural and propagandist purposes indicated a new direction in German art life. Following Darre, Alfred Rosenberg's pseudo-mystical *The Myth of the Twentieth Century* (1930) carried the 'blood and soil' ethos into cultural ideology, and Rosenberg was able to perpetuate his ideas through his own cultural activities. In 1928 he was in charge of the Kampfbund für Deutsche Kultur (League of Defence of German Culture), a society designed to spread racism through travelling lectures and exhibitions. Rosenberg's League lost its influence in 1933, when Hitler took charge of the state cultural machine, but the ideas perpetuated by the society were consolidated under Hitler's regime.[14] It is significant that neither Schultze-Naumburg nor Darre and Rosenberg were innovative in their theories. All drew upon prevailing nationalist ideologies of culture, while Schultze-Naumburg also looked back to his associations with the Deutscher Werkbund and that institution's goal to foster a morally regenerative and unified visual culture.

Similarly derivative were the more overtly technological aspects of fascism, as Rosenberg's conservative theories, and his desire to resurrect a 'true' German culture were in many ways in opposition to the modernising tendencies of Hitler's principal cultural campaigner Josef Goebbels. Goebbels went beyond Hitler's personal obsessions with art and architecture to deal with the multi-faceted aspects of modernist mass culture. In March 1933 Hitler founded the Reich Ministry for Propaganda with Goebbels as director and, from this point onwards, art became not an individual expression of creative freedom, but a propagandist tool for the state. Hitler expressed his desire to harness art for the sake of propaganda in two speeches, the first of which he delivered in the Reichstag on 23 March 1933:

> Simultaneously with this political purification of our public life, the Government of the Reich will undertake a moral purging of the body corporate of the nation. The entire educational system, the theatre, the cinema, literature, the press and the wireless – all these will be used as means to this end and valued accordingly.[15]

And later, in a speech at the Nuremberg party rally of 6 September 1938, he further defended these propagandist impulses as necessary for his mission of unification and his desire for German racial 'purity'. Speaking of the history of the Nazi party, he proclaimed:

> Its task was to cleanse from [the Jewish] influence the life of the German people, our race and culture. It had to put an end to the thoughtlessness of public opinion. It had to take into its hands all the means of guiding the people – press, theatre, films and all other forms of propaganda – and to direct them towards a single goal.[16]

The Reich Ministry for Propaganda ensured the centralisation of art institutions, which was the first step in the desire for a 'single goal' for all the arts. In September 1933, the Ministry oversaw the founding of the Reichskulturkammer (Reich Chambers of Culture), which was divided into separate branches for film, literature, theatre, music, press, radio and the visual arts. In order to be a practitioner in any of these disciplines, an artist first had to be vetted and ratified by the relevant chamber. This made it possible to exclude any 'undesirable' artists from their profession by prohibiting them from practising. More importantly, it made each artist a sort of unpaid civil servant, whose very existence depended on the good graces of an intractable and narrow-minded regime.

This new bureaucracy – designed to foster the cultural unity of the Nazi regime – was ironically based on a fragmentation of the arts that pulled against all avant-garde ideas of *Gesamtkunstwerk*.[17] This was recognised by one of Hitler's favourite architects, Albert Speer, who wrote about it in his retrospective view of the culture of the 1930s:

> Worse still was the restriction of responsibility to one's own field. Everyone kept to his own group – of architects, physicians, jurists, technicians, soldiers, or farmers ... people were immured in isolated, closed-off areas of life ... The disparity between this and the *Volksgemeinschaft* (community of the people) proclaimed in 1933 always astonished me.[18]

The atomisation of the cultural world served to quell the innovative associations between artists, architects, performers and designers that had characterised the 1920s, even while these separate spheres were retained and fostered through the uncompromising new government bureaucracy.

However, the creation of this new structure did not lead immediately to cultural stasis. Although the art of the Third Reich has been subsequently represented as conservative, in the early days of the regime there were tensions within the movement. Unlike Rosenberg, who upheld Greek beauty as the highest ideal of art, Goebbels was a devotee of modern culture. He appreciated Expressionist art and was a film enthusiast. His ideas were shared by other members of the Nazi party, including the painter Andreas Schreiber, who led a group of Berlin students in a defence of Expressionist art. These students, who demonstrated their support in 1933, were opposed to Rosenberg's League of German Culture for its attempts to suppress the work of such artists as Nolde. To these students, Nolde's work could be approved not only because the artist was himself a member of the Nazi party, but because it was important that the party embrace modernity as part of its cultural programme. Expressionism had often been interpreted as a characteristically 'German' art form, bearing a strong formal relationship to the German medieval heritage. On these lines, the students could defend its place in the Nazi cultural programme. However, Hitler savagely squashed their rebellion in a subsequent speech; their activities were suppressed and they were expelled from the party.

Goebbels was sympathetic to this demonstration of adherence to 'modern' tendencies in art, and he embraced modernity further in a speech of 15 March 1933 on the aims of the propaganda ministry. According to Goebbels, the Ministry's purpose was to 'enlighten' the people, but, more importantly, he emphasised that 'it must be our task to instil into these propaganda facilities a modern feeling and bring them up to date. Technology must not be allowed to proceed ahead of the Reich; the Reich must go along with technology. Only the most modern things are good enough.'[19] Although Hitler never went as far as Goebbels, he too recognised that Germany had to be 'modern' in order to compete in a modern world. Even while he and his cohorts were extolling a 'blood and soil' methodology that valorised the life of the peasant, they were using the tools of modern life, especially film, posters and mass media, to perpetuate their message.[20] Film was especially favoured by Hitler's immediate circle, who spent many tedious hours at his mountain retreat in Obersalzburg, watching and rewatching the latest cinematic examples of popular entertainment.[21]

Hitler managed to strike a balance between the progressivist enthusiasm of Goebbels and the classicist sympathies of Rosenberg in a speech to the Nuremberg party rally of 1934. Here, he attacked the extremes of modernism and historicism, thus showing no real affiliation to either of his cultural magnates. However, the fact that Goebbels remained propaganda minister, while Rosenberg was increasingly marginalised, indicates that Hitler's sympathies were with the modern world – at least inasmuch as he could use modernity to enhance his own power.

Meanwhile, Goebbels went to work using methods which proved to be unquestionably effective. It was particularly important for Hitler that his

cultural message could reach the most humble family in the nation, even those who had previously had no interest in or access to art, literature or film. Through such organisations as Kraft durch Freude (Strength through Joy), German workers were treated to regular art exhibitions and cultural tours, while the Schönheit der Arbeit (Beauty of Work) organisation under Albert Speer was responsible for acquiring works of art to hang in factories and offices. The mentality here was certainly 'bread and circuses', but the seriousness and relentless cultural message must have wearied as many as it inspired.

The pretence that a culturally unenlightened public could suddenly become connoisseurs of art was fed by Goebbels' ban on art criticism. His decree was issued in November 1936, and it condemned art criticism as part of the 'Jewish domination of art', designed only to create changing 'fashions' in art, which could then be exploited by a corrupt art market. 'The critic', according to Goebbels, 'is to be superseded by the art editor. The reporting of art should not be concerned with values, but should confine itself to description. Such reporting should give the public a chance to make its own judgements, should stimulate it to form an opinion about artistic achievements through its own attitudes and feelings.'[22] Implicit in this attack, was the formative role of dealers like Walden and Hartlaub. The condemnation of critics served to praise the taste of the 'true German' public by suggesting that they had a 'natural' understanding of art and an ability to judge.

The abolition of criticism was part of an ongoing attempt to gag the forces of avant-gardism and to squash the Jewish input into cultural production. Other, more effective, techniques were also used. First of all, the Professional Civil Service Restoration Act of April 1933 enabled the government legally to dismiss any museum official or university professor it wished. In the wake of this act, artists such as Dix, Liebermann, Klee and Beckmann were removed (or resigned) from academic professorships, while museum directors such as Hartlaub were forced out of their posts. Nazi-approved officials were nominated in their stead. Second, Hitler in his Nuremberg party speeches, began a series of systematic attacks on modern art. He focused on 'Dadaists, Cubists and Futurists' and what he called the 'inner experience' or 'realism' that they emphasised in their art. He claimed that modern art did its best to degrade the nobility of the German people and that its producers were either insane or evil. In an echo of Wilhelm II's speech at the Berlin Siegesallee in 1901, Hitler insisted: 'It is not the function of art to wallow in dirt for dirt's sake, never its task to paint men only in the state of decomposition, to draw cretins as the symbol of motherhood, to picture hunch-backed idiots as representative of manly strength.'[23] There was little consistency in the objects of Hitler's attack: he did not really focus on a particular style; Expressionism, Constructivism and the Neue Sachlichkeit all drew his contempt. He was more concerned to disparage any art that was associated with the Weimar Republic, as he wished to attribute all the evils and problems of modern life to the Weimar coalition governments. Hitler appealed to a population that was largely ignorant of modernism, and his series of 'degenerate art' exhibitions were designed to inflame the prejudices of the uninitiated.[24]

The degenerate art and music exhibitions were held throughout Germany from 1933 to 1941, and they were the most effective blows against the success

of the avant-garde. The most famous of these was the Munich 'Degenerate Art' exhibition of 1937, but it was preceded by a number of similar shows from the time of Hitler's assumption of power. These exhibitions took place in Mannheim, Karlsruhe, Dresden, Munich, Berlin and Vienna. Some were sponsored by the League for the Defence of German Culture; others were financed by local government. Most of them were held in the principal public museums. All of them gathered together examples of avant-garde artists whose works had become acceptable and valuable during the 1920s. However, the aim of the exhibitions was not to display such works to their advantage, but to condemn them and open them up to public derision.

These exhibitions shared a number of techniques and approaches. First of all, their titles were politically tendentious. Titles such as 'Images of Cultural Bolshevism' and 'Official Art in Germany 1918–1933' clearly attacked the cultural policies of the Weimar Republic. The Nazis thereby attempted to harness what they saw as a decline in art with what they represented to be an evil, communistic government. The most famous artists of the 1920s were labelled 'November criminals', whether or not they had shown any sympathy with the November Revolution. Second, many of the exhibitions were racist in their implications. The label 'degenerate' evoked a *fin de siècle* taxonomy of madness which the Nazis used as part of their anti-Semitic campaign.[25] Art by Jews or containing Jewish subject matter was particularly singled out for contempt, and the Munich exhibition 'The Eternal Jew' was based entirely around the Hitler's Jewish conspiracy theory. Many exhibitions included works labelled with the names of the art dealers who had sold them, and the recurrence of names such as Walden, Cassirer and Flechtheim seemed to reinforce the anti-Semitic theories of the Nazis. Finally, each of these exhibitions contained labelling which specified the purchase price of the works of art. As many of them were bought during the early 1920s inflationary period, these prices could be millions of Marks. This appeal to economic probity was as effective as any other tactic in condemning the works of a whole generation of artists.

The major exhibition of 'Degenerate Art' took place in Munich from 19 July to 30 November 1937. It opened only one day after the First Great German Art Exhibition (see below), which consisted of many dreary rooms of government-approved art. In June 1937, a commission of 'art experts' had robbed public galleries over a period of only 10 days to gather the works which would hang in the exhibition.[26] The commission was headed by Adolf Ziegler, who was president of the Reich Chamber of Fine Art, and its other members included an SS officer with cultural pretensions and Wolfgang Willrich, the author of a racist tome entitled *Cleansing of the Temple of Art*. Indeed, art cleansing appeared to be the aim of this committee, as they proceeded to remove thousands of works from public museums. The criteria for selection were vague and allowed the committee a great deal of freedom. Hitler specified that the degenerate works should be those produced after 1910, as he felt that art went into decline from that date (roughly the period of the first German abstract works). Other criteria for selection were works which offended against German sentiment, distorted natural form or revealed 'inadequate craftsmanship'. The decision as to which works fit these descriptions was

obviously arbitrary, and the committee veered outside their duties by choosing art by non-Germans, as well as works produced before 1910.

Their selection included examples of some of the most important works by the most famous and talented artists of the previous two generations. The Germans included artists as diverse as Barlach, Beckmann, Corinth, Dix, Feininger, Grosz, Hausmann, Kandinsky, Kirchner, Itten, Marc, Nolde and Schlemmer; the French were represented by Delaunay, Gauguin and Matisse, the Italians by de Chirico, the Russians by Chagall, the Belgians by Ensor, the Scandinavians by Munch and the Hungarians by Moholy-Nagy. Modernist tendencies of all sorts had their place in the final exhibition, which contained 650 works by 112 artists from 32 separate German art collections. The bitter irony of Hitler's *Kunstraub* (art plunder) campaign was that it was facilitated by the fact that many German museum directors had been imaginative and progressive in their acquisitions policies for decades. The wealth of avant-garde art amassed in these museums made them an easy target for this cultural cleansing.

If attendance numbers are taken as evidence, the exhibition proved to be a monstrous success. Over two million people attended it, and it then toured throughout Germany as a banner to the death of the avant-garde. The exhibition achieved this public effectiveness through its novel arrangement and the catalogue that accompanied it. The hanging of the exhibition was unique, but it bore a startling resemblance to the deliberately chaotic Dada exhibitions of the early 1920s. Works were hung without frames or crooked, and they were squashed together to create a claustrophobic atmosphere. Their labels included the prices paid for them, often with the accompanying line 'paid for by the taxes of the German working people'. The walls themselves became part of the exhibition. They bore handwritten quotations or inscriptions which either attacked the works on display, or were out-of-context quotations from the artists designed to show their subversiveness and malign influence.

The resemblance to the nihilistic disarray of, for instance, the International Dada Fair of 1920 (see figure 32) was tempered by the deliberation underlying the ostensible chaos of the exhibition. Each room had a theme that represented one or more aspects of the Nazi world view. For instance, Room 2, with its inscriptions 'revelation of the Jewish racial soul' and 'the cultural Bolshevik's order of battle' attempted to link works by Jewish artists to those of artists with communist affiliations. The large Room 3 was dominated by the labels 'an insult to German womanhood' and 'the ideal – cretin and whore', and concentrated on representations of prostitutes, nudes and war cripples, the images of which were set against quotations from Hitler's speeches. Room 5 was a systematic attack on abstract art of all kinds. The inscriptions equated this work to the art of the insane and were intended to incite the maximum astonishment and disgust in the audience.

The effect of the exhibition must have been very striking. Many of the visitors had never had any previous access to modern art, and this would have been their first introduction to the work of abstract or Expressionist artists. The crowded nature of the exhibition was intended to confuse and alarm the audience; the bold graffiti left little room for personal observation and judgement. It has been suggested that more sensitive visitors may have attended the

exhibition as a last homage to styles of art that were destined to be eradicated under the Nazis, but there will have been just as many people who would have been convinced by the relentless propaganda of the exhibition itself. Hitler's earlier observations about mass gullibility were here tested in their entirety, and his methods proved to be very effective. The exhibition display had a crucial role to play in public brainwashing, but the exhibition catalogue provided a further framework for Hitler's ideology.

Just as the exhibition – in some superficial ways – drew on ideas of display explored by the Dadaists, so the catalogue offered a kind of grotesque parody of avant-garde publications like the Blaue Reiter Almanac. The catalogue was not published until November 1937, just before the exhibition closed, but its format was used as an organising principle when the exhibition toured to other cities in Germany between 1937 and 1941. The catalogue combines quotations, images and description in a flagrant abuse of modern art. The verso pages contain a running commentary on the exhibition display, as well as quotations from speeches by Hitler, whereas the recto pages include illustrations of the 'degenerate' art with out-of-context quotations by left-wing or Jewish writers and artists who were popular during the Weimar Republic. More than the exhibition display itself, the catalogue revealed the political motivations behind the display. The introduction states the purposes of the exhibition, one of which is to 'expose the common roots of political anarchy and cultural anarchy and to unmask degenerate art as art-Bolshevism in every sense of the term'.[27]

In the catalogue, the taxonomy of the exhibition space became crystallised and codified, and all modern art was seen as exemplary of one of nine tendencies. The division of modern art into subject and style categories mirrors the divisions of 'approved' German art into opposing categories based on Hitler's concepts of racial purity and military valour. However, unlike Hitler's approved art, which was primarily in an academic/classical style, 'Degenerate Art' was represented as the many stylistic idiosyncrasies of the Weimar period and before. Thus Group 1 in the catalogue comprises works which show 'the progressive collapse of sensitivity to form and colour, the conscious disregard for the basics of technique that underlie fine art, the garish spattering of colour, the deliberate distortion of drawing, and the total stupidity of the choice of subject matter'. Religious themes form the core of Group 2, where the works of Nolde, Beckmann and others are derided as 'mumbo jumbo' and condemned as a mockery of German piety. Group 3 consists of 'crudely tendentious proletarian art', and Group 4 likewise is seen to serve Marxist ends, as it shows anti-war works which deprive Germans 'of their profound reverence for all the military virtues'. The many representations of prostitutes used by Weimar artists as an attack on the capitalist system form Group 5, which echoes the Nazi idea of moral degeneracy: 'To those artists whom it presents, the entire world is clearly no more or less than a brothel and the human race is exclusively composed of harlots and pimps'. Groups 6 and 7 highlight the Nazi racial agenda by deriding the primitivist emphasis of Expressionism through attacks on representations of 'Negroes' and 'South Sea Islanders'. Group 8, also with a racist theme, is devoted entirely to art produced by Jews. In Group 9, the catalogue returns to the issue of style and

relates it to racist ideas. Here, abstract art is labelled 'Sheer Insanity', and the success of all 'isms' is attributed to the machinations of Jewish art dealers such as Flechtheim.[28] The last few pages of the catalogue dissolve into incoherent rage and spluttering invective, as works of art by Klee and Kokoschka are juxtaposed with the art of mental patients.

With these categories, Hitler and his cultural henchmen could find a means to attack all forms of avant-gardism. Any type of abstraction, whether it was Expressionism or Cubism could be classified as evidence of insanity. Religious subject-matter was attacked, if it was represented by a Jewish artist, or failed to adhere to the canons of conventional religious art. Works by *Neue Sachlichkeit* artists, which could not be faulted with the accusation of 'sloppy style' could be condemned as examples of Bolshevik propaganda or as representations of prostitutes. Regardless of their focus, style or orientation, the works of art produced before and during the Weimar Republic could be labelled 'degenerate' on the slightest excuse. Having created the category, the Nazis then proceeded to tour the exhibition throughout Germany. By arousing public anger and contempt, and playing on mass ignorance of modern art, the Nazis found a method to make the public themselves attack and revile the art of the previous generation. The subsequent expurgation and destruction of that art was thereby made easier for them. Those avant-garde artists who could escape from Germany did so – many travelling to America or England. Those who were forced by circumstances to remain endured years of 'inner exile', during which they were forbidden to practice their art, even in private.[29]

As the 'Degenerate Art' exhibition toured Germany, its contents changed; works were added – as more museums were plundered – and removed, as the Propaganda Ministry destroyed, kept or sold a number of the most prominent works. It was Hermann Goering who first suggested that these examples of degeneracy be sold for hard foreign currency, and a Commission for the Disposal of Products of Degenerate Art was set up under Goebbels. But despite the market and aesthetic value of many of these works, other European countries were, for the most part, too shocked at the Nazis' repressive cultural tactics to collaborate in international sales, and a number of countries launched counter-exhibitions in protest against Hitler's campaign.[30] The one major exception was the Galerie Fischer in Lucerne, which was responsible for auctioning a number of important works from the 'Degenerate Art' exhibition in 1939. Although many of the works were sold, some potential buyers were reluctant to participate, and the prices obtained were not as high as they could have been. The Nazis therefore found it difficult to acquire substantial sums for the 'degenerate' works, although they continued to confiscate them. Many paintings, graphics and sculptures were destroyed.

Although they were not averse to using modernist techniques and media when it suited their purpose, the Nazis saw the eradication of all the modern stylistic 'isms' as the first stage in their cultural programme. The next step was to privilege a form of art that was ostensibly realistic in style and unquestionably nationalist or racist in content. Here they did not create a 'Nazi style', but they took advantage of the many artists throughout Germany whose own stylistic development had progressed in opposition to that of the avant-garde. By drawing these artists to their cause, the Nazis capitalised on the resentment

of artists who had been bypassed by the market success of modern art movements. The Nazi-approved art did not emerge out of a vacuum, but the Nazis gave their seal of approval to an art previously considered too mediocre to warrant public accolade.

Just as the Nazis used the exhibition to destroy modern art, so they used the same forum to promote their own brand of official art. The 'Great German Art Exhibitions' were held in Munich eight times between 1937 and 1944. Each one was larger than the last, and each was arranged by theme. Hitler approved the erection of a special building in Munich, the House of German Art (figure 47), designed by Paul Ludwig Troost, to house the annual exhibitions. Hitler himself laid the foundation stone on 15 October 1933, and from the first 'German Art' exhibition of 1937, he intervened regularly in the selection of works and the awarding of prizes. The choice of Munich, the House of German Art itself, the events surrounding the exhibitions, and the layout of the exhibitions all reveal how closely the Nazis calculated their cultural programme.

The choice of Munich for these grand exhibitions was significant, as Munich's status as *Kunststadt* had been supplanted by Berlin. Hitler's well-known distaste for Berlin may have been related to this cultural hegemony, which was gained in the wake of rapid industrialisation. Munich did not change as fast as Berlin in either physical appearance or social structure, and Hitler found a certain comfort in the similarity between Munich of the 1930s and the Munich of Ludwig I of Bavaria in the nineteenth century. The choice of Munich was also important, as it had been the home of the Glaspalast and the annual exhibitions of German art which had been disrupted by the Secession in the 1890s. The Glaspalast itself had burned down in 1931, and Hitler decided to build his new House of German Art on the site of the old exhibition building.

With its glass and iron framework, the Glaspalast had been a progressive building when it was first erected in the nineteenth century. The House of German Art, by contrast, was intended to be seen as timeless. Troost's design was a severe Greek Doric, with a monumental facade that was calculated to intimidate, rather than inspire. The use of the Greek style was approved by Hitler, who saw classicism as the root of Aryan beauty, but Troost's austere classicism reveals some of the contradictions inherent in Nazi traditionalism. The building's lack of ornament and angular severity, for instance, relate closely to the international style modernism of the 1930s. This reconciliation of classicism and modernism epitomised the architecture approved by Hitler and demonstrated again the way he selectively employed the innovations and experiments of modernism for reactionary purposes. Despite its historicist

47 Paul Ludwig Troost, contemporary illustration of the Haus der Deutschen Kunst

pretensions, the House of German Art was thus a modern building in terms of style and, inside, the most progressive modes of heating and lighting were employed to enhance the impressiveness of the building. The building was meant to be a monument to Hitler's cultural aspirations, and it is significant that it was one of the first new works of architecture erected under his dictatorship.

The Great German Art exhibitions were directed towards what could be considered an elite art world, but they were accompanied by celebrations, ceremonies and rituals that associated this high art with the popular entertainment of mass culture.[31] Each year, the opening of the Great German Art Exhibition was preceded by a 'Day of German Art' (usually a whole weekend) – a massive pageant and festival which celebrated the place of art in the modern world. The first 'Day of German Art' took place before the first Great German Art Exhibition in July 1937, and it included a parade with hundreds of costumed participants, many floats and over 400 animals. The parade was not simply a superficial piece of pageantry, as it symbolised the history of the German Reich, as seen through the eyes of Hitler. The visual elements of costumes, banners, floats and other parade paraphernalia were thus related to the static examples of painting and sculpture displayed in Troost's timeless memorial to art. German history was glorified through spectacle and parade, and all aspects of history were constructed as leading inexorably to the apotheosis of Hitler. Through methods such as these, Hitler used culture to validate his authority and to create around himself an aura of infallibility. Without resurrecting the old notion of the Divine Right of Kings, Hitler's cultural policies reinforced his idea that he ruled without challenge or question. In this respect, visual culture was no more than one of many tools that he used to construct his own image.

With the pageant, display and publicity that surrounded it, the Great German Art Exhibition should have been a stunning and awe-inspiring event. Certainly the parades and ceremonials were popular. However, we have very little evidence of the responses of those who witnessed the exhibitions, and many of these are retrospective judgements. It is clear that attendance at the Great German Art Exhibition of 1937 was significantly lower than that of the Degenerate Art Exhibition, which took place at the same time and was only a short walk away. Loathing, disgust and outrage (or surreptitious admiration) may have had a greater lure for the public than blandness, mediocrity and political predictability.

The works in the Great German Art exhibitions, their style and their subject matter were not new. It is important to realise that many of the cultural, social and political themes that dominated visual culture from the early years of unification emerged in an altered, but no less enduring, form in the official art of the fascist regime. Rural versus urban tensions, the pull of modernity, the problem of primitivism, the question of style and, most importantly, the political function of art are the frameworks for understanding German art both before and during the Nazi domination. This does not mean that German history and German culture developed inexorably towards the fascist world view, but that Hitler and his henchmen tapped into the concerns of German society to weave their cultural and social policies. They took what was already available, distorted it and moulded it to their own purpose.

48 Oskar Martin-Amorbach, *Evening*

Perhaps one of the most obvious ambivalences of the Nazi cultural pro-
gramme was its attitude to urbanisation, manifested in the contrast between
the landscape painting shown at the Great German Art Exhibitions and
cinematic and architectural commissions. Unlike the paintings of the urban
scene that dominated avant-garde art during the Weimar Republic, scenes
of country and peasant life filled the walls of the House of German Art
from 1937 onwards (figure 48). These works bore a strong relationship to
nineteenth-century traditions – to the peasant paintings of Leibl and the land-
scapes of Thoma. They showed humble peasants ploughing, sowing, harvesting,
or interacting with their voluminous families. Many landscapes concentrated
on the fecundity and beauty of the countryside, which was unspoiled by
modern technology or, indeed, any form of modernity. The falseness of this
image was palpable. Although Leibl and Thoma had glorified rural life in
their paintings, they were producing art at a time when Germany had not yet
undergone the sweeping changes of industrialisation. By the 1930s techno-
logical innovation had revolutionised German agricultural production, and
the few pockets of feudal techniques that remained were not visible to the vast
majority of the population. But Hitler nostalgically advocated a glorification

of lost peasant traditions as a means of reinforcing the 'blood and soil' ideology that he had borrowed from such commentators as Darre.

The landscape and the peasant view were among the most important subjects in public exhibitions, and several travelling shows, with titles like 'Nordic Land' and 'German Land-German Man' took the messages of peasant superiority throughout the country. These rural scenes were also significant in other ways. One of Hitler's thorniest problems was how to unify and control a country in which regional traditions were still strong and regional loyalties remained intractable. His speeches show that he changed his perspective from a mild toleration of regional difference to an insistence that such differences were to the detriment of Germany as a whole. For the most part, landscape paintings were generalised, and it was impossible to isolate a particular region simply by looking at them. Their titles also tended to be allegorical, with 'Blood and Soil' and 'German Land' among the most popular. However, in a number of instances, the titles of landscapes gave them particular regional reference, and in propaganda pamphlets the Nazis were prone to identifying the landscapes as particular parts of the country. In this way, Hitler's cultural acolytes could appeal to the regional loyalties of individuals, even while they equated distinct parts of Germany with the ideals of the whole nation. Here he resurrected ideas of cultural commentators such as Langbehn, whose theories had inspired artists' colonies at the turn of the century.

Given all the emphasis on ruralism, it would perhaps seem logical that the Nazis would develop their architectural programme to take this into account.[32] The architects of the Weimar Republic had concentrated their energies on urban development, and especially the problems of urban housing. However, Hitler showed very little interest in rural housing developments, and the few examples of vernacular architecture that were erected during his regime were confined to hostels for the Hitler Youth and Ordensburgen (order castles) (figure 49), which were schools for the training of boys to be good Nazis when they grew up. The Ordensburgen were particularly interesting, as they were designed in a neo-Romanesque style to resemble medieval castles. As the boys were to learn military values within them, this style was considered to be particularly appropriate, just as youth hostels were pastiches of Alpine huts to reflect their emphasis on healthy outdoor activities.

But only a handful of hostels and three Ordensburgen were ever built. The bulk of the Nazi building programme was supervised by Hitler himself and was concentrated in the cities that Hitler allegedly detested. While paintings in the Great German Art Exhibition showed few views of workers in factories and even fewer urban

49 Hermann Giesler, Ordensburg Sonthofen in Allgäu

scenes, Hitler and his architects spun fantasies of the new metropolises that they intended to create. Architecture was the most important of the arts to Hitler, and increasingly he turned his attention away from painting in order to participate actively in major building programmes. Hitler's attitude towards architecture bears some surprising parallels to the utopian visions of Bruno Taut – an architect whose circle was roundly condemned as Bolshevik by the Nazis. Both men privileged architecture above all the other arts, and both desired a non-utilitarian form of architecture that would appeal to a mass population. Taut, however, saw architecture as a means of improving the life of a downtrodden proletariat, and he turned away from his fantasies when confronted with the more immediate realities of urban housing shortage. To Hitler, architecture was a means of overwhelming and intimidating this same downtrodden population. Taut's functionless 'crystal cities' remained on paper, whereas Hitler allocated a large proportion of state funds to the erection of monuments to his own greatness.

In Hitler's architectural plans, the city was particularly important, despite the dominant 'blood and soil' ethos of Nazi ideology.[33] Great monuments of architecture needed to be in places where they would be seen by large numbers of people, and small rural housing developments or even urban apartment blocks would not serve the appropriate purpose. He concentrated his building programme on three cities – his favoured Munich, his despised Berlin and Nuremberg, which was the seat of the annual party rally. Hitler's decision to turn his native Linz, in Austria, into the cultural capital of the German Reich, never came to fruition.[34] Each of these cities had a significance for Hitler and for Germany as a whole: Munich, with its artistic heritage; Berlin, the seat of Prussian militarism, and Nuremberg, one of the most important centres of medieval Germany. Only a handful of architects were trusted enough to collaborate with Hitler's plans, and among these the most notable, Speer, was in his early twenties when he began working for Hitler. By all accounts, many of the architectural ideas were Hitler's own and he made a number of changes to Speer's drafts. Several elements are common to Hitler's architectural fantasies. They were all monumental; they were rarely functional; they were designed in a severe neoclassical style; and they could not have been built without modern technology.

Aside from Troost's House of German Art, there were several other new buildings in Munich. In order to link himself with Munich's artistic tradition, Hitler arranged for Troost to develop the Königsplatz, where the neoclassical Glyptothek of Ludwig I already stood. Echoing the nineteenth-century building, Troost added two temples to honour the victims of the 1923 putsch, as well as a 'Führer Building' and an 'Administration Building', which were intended to be Hitler's Munich headquarters. The function of the buildings and the style in which they were built indicates Hitler's obsessions. The putsch of 1923 was a brawling, abortive affair which gained nothing but the imprisonment of Hitler and some of his fellow Nazis. To glorify its victims as if they were war heroes was one of the ways in which Hitler attempted to rewrite his party's history as a history of struggle and repression. The other two buildings were identical and created a strong visual focus for the square, all of which was conceived in a neoclassical style.

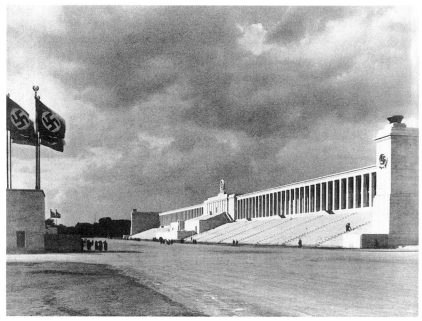

50 Albert Speer, Zeppelin Field in Nuremberg

Similarly, Nuremberg, despite its medieval heritage, hosted a new sports complex in the modernist neoclassicism of the fascist regime (figure 50). As Nuremberg was the centre of the annual party rallies, Hitler and Speer conceived of a gigantic sports complex which would serve as parade grounds and assembly spaces for the masses of adoring supporters who flocked there to hear Hitler's speeches. The entire area of the sports field was to be 11 miles; the Zeppelin Field was designed to accommodate 340,000, with an accompanying parade ground that could hold 500,000 marchers at once. Only a small portion of the sports complex was built, but the designs and models for it reveal Hitler's megalomania, which allowed him to justify vast expenditure of public funds for the glorification of himself.

Hitler's plans for Berlin were the most obsessional and excessive. With the help of Speer, he hoped to reconstruct the centre of Berlin to flow from a vast avenue reminiscent of Haussmann's Paris boulevards. At one end of this avenue, a triumphal arch larger than the Eiffel Tower would loom. On it would be inscribed the names of the 1.8 million German victims of the First World War. From the triumphal arch, an extensive boulevard would lead to Adolf Hitler Square, which would be dominated by a great domed hall, many times larger than St Peter's in Rome, and designed to hold 800,000 people. None of these plans were realised, but Speer did enlarge the old Reich Chancellery in Berlin to include, among other things, a marble hall that was twice as long as the Hall of Mirrors at Versailles. The competition with Paris and Rome was deliberate. Berlin was meant to be the largest, the grandest, the most overwhelming city in the world.

Hitler's desire to sway the German population was complemented by his attempts to prove his superiority to other parts of Europe. One of his

most extensive building programmes was the new sports complex for the Olympic Games held in Berlin in 1936 and designed to impress the world with Germany's superiority. The effect of the games was enhanced by another example of Nazi modernity in action. This was a film by Leni Riefenstahl entitled *Olympia Feast of Nations*, which used the most advanced cinematic techniques to create a relationship between modern German athletes and Greek gods.[35] Just as Nazi architecture drew upon both tradition and modernity, so Riefenstahl's *Olympia* played upon the body culture of the ancient Olympics (figure 51) while also employing strikingly modern shots of sports action that remained influential on sports photography of the late twentieth century (figure 52). Riefenstahl's other famous homage to Hitler, *Triumph of the Will*, was a 'document' of the 1934 Nuremberg party rally, which employed montage, non-narrative action, unusual camera angles and evocative music to overwhelm its audience with the beauty and majesty of Hitler's power. Riefenstahl's concentration on objects, unexpected viewpoints and fragmented shots bore a striking relationship to the effects of early *Neue Sachlichkeit* films such as *Berlin, die Symphonie der Großstadt* (see figure 46). In Riefenstahl's films, as with the architecture of Troost, the reconciliation of modernity with tradition becomes a hallmark of the Nazi approach to the visual arts.

The rural/urban dichotomy was not the only aspect of German culture that the Nazis used for their own purposes. They also employed prevalent race theories to create an ideal image of German male and female beauty. As usual, they began their campaign by attacking the racial nature of previous representation. Through the 'Degenerate Art' exhibitions, the primitivist emphasis of much Expressionist art was equated with racial intermixing and the privileging of 'lower' non-Western peoples. The Nazis condemned such 'Negroid' images as damaging to Aryan racial consciousness and, in their own art, they replaced primitivism with a seemingly objective view of 'genuine' German people. Here again, they managed by a sleight of hand to reconcile the seemingly irreconcilable. The 'Degenerate Art' exhibitions had launched a systematic attack on the 'brothel art' of the Weimar Republic and maligned its 'denigration of German womanhood'. However, one of the most popular forms of 'approved' art was the female nude, and paintings of the female nude ranged from the superfluous to the salacious.[36] Hitler himself owned a triptych of nudes by the painter Adolf Ziegler, who was known as the 'Master of the Pubic Hair'. Works such as this seemed to dispense with the appropriation of nudity as part of the discourse of male avant-garde bohemianism. While Expressionist artists, such as those in

51 Still from *Olympia, Feast of Nations*, film by Leni Riefenstahl, 1936

52 Still from *Olympia, Feast of Nations*, film by Leni Riefenstahl, 1936

the Brücke circle, had fashioned their identities partly through their sexual and artistic relations with female models, Nazi artists such as Ziegler reconfigured women as allegorical embodiments of beauty.[37] In both cases, the nude model functioned as sexual object, but the role of women within modernism and modernist discourse was much more complex, as the Nazis resurrected old formulas about women's place that had seemingly been obliterated by the 'new woman' phenomenon of the 1920s.

By contrast, in representations of the male nude – a subject less colonised by the avant-garde – Nazi art approached genuine innovation. The classicising yet modernistically simplified male nudes of sculptors like Arno Breker – as with Riefenstahl's camera shots of muscular male bodies – reveal how sculpture could become representative of Aryan perfection. Sculpture was much more important to the Nazis than it had been to the avant-garde before the 1930s, despite the experiments of Brücke artists and individuals like Kollwitz and Barlach. In Nazi Germany, sculpture proved a suitably literal vehicle for racist propaganda. The emphasis on nudity was defended as healthy by recourse to current nudist trends, which were fuelled by journals such as *Kraft und Schönheit* (*Strength and Beauty*) and *Die Schönheit* (*Beauty*). In his speech at the opening of the House of German Art in 1937, Hitler had referred to the relationship between beauty and racial purity. He said: 'The way in which our people was composed has produced the many-sidedness of our own cultural development, but as we look upon the final result of this process we cannot but wish for an art which may correspond to the increasing homogeneity of our racial composition.'[38] The nude seemed to supply the code that Hitler needed, whereas paintings of clothed German types needed explanations

to reinforce their racial subtext. One such painting of an ideal German girl (figure 53) was captioned in a contemporary publication by a reference to her 'type, bearing, expression and costume' which were all completely German,[39] to reinforce the perhaps not wholly obvious Aryan implications of the painting.

By contrast, paintings tended to avoid anti-Semitic caricature. While wishing to fuel anti-Semitism through propaganda, the Nazis, like the communists of the 1920s, were suspicious of the efficacy of an art form that was inherently unstable and potentially ridiculed everything. Representations of the Jews were reserved for several films of 1939 and 1940, including the infamous *Jud Süss*.[40] This costume drama, set in the eighteenth century, savagely attacked the Jews for their financial machinations, and make-up was used extensively to exaggerate the Jewish characters and distinguish them visually from the Aryan heroes of the film. The actor, Werner Krauss, played nearly all the Jewish characters. According to the film's director, Veit Harlan, this doubling of roles was intended 'to show how all these different temperaments and characters – the pious Patriarch, the wily swindler, the penny-pinching merchant and so on – are ultimately derived from the same roots'.[41] The extent of Nazi racism can be gauged from the fact that Goebbels demanded that critics of the film should not label it as 'anti-Semitic' but as a 'realistic' picture of the Jews. Here, again, Nazi visual culture showed its indebtedness to the work of the previous generation, as *Jud Süss* relied on the Expressionist technique of demonising the villain through exaggerated costume, make-up and gesture.[42] Cinematic representations of the Jews did not persist after 1940, as the genocidal Nazi campaign against them soon alleviated the necessity for any representations at all. The Nazis removed images of the Jews from art and replaced them with imaginary depictions of Aryan perfection.

The Nazis did not simply adapt the subject-matter of previous art to their own purposes. They also employed a particular kind of realist style as a way of implying that their message was a true one. Indeed, there is very little difference in stylistic terms between the technique of *Neue Sachlichkeit* artists such as Dix and that of Nazi portraitists such as Hitler's favoured Conrad Hommel. The difference lies more in subject-matter. In his Nuremberg culture speech of 11 September 1935, Hitler claimed:

> I am . . . convinced that art, since it forms the most uncorrupted, the most immediate reflection of the life of the people's soul, exercises unconsciously by far the greatest direct influence upon the masses of the people, but always subject to one condition: that it draws a true picture of that life and of the inborn capacities of a people and does not distort them.[43]

53 Bernhard Dörries, *German Girl*

However, these seemingly noble sentiments were contradicted by Hitler's own loathing of 'naturalist' art which depicts life as it is in all its seediness and misery. Hitler advocated a style of art which appeared 'realistic', but it was important to him that the ingredients of life be chosen carefully and moulded into his vision of the world, before they were presented to the public as 'realistic'.[44] The advantage of such 'realism' was that it had a universal legibility and was easily shaped into whatever form Hitler wished. A 'realist' style could present lies in a plausible guise.

As the Second World War drew near, this distorted vision became even more exaggerated. Portraits of Hitler were unashamedly allegorical, showing him in the armour of a medieval warrior or in some kind of heroic action. The experimental portraiture of Expressionism and the creative traditionalism of the *Neue Sachlichkeit* gave way to the kind of conventionalism that had characterised portraits of monarchs in the nineteenth century. The fact that portraiture was one of the most important genres of art during the Third Reich indicates the extent to which the cult of personality overcame all other considerations. Portraiture, seemingly the most 'objective' or least imaginative form of art was given primacy over ideal paintings of landscapes and nudes. The illusion of reality was consolidated by these images, and individuals in the government became substitutes for religious icons in the eyes of the public.

There was one other type of subject that was particularly favoured by Hitler and the Nazis. This was the representation of the soldier, either in battle or as a heroic individual. As a counter to the crippled war veterans of Dix and Grosz, artists such as Elk Eber glorified the German soldier of the First World War and created new models for a younger generation to emulate

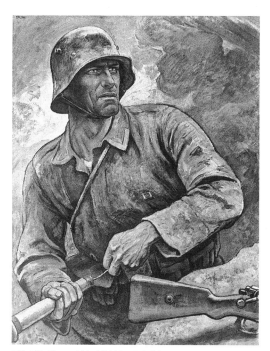

(figure 54). As Hitler became engaged in conflict with other nations and Germany again entered war in 1939, such artists had only to adapt their representations of war to suit the contemporary situation. While such images could have power and efficacy in a time of peace, they had little impact in the midst of a real war, and the newsreel took on greater and greater importance as the war intensified. The Second World War redirected Hitler's energies, and his cultural mission was aborted. He was forced to concentrate on his imperialist ambitions and then his monumental failures, while the great bronze doors of Speer's Reich Chancellery in Berlin were melted down for gun metal and his architectural plans lay dormant on the draftsman's table. Hitler's campaign for cultural reform came to a halt, but not before he had viciously dismantled a system which may have been riven with conflict but which nevertheless gave Germany some of

54 Elk Eber, *World War I Soldier*

the most powerful, evocative and socially committed visual culture of its entire history. The cultural unity of Germany under Hitler's dictatorship undermined the values that artists had been striving for since 1870.

However, as I stated in the introduction to this book, it is important not to see this as an inevitable teleology. First of all, while both traditionalism and modernity in the visual arts worked in counterpoint from the time of the Secession exhibitions to that of Hitler's dictatorship, Hitler was consciously exploiting what had been a healthy tension. By merging traditional ideas with modern methods, Hitler eradicated the complex dialectic between them that had existed in German modernism for decades. Second, and perhaps more significantly, Hitler's 'victory' over the avant-garde was a Pyrrhic one. While he temporarily halted the practice of many talented artists in Germany, other avant-garde practitioners who had thrived in Germany before Hitler, emigrated or went into exile, having an important impact on cultural developments elsewhere.[45] Among these, Kokoschka settled in England, Kandinsky in Paris, and Heartfield, Beckmann, Schwitters, Gropius and Ernst in the United States. In this process of exile, however, fractures remain just as important as continuities, for not all emigrant or exiled artists adopted an unequivocal political stance or a strong anti-fascist line.[46]

Finally, while the Second World War in Germany certainly interrupted the development of the visual arts – much more firmly than the First World War had done – the high profile of visual culture that had characterised the fascist regime of the Nazis persisted after the war was over. Since the Second World War, Germans have attempted to come to terms with the atrocities of the Holocaust and the consequences of their own involvement, and it is no surprise that part of this self-reflection involves a consideration of pre-war visual culture.[47] The squeamishness about political content in West German art after the war was no less political than the vehement anti-fascism of East German art. In both we can see the legacy of German art's attachment to culture, politics and society that came to the surface soon after the unification of Germany in 1871. Thus Hitler's reaction was an important aspect of German art history, but not a final or decisive one. The originality, technological innovation and developed aesthetics of the visual arts in Germany had created a unique and potent combination of elements when Hitler – a dictator obsessed by the arts – came to power. It is important not to read into this denouement an inevitability, or to trace back through every manifestation of German modernism the seeds of its eventual destruction. The Nazi *Kunstraub* involved more than a theft of works of art from museums, but a plundering of theories, techniques, technologies and philosophies that had been carefully built up since unification. The Nazis achieved an illusion of a *Volksgemeinschaft* at the expense of gagging much individual expression and sending many talented people into exile and despair. The illusory homogeneity of cultural unity at the beginning of the Second World War dissolved very quickly afterwards, when a re-divided Germany sought to recreate a culture that had been brutally destroyed by dictatorship. What remained was a new tension between tradition and modernity that Hitler had interrupted, but not destroyed.

NOTES

1 Quoted in Stephanie Barron (ed.), *'Degenerate Art': The Fate of the Avant-Garde in Nazi Germany*, Los Angeles, 1991, p. 360.

2 Albert Speer, *Inside the Third Reich*, Eng. trans., New York, 1996, p. 692.

3 Walter Benjamin, 'The work of art in the age of mechanical reproduction', in *Illuminations*, ed. Hannah Arendt, London, 1992, pp. 211–44 (quotation on p. 234).

4 There are a number of very useful sources on Nazi culture. See, for instance, Brandon Taylor and Wilfried van der Will (eds), *The Nazification of Art: Art, Design, Music, Architecture and Film in the Third Reich*, Winchester, 1990; Peter Adam, *The Arts of the Third Reich*, London, 1992; Berthold Hinz, *Art in the Third Reich*, Oxford, 1980; Berthold Hinz (ed.), *NS-Kunst: 50 Jahre danach: neue Beiträge*, Marburg, 1989; Peter Labayani, 'Images of fascism: visualisation and aestheticisation in the Third Reich', in Michael Laffan (ed.), *The Burden of German History 1919–45*, London, 1988, pp. 151–77; Klaus Backes, *Hitler und die bildenden Künste: Kulturverständnis und Kunstpolitik im Dritten Reich*, Cologne, 1988; Sabine Weissler (ed.), *Design in Deutschland 1933–45: Asthetik und Organisation des Deutschen Werkbund im 'Dritten Reich'*, Giessen, 1990; and Joseph Wulf, *Die bildenden Künste im Dritten Reich: eine Dokumentation*, Gütersloh, 1963.

5 For the patterns in totalitarian appropriation of the arts, see Igor Golomstock, *Totalitarian Art: In the Soviet Union, the Third Reich, Fascist Italy and the People's Republic of China*, London, 1990, p. xiii. See also Jan Tabor (ed.), *Diktatur: Architektur, Bildhauerei und Malerei in Österreich, Deutschland, Italien und der Sowjet-union 1922–56*, 2 vols, Baden, 1994.

6 For the cultural scene in Vienna during Hitler's stay there, see Ian Kershaw, *Hitler 1889–1936*, London, 1998, pp. 30–49.

7 Norman H. Baynes (ed.), *The Speeches of Adolf Hitler*, 2 vols, London and New York, 1942, vol. 1, p. 106.

8 Adolf Hitler, *Mein Kampf* (1924), Boston, 1971, p. 258.

9 As Golomstock, *Totalitarian Art*, points out, Hitler tended to label all new movements Dada, just as Lenin called them Futurism.

10 Hitler, *Mein Kampf*, pp. 180–1.

11 Robin Reisenfeld, 'Collecting and collective memory: German Expressionist art and modern Jewish identity', in Catherine M. Soussloff (ed.), *Jewish Identity in Modern Art History*, Berkeley, 1999, pp. 114–34.

12 See especially Paul Schultze-Naumburg, *Kunst und Rasse*, Munich, 1928. Some of Schultze-Naumburg's earlier works, such as *Der Bau des Wohnhauses*, 3rd edn, Munich, 1924, show his interest in engineering and modern technology that was a legacy of his pre-war association with the Werkbund. For the many facets of Schultze-Naumburg's career, see Norbert Borrmann, *Paul Schultze-Naumburg 1869–1949: Maler, Publizist, Architekt vom Kulturreformer der Jahrhundertwende zum Kulturpolitiker im Dritten Reich*, Essen, 1989.

13 For racial theories and how they affected architecture, see Barbara Miller Lane, *Architecture and Politics in Germany 1918–45*, 2nd edn, Cambridge, Mass., 1985; and Robert R. Taylor, *The Word in Stone: The Architecture of National Socialism*, Berkeley and Los Angeles, 1974.

14 Alfred Rosenberg, *Der Mythus des 20. Jahrhunderts*, Munich, 1930; and Richard Darre, *Das Bauerntum als Lebensquell der nordischen Rasse*, Munich, 1929.

15 Baynes, *Speeches of Hitler*, vol. 1, p. 568.

16 *Ibid.*, p. 121.

17 Hitler was, of course, a great admirer of Wagner, but he veered towards Wagner's anti-Semitism and notions of a *Volksgemeinschaft*, rather than the *Gesamtkunstwerk*. However, the *Gesamtkunstwerk* idea may have underlain Hitler's obsession with public pageantry. See Robert Wistrich, *Weekend in Munich: Art, Propaganda and Terror in the Third Reich*, London, 1996, p. 21.

18 Speer, *Inside the Third Reich*, p. 67.

19 Quoted in Jeremy Noakes and Geoffrey Pridham (eds), *Documents on Nazism 1919–1945*, London, 1974, p. 334.

20 This is discussed in Jeffrey Herf, *Reactionary Modernism: Technology, Culture and Politics in Weimar and the Third Reich*, Cambridge, 1984.

21 Speer, *Inside the Third Reich*, pp. 141–2.

22 Quoted in George Mosse, *Nazi Culture: Intellectual, Cultural and Social Life in the Third Reich*, 2nd edn, London, 1981, pp. 162–3.

23 Baynes, *Speeches of Hitler*, vol. 1, p. 579.

24 For the Degenerate Art exhibitions, see especially Barron, '*Degenerate Art*'; and Peter-Klaus Schuster (ed.), *Die 'Kunststadt' München 1937. Nationalsozialismus und 'Entartete Kunst'*, Munich, 1987.

25 See Max Nordau, *Degeneration*, Eng. trans., London, 1895, which popularised the term. For a discussion of Nordau, see Shearer West, *Fin de Siècle: Art and Society in an Age of Uncertainty*, London, 1993.

26 On the many different ways Nazis plundered the art of conquered territories, see Jonathan Petropoulos, *Art as Politics in the Third Reich*, Chapel Hill, 1996.

27 A facsimile and translation of the exhibition catalogue is reproduced in Barron, '*Degenerate Art*'. This quotation is taken from p. 360.

28 *Ibid.*, pp. 364–80.

29 See Gerhard Schoenberner, *Artists Against Hitler: Persecution, Exile, Resistance*, Bonn, 1984.

30 Keith Holz, 'Scenes from exile in Western Europe: the politics of individual and collective endeavor among German artists', in Stephanie Barron (ed.), *Exiles and Emigrés: The Flight of European Artists from Hitler*, exhibition catalogue, Los Angeles, 1997, pp. 43–56.

31 Wistrich, *Weekend in Munich* discusses the 'Day of German Art' and the festivities that accompanied it, and analyses the footage of a contemporary amateur film shot of the event.

32 See Taylor and van der Will, *Nazification of Art*; Taylor, *Word in Stone*; and Lane, *Architecture in Germany*.

33 For the ways in which the Nazis tried to reclaim the city from the decadent stereotypes of the Weimar Republic, see Linda Schulte-Sasse, 'Retrieving the city as *Heimat*: Berlin in Nazi cinema', in Charles Haxthausen and Heidrun Suhr (eds), *Berlin Culture and Metropolis*, Minneapolis and Oxford, 1990, pp. 166–86.

34 See Monika Ginzkey Puloy, 'High art and National Socialism Part I: The Linz Museum as ideological arena', *Journal of the History of Collections*, 8:2 (1996), 201–16.

35 See Audrey Salkeld, *A Portrait of Leni Riefenstahl*, London, 1996; Leni Riefenstahl, *Leni Riefenstahl: A Memoir*, New York, 1993; and Leni Riefenstahl, *Olympia*, London, 1994.

36 For the place of women in Nazi cultural politics, see Renate Bridenthal, Atina Grossman and Marion Kaplan (eds), *When Biology Became Destiny: Women in Weimar and Nazi Germany*, New York, 1984; Claudia Koonz, *Mothers in the Fatherland: Women, the Family and Nazi Politics*, London, 1987; M. McNichols-Webb, *Art as Propaganda: A Comparison of the Imagery and Roles of Woman as Depicted in German Expressionist, Italian Futurist and National Socialist Art*, Ann Arbor, 1988; and Annie Richardson, 'The Nazification of women in art' in Taylor and van der Will, *Nazification of Art*, pp. 53–79.

37 For male avant-garde bohemianism, see Irit Rogoff, 'The anxious artist – ideological mobilisations of the self in German modernism', in Irit Rogoff (ed.), *The Divided Heritage: Themes and Problems in German Modernism*, Cambridge, 1991, pp. 116–47.

38 Baynes, *Speeches of Hitler*, vol. 1, p. 587.

39 'Das Bild ist in Typ, Haltung und Ausdruck, in Kostüm und Umgebung deutsch': *Deutschlands Werden seit 1933*, Berlin, [1933], n.p.

40 For the Nazi approach to cinema, see David Hull, *Film in the Third Reich: Art and Propaganda in Nazi Germany*, New York, 1973; Erwin Leiser, *Nazi Cinema*, London, 1974; Taylor and van der Will, *Nazification of Art*; Richard Taylor, *Film Propaganda: Soviet Russia and Nazi Germany*, London, 1979; and David Welch, *Propaganda and the German Cinema 1933–1945*, Oxford, 1983.

41 Veit Harlan in *Der Film*, 20 January 1940, quoted in Leiser, *Nazi Cinema*, p. 152.

42 Nosferatu, for instance, may have been intended to be an anti-Semitic caricature. See Ernst Prodolliet, *Nosferatu: Die Entwicklung des Vampirfilms von Friedrich Wilhelm Murnau bis Werner Herzog*, Olten, 1980.

43 Baynes, *Speeches of Hitler*, vol. 1, p. 574.

44 Golomstock, *Totalitarian Art*, describes it as 'ideology and myth in the guise of reality' (p. 198).

45 See Barron, *Exiles*, for a full list and thorough discussion of the implications of German artists taking their ideas and influence to other countries, especially America.

46 Holz, 'Scenes from Exile', p. 53, makes some interesting points about some resolutely non-political German artists: 'Beckmann and Kandinsky remained committed to artistic practices that perpetuated the German romantic and bourgeois ideals of individual

self-formation. Their continued devotion to art making as a solitary, purely aesthetic activity nearly blinded them at times to the proximity of their own views to the aestheticised politics and depoliticized art of German National Socialism or Italian fascism.'

47 See the approach of Hans Belting, *The Germans and Their Art: A Troublesome Relationship*, New Haven and London, 1998; and Eckhart Gillen (ed.), *German Art from Beckmann to Richter: Images of a Divided Country*, New Haven and London, 1997.

Bibliography and further reading

JOURNALS

Die Aktion (1911–32)
Der blutige Ernst (1919)
Jedermann sein eigener Fußball (1919)
Die Jugend (1896–1940)
Der Knüppel (1923–27)
Das Kunstblatt (1917–32)
Neue Jugend (1916–17)
Pan (1895/96–1899/1900)
Die Pleite (1919–24)
Der Querschnitt (1921–33)
Simplicissimus (1896–1963)
Der Sturm (1910–32)

PRIMARY SOURCES

An alle Künstler, Berlin, 1919

Anon., *Der heimliche Kaiser oder der Dampfbau oder der Wildgewordene Bleimchenkaffee. Unheimliches Geheimnis*, Stuttgart, 1891

Anz, Thomas and Michael Stark (eds), *Expressionismus: Manifeste und Dokument zur deutschen Literatur 1910–20*, Stuttgart, 1982

Baader, Johannes, *Johannes Baader Oberdada: Schriften, Manifeste, Flugblätter, Billets, Werke und Taten*, ed. Hanne Bergius, Norbert Miller and Karl Riha, Giessen, 1977

Bahr, Hermann, *Expressionism*, Munich, 1916, Eng. trans., London, 1925

Ball, Hugo, *Flight Out of Time: A Dada Diary*, ed. John Elderfield, Berkeley and Los Angeles, 1996

Ball, Hugo, *Zur Kritik der deutschen Intelligenz*, Bern, 1919

Barlach, Ernst, *Das dichterische Werk*, 3 vols, Munich, 1956

Barlach, Ernst, *Die Briefe*, ed. Friedrich Dross, 2 vols, Munich, 1968–69

Barlach, Ernst, *Ein selbstenzähltes Leben*, Berlin, 1928

Barlach, Ernst, *Ernst Barlach. Die Briefe*, ed. Friedrich Dross, 2 vols, Munich, 1968–69

Barlach, Ernst, *Güstrower Tagebuch 1914–17*, Munich, 1984

Baynes, Norman H., *The Speeches of Adolf Hitler*, 2 vols, London and New York, 1942

Beckmann, Max, 'Gedanken über zeitgemäße und unzeitgemäße Kunst', *Pan*, 2 (1912), 499–502; Eng. trans. in *Max Beckmann: Self-Portrait in Words*, ed. Barbara Copeland Buenger, Chicago and London, 1997, pp. 115–17

Beckmann, Max, *Briefe im Kriege 1914/15* (1916), Munich, 1984

Beckmann, Max, *Briefe*, ed. Klaus Gallwitz, Uwe Schneede and Stephan von Wiese, Munich, 1993–96

Beckmann, Max, *Leben in Berlin: Tagebuch 1908–09*, Munich, 1983

Beckmann, Max, *Max Beckmann: Self-Portrait in Words*, ed. Barbara Copeland Buenger, Chicago, 1997

Benjamin, Walter, *One Way Street and Other Writings*, Eng. trans. Edmund Jephcott and Kingsley Shorter, London, 1979

Benjamin, Walter, 'The work of art in the age of mechanical reproduction', in *Illuminations*, ed. Hannah Arendt, London, 1992, pp. 211–44

Bergson, Henri, *Creative Evolution* (1907), London, 1911

Bewer, Max, *Rembrandt und Bismarck*, Dresden, 1891

Blümner, Rudolf, 'Einführung', *Der Sturm: Einführung*, Berlin, 1917

Cassirer, Else (ed.), *Künstlerbriefe aus dem neunzehnten Jahrhundert*, Berlin, 1919

Corinth, Lovis, *Gesammelte Schriften*, Berlin, 1920

Corinth, Lovis, *Legenden aus dem Künstlerleben*, Berlin, 1909

Corinth, Lovis, *Selbstbiographie*, ed. Charlotte Berend Corinth, Leipzig, 1926

Darre, Richard, *Das Bauerntum als Lebensquell der nordischen Rasse*, Munich, 1929

Deutschlands Werden seit 1933, Berlin, [1933]

Ein Dokument deutscher Kunst: Die Ausstellung der Künslter-kolonie in Darmstadt, Munich, 1901

Edschmid, Kasimir, *Über den Expressionismus in der Literatur und die neue Dichtung*, Berlin, 1919

Einstein, Carl, *Die Kunst des 20. Jahrhunderts* (1926), Leipzig, 1988

Einstein, Carl, *Negerplastik* (1915), Munich, 1920

Endell, August, *Die Schönheit der großen Stadt*, Stuttgart, 1908, reprint Berlin, 1984

Endell, August, *Uber die Schönheit: eine Paraphrase über die Münchener Kunstausstellung 1896*, Munich, 1896

Ernst, Max, *Beyond Painting and Other Writings by the Artist and his Friends*, ed. Robert Motherwell, New York, 1948

Ernst, Max, *Ecritures*, Paris, 1971

Fechter, Paul, *Der Expressionismus*, Munich, 1914, 3rd edn, 1919

Fritsch, Theodor, *Die Stadt der Zukunft*, Leipzig, 1896

Gropius, Walter, *The New Architecture and the Bauhaus*, Boston, 1965

Gropius, Walter (ed.), *The Theatre of the Bauhaus*, Middleton, 1961

Grosz, George, *The Autobiography of George Grosz: A Small Yes and a Big No* (1955), Berkeley, 1997

Grosz, George and John Heartfield, 'Der Kunstlump', *Der Gegner*, 1:10–12 (1919/20), 48–56

Grosz, George and Wieland Herzfelde, *Die Kunst ist in Gefahr*, Berlin, 1925

Haeckel, Ernst, *The Riddle of the Universe at the Close of the Nineteenth Century*, Eng. trans., London, 1900

Hahl-Koch, Jelena (ed.), *Arnold Schoenberg, Wassily Kandinsky: Letters, Pictures and Documents*, London, 1984

Hahn, Peter (ed.), *Bauhaus Berlin ... eine Dokumentation*, Weingarten, 1985

Hartlaub, Gustav, *Ausstellung: Neue Sachlichkeit*, Mannheim, 1925

Hausmann, Raoul, *Am Anfang war Dada*, Giessen, 1980

Hildebrandt, Hans, *Die Frau als Künstlerin*, Berlin, 1928

Hitler, Adolf, *Mein Kampf* (1924), Boston, 1971

Hoberg, Annegret (ed.), *Wassily Kandinsky and Gabriele Münter: Letters and Reminiscences 1902–1914*, Munich, 1994

Howard, Ebenezer, *Tomorrow: A Peaceful Path to Real Reform*, London, 1898

Huelsenbeck, Richard (ed.), *Dada Almanach. Im Auftrag des Zentralamts der deutschen Dada-Bewegung*, Berlin, 1920

Huelsenbeck, Richard, *Dada: ein literarische Dokumentation*, Hamburg, 1964

Huelsenbeck, Richard, *Memoirs of a Dada Drummer* (1969), ed. Hans J. Kleinschmidt, Berkeley and Los Angeles, 1991

Hüneke, Andreas (ed.), *Der Blaue Reiter. Dokumente einer geistigen Bewegung*, Leipzig, 1989

Itten, Johannes, *Mein Vorkurs am Bauhaus*, Eng. trans. as *Design and Form, the Basic Course at the Bauhaus*, London, 1975

Ja! Stimmen des Arbeitsrates für Kunst in Berlin, Berlin, 1919

Jawlensky, Alexei, *Meditationen*, ed. W. A. Nagel, Hanau, 1983

Kaes, Anton, Martin Jay and Edward Dimendberg (eds), *The Weimar Republic Sourcebook*, Berkeley and Los Angeles, 1994

Kandinsky, Vassily, *et al.*, *Im Kampf am die Kunst: die Antwort auf das 'Protest deutschen Künstler'*, Munich, 1911

Kandinsky, Wassily and Franz Marc (eds), *The Blaue Reiter Almanac* (1912), Eng. trans. and ed. Klaus Lankheit, London, 1974

Kandinsky, Vassily and Franz Marc, *Wassily Kandinsky, Franz Marc. Briefwechsel*, ed. Klaus Lankheit, Munich, 1983

Kirchner, Ernst Ludwig, *Briefwechsel 1910–1935*, Stuttgart, 1990

Klee, Felix (ed.), *Paul Klee: His Life and Work in Documents*, New York, 1962

Klee, Paul, *Paul Klee: Schriften, Rezensionen und Aufsätze*, ed. Christian Geelhaar, Cologne, 1976

Klee, Paul, *Pädagogisches Skizzenbuch*, Eng. trans. by Sibyl Moholy-Nagy as *Pedagogical Sketchbook*, London, 1953

Klee, Paul, *Tagebücher 1898–1918: Texte und Perspektiven*, ed. Felix Klee, Cologne, 1957; *The Diaries of Paul Klee 1898–1918*, ed. Felix Klee, Berkeley and Los Angeles, 1968

Klee, Paul, *The Notebooks of Paul Klee*, ed. Jürg Spiller; volume I: *The Thinking Eye*; volume 2: *The Nature of Nature*, London, 1961, 1973

Klinger, Max, *Malerei und Zeichnung* (1891), 5th edn, Leipzig, 1907

Knust, Herbert (ed.), *George Grosz Briefe 1913–59*, Reinbeck bei Hamburg, 1979

Koch, Alexander (ed.), *Großherzog Ernst Ludwig und die Ausstellung der Künstlerkolonie in Darmstadt*, Darmstadt, 1901

Kokoschka, Oskar, *Briefe*, ed. Olga Kokoschka and Heinz Spielmann, 4 vols, Düsseldorf, 1984–88, selection in Eng. trans. as *Oskar Kokoschka: Letters 1905–1976*, London, 1992

Kokoschka, Oskar, *Die träumenden Knaben* (1908), Vienna, 1968

Kokoschka, Oskar, *My Life* (1971), Eng. trans., London, 1974

Kokoschka, Oskar, *Oscar Kokoschka Letters*, London, 1992

Kokoschka, Oskar, *Oskar Kokoschka: der Sturm: die Berliner Jahre 1910–1916*, Pochlarn, 1986

Kollwitz, Käthe, *Tagebuchblätter und Briefe*, ed. Hans Kollwitz, Berlin, 1948, Eng. trans. as *The Diary and Letters of Käthe Kollwitz*, Evanston, 1988

Kollwitz, Käthe, *Aus meinem Leben. Ein Testament des Herzens*, Freiburg, 1992

Kollwitz, Käthe, *Briefe an den Sohn 1904 bis 1945*, Berlin, 1992

Köppen, Alfred, *Die moderne Malerei in Deutschland*, Bielefeld and Leipzig, 1902

Kracauer, Siegfried, *The Mass Ornament: Weimar Essays*, ed. Thomas Y. Levin, Cambridge, Mass., 1995

Landesberger, Franz, *Impressionismus und Expressionismus: eine Einfuhrung in das Wesen der neuen Kunst*, Leipzig, 1920

Leibl, Wilhelm, *Wilhelm Leibl (1844–1900): Briefe mit historisch-kritischen kommentar*, Hildesheim, 1996

Liebermann, Max, *Die Phantasie in der Malerei*, ed. Günter Busch, Frankfurt, 1978

Liebermann, Max, *Gesammelte Schriften*, Berlin, 1922

Liebermann, Max, *Siebzig Briefe*, ed. Franz Landesberger, Berlin, 1937

Lindsay, Kenneth and Peter Vergo (eds), *Kandinsky: Complete Writings on Art*, 2 vols, Boston and London, 1982

Ludewig, Peter (ed.), *Schrei in die Welt: Expressionismus in Dresden*, Zurich, 1990

Macke, August and Franz Marc, *August Macke-Franz Marc Briefwechsel*, ed. Wolfgang Macke, Cologne, 1964

Macke, August, *Briefe an Elisabeth und die Freunde*, ed. Werner Frese and Ernst-Gerhard Güse, Munich, 1987

Marc, Franz, '*Der blaue Reiter prasentiert Eurer Hoheit sein blaues Pferd': Karten und Briefe*, Munich, 1989

Marc, Franz, *Briefe aus dem Felde*, Munich, 1966

Marc, Franz, *Briefe, Aufzeichnungen und Aphorismen*, 2 vols, Berlin, 1920

Marc, Franz, *Franz Marc Schriften*, ed. Klaus Lankheit, Cologne, 1978

Marées, Hans von, *Briefe*, Munich, 1923

Meidner, Ludwig, 'Anleitung zum Malen von Großstadtbildern', *Kunst und Künstler*, 12 (1914), 299–301; Eng. trans. in Rose-Carol Washton-Long (ed.), *German Expressionism: Documents from the End of the Wilhelmine Empire to the Rise of National Socialism*, Berkeley and Los Angeles, 1995, pp. 101–3

Meier-Graefe, Julius, *Der Fall Böcklin und die Lehre von der Einheiten*, Stuttgart, 1905

Meier-Graefe, Julius, *Die Entwicklungsgeschichte der modernen Kunst*, 2 vols, Munich, 1904, Eng. trans. by Florence Simmonds and George W. Chrystal as *Modern Art: Being a Contribution to a New System of Aesthetics*, 2 vols, New York, 1968

Meisel, Victor (ed.), *Voices of German Expressionism*, Englewood Cliffs, 1970

Modersohn-Becker, Paula, *Paula Modersohn-Becker in Briefen und Tägebuchern*, ed. G. Busch and L. von Rinken, Frankfurt, 1979

Modersohn-Becker, Paula, *The Letters and Journals of Paula Modersohn-Becker*, ed. Diane J. Radycki, Metuchen, NJ, and London, 1980

Moholy-Nagy, László, *Malerei-Photographie-Film*, Dessau, 1925, 2nd edn as *Malerei-Fotografie-Film*, 1927

Muthesius, Hermann, *Das englische Haus*, 3 vols, Berlin, 1904–5

Muthesius, Hermann, *Die englische Baukunst der Gegenwart*, 2 vols, Leipzig and Berlin, 1900

Neumann, Carl, *Der Kampf um die neue Kunst*, Berlin, 1896

Neumann, Eckhard (ed.), *Bauhaus and Bauhaus People: Personal Opinions and Recollections of Former Bauhaus Members and Their Contemporaries*, New York and London, 1993

Nietzsche, Friedrich, *The Birth of Tragedy and Other Writings*, ed. Raymond Geuss and Ronald Speirs, Cambridge, 1999

Nietzsche, Friedrich, *Thus Spoke Zarathustra*, Harmondsworth, 1969

Noakes, Jeremy and Geoffrey Pridham (eds), *Documents on Nazism 1919–1945*, London, 1974

Nolde, Emil, *Briefe aus den Jahren 1894–1926*, ed. Martin Urban, Hamburg, 1967

Nolde, Emil, *Briefe aus den Jahren 1894–1926*, ed. Max Sauerlandt, Berlin, 1927

Nolde, Emil, *Das eigene Leben*, Berlin, 1931

Nolde, Emil, *Jahre der Kämpfe*, Berlin, 1934

Nolde, Emil, *Mein Leben*, Cologne, 1976

Nolde, Emil, *Reisen, Ächtung, Befreiung*, Cologne, 1967

Nolde, Emil, *Welt und Heimat*, Cologne, 1965

Nordau, Max, *The Conventional Lies of Our Civilization*, Eng. trans., Chicago, 1884

Nordau, Max, *Degeneration*, Eng. trans., London, 1895

Obrist, Hermann, *Neue Möglichkeiten in der bildenden Kunst*, Leipzig, 1903

Pechstein, Max, *Max Pechstein – Erinnerungen*, ed. Leopold Reidemeister, Wiesbaden, 1960

Penzler, Johannes (ed.), *Die Reden Kaiser Wilhelms II*, Leipzig, 1907

Pudor, Heinrich, *Ein ernstes Wort über 'Rembrandt als Erzieher'*, Göttingen, 1890

Richter, Hans, *Dada: Art and Anti-Art*, New York, 1965

Riefenstahl, Leni, *Leni Riefenstahl: A Memoir*, New York, 1993

Riefenstahl, Leni, *Olympia*, London, 1994

Riehl, Wilhelm, *Die Naturgeschichte des deutschen Volkes als Grundlage einer deutschen Sozialpolitik*, 3 vols, Stuttgart and Augsburg, 1857

Rilke, Rainer Maria, *Das Stundenbuch*, Wiesbaden, 1959

Rilke, Rainer Maria, *Worpswede, Rodin, Aufsätze*, vol. 5 of *Sämtliche Werke*, Frankfurt, 1965

Roh, Franz, *Nach-Expressionismus, magischer Realismus: Probleme der neuesten europäischen Malerei*, Leipzig, 1925

Rosenberg, Alfred, *Der Mythus des 20. Jahrhunderts*, Munich, 1930

Scheffauer, Herman George, *The New Vision in the German Arts*, London, 1924

Schlemmer, Oskar, *Idealist der Form: Briefe, Tagebücher, Schriften 1912–1943*, ed. Andreas Huneke, Leipzig, 1990

Schlemmer, Oskar, *Oskar Schlemmer: Briefe und Tagebücher*, ed. Tut Schlemmer, Stuttgart, 1977, Eng. trans. as *The Letters and Diaries of Oskar Schlemmer*, Middletown, 1972

Schlemmer, Oskar, *The Theatre of the Bauhaus*, Baltimore, 1996

Schmidt, Dieter (ed.), *Manifeste, Manifeste 1905–33. Schriften deutscher Künstler des zwanzigsten Jahrhunderts*, Dresden, 1965

Schneede, Uwe (ed.), *Die zwanziger Jahre: Manifeste und Dokumente deutscher Künstler*, Cologne, 1979

Schopenhauer, Arthur, *Die Welt als Wille und Vorstellung*, 2 vols, Leipzig, 1844, Eng. trans. as *The World as Will and Representation*, New York, 1969

Schultze-Naumburg, Paul, *Der Bau des Wohnhauses*, 3rd edn, Munich, 1924

Schultze-Naumburg, Paul, *Kunst und Rasse*, Munich, 1928

Schur, Ernst, *Der Fall Meier-Graefe*, Berlin, 1905

Schwitters, Kurt, *Kurt Schwitters. Das literarische Werk*, ed. Friedhelm Lach, 5 vols, Cologne, 1973–81

Schwitters, Kurt, *Poems, Performance Pieces, Proses, Plays, Poetics*, ed. Jerome Rothenberg, Philadelphia, 1993

Seven Expressionist Plays: Kokoschka to Barlach, 2nd edn, London, 1980

Simmel, Georg, 'The metropolis and mental life' (1903), Eng. trans. in Donald Levine (ed.), *Georg Simmel on Individuality and Social Forms*, Chicago and London, 1971

Simmel, Georg, *The Philosophy of Money* (1900), Eng. trans., London, 1990

Singer, H. W., *Briefe von Max Klinger aus den Jahren 1874 bis 1919*, Leipzig, 1924

Speer, Albert, *Inside the Third Reich*, Eng. trans., New York, 1996

Sydow, Eckart von, *Die deutsche expressionistische Kultur und Malerei*, Berlin, 1920

Taut, Bruno, *Alpine Architektur*, Hagen, 1919

Taut, Bruno, *Die Auflösung der Städte oder die Erde eine gute Wohnung oder auch: der Weg zur Alpinen Architektur*, Hagen, 1920

Taut, Bruno, *Die Stadtkrone*, Jena, 1919

Taut, Bruno, *The Crystal Chain Letters*, ed. Iain Boyd Whyte, Cambridge, Mass., 1985

Thode, Henry, *Böcklin und Thoma: acht Vorträge über neudeutsche Malerei*, Heidelberg, 1905

Thoene, Peter, *Modern German Art*, trans. Charles Fullman, Harmondsworth, 1938

Tschudi, Hugo von, *Gesammelte Schriften zur neuen Kunst*, ed. E. Schwedeler-Meyer, Munich, 1912

Tucholsky, Kurt, *Deutschland, Deutschland über alles: ein Bilderbuch von Kurt Tucholsky und vielen Fotografen montiert von John Heartfield*, Berlin, 1929

Van de Velde, Henry, *Die Renaissance im modernen Kunstgewerbe*, Berlin, 1901

Van de Velde, Henry, *Geschichte meines Lebens*, Munich, 1962

Vinnen, Carl (ed.), *Ein Protest deutscher Künstler*, Jena, 1911

Vogeler, Heinrich, *Erinnerungen*, Berlin, 1952

Walden, Herwarth, *Einblick in Kunst. Expressionismus, Futurismus, Kubismus*, Berlin, 1917, 2nd edn 1924

Walden, Herwarth, *Expressionismus: Die Kunstwende* (1918), Berlin, 1973

Walden, Herwarth, *Die neue malerei*, Berlin, 1919

Washton-Long, Rose-Carol, *German Expressionism: Documents from the End of the Wilhelmine Empire to the Rise of National Socialism*, Berkeley, 1995

Werner, Anton von, *Erlebnisse und Eindrücke, 1870–1890*, Berlin, 1913

Westheim, Paul, 'Das "Ende des Expressionismus"', *Das Kunstblatt*, 4:6 (June 1920)

Westheim, Paul, *Für und wider: kritische Ammerkungen zur Kunst der Gegenwart*, Potsdam, 1923

Westheim, Paul, *Wilhelm Lehmbruck*, Potsdam, 1919

Worringer, Wilhelm, *Abstraction and Empathy* (1908), Eng. trans. Michael Bullock, London, 1953

Worringer, Wilhelm, *Formprobleme der Gotik*, Leipzig, 1911

Wulf, Joseph, *Die bildenden Künste im Dritten Reich: eine Dokumentation*, Gütersloh, 1963

SECONDARY SOURCES

Adam, Peter, *The Arts of the Third Reich*, London, 1992

Ades, Dawn, *Photomontage*, 2nd edn, London, 1986

Adkins, Helen, *Neue Sachlichkeit – Deutsche Malerei seit dem Expressionismus*, exhibition catalogue, Berlin, 1988

Adolph Menzel 1815–1905: Between Romanticism and Impressionism, New Haven and London, 1996

Aichele, K. P., 'Paul Klee's operatic themes and variations', *Art Bulletin*, 68 (1986), 450–66

Alexej von Jawlensky: Catalogue Raisonné of the Oil Paintings, 3 vols, London, 1991–93

Allen, Ann Taylor, *Satire and Society in Wilhelmine Germany: Kladderadatsch and Simplicissimus 1890–1914*, Lexington, Kentucky, 1984

Allgeyer, Julius, *Anselm Feuerbach*, ed. Carl Neumann, 2 vols, Berlin and Leipzig, 1904

Anderson, Benedict, *Imagined Communities: Reflections on the Origin and Spread of Nationalism*, London and New York, 1991

Ankum, Katharina von (ed.), *Women in the Metropolis: Gender and Modernity in Weimar Culture*, Berkeley, 1997

Anselm Feuerbach: Gemälde und Zeichnungen, exhibition catalogue, Karlsruhe, 1976

Antliff, Mark, *Inventing Bergson: Cultural Politics and the Parisian Avant-Garde*, Princeton, 1993

Apel, Dora, ' "Heroes" and "whores": the politics of gender in Weimar anti-war imagery', *Art Bulletin*, 72:3 (1997), 366–84

Art et résistance: les peintres allemands de l'entre-deux-guerres, The Hague, 1995

Art in Berlin 1815–1989, exhibition catalogue, Atlanta, 1989

Aschheim, Steven E., *The Nietzsche Legacy in Germany 1880–1990*, Berkeley and Oxford, 1992

August Macke, exhibition catalogue, Munster and Munich, 1986

August Sander: 'In photography there are no unexplained shadows!', exhibition catalogue, London, 1996

Aust, Gunter, 'Die Ausstellung des Sonderbundes 1912 in Köln', *Wallraf-Richartz Jahrbuch*, 22 (1961), 276–9

Backes, Klaus, *Hitler und die bildenden Künste: Kulturverständnis und Kunstpolitik im Dritten Reich*, Cologne, 1988

Banham, Reyner, *Theory and Design in the First Machine Age*, Cambridge, Mass., 1981

Barlow, John, *German Expressionist Film*, Boston, 1982

Barnett, Vivian Endicott and Josef Helfenstein, *Die Blaue Vier*, Cologne, 1997

Barnett, Vivian Endicott, *Kandinsky Watercolours: Catalogue Raisonné*, 2 vols, London, 1992–94

Barron, Stephanie (ed.), *'Degenerate Art': The Fate of the Avant-Garde in Nazi Germany*, Los Angeles, 1991

Barron, Stephanie (ed.), *Exiles and Emigrés: The Flight of European Artists from Hitler*, exhibition catalogue, Los Angeles, 1997

Barron, Stephanie (ed.), *German Expressionism 1915–1925: The Second Generation*, Munich and Los Angeles, 1989

Barron, Stephanie, *German Expressionist Sculpture*, Chicago, 1983

Barron, Stephanie and Wolf-Dieter Dube (eds), *German Expressionism: Art and Society*, London, 1997

Barthes, Roland, *Camera Lucida*, Eng. trans. Richard Howard, London, 1984

Bartmann, Dominik, *Anton von Werner: Zur Kunst und Kunstpolitik im deutschen Kaiserreich*, Berlin, 1985

Bauschatz, Paul, 'Paul Klee's Anna Wenne and the work of art', *Art History*, 19:1 (1996), 74–101

Bayer, Herbert, Walter Gropius and Ise Gropius (eds), *Bauhaus 1919–1928*, London, 1975

Becker, Edwin, *Franz von Stuck: Eros and Pathos*, exhibition catalogue, Amsterdam, 1995

Beckmann, Peter, *Max Beckmann: Leben und Werk*, Stuttgart and Zurich, 1982

Behr, Shulamith, *Conrad Felixmüller: Works on Paper*, London, 1994

Behr, Shulamith, *Women Expressionists*, Oxford, 1988

Behr, Shulamith and Amanda Wadsley (eds), *Conrad Felixmüller: Between Politics and the Studio*, exhibition catalogue, Leicester, 1994

Behr, Shulamith, David Fanning and Douglas Jarman (eds), *Expressionism Reassessed*, Manchester, 1993

Belting, Hans, *The Germans and Their Art: A Troublesome Relationship*, New Haven and London, 1998

Belting, Hans, *Max Beckmann: Tradition as a Problem in Modern Art*, New York, 1989

Benson, Timothy, *Expressionist Utopias: Paradise, Metropolis, Architectural Fantasy*, exhibition catalogue, Los Angeles, 1993

Benson, Timothy, *Raoul Hausmann and Berlin Dada*, Ann Arbor, 1987

Berend-Corinth, Charlotte and Hans Konrad Röthel, *Lovis Corinth: die Gemälde*, Munich, 1992

Berger, Renate, *Malerinnen auf dem Weg ins 20. Jahrhundert: Kunstgeschichte als Sozialgeschichte*, Cologne, 1982

Berghaus, Günter, '"Girlkultur": feminism, Americanism and popular entertainment in Weimar Germany', *Journal of Design History*, 1:3–4 (1988), 193–219

Bergius, Hanne, *Das Lachen Dadas: Die Berliner Dadaisten und ihre Aktionen*, Giessen, 1989

Bergius, Hanne and Karl Riha, *Dada Berlin: Texte, Manifeste, Aktionen*, Stuttgart, 1977

Bergmann, Klaus, *Agrarromantik und Großstadtfeindschaft*, Meisenheim, 1970

The Berlin of George Grosz: Drawings, Watercolours and Prints, exhibition catalogue, London, 1997

Bessell, Richard and E. J. Feuchtwanger (eds), *Social Change and Political Development in Weimar Germany*, London, 1981

Betterton, Rosemary, 'Mother figures: the maternal nude in the work of Käthe Kollwitz and Paula Modersohn-Becker', in Griselda Pollock (ed.), *Generations and Geographies in the Visual Arts: Feminist Readings*, London and New York, 1996, pp. 159–79

Bhabha, Homi, *The Location of Culture*, London and New York, 1994

Bierbaum, Otto Julius, *Stuck*, Bielefeld and Leipzig, 1899

Der Blaue Reiter: Kandinsky, Marc und ihre Freunde, exhibition catalogue, Hanover, 1989

Bletter, Rosemarie Haag, 'The interpretation of the glass dream – Expressionist architecture and the history of the crystal metaphor', *Journal of the Society of Architectural Historians*, 40:1 (1981), 20–43

Bloch, Ernst, *The Utopian Function of Art and Literature: Selected Essays*, Cambridge, Mass., 1988

The Blue Four: Feininger, Jawlensky, Kandinsky and Klee in the New World, New Haven and London, 1998

Bogner, Dieter and Eva Badura-Triska (eds), *Johannes Itten: meine Symbole, meine Mythologien werden die Formen und Farben sein*, exhibition catalogue, Vienna, 1988

Boorman, H., 'Re-thinking the Expressionist era: Wilhelmine cultural debates and Prussian elements in German Expressionism', *Oxford Art Journal*, 9 (1986), 3–15

Borrmann, Norbert, *Paul Schultze-Naumburg 1869–1949: Maler, Publizist, Architekt vom Kulturreformer der Jahrhundertwende zum Kulturpolitiker im Dritten Reich*, Essen, 1989

Bott, Gerhard, *Kunsthandwerk um 1900: Art Nouveau, Modern Style, Nieuwe Kunst*, exhibition catalogue, Darmstadt, 1965

Boulboulle, Guido, *Worpswede: Kulturgeschichte eines Künstlerdorfes*, Cologne, 1989

Bowlt, John and Rose-Carol Washton-Long (eds), *The Life of Vasili Kandinsky in Russian Art: A Study of 'On the Spiritual in Art'*, Newtonville, Mass., 1980

Bradley, William, *The Art of Emil Nolde in the Context of North German Painting and Volkisch Ideology*, Evanston, 1981

Bradley, William, *Emil Nolde and German Expressionism: A Prophet in His Own Land*, 1986

Brand, B., *Fritz von Uhde, das religiöse Werk zwischen künstlerischen Intention und Offentlichkeit*, Heidelberg, 1983

Brenner, Hildegard, *Ende einer bürgerlichen Kunstinstitution: die politische Formierung der Preußischen Akademie der Künste ab 1933*, Stuttgart, 1972

Brenner, Hildegard, *Die Kunstpolitik des Nationalsozialismus*, Hamburg, 1963

Brenner, Michael, *The Renaissance of Jewish Culture in Weimar Germany*, New Haven, 1996

Brettell, Richard, *Modern Art 1851–1929: Capitalism and Representation*, Oxford, 1999

Breuer, Gerda and Ines Wagemann, *Ludwig Meidner 1884–1966. Maler, Zeichner, Literat*, 2 vols, Stuttgart, 1991

Breuilly, John, *Nationalism and the State*, Manchester, 1982

Bridenthal, Renate, Atina Grossman and Marion Kaplan (eds), *When Biology Became Destiny: Women in Weimar and Nazi Germany*, New York, 1984

Bridgwater, Patrick, *The Expressionist Generation and Van Gogh*, Hull, 1987

Bronner, Stephen Eric and Douglas Kellner (eds), *Passion and Rebellion: The Expressionist Heritage*, London, 1983

Bruch, Rüdiger vom, *Weltpolitik als Kulturmission: Auswärtige Kulturpolitik und Bildungsbürgertum in Deutschland am Vorabend des Ersten Weltkrieges*, Paderborn, 1982

Brühl, Georg, *Herwarth Walden und 'Der Sturm'*, Leipzig, 1983

Budd, Mike (ed.), *The Cabinet of Dr Caligari: Texts, Contexts, Histories*, New Brunswick, 1990

Buderer, Hans-Jürgen, *Neue Sachlichkeit: Bilder auf der Suche nach der Wirklichkeit*, Munich, 1994

Bunge, Matthias, *Max Liebermann als Künstler der Farbe*, Berlin, 1990

Burckhardt, Lucius (ed.), *The Werkbund: Studies in the History and Ideology of the Deutscher Werkbund 1907–33*, London, 1980

Bushart, Magdalena, *Der Geist der Gotik und die expressionistische Kunst: Kunstgeschichte und Kunsttheorie 1911–1925*, Munich, 1990

Callen, Anthea, *Angel in the Studio: Women in the Arts and Crafts Movement 1870–1914*, London, 1979

Camfield, William, *Max Ernst: Dada and the Dawn of Surrealism*, Munich, 1993

Campbell, Joan, *The German Werkbund: The Politics of Reform in the Applied Arts*, Princeton, 1978

Carey, Frances and Anthony Griffiths, *The Print in Germany 1880–1933: The Age of Expressionism*, London, 1984

Caspar David Friedrich to Ferdinand Hodler: A Romantic Tradition, exhibition catalogue, Frankfurt and Leipzig, 1993

Chadwick, Whitney, *Women Artists and the Surrealist Movement*, London, 1985

Chapple, Gerald and Hans Schulte (eds), *The Turn of the Century: German Literature and Art 1880–1915*, Bonn, 1981

Clair, Jean, *Lost Paradise: Symbolist Europe*, exhibition catalogue, Montreal, 1995

Clarke, Graham, 'Public faces, private lives: August Sander and the social typology of the portrait photograph', in Graham Clarke (ed.), *The Portrait in Photography*, London, 1992, pp. 71–93

Coates, Paul, *The Gorgon's Gaze: German Cinema, Expressionism and the Image of Horror*, Cambridge, 1991

Comini, Alessandra, 'Gender or genius? The women artists of German Expressionism', in Norma Broude and Mary Garrard (eds), *Feminism and Art History: Questioning the Litany*, New York, 1982

Conrad Felixmüller: Werke und Dokumente, exhibition catalogue, Nürnberg, 1981

Coombes, Annie, *Reinventing Africa: Museums, Material Culture and Popular Imagination in Late Victorian and Edwardian England*, New Haven, 1994

Cork, Richard, *A Bitter Truth: Avant-Garde Art and the Great War*, New Haven and London, 1994

Costantini, Paolo (ed.), *La fotografia al Bauhaus*, exhibition catalogue, Venice, 1993

Craig, Gordon, *Germany 1866–1945*, Oxford, 1981

Crockett, Dennis, *German Post-Expressionism: The Art of the Great Disorder 1918–1924*, University Park, 1999

Crone, Rainer and Joseph Leo Koerner, *Paul Klee: Legends of the Sign*, New York, 1991

Dech, Gertrud, *Schnitt mit dem Kuchen-Messer: Dada durch die letzte Weimarer Bierbauchkulturepoche Deutschlands*, Münster, 1981

Der deutscher Künstlerbund im Darmstadt, exhibition catalogue, Berlin, 1991

Derouet, Christian and Jessica Boissel, *Kandinsky: oeuvres de Vassily Kandinsky*, exhibition catalogue, Paris, 1984

Deshmukh, Marion, 'German Impressionist painters and World War I', *Art History*, 4:1 (1981), 66–79

Deutsch, Rosalynd, 'Alienation in Berlin: Kirchner's street scenes', *Art in America*, (January 1983), pp. 65–72

Die Rheinischen Expressionisten: August Macke und seine Malerfreunde, Recklinghausen, 1980

Dietrich, Dorothea, *The Collages of Kurt Schwitters: Tradition and Innovation*, Cambridge, 1993

Doane, Mary Ann, Patricia Mellencamp and Linda Williams (eds), *Re-Vision: Essays in Feminist Film Criticism*, Los Angeles, 1984

Doede, Werner, *The Berlin Secession*, Berlin, 1977

Ein Dokument deutscher Kunst: Darmstadt 1901–1976, exhibition catalogue, 5 vols, Darmstadt, 1976–77

Donahue, Neil H. (ed.), *Invisible Cathedrals: The Expressionist Art History of Wilhelm Worringer*, University Park, 1995

Dube, Annemarie and Wolf-Dieter, *Erich Heckel, das graphische Werk*, 2 vols, Hamburg and New York, 1964–65, reprint 1974

Dube, Wolf-Dieter, *Der Expressionismus in Wort und Bild*, Stuttgart and Geneva, 1983

Dube, Wolf-Dieter, *Expressionism*, London, 1972

Dube-Heynig, Annemarie, Roman Norbert Ketterer and Wolfgang Henze, *Ernst Ludwig Kirchner: Postkarten und Briefe an Erich Heckel im Altonaer Museum in Hamburg*, Cologne, 1984

Düchers, Alexander, *Max Klinger*, Berlin, 1976

Eberle, Matthias, *Max Liebermann 1847–1935*, Munich, 1995–96

Eberle, Matthias, *World War I and the Weimar Artists: Dix, Grosz, Beckmann, Schlemmer*, New Haven, 1985

Edvard Munch: The Frieze of Life, exhibition catalogue, London, 1992

Eichner, Johannes, *Kandinsky und Gabriele Münter: von Ursprüngen der modernen Kunst*, Munich, 1957

Eimert, Dorothea, *Der Einfluß der Futurismus auf die deutsche Malerei*, Cologne, 1974

Eisner, Lotte, *The Haunted Screen: Expressionism in the German Cinema and the Influence of Max Reinhardt*, London, 1965

Elderfield, John, *Kurt Schwitters*, London, 1985

Elger, Dietmar, *Expressionism: A Revolution in German Art*, Cologne, 1989

Eliel, Carol, *The Apocalyptic Landscapes of Ludwig Meidner*, Munich, 1989

Elsaesser, Thomas, 'Social mobility and the fantastic German silent cinema', in James Donald (ed.), *Fantasy and the Cinema*, London, 1989, pp. 23–88

Emil Nolde: Catalogue Raisonné of the Oil Paintings, 2 vols, London, 1990

Erich Heckel 1883–1970: Gemälde, Aquarelle, Zeichnungen und Graphik, exhibition catalogue, Munich, 1983

Erlhoff, Michael, *Raoul Hausmann, Dadasoph: Versuch einer politisierung der Ästhetik*, Hanover, 1982

Ernst Barlach, exhibition catalogue, 3 vols, Berlin, 1981

Ernst Ludwig Kirchner 1880–1938, exhibition catalogue, Berlin, 1979

Erpel, Fritz, *Max Beckmann, Leben in Werk: die Selbstbildnisse*, Berlin, 1985

Evans, Richard, *The Feminist Movement in Germany 1894–1933*, London, 1976

Evers, Ulrike, *Deutsche Künstlerinnen des 20. Jahrhunderts*, Hamburg, 1983

The Expressionist Revolution in German Art 1871–1933, Leicester, 1978

Feilchenfeldt, Walter, *Vincent van Gogh and Paul Cassirer: The Reception of Van Gogh in Germany*, Zwolle, 1988

Figures du moderne 1905–14: Dresde, Munich, Berlin: l'expressionisme en Allemagne, exhibition catalogue, Paris, 1992

Fineberg, Jonathan David, *The Innocent Eye: Children's Art and the Modern Artist*, Princeton, 1997

Fineberg, Jonathan David, *Kandinsky in Paris 1906–1907*, Ann Arbor, 1984

Finke, Ulrich, *German Painting: From Romanticism to Expressionism*, London, 1974

Fischer, Wend, *Zwischen Kunst und Industrie: Der Deutscher Werkbund*, Munich, 1975

Flavell, M. Kay, *George Grosz: A Biography*, New Haven, 1988

Forster-Hahn, Françoise (ed.), *Imagining Modern German Culture 1889–1910*, Washington, DC, 1996

Franciscono, Marcel, *Paul Klee: His Work and Thought*, Chicago, 1991

Franciscono, Marcel, *Walter Gropius and the Creation of the Bauhaus in Weimar: The Ideals and Artistic Theories of its Founding Years*, Urbana, 1971

Franz, Erich, *Franz Marc: Krafte der Natur: Werke, 1912–1915*, exhibition catalogue, Ostfildern, 1993

Franz, Marc, 'Der Blaue Reiter prasentiert Eurer Hoheit sein blaues Pferd', exhibition catalogue, Munich, 1989

Franz von Stuck, exhibition catalogue, Munich, 1982

Frevert, Ute, *Women in German History: From Bourgeois Emancipation to Sexual Liberation*, Oxford, 1989

Friedel, Helmut (ed.), *Süddeutsche Freiheit: Kunst der Revolution in München 1919*, exhibition catalogue, Munich, 1993

Frisby, David, *Fragments of Modernity: Theories of Modernity in the Work of Simmel, Kracauer and Benjamin*, Cambridge, 1985

Fullner, Karin, *Richard Huelsenbeck: Texte und Aktionen eines Dadaisten*, Heidelberg, 1983

Gabler, Karlheinz (ed.), *Erich Heckel und sein Kreis. Dokumente, Fotos, Briefe, Schriften*, Stuttgart, 1983

Gabriele Münter, 1877–1962: Retrospektive, exhibition catalogue, Munich, 1993

Gage, John, *Colour and Culture: Practice and Meaning from Antiquity to Abstraction*, London, 1993

Gartner, Heinz, *Worpswede war ihr Schicksal: Modersohn, Rilke und das Mädchen Paula*, Düsseldorf, 1994

Gay, Peter, *Weimar Culture: The Outsider as Insider*, Harmondsworth, 1968

Geelhaar, Christian, *Paul Klee and the Bauhaus*, Greenwich, 1973

Geelhaar, Christian, *Paul Klee, Life and Work*, New York, 1982

Gellner, Ernest, *Nations and Nationalism*, Oxford, 1983

German Realism of the Twenties: The Artist as Social Critic, exhibition catalogue, Minneapolis, 1980

Giedion, Sigfried, *Walter Gropius* (1954), New York, 1992

Gillen, Eckhart (ed.), *German Art from Beckmann to Richter: Images of a Divided Country*, New Haven and London, 1997

Gleisberg, Dieter, *Conrad Felixmüller Leben und Werk*, Dresden, 1982

Godé, Maurice, *Der Sturm de Herwarth Walden: l'utopie d'un art autonome*, Nancy, 1990

Gold, Helmut and Annette Koch (eds), *Fräulein vom Amt*, Munich, 1993

Gollek, Rosel (ed.), *Franz Marc 1880–1916*, exhibition catalogue, Munich, 1980

Golomstock, Igor, *Totalitarian Art: In the Soviet Union, the Third Reich, Fascist Italy and the People's Republic of China*, London, 1990

Gordon, Donald, 'On the origin of the word "Expressionism"', *Journal of the Warburg and Courtauld Institutes*, 29 (1966), 368–85

Gordon, Donald, *Ernst Ludwig Kirchner*, Cambridge, Mass., 1968

Gordon, Donald, *Expressionism: Art and Idea*, New Haven and London, 1987

Götz, Adriani, *Hannah Höch: Fotomontagen, Gemälde, Aquarelle*, Cologne, 1980

Greenberg, Alan, *Artists and Revolution: Dada and the Bauhaus, 1917–1925*, Ann Arbor, 1979

Grohmann, Will, *E. L. Kirchner*, London, 1961

Grohmann, Will, *Paul Klee*, London, 1987

Grohmann, Will, *Wassily Kandinsky: Life and Work*, London, 1959

Gruber, Helmut, 'Willi Münzenberg's German communist propaganda empire 1921–1933', *Journal of Modern History*, 38:3 (1966), 278–97

Guilbaut, Serge, *How New York Stole the Idea of Modern Art*, Chicago, 1983

Günther, Sonja, *Interieurs um 1900. Bernhard Pankok, Bruno Paul und Richard Riemerschmid als Mitarbeiter der Vereinigten Werkstätten für Kunst im Handwerk*, Munich, 1971

Güse, Ernst-Gerhard (ed.), *August Macke: Gemälde, Aquarelle, Zeichnungen*, exhibition catalogue, Munich, 1986

Güse, Ernst-Gerhard, *Paul Klee: Dialogue with Nature*, Munich, 1991

Gutbrod, Evelyn, *Die Rezeption des Impressionismus in Deutschland 1880–1910*, Stuttgart, 1980

Guttsman, W. L., *Art for the Workers: Ideology and the Visual Arts in Weimar Germany*, Manchester, 1997

G. W., 'The Secessionists of Germany', *Studio*, 4 (1894), 24–8

Hahl-Koch, Jelena, *Marianne Werefkin und der russische Symbolismus: Studien zur Aesthetik und Kunsttheorie*, Munich, 1967

Halliday, John, *Karl Kraus, Franz Pfemfert and the First World War: A Comparative Study of 'Die Fackel' and 'Die Aktion' between 1911 and 1928*, Passau, 1986

Hamann, Richard and Jost Hermand, *Stilkunst um 1900: Epochen deutscher Kultur von 1870 bis zur Gegenwart*, Berlin, 1967

Hammann, Otto, *Bilder aus der letzten Kaiserzeit*, Berlin, 1922

Hancke, E., *Max Liebermann*, Berlin, 1914

Hannah Höch 1889–1978: Collages, exhibition catalogue, Stuttgart, 1985

Hannah Höch 1889–1978: ihr Werk, ihr Leben, ihre Freunde, exhibition catalogue, Berlin, 1989

Hans Thoma: Lebensbilder, exhibition catalogue, Konigstein im Taunus, 1989

Hans von Marées, exhibition catalogue, Munich, 1987

Harlekin und Akrobat: die Welt der Artisten im Rheinischen Expressionismus, exhibition catalogue, Bonn, 1997

Harrison, Charles and Paul Wood (eds), *Art in Theory 1900–1990*, Oxford, 1992

Hartley, Keith, Henry Meyrich Hughes, Peter-Klaus Schuster and William Vaughan (eds), *The Romantic Spirit in German Art 1790–1990*, exhibition catalogue, London, 1994

Harzenetter, Markus, *Zur Münchner Secession: Genese, Ursachen und Zielsetzungen*, Munich, 1992

Haus, Andreas, *Moholy-Nagy: Photographs and Photograms*, London, 1980

Haxthausen, Charles W. and Heidrun Suhr (eds), *Berlin Culture and Metropolis*, Minneapolis and Oxford, 1990

Haxthausen, Charles W., *Paul Klee: The Formative Years*, New York, 1981

Heartfield, John, *Schnitt entlang der Zeit: Selbstzeugnisse, Erinnerungen, Interpretationen*, ed. Roland März, Dresden, 1981

Heibel, Yule F., *Reconstructing the Subject: Modernist Painting in Western Germany 1945–50*, Princeton, 1995

Heiderich, Ursula, *August Macke: Skizzenbücher*, 2 vols, Stuttgart, 1987

Heinrich Vogeler: Kunstwerke, Gebrauchsgegenstände, Dokumente, exhibition catalogue, Berlin, 1983

Heller, Reinhold, *Art in Germany 1909–1936: From Expressionism to Resistance. The Marvin and Janet Fishman Collection*, Munich, 1990

Heller, Reinhold, *Brücke: German Expressionist Prints from the Granvil and Marcia Specks Collection*, Evanston, 1988

Heller, Reinhold, *Gabriele Münter: The Years of Expressionism 1903–1920*, Munich and New York, 1998

Heller, Reinhold, *Munch: His Life and Work*, London, 1984

Herbert, Barry, *German Expressionism: die Brücke and der Blaue Reiter*, London, 1983

Herf, Jeffrey, *Reactionary Modernism: Technology, Culture and Politics in Weimar and the Third Reich*, Cambridge, 1984

Hermand, Jost, 'Das Bild der "großen Stadt" im Expressionismus', in Klaus Scherpe (ed.), *Die Unwirklichkeit der Städte: Großstadtdarstellungen zwischen Moderne und Postmoderne*, Reinbek, 1988

Hermand, Jost, *Jugendstil*, Darmstadt, 1971

Hertel, Christiane, 'Irony, dream and kitsch: Max Klinger's *Paraphrase of the Finding of a Glove* and German modernism', *Art Bulletin*, 74:1 (1992), 91–114

Herzfelde, Wieland, *John Heartfield: Leben und Werk*, Dresden, 1971

Heskett, John, *German Design 1870–1918*, New York, 1986

Hess, Hans, *George Grosz*, London, 1974, reprint New Haven, 1985

Hesse-Frielinghaus, Herte, *Karl Ernst Osthaus: Leben und Werk*, Recklinghausen, 1971

Hierholzer, Michael, *Zeitfragen im Spiegel der Künste: Beispiele aus Literatur, bildender Kunst und Film vom Kaiserreich bis zum vereinten Deutschland*, Bonn, 1996

Hiesinger, Kathryn Bloom (ed.), *Art Nouveau in Munich: Masters of Jugendstil*, exhibition catalogue, Munich, 1988

Hight, Eleanor, *Picturing Modernism: Moholy-Nagy and Photography in Weimar Germany*, Boston, 1995

Hinton Thomas, Richard, *Nietzsche in German Politics and Society 1890–1914*, Manchester, 1983

Hinz, Berthold (ed.), *NS-Kunst: 50 Jahre danach: neue Beiträge*, Marburg, 1989

Hinz, Berthold, *Art in the Third Reich*, Oxford, 1980

Hirschbach, Frank (ed.), *Germany in the Twenties: The Artist as Social Critic*, New York, 1980

Hoberg, Annegret and Helmut Friedel (eds), *Der Blaue Reiter und das neue Bild: von der "Neuen Künstlervereinigung München" zum "Blaue Reiter"*, Munich, 1999

Hoberg, Annegret and Helmut Friedel (eds), *Gabriele Münter*, exhibition catalogue, Munich, 1992

Hodin, J. P., *Ludwig Meidner: seine Kunst, seine Persönlichkeit, seine Zeit*, Darmstadt, 1973

Hoff, August, *Wilhelm Lehmbruck: Life and Work*, London, 1969

Hofmaier, James, *Max Beckmann: Catalogue Raisonné of the Prints*, 2 vols, Bern, 1990

Hooper, Kent W., *Ernst Barlach's Literary and Visual Art: The Issue of Multiple Talent*, Ann Arbor, 1987

Horst, Ludwig, *Kunst, Geld und Politik um 1900 in München. Formen und Ziele der Kunstfinanzierung und Kunstpolitik während der Prinzregentenära (1886–1912)*, Berlin, 1986

Howard, Jeremy, *Art Nouveau: International and National Styles in Europe*, Manchester, 1996

Hubrich, Hans-Joachim, *Hermann Muthesius: die Schriften zu Architektur, Kunstgewerbe, Industrie in der 'Neuen Bewegung'*, Berlin, 1980

Hull, David, *Film in the Third Reich: Art and Propaganda in Nazi Germany*, New York, 1973

Huter, Karl-Heinz, *Das Bauhaus in Weimar*, Berlin, 1982

Huyssen, Andreas, 'Mass culture as woman: modernism's other', in *idem*, *After the Great Divide: Modernism, Mass Culture, Postmodernism*, Bloomington, 1986, pp. 44–62

Isaacs, Reginald, *Gropius: An Illustrated Biography of the Creator of the Bauhaus*, Boston, 1991

Itten, Johannes, *Design and Form: The Basic Course at the Bauhaus*, London, 1975

Iversen, Margaret, *Alois Riegl: Art History and Theory*, Cambridge, Mass., 1993

Jähner, Horst, *Künstlergruppe Brücke. Geschichte einer Gemeinschaft und das Lebenswerk ihrer Repräsentanten*, Stuttgart, 1984

James, Kathleen, *Erich Mendelsohn and the Architecture of German Modernism*, Cambridge, 1997

Janaway, Christopher, 'Schopenhauer', in idem, *German Philosophers*, Oxford, 1997, pp. 221–337

Jarzombek, Mark, 'The *Kunstgewerbe*, the *Werkbund* and the aesthetics of culture in the Wilhelmine period', *Journal of the Society of Architectural Historians*, 53:1 (1994), 7–19

Jelavich, Peter, *Berlin Cabaret*, Cambridge, Mass., 1993

Jelavich, Peter, *Munich and Theatrical Modernism*, Cambridge, Mass., 1985

Jensen, Robert, *Marketing Modernism in Fin-de-Siècle Europe*, Princeton, 1994

Joachimides, C., Norman Rosenthal and Wieland Schmied (eds), *German Art in the Twentieth Century: Painting and Sculpture 1905–1985*, exhibition catalogue, London, 1985

John Heartfield: Idee und Konzeption, exhibition catalogue, Cologne, 1991

Jones, M. S., *Der Sturm: A Focus of Expressionism*, Columbia, 1984

Jordan, Jim J., *Paul Klee and Cubism*, Princeton, 1984

Jung, Uli and Walter Schatzberg (eds), *Filmkultur zur Zeit der Weimarer Republik*, Munich, 1992

Junge, Henrike (ed.), *Avant-Garde und Publikum: Zur Rezeption avantgardistischer Kunst in Deutschland 1905–33*, Cologne, 1992

Jurgen, Gustav, *August Macke*, Kirchdorf, 1989

Kagen, Andrew, *Paul Klee: Art and Music*, Ithaca and London, 1983

Kandinsky in Munich 1896–1914, exhibition catalogue, New York, 1982

Kandinsky in Paris 1934–1944, exhibition catalogue, New York, 1985

Kandinsky: The Russian and Bauhaus Years 1915–1933, exhibition catalogue, New York, 1983

Kane, Martin, *Weimar Germany and the Limits of Political Art: A Study of the Work of George Grosz and Ernst Toller*, Tayport, 1987

Kaplan, Louis, *László Moholy-Nagy: Biographical Writings*, Durham, 1995

Karcher, Eva, *Otto Dix 1891–1969: His Life and Works*, Cologne, 1988

Karl Schmidt-Rottluff: Ausstellungen zum 100. Geburtstag des Künstler, exhibition catalogue, Berlin, 1984

Karl Schmidt-Rottluff: das nachgelassene Werk seit den zwanziger Jahren: Malerei, Plastik, Kunsthandwerk, exhibition catalogue, Berlin, 1977

Karl Schmidt-Rottluff, exhibition catalogue, Paris, 1995

Karl Schmidt-Rottluff: der Maler, exhibition catalogue, Stuttgart, 1992

Kasten, J., *Der expressionistische Film*, Münster, 1990

Käthe Kollwitz, Schmerz und Schuld, exhibition catalogue, Berlin, 1995

Kershaw, Ian, *Hitler 1889–1936*, London, 1998

Klein, Nina and H. Arthur Klein, *Käthe Kollwitz: Life in Art*, New York, 1972

Kleine, Gisela, *Gabriele Münter und Wassily Kandinsky: Biographie eines Paares*, Frankfurt am Main, 1991

Kliemann, Helga, *Die Novembergruppe*, Berlin, 1969

Koch, Stephen, *Double Lives: Stalin, Willi Münzenberg and the Seduction of the Intellectuals*, London, 1995

Kockerbeck, Christoph, *Ernst Haeckel's 'Kunstformen der Natur' und ihr Einfluss auf die deutsche bildende Kunst der Jahrhundertwende*, Frankfurt am Main, 1986

Koonz, Claudia, *Mothers in the Fatherland: Women, the Family and Nazi Politics*, London, 1987

Kracauer, Siegfried, *From Caligari to Hitler: A Psychological History of the German Film*, Princeton, 1947

Krahmer, Catherine, *Käthe Kollwitz in Selbstzeugnissen und Bilddokumenten dargestellt*, Reinbeck bei Hamburg, 1981

Kratzsch, Gerhard, *Kunstwart und Dürerbund: ein Beitrag zur Geschichte der Gebildeten im Zeitalter des Imperialismus*, Göttingen, 1969

Krause, Jürgen, *'Märtyrer' und 'Prophet': Studien zum Nietzsche-Kult in der bildenden Kunst der Jahrhundertwende*, Berlin, 1984

Krempel, Ulrich (ed.), *Am Anfang 'das junge Rheinland': zur Kunst und Zeitgeschichte einer Region 1918–1945*, Düsseldorf, 1985

Kuenzi, Andre, *Klee: Catalogue Raisonné*, Martigny, 1985

Kuhns, David, *German Expressionist Theatre: The Actor and the Stage*, Cambridge, 1997

Kurt Schwitters, exhibition catalogue, London, 1985

Kurt Schwitters, exhibition catalogue, Paris, 1994

Kurtz, Rudolf, *Expressionismus und Film*, Berlin, 1926

Kuspit, Donald, *Albert Renger-Patzsch: Joy Before the Object*, Santa Monica, 1993

Kuspit, Donald, *The Cult of the Avant-Garde*, Cambridge, 1993

Lach, Friedhelm, *Der Merz Künstler Kurt Schwitters*, Cologne, 1971

Lackner, Stephan, *Max Beckmann, Switzerland*, London, 1991

Laffan, Michael (ed.), *The Burden of German History 1919–45*, London, 1988

Lambourne, Nicola, 'Production versus destruction: art, World War I and art history', *Art History*, 22:3 (1999), 347–63

Lanchner, Carolyn, *Paul Klee*, New York, 1987

Lane, Barbara Miller, *Architecture and Politics in Germany 1918–45*, 2nd edn, Cambridge, Mass., 1985

Langbehn, August Julius, *Rembrandt als Erzieher*, Leipzig, 1890

Lankheit, Klaus, *Franz Marc, Katalog der Werke*, Cologne, 1970

Lankheit, Klaus (ed.), *Franz Marc. Sein Leben und seine Kunst*, Cologne, 1976

Laqueur, Walter, *Weimar: A Cultural History 1918–33*, New York, 1974

Laqueur, Walter, *Young Germany: A History of the German Youth Movement*, 2nd edn, New Brunswick and London, 1984

Large, David (ed.), *Wagnerism in European Culture and Politics*, Ithaca, 1984

Lasko, Peter, 'The student years of die Brücke and their teachers', *Art History*, 20:1 (1997), 61–99

Latham, Ian, *Joseph Maria Olbrich*, London, 1980

Lavin, Maud, *Cut with the Kitchen Knife: The Weimar Photomontages of Hannah Höch*, New Haven and London, 1993

Legge, Elizabeth, *Max Ernst: The Psychoanalytic Sources*, Ann Arbor, 1989

Leiser, Erwin, *Nazi Cinema*, London, 1974

Lenman, Robin, *Artists and Society in Germany 1850–1914*, Manchester, 1997

Lenman, Robin, 'A community in transition: painters in Munich 1886–1924', *Central European History*, 15:1 (March 1982), 3–33

Lenman, Robin, 'Painters, patronage and the art market in Germany 1850–1914', *Past and Present*, 123 (1989), 109–40

Leopold, John A., *Alfred Hugenberg: The Radical Nationalist Campaign Against the Weimar Republic*, New Haven, 1977

Levine, Frederick S., 'The iconography of Franz Marc's *Fate of the Animals*', *Art Bulletin*, 58 (1976), 269–77

Levine, Frederick S., *The Apocalyptic Vision: The Art of Franz Marc in German Expressionism*, New York, 1979

Lewis, Beth Irwin, *George Grosz: Art and Politics in the Weimar Republic*, 1971, 2nd edn, Princeton, 1991

Linnebach, Andrea, *Arnold Böcklin und die Antike: Mythus, Geschichte, Gegenwart*, Munich, 1991

Lloyd, Jill, 'Emil Nolde's "ethnographic" still lifes: primitivism, tradition and modernity', in Susan Hiller (ed.), *The Myth of Primitivism: Perspectives on Art*, London and New York, 1991, pp. 90–112

Lloyd, Jill, *German Expressionism: Primitivism and Modernity*, New Haven, 1991

Lodder, Christina, *Russian Constructivism*, New Haven and London, 1983

Löffler, Fritz and Emilio Bertonati (eds), *Dresdener Sezession 1919–25*, Munich, 1977

Lovis Corinth, exhibition catalogue, London, 1996

Lucáks, Georg, '"Große und Verfall" des Expressionismus' (1934), in *Werke*, Neuwied and Berlin, 1971, vol. 4, pp. 109–49

Luckhardt, Ulrich, *Lyonel Feininger*, Munich, 1989

McCloskey, Barbara, *George Grosz and the Communist Party: Art and Radicalism in Crisis 1918 to 1936*, Princeton, 1997

McKay, Carol, '"Fearful dunderheads": Kandinsky and the cultural referents of criminal anthropology', *Oxford Art Journal*, 19:1 (1996), 29–41

McKay, Carol, 'Kandinsky's ethnography: scientific fieldwork and aesthetic reflection', *Art History*, 17 (1994), 182–208

McNichols-Webb, M., *Art as Propaganda: A Comparison of the Imagery and Roles of Woman as Depicted in German Expressionist, Italian Futurist and National Socialist Art*, Ann Arbor, 1988

Mai, Ekkehard and Peter Paret (eds), *Sammler, Stifter und Museeen: Kunstförderung in Deutschland im 19. und 20. Jahrhundert*, Cologne, 1993

Maier-Metz, Harald, *Expressionismus-Dada-Agitprop: Zur Entwicklung des Malik-Kreises in Berlin 1912–1924*, Frankfurt am Main, 1984

Makela, Maria, *The Munich Secession: Art and Artists in Turn-of-the Century Munich*, Princeton, 1990

Manheim, Ron, 'Expressionismus: Zur Entstehung eines Kunsthistorischen Stil- und Periodenbegriffes', *Zeitschrift für Kunstgeschichte*, 49:1 (1986), 73–91

Mannheim, Karl, *Ideology and Utopia: An Introduction to the Sociology of Knowledge*, London, 1954

Manskopf, Johannes, *Böcklins Kunst und die Religion*, Munich, 1905

Margolin, Victor, *The Struggle for Utopia: Rodchenko, Lissitzky, Moholy-Nagy 1917–46*, Chicago, 1997

Martel, Gordon (ed.), *Modern Germany Reconsidered 1870–1945*, London and New York, 1992

März, Roland, *Franz Marc*, Berlin, 1984

Masini, Lara-Vinca, *Art Nouveau*, London, 1984

Max Beckmann, Frankfurt 1915–1933, exhibition catalogue, Frankfurt, 1983

Max Beckmann: Gemälde 1905–50, Stuttgart, 1990

Max Ernst: A Retrospective, exhibition catalogue, London, 1991

Max Ernst: Beyond Surrealism, exhibition catalogue, New York, 1986

Max Liebermann in seiner Zeit, exhibition catalogue, Berlin and Munich, 1979–80

Max Slevogt: Gemälde, Aquarelle, Zeichnungen, exhibition catalogue, Stuttgart, 1992

Meffre, Liliane, *Carl Einstein et la problématique des avant-gardes dans les arts plastiques*, Berne, 1989

Mehring, Walter, *Berlin Dada: eine Chronik mit Photos und Dokumenten*, Zurich, 1959

Meissner, Franz Herrmann, *Max Klinger*, Berlin and Leipzig, 1899

Mellor, David (ed.), *Germany, the New Photography*, London, 1978

Meskimmon, Marsha, *'We Weren't Modern Enough': Women Artists and the Limits of German Modernism*, London, 1999

Meskimmon, Marsha and Martin Davies (eds), *Domesticity and Dissent: The Role of Women Artists in Germany 1918–1938*, exhibition catalogue, Leicester, 1992

Meskimmon, Marsha and Shearer West (eds), *Visions of the 'Neue Frau': Women and the Visual Arts in Weimar Germany*, Aldershot, 1995

Michalski, Sergiusz, *New Objectivity*, Cologne, 1994

Mirzoeff, Nicholas (ed.), *The Visual Culture Reader*, London, 1998

Mochon, Anne, *Gabriele Münter: Between Munich and Murnau*, Cambridge, Mass., 1980

Moeller, Gisela, *Peter Behrens in Düsseldorf: Die Jahre von 1903 bis 1907*, Weinheim, 1991

Moeller, Magdalena, *August Macke*, Cologne, 1988

Moeller, Magdalena, *Der Blaue Reiter*, Cologne, 1987

Moeller, Magdalena, *Ernst Ludwig Kirchner: die Strassenszenen 1913–1915*, Munich, 1993

Moeller, Magdalena, *Karl Schmidt-Rottluff: Werke aus der Sammlung des Brücke-Museums, Berlin*, Munich, 1997

Moeller, Magdalena, *Der Sonderbund*, Cologne, 1984

Moffett, Kenworth, *Meier-Graefe as Art Critic*, Munich, 1973

Mosse, George, *Nazi Culture: Intellectual, Cultural and Social Life in the Third Reich*, 2nd edn, London, 1981

Motherwell, Robert (ed.), *The Dada Painters and Poets. An Anthology*, New York, 1951

Murray, Bruce, *Film and the German Left in the Weimar Republic: From Caligari to Kuhle Wampe*, Austin, 1990

Nagel, Otto, *Käthe Kollwitz*, London, 1971

Naylor, Gillian, *The Bauhaus Reassessed: Sources and Design Theory*, London, 1985

Nelson, Thomas K., 'Klinger's *Brahmsphantasie* and the cultural politics of absolute music', *Art History*, 19:1 (1996), 26–43

Nerdinger, Winfried (ed.), *Richard Riemerschmid: Vom Jugendstil zum Werkbund, Werke und Dokumente*, Munich, 1982

Nerdinger, Winifried, 'Richard Riemerschmid und der Jugendstil', *Die Weltkunst*, 52 (1982), 894–7

Neue Pinakothek, Munich, 1989

Noun, Louise, *Three Berlin Artists of the Weimar Era: Hannah Höch, Käthe Kollwitz, Jeanne Mammen*, exhibition catalogue, Des Moines, 1994

Oskar Schlemmer: der Folkwang-Zyklus: Malerei um 1930, exhibition catalogue, Stuttgart, 1993

Ostini, Fritz von, *Uhde*, Bielefeld and Leipzig, 1912

Otto Dix 1891–1969, exhibition catalogue, London, 1992

Otto, Christian F., 'Modern environment and historical continuity: the *Heimatschutz* discourse in Germany', *Art Journal*, 43:2 (1983), 148–57

Overy, Paul, *Kandinsky: The Language of the Eye*, London, 1969

Pachnicke, Peter and Klaus Honnef (eds), *John Heartfield*, New York, 1992

Paret, Peter, *Art as History: Episodes in the Culture and Politics of Nineteenth-Century Germany*, Princeton, 1988

Paret, Peter, *The Berlin Secession: Modernism and its Enemies in Imperial Germany*, Cambridge, Mass., 1980

Paret, Peter, 'The Tschudi affair', *Journal of Modern History*, 53 (1981), 589–618

Passuth, Krisztina, *Moholy-Nagy*, London, 1985

Paul, Barbara, *Hugo von Tschudi und die moderne französische Kunst im deutschen Kaiserreich*, Mainz, 1993

Paula Modersohn-Becker, Worpswede, exhibition catalogue, Worpswede, 1989

Pauli, Gustav (ed.), *Liebermann: eine Auswahl aus dem Lebenswerk des Meisters*, Stuttgart and Berlin, 1922

Pehnt, Wolfgang, *Expressionist Architecture*, London, 1973

Perry, Gillian, *Paula Modersohn-Becker: Her Life and Work*, London, 1989

Pese, Claus, *Franz Marc: Leben und Werk*, Stuttgart, 1989, Eng. trans., Stuttgart, 1990

Petro, Patrice, *Joyless Streets: Women and Melodramatic Representation in Weimar Germany*, Princeton, 1989

Petropoulos, Jonathan, *Art as Politics in the Third Reich*, Chapel Hill, 1996

Petzet, Michael (ed.), *Wilhelm Leibl und sein Kreis*, exhibition catalogue, Munich, 1974

Peukert, Detlev, *The Weimar Republic: The Crisis of Classical Modernity*, London, 1991

Pevsner, Niklaus, *Pioneers of Modern Design: From William Morris to Walter Gropius* (1960), Harmondsworth, 1974

Pfefferkorn, Rudolf, *The Berliner Secession*, Berlin, 1972

Photography at the Bauhaus, exhibition catalogue, London, 1990

The Photomontages of Hannah Höch, exhibition catalogue, Minneapolis, 1996

Pirsich, Volker, *Der Sturm: eine Monographie*, Herzberg, 1985

Poggi, Christine, *In Defiance of Painting: Cubism, Futurism and the Invention of Collage*, New Haven and London, 1992

Pois, Robert, *Emil Nolde*, Washington, DC, 1982

Poling, Clark, *Kandinsky's Teaching Theory at the Bauhaus*, New York, 1986

Pommer, Richard, *Weissenhof 1927 and the Modern Movement in Architecture*, Chicago and London, 1991

Posener, Julius, *Hans Poelzig: Reflections on His Life and Work*, New York, 1992

Prange, Regine, *Das Kristalline als Kunstsymbol: Bruno Taut und Paul Klee*, Hildesheim, 1991

Prawer, S. S., *Caligari's Children: The Film as Tale of Terror*, New York, 1980

Prelinger, Elizabeth, *Käthe Kollwitz*, New Haven, 1992

Prodolliet, Ernst, *Nosferatu: Die Entwicklung des Vampirfilms von Friedrich Wilhelm Murnau bis Werner Herzog*, Olten, 1980

Puloy, Monika Ginzkey, 'High art and National Socialism Part I: The Linz Museum as ideological arena', *Journal of the History of Collections*, 8:2 (1996), 201–16

Raabe, Paul (ed.), *Ich schneide die Zeit aus: Expressionismus und Politik in Franz Pfemfert's 'Aktion' 1911–1918*, Munich, 1964

Raabe, Paul (ed.), *The Era of German Expressionism*, London, 1974

Raabe, Paul (ed.), *Index Expressionismus: Bibliographie der Beiträge in den Zeitschriften und Jahrbüchern des literarischen Expressionismus 1910–1925*, 18 vols, Nendeln, 1972

Raabe, Paul, *Die Zeitschriften und Sammlungen des literarischen Expressionismus*, Stuttgart, 1964

Ranfft, Erich, 'Widening contexts for German Expressionist sculpture before 1945', *Art History*, 16:1 (1993), 184–90

Rees, Paul, 'Edith Buckley, Ada Nolde and die Brücke: bathing, health and art in Dresden 1906–1911', in *German Expressionism in the UK and Ireland*, ed. Brian Keith Smith, Bristol, 1985

Reisenfeld, Robin, 'Cultural nationalism, Brücke and the German woodcut: the formation of a collective identity', *Art History*, 20:2 (1997), 289–312

Reynolds, Dee, *Symbolist Aesthetics and Early Abstract Art*, Cambridge, 1995

Rheinische Expressionisten, exhibition catalogue, Bonn, 1993

Rhodes, Colin, *Primitivism and Modern Art*, London, 1994

Richard, Lionel (ed.), *Phaidon Encyclopedia of Expressionism*, Oxford, 1978

Roessler, Arthur, *Neu-Dachau. Ludwig Dill, Adolf Hölzel, Arthur Langhammer*, Bielefeld and Leipzig, 1905

Roethel, Hans K. and Jean K. Benjamin, *Kandinsky: Catalogue Raisonné of the Oil Paintings*, 2 vols, London, 1984

Roethel, Hans, *Kandinsky*, Oxford, 1979

Rogoff, Irit (ed.), *The Divided Heritage: Themes and Problems in German Modernism*, Cambridge, 1991

Rohe, Franz, *German Art in the Twentieth Century*, London, 1968

Rohrl, Boris, *Wilhelm Leibl: Leben und Werk*, Hildesheim, 1994

Rosenbach, Detlev, *Alexej von Jawlensky: Leben und druckgraphisches Werk*, Hanover, 1985

Rosenhagen, Hans, *Uhde*, Stuttgart and Leipzig, 1908

Rosenhagen, Hans, *Liebermann*, Bielefeld and Leipzig, 1900

Rosenthal, Mark, *Franz Marc*, Munich, 1989

Roskill, Mark, *Klee, Kandinsky and the Thought of Their Time: A Critical Perspective*, Urbana, 1992

Rotzler, Willy, *Johannes Itten, Werke und Schriften*, Zurich, 1978

Rowland, Anna, *Bauhaus Source Book*, Oxford, 1990

Rubin, William (ed.), *Primitivism in 20th Century Art*, exhibition catalogue, New York, 1984

Ruhmer, Eberhard, *Der Leibl-Kreis und die reine Malerei*, Rosenheim, 1984

Sabarsky, Serge, *Graphics of the German Expressionists*, London, 1986

Sachsse, Rolf, *Lucia Moholy: Bauhaus fotografin*, Berlin, 1995

Salkeld, Audrey, *A Portrait of Leni Riefenstahl*, London, 1996

Sander, August, *Citizens of the Twentieth Century*, ed. Günther Sander, Cambridge, Mass., 1986

Sawelson-Gorse, Naomi (ed.), *Women in Dada: Essays on Sex, Gender and Identity*, Cambridge, Mass., 1998

Schäfer, Jörgen, *Dada Köln: Max Ernst, Hans Arp, Johannes Theodor Baargeld und ihre literarischen Zeitschriften*, Wiesbaden, 1993

Schama, Simon, *Landscape and Memory*, London, 1995

Scheper, Dirk, *Oskar Schlemmer: das triadische Ballett und die Bauhausbuhne*, Berlin, 1988

Schlemmer, Oskar, *Man: Teaching Notes from the Bauhaus*, London, 1971

Schmalenbach, Fritz, *Jugendstil. Ein Beitrage zu Theorie und Geschichte der Flächenkunst*, Würzburg, 1934

Schmalenbach, Fritz, 'The term Neue Sachlichkeit', *Art Bulletin*, 22:3 (1940), 161–5

Schmalenbach, Werner, *Kurt Schwitters*, London, 1970

Schmalhausen, Bernd, *'Ich bin doch nur ein Maler': Max und Martha Liebermann im Dritten Reich*, Hildesheim, 1994

Schmid, Heinrich, *Arnold Böcklin: eine Auswahl der Hervorragendsten Werke des Künstlers*, 4 vols, Munich, 1892–1901

Schmid, Max, *Klinger*, Bielefeld and Leipzig, 1899

Schmied, Wieland (ed.), *Neue Sachlichkeit and German Realism of the Twenties*, exhibition catalogue, London, 1979

Schmied, Wieland, *Neue Sachlichkeit und Magischer Realismus in Deutschland 1918–33*, Hanover, 1969

Schneede, Uwe, *The Essential Max Ernst*, London, 1972

Schoell-Glass, Charlotte, 'An episode of cultural politics during the Weimar Republic: Aby Warburg and Thomas Mann exchange a letter each', *Art History*, 21:1 (1998), 107–28

Schoenberner, Gerhard, *Artists Against Hitler: Persecution, Exile, Resistance*, Bonn, 1984

Schorske, Carl, *Fin-de-Siècle Vienna: Politics and Culture*, New York, 1980

Schräder, Bärbel and Jürgen Schebera, *The Golden Twenties: Art and Literature in the Weimar Republic*, New Haven, 1988

Schubert, Dietrich, *Die Kunst Lehmbrucks*, Worms, 1981

Schult, Friedrich, *Barlach. I. Das plastische Werk* (1960), *II. Das grafische Werk* (1958); *III. Werkkatalog der Zeichnungen* (1971), all Hamburg

Schulz-Hoffmann, Carla and Judith C. Weiss, *Max Beckmann: Retrospective*, exhibition catalogue, New York, 1984

Schuster, Peter-Klaus (ed.), *Die 'Kunststadt' München 1937. Nationalsozialismus und 'Entartete Kunst'*, Munich, 1987

Schwartz, Frederic, 'Commodity signs: Peter Behrens, the AEG and the trademark', *Journal of Design History*, 9:3 (1996), 153–84

Schwartz, Frederic, *The Werkbund: Design Theory and Mass Culture Before the First World War*, New Haven and London, 1996

Schweiger, Werner, *Der junge Kokoschka. Leben und Werk 1904–1914*, Vienna, 1983

Shields, Rob, *Places on the Margin: Alternative Geographies of Modernity*, London and New York, 1991

Simmons, Sherwin, 'War, revolution, and the transformation of the German humor magazine 1914–1927', *Art Journal*, 52:1 (1993), 46–54

Soussloff, Catherine M. (ed.), *Jewish Identity in Modern Art History*, Berkeley, 1999

Spalek, John (ed.), *German Expressionism in the Fine Arts: A Bibliography*, Los Angeles, 1977

Spieler, Reinhard, *Max Beckmann 1884–1950: The Path to Myth*, Cologne, 1995

Spies, Werner, *Max Ernst Collages: The Invention of the Surrealist Universe*, London, 1991

Spies, Werner, *Max Ernst Frottages*, London, 1986

Spies, Werner, *Max Ernst Oeuvre-Katalog*, 6 vols, Houston and Cologne, 1975–79

Stachura, Peter D., *The German Youth Movement 1900–1945: An Interpretative and Documentary History*, London, 1981

Stather, Martin, *Die Kunstpolitik Wilhelms II*, Konstanz, 1994

Stern, Fritz, *The Politics of Cultural Despair: A Study in the Rise of Germanic Ideology*, Berkeley, 1961

Symboles et réalités. La peinture allemande 1845–1905, exhibition catalogue, Paris, 1985

Tabor, Jan (ed.), *Diktatur: Architektur, Bildhauerei und Malerei in Österreich, Deutschland, Italien und der Sowjet-union 1922–56*, 2 vols, Baden, 1994

Tanner, Michael, 'Nietzsche', in *German Philosophers*, Oxford, 1997, pp. 344–434

Tatar, Maria, *Lustmord: Sexual Murder in Weimar Germany*, Princeton, 1995

Tavel, Hans Christoph von (ed.), *Der Blaue Reiter*, exhibition catalogue, Bern, 1986

Taylor, Brandon and Wilfried van der Will (eds), *The Nazification of Art: Art, Design, Music, Architecture and Film in the Third Reich*, Winchester, 1990

Taylor, Richard, *Film Propaganda: Soviet Russia and Nazi Germany*, London, 1979

Taylor, Robert R., *The Word in Stone: The Architecture of National Socialism*, Berkeley and Los Angeles, 1974

Taylor, Ronald, *Berlin and its Culture: A Historical Portrait*, New Haven and London, 1997

Taylor, Seth, *Left-Wing Nietzscheans: The Politics of German Expressionism 1910–1920*, Berlin and New York, 1990

Teeuwisse, Klaus, *Vom Salon zur Secession. Berliner Kunstleben zwischen Tradition und Aufbruch zur Moderne 1871–1900*, Berlin, 1986

Theweleit, Klaus, *Male Fantasies*, volume 1: *Women, Floods, Bodies, History*, Minneapolis, 1987; volume 2: *Male Bodies: Psychoanalysing the White Terror*, Oxford, 1989

Thiem Gunther and Armin Zweite (eds), *Karl Schmidt-Rottluff: Retrospektive*, Munich, 1989

Thode, Henry, *Arnold Böcklin*, Heidelberg, 1905

Thürlemann, Felix, *Kandinsky über Kandinsky: Der Künstler als Interpret eigener Werke*, Bern, 1986

Tönnies, Ferdinand, *Community and Association* (1887), Eng. trans. by Charles Loomis, London, 1955

Tower, Beeke Sell, *Klee and Kandinsky in Munich and the Bauhaus*, Ann Arbor, 1981

Twohig, Sarah O'Brien, *Max Beckmann's Carnival*, London, 1984

Uhde-Stahl, Brigitte, *Paula Modersohn-Becker: Frau, Künstlerin, Mensch*, Stuttgart, 1989

Uhr, Horst, *Lovis Corinth*, exhibition catalogue, Berkeley, 1990

Urban, Martin, *Emil Nolde: Catalogue Raisonné*, London, 1987

Väth-Hinz, Henriette, *Odol: Reklame-Kunst um 1900*, Giessen, 1985

Vaughan, William, *German Romantic Painting*, New Haven and London, 1980

Verdi, Richard, *Klee and Nature*, London, 1984

Verein der Berliner Künstlerin (ed.), *Käthe, Paula und der ganze Rest: Künstlerinnen Lexicon*, Berlin, 1992

Verein der Berliner Künstlerin (ed.), *Profession ohne Tradition. 125 Jahre Verein Berliner Künstlerin*, Berlin, 1992

Vergo, Peter, *Art in Vienna 1898–1918*, 2nd edn, Oxford, 1981

Vergo, Peter, *Emil Nolde*, exhibition catalogue, London, 1995

Vester, Karl-Egon, *Gabriele Münter*, exhibition catalogue, Hamburg, 1988

Vezin, Annette, *Kandinsky and the Blaue Reiter*, Paris, 1992

Vierhuff, Hans Gotthard, *Die neue Sachlichkeit: Malerei und Fotografie*, Cologne, 1980

Vogel, Julius, *Max Klingers Leipziger Skulpturen*, 2nd edn, Leipzig, 1902

Vogt, Paul, *Expressionism: German Painting 1905–1920*, New York, 1980

Vogt, Paul, *The Blue Rider*, Woodbury, 1980

Walden, Nell and Lothar Schreyer, *Der Sturm. Ein Erinnerungsbuch an Herwarth Walden und die Künstler aus dem Sturmkreis*, Baden-Baden, 1954

Walker, John A. and Sarah Chaplin, *Visual Culture: An Introduction*, Manchester and New York, 1997

Washton-Long, Rose-Carol, *Kandinsky: The Development of an Abstract Style*, Oxford, 1980

Washton-Long, Rose-Carol, 'Kandinsky's abstract style: the veiling of apocalyptic folk imagery', *Art Journal*, 34 (1975), 217–28

Wassily Kandinsky: Zeichnungen und Aquarelle, Munich, 1974

Webster, Gwendolen, *Kurt Merz Schwitters: A Biographical Study*, Cardiff, 1997

Weinstein, Joan, *The End of Expressionism: Art and the November Revolution in Germany 1918/19*, Chicago and London, 1990

Weiss, Jeffrey, *The Popular Culture of Modern Art: Picasso, Duchamp and Avant-Gardism*, New Haven and London, 1994

Weiss, Peg, *Kandinsky and Old Russia: The Artist as Ethnographer and Shaman*, New Haven, 1995

Weiss, Peg, *Kandinsky in Munich: The Formative Jugendstil Years*, Princeton, 1979

Weissler, Sabine (ed.), *Design in Deutschland 1933–45: Ästhetik und Organisation des Deutschen Werkbund im 'Dritten Reich'*, Giessen, 1990

Welch, David, *Propaganda and the German Cinema 1933–1945*, Oxford, 1983

Weltge, Sigrid, *Bauhaus Textiles: Women Artists and the Weaving Workshop*, London, 1993

Werckmeister, O. K., *The Making of Paul Klee's Career 1914–1920*, Chicago, 1989

West, Shearer, *Fin de Siècle: Art and Society in an Age of Uncertainty*, London, 1993

West, Shearer, 'National desires and regional realities in the Venice Biennale 1895–1914', *Art History*, 18:3 (1995), 404–34

West, Shearer, 'Portraiture in the twentieth century: masks or identities?', in Christos M. Joachimides and Norman Rosenthal (eds), *The Age of Modernism: Art in the Twentieth Century*, exhibition catalogue, Berlin, 1997, pp. 65–71

Weyandt, Barbara, *Farbe und Naturauffassung im Werk von August Macke*, Hildesheim, 1994

Whitford, Frank, *Bauhaus*, London, 1984

Whitford, Frank, *Expressionist Portraits*, London, 1987

Whitford, Frank, *Oskar Kokoschka: A Life*, London, 1986

Whyte, Iain Boyd, *Bruno Taut and the Architecture of Activism*, Cambridge, 1982

Wichmann, Siegfried, *Jugendstil: Art Nouveau*, Munich, 1977

Wiedmann, August, *Romantic Roots in Modern Art: Romanticism and Expressionism*, Old Woking, 1979

Wietek, Gerhard, *Deutsche Künstlerkolonien und Künstlerorte*, Munich, 1976

Wietek, Gerhard, *Schmidt-Rottluff: Oldenburger Jahre 1907–1912*, Mainz, 1995

Wilhelm Leibl zum 150.Geburtstag, exhibition catalogue, Munich, 1994

Willett, John, *Expressionism*, London, 1970

Willett, John, *The New Sobriety: Art and Politics in the Weimar Period 1917–33*, London, 1978

Willett, John, *The Weimar Years: A Culture Cut Short*, London, 1984

Williams, Raymond, *The Country and the City*, London, 1985

Windecker, Sabine, *Gabriele Münter: eine Künstlerin aus dem Kreis des 'Blauen Reiter'*, Berlin, 1991

Windsor, Alan, *Peter Behrens: Architect and Designer 1868–1940*, New York, 1981

Wingler, Hans, *The Bauhaus – Weimar, Dessau, Berlin, Chicago 1919–1944*, Cambridge, Mass., 1978

Winskell, Kate, 'The art of propaganda: Herwarth Walden and "Der Sturm", 1914–1919', *Art History*, 18:3 (1995), 315–44

Wistrich, Robert, *Weekend in Munich: Art, Propaganda and Terror in the Third Reich*, London, 1996

Worpswede Künstler Kolonie Norddeutschlands, exhibition catalogue, Worpswede, 1992

Worpswede: 100 Jahre Künstlerort, Fischerhude, 1989

Zangs, Christiane, *Die künstlerische Entwicklung und das Werk Menzels im Spiegel der zeitgenossischen Kritik*, Aachen, 1992

Zdenek, Felix (ed.), *Lovis Corinth*, exhibition catalogue, Cologne, 1985

Zenser, Hildegard, *Max Beckmann's Selbstbildnisse*, Munich, 1984

Zweite, Armin (ed.), *Alexej Jawlensky 1864–1941*, exhibition catalogue, Munich, 1983

Zweite, Armin, *The Blue Rider in the Lenbachhaus, Munich*, Munich, 1989

Index

Note: **bold** type indicates an illustration